W9-CAP-116

modernist design 1880-1940

modernism

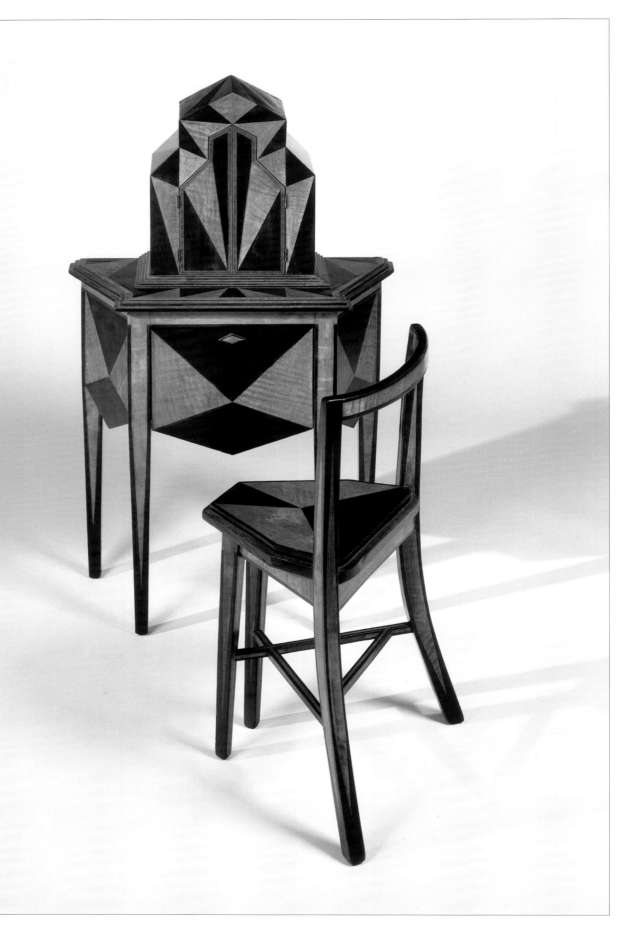

modernist design 1880-1940

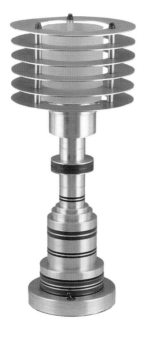

TEXT BY

Alastair Duncan

THE NORWEST COLLECTION

NORWEST CORPORATION

MINNEAPOLIS

ANTIQUE COLLECTORS' CLUB

British Library Cataloguing-in-Publication Data
A catalogue record for this book is available from the British Library

Printed in England
by the Antique Collectors' Club Ltd., Woodbridge, Suffolk
on Consort Royal Era Satin paper
supplied by the Donside Paper Company, Aberdeen, Scotland

FRONTISPIECE:

ABEL FAIDY (1895-1965) Swiss American
Telephone Stand and Chair, c.1927. Ebonized walnut and maple marquetry with mechanized doors.
Attributed to Abel Faidy.
Telephone Stand: H: 44in (111.8cm) x W: 26 ½in (67.3cm) x D: 13in (33cm)
Chair: H: 30in (76.2cm) x D: 14in (35.6cm)

TITLE PAGE:
WALTER VON NESSEN (1889-1943) Table Lamp, 1935. See page 199.

HECTOR GUIMARD (1867-1942) French
Jardinière, c.1900. Cast iron. The design appears in Guimard's portfolio, *Fontes Artistiques*, pl. 41.
H: 8in (20.3cm) x W: 40in (101.6cm) x D: 9in (22.9cm)

CREDITS

Andrew Geoffrey Winton: Designer

Diana McMillan: Editor

PHOTOGRAPHERS:

Feliciano, New York

Gerry Mathiason, Minneapolis

Gary Mortensen, Minneapolis

Ed Watkins, New York

Petronella Ytsma, St. Paul

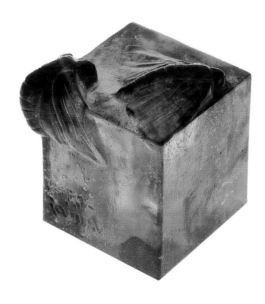

GABRIEL ARGY-ROUSSEAU (1885-1953) French
Paperweight, 1923. Pâte-de-crystal. Cube form with two carved moths on top.
Marks: G. ARGY-ROUSSEAU etched on side.
H: 2 ½in (6.4cm) x W: 1 ⅞in (4.8cm) x D: 2 ¼in (5.7cm)

CONTENTS

865 67

800 62

IDS Elevation 776.0

Last occupiable floor 58

735 57

HVAC

140 30'

678 52

CityCenter I elevation 650

605 47

540 42

CityCenter II (estimated elev. 465)

475 37

170' 30'

410 32

345 27

25

280 22

215 17

150 12

120'

85 7

CityCenter Retail Elev. 85.0 FMBank 30

33 5

17 2

0

Marquette

13 13 12 13

Marquette

Nicollet Mall

Program Goal

Gross 1,175,000

Net 1,075,000

Gross Area 1,278,320 - 1,175,000 = 103,320 (8%)

or

1,278,320 @ 87% efficiency =

1,112,138 SF Net Rentable,

1,112,138 - 1,075,000 = 37,138 (3%)

198'0"

7th Street

132'0"

OFFICE TOWER

BANK

Service 6th Street

Winter Garden

43,560 SF

Marquette 330'-0"

Floor Plate Similar Scheme A

112'

270'

Assumptions:

1.) Norwest Center Street Level Skyway Typical O...

2.) CityCenter II Five Lev... 345 by ... w/ 25 ta...

10,

12

19

25

30

17

38

NORWEST

INTRODUCTION

MODERNISM AT NORWEST

In 1987, Norwest Corporation initiated a fully coordinated arts program to complement its new spaces in Norwest Center, a 57-story office tower in downtown Minneapolis designed by Cesar Pelli & Associates.

The concept of the program – to acquire a Modernism collection comprised of late 19th- to early 20th-century decorative and applied arts, and paperworks – was prompted in large part by the character of the building and its interior spaces. The grand lobby concourse, the respectful incorporation of architectural elements (chandeliers, wall sconces and balustrades) salvaged[1] from Norwest's previous building, and the ideal location at one of the city's busiest crossroads, were the sources of inspiration for a pedestrian *boulevard d'art*.

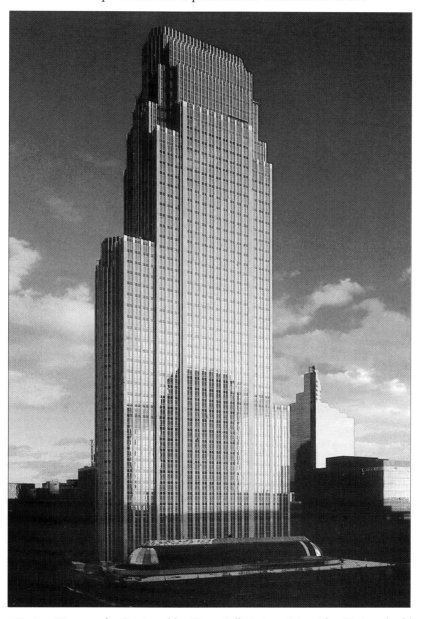

Norwest Center, Minneapolis. Designed by Cesar Pelli & Associates. The 57-story building was formally dedicated in January, 1989, in the same month the corporation was founded 60 years earlier.

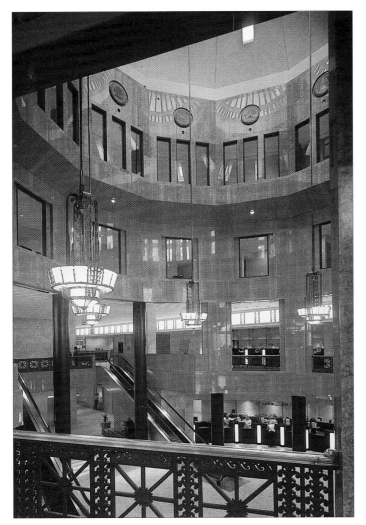
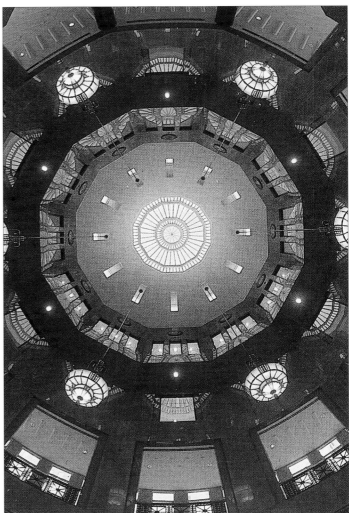

Interior view of rotunda dome. Massive hand-wrought bronze chandeliers, plaster medalions and a balustrade that graced the grand banking hall of the old Northwestern National Bank Building were salvaged following the 1982 fire, carefully restored and integrated into the design of the banking rotunda.

Initially, a series of sixteen specially-designed vitrines (showcases) was symmetrically aligned along two corridors. In 1992, five smaller vitrines were added to the skyway level, an elevated passageway linking commercial buildings throughout the heart of the city; two years later, eight additional cases were installed in an adjacent office building. The collection's debut and the formal opening of Norwest Center were timed to coincide in January 1989. Thereafter, works from the collection have been presented in thematic exhibitions expressly for the public, each examining aspects of Modernism.

While confusion persists over the precise meanings of *modern, moderne, modernist, modernism* and *contemporary* as applied to art, architecture and design, the term *Modernism* has been adopted by the art community in recent years to describe a diverse range of architecture, decorative, applied and graphic arts created between 1880 and 1940, from the emergence of the British Arts and Crafts Movement to the outbreak of the Second World War. The period is elastic, some preferring to include The Aesthetic Movement (1860-1880) as well; others have extended the dates to include the '50s. The term commonly applies to those forward-looking architects, designers and craftsmen who managed to escape *historicism,* the tyranny of previous historical styles and a calcified culture.

View of east and west promenades showing vitrines installed on the ground floor.

Centuries of servitude to revivalist design in form and decoration were forever liberated by their groundbreaking visions. A new, international design vocabulary emerged and the tenets of Modernism continue to inform much of today's art, design and architecture.

The principal movements commonly associated with the decorative and applied arts within this 60-year period include[2]:

ARTS AND CRAFTS
(1875-1915)
British and American phases

ART NOUVEAU
(1880-1910)
European and American phases

WIENER WERKSTÄTTE
(1903-1933)
Including Vienna Moderne (1895-1930)

DE STIJL
(1917-1928)
Including Dutch Modern (1920-1950)

BAUHAUS
(1919-1933)
Including Deutsche Werkbund (1907-1934)

ART DECO
(1920-1940)
European and American (Art Moderne) phases

Views of vitrines installed with works selected from the Norwest collection.

Significant works representing the salient components of these movements as well as innovative, one-of-a-kind objects have been acquired. The works are exhibited on a rotating basis, installed in gallery spaces when not on view in the vitrines. The collection's emphasis is on three-dimensional works (ceramics, glassware, metalwork and selected furniture) by artist-designers identified with the six great classical design movements of the century. Paperworks, particularly posters (for their exemplary layout and typography) are acquired for the shallow vitrines as well as gallery spaces.

To provide the broadest historical context, efforts have been made to round out artist and media representation, but the overriding objective has been to acquire works conveying ideals of quality design – *design as art* [3]. The collection is neither comprehensive nor systematic. Many canonized figures and their respective works are represented, yet so too are numerous unknown and unheralded talents. Many pieces are well on their way to becoming widely recognized icons of modernity. Given the vitrines' size limitations as well as other restrictive factors (climate-control, security, storage, fragility, and costs), the collection does not include jewelry, fashion, textiles, crafts, architectural fragments, paintings, prints, drawings or photography. Only limited furniture has been acquired, a high priority given to works that may be installed in the vitrines [4]. Today, the collection numbers approximately 450 works, divided almost equally between objects and paperworks. It is a relatively small body of works, even by corporate standards, yet there is a considerable range of media, from William Morris wallpaper sheets dating as early as the 1870s to a 1939 Tiffany tea service;

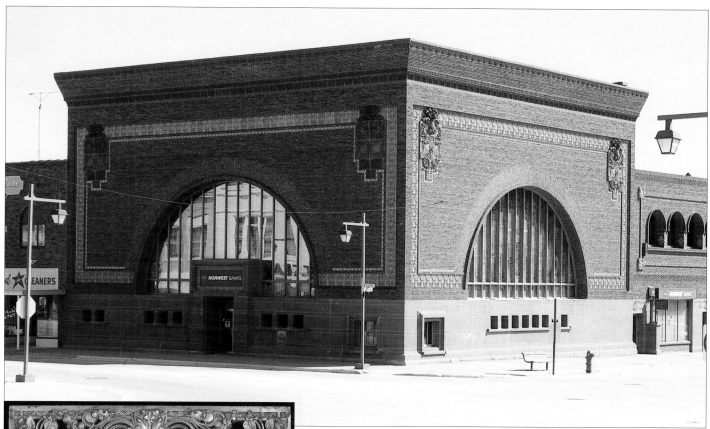

LOUIS H. SULLIVAN (1856-1924)
Norwest Bank Owatonna (formerly The National Farmers' Bank), 1906-08.
George Grant Elmslie (1871-1952) Chief Draftsman.

Louis Sullivan 1856-1924 Bank Owatonna Minn
Architecture USA 18c

Norwest Bank Owatonna was commemorated on a United States postage stamp issued in 1981.

GEORGE GRANT ELMSLIE (1871-1952) American
Teller Wicket, 1908. Bronze-plated cast-iron.
The National Farmers' Bank in Owatonna, Minnesota, perhaps the most famous small-town bank building in America, is the first of eight bank commissions received at the end of architect Louis Sullivan's career. It is among the finest examples of Sullivan's genius in integrating ornament with modernist structural expression, using it as a means to heighten perception of a building's fundamental structural and sensual aspects. Although located on what was then the remote prairie, the bank was recognized internationally as an architectural masterpiece soon after opening in 1908. The finest talent, materials and craftsmanship that Sullivan had at his disposal were incorporated into this initial commission. Principal among them were the services of George Grant Elmslie, chief draftsman in Sullivan's office. It was Elmslie who executed most of the drawings for the bank and who designed the eight teller wickets (all but two were sold for scrap iron in 1940). Made of bronze-plated cast-iron, Elmslie was to later complain that his *grilles* were "overlyrical." Despite his reservations, however, they are now regarded as among his greatest achievements as an ornamentalist.

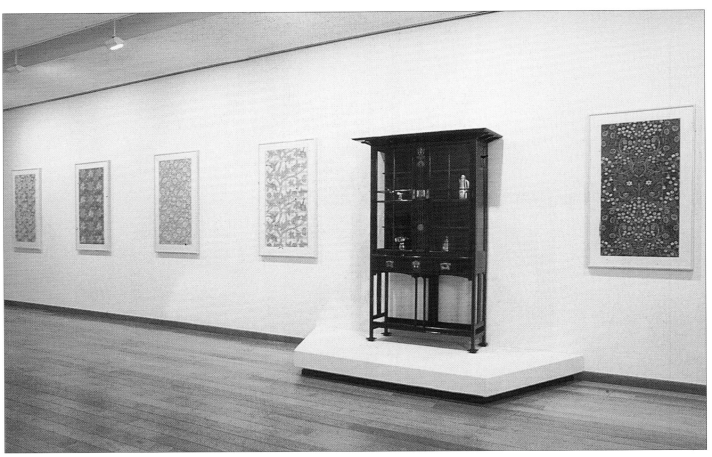

View of Fourth Floor Gallery installed with works from the Norwest collection.

from a fully operational bank by Louis H. Sullivan to an Art Moderne ice gun.

When the program was conceived, the vitrines provided the principal impetus and rationale for the collection. The idea of giving over four customer dining rooms to one of the major styles, the installation of floor-to-ceiling vitrines as architectural elements on the third and fourth floors, and the addition of a C-shaped, fourth-floor gallery grew out of the collection almost naturally while working with Studios, an interior design firm in San Francisco. They were a major creative force in extending the art program into the interiors.

The first and most important acquisition for the collection was acquired by Norwest in 1982, before the arts program existed; it too served as an early inspiration for the collection. The Owatonna Bank (formerly the National Farmers' Bank) by architect Louis H. Sullivan is an hour's drive from Minneapolis. The first of eight rural bank commissions Sullivan was to receive in the late stages of his career, between 1906 and 1919, it resulted from a serendipitous partnership between architect, patron (Carl K Bennett), a banker in Owatonna, and chief draftsman, George Grant Elmslie. Today, Sullivan is recognized as one of American's pre-eminent architects, a master at balancing geometric form with organic ornament.

Deceptively simple from the outside, the exterior embellishments only hint at what lies within. A single architectural vestibule invites one through a solid, unitary form into a large banking room bathed in natural light, resplendent with floral ornamentation. The stained glass windows emit a pervasive glow heightened further by the color harmonies of the terra-cotta decorations. Sullivan proudly and fondly referred to his giant jewel box as a *color symphony*. The

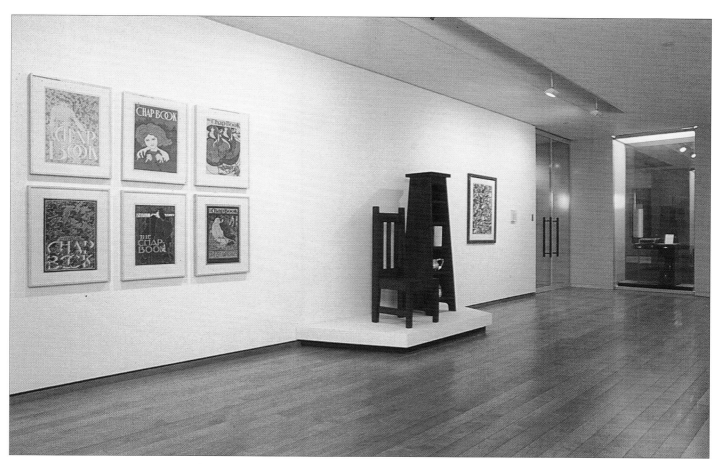

View of Fourth Floor Gallery installed with works from the Norwest collection.

building provides interesting links to the collection as well. The terra-cotta work designed by George Elmslie was executed by William Gates who designed the collection's architectonic Teco vase and the bank's jardinières. In 1989, Norwest acquired its second Sullivan-designed bank, this one in Cedar Rapids, Iowa. It too has been restored and is now fully operational.

The exhibitions presented in Norwest Center are a critical component of the arts program. Since its opening in 1989, ten exhibitions[5] have been presented, all based on modernist themes and all comprised of works selected from the collection. The vitrines offer an opportunity to present sharply-focused visual essays, often with a single work in each. The collection is broad enough to accommodate exhibitions examining aspects of a particular style, media, object type or the work of a single artist-designer; brochures and annotated labels supplement each exhibition. Special slide-talks by guest lecturers are presented for employees on related design topics such as architecture and fashion, areas not covered by the collection.

The six decades from 1880 to 1940 constitute one of the richest periods of accomplishment in the history of western design, certainly one of the most productive and aesthetically innovative. A remarkable body of gifted artist-designers – many now recognized as the master formgivers of the century[6] – produced the quintessential elements of modernist design. It is a period characterized by restless creative probing, exquisite craftsmanship, contrasting leit-motifs[7], methodical explorations, and endless tensions, dualities and contradictions, from the x-rated, languid curve to the no-nonsense right angle, from ornament in excess to spareness in the extreme. It is a period in which

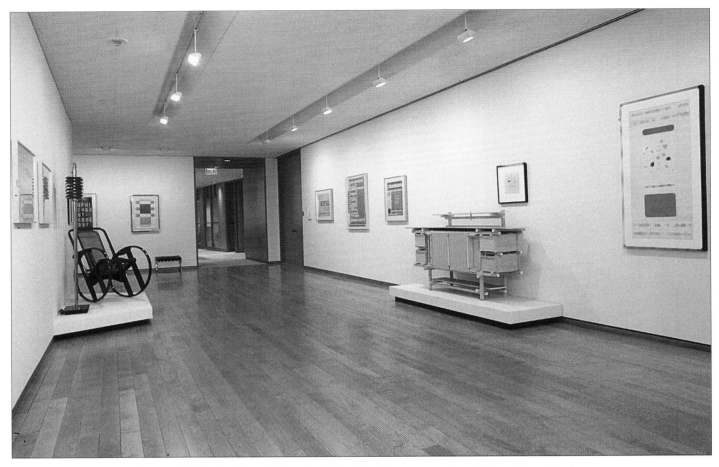

View of west wall, Fourth Floor Gallery installed with *Horseman* poster, 1919 and shopping bag, c.1935, both by Bart van der Leck; sideboard, 1919 (original design) and other De Stijl poster designs.

conceits of mind, mood and matter have been ingeniously integrated into timeless emblems of modernity, lasting testaments to individuality and creative genius.

Remarkable as this may be, there is little evidence of it to be found in American institutions. In fact, the Norwest collection of Modernism serves an a telling commentary on modern design in America. That a collection of important works could be assembled in such a short period says more about design awareness in the United States than it does about collecting prowess. The decorative and applied arts have always been subordinated to the fine arts in American museums: acquisition funds, gallery space, exhibitions and curator salaries have become available begrudgingly at best[8]. For 20th-century design, the situation is both unresolved and ironic inasmuch as most art museums now aggressively use architects and designers to make their collections, publications and exhibitions more accessible. In fact, today's ultra-designed museum has become the cathedral of the modern world.

Yet, only a handful of American museums – unlike their European counterparts – have even begun to think seriously about the formation of comprehensive applied arts collections. This predicament is particularly incongruous when compared to the many museums having large departments devoted to 20th-century painting and sculpture, let alone art centers devoted exclusively to contemporary art. Fortunately, there has been some progress. Only 30 years ago these same encyclopedic museums refused to collect works by living artists as a matter of policy. Many have since established serious photography departments

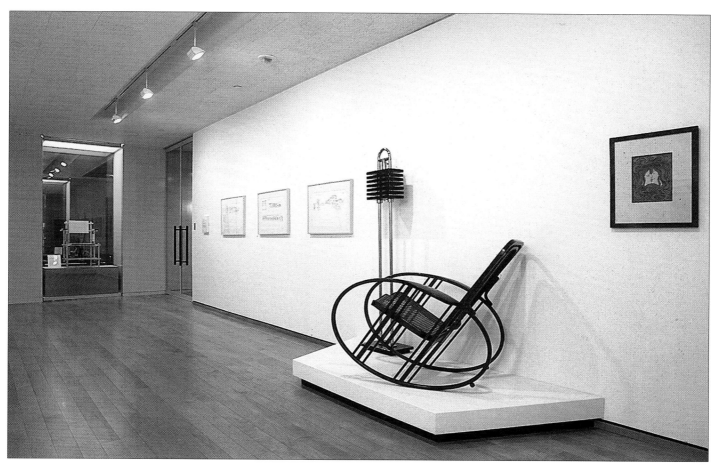

View of east wall, Fourth Floor Gallery installed with works from the Norwest collection.

and recently several have added architecture to their list of curatorial programs. Initiatives for the serious study and enjoyment of contemporary design, however, have yet to follow.

These issues reflect a lack of knowledge, if not implied resistance to design in our society. The Federal government (unlike in Europe and Japan) has yet to consider the design industry to be part of our national identity or even a critical factor in our economy. This, despite painful lessons learned in the automobile and high-tech electronics industries, both totally revolutionized by the superior design of the Japanese. The Scandinavians, British, French, Italians and Germans have long demonstrated on-going commitments to design as a matter of national policy.

Within the art market itself, the applied arts are considered less valuable than the fine arts. A design object may be purchased for only a fraction of the cost of a painting, drawing or sculpture by artists of comparable merit. Because monetary values are indicative of what a capitalist society considers important, the message is transmitted to museums in both overt and indirect ways. The issue of the unique, hand-made object vs. the machine-aided (or worse, machine-made), mass-produced object is no better resolved for museums than it was at the turn of the century, a situation further complicated by the role of crafts in public collections.

Moreover, it is difficult, if not impossible to study the applied arts at the graduate level within art history departments at many of our major universities though these same departments have large faculties in 20th-century architecture,

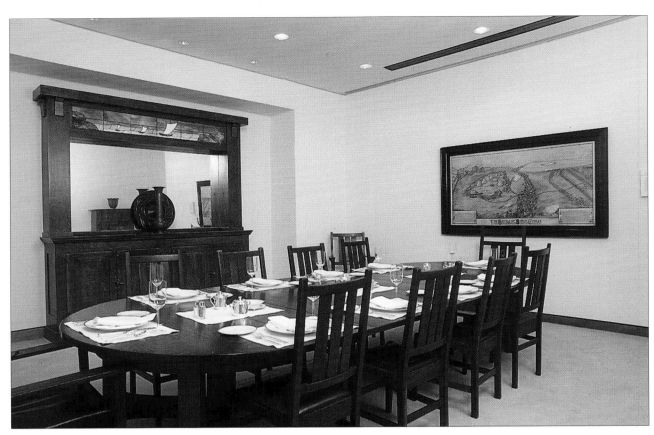

Arts and Crafts Dining Room.

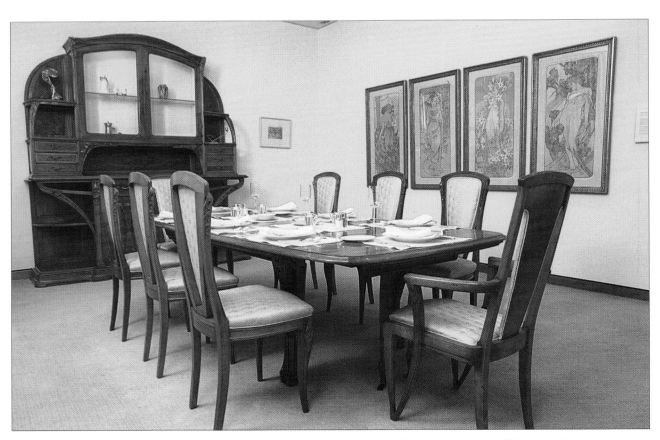

Art Nouveau Dining Room showing Louis Majorelle *Chicorée* dining room suite, c.1902 and *The Flowers*, 1897 by Alphonse Maria Mucha.

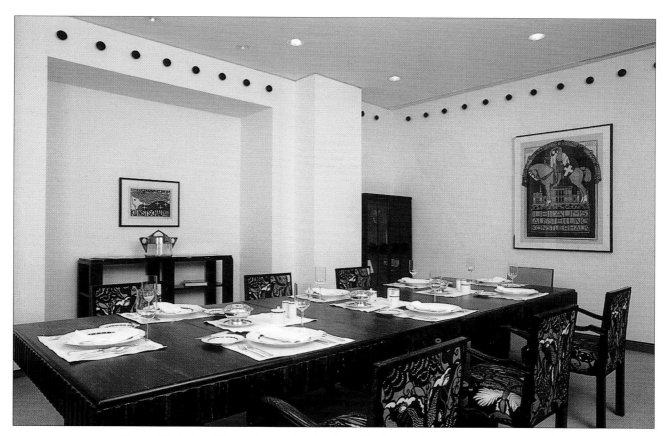

Wiener Werkstätte Dining Room showing Josef Hoffmann dining room suite, 1913-14.

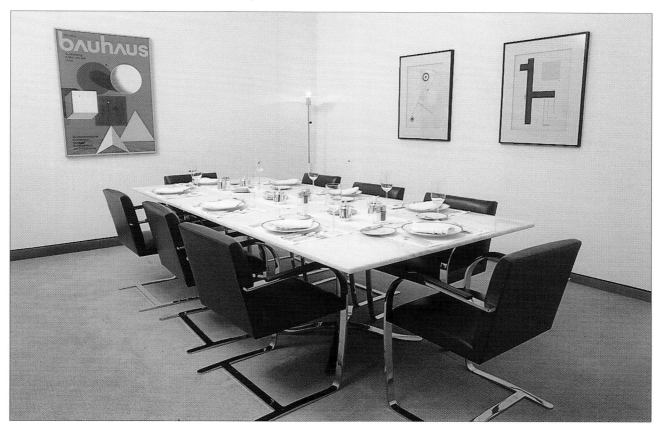

Bauhaus Dining Room.

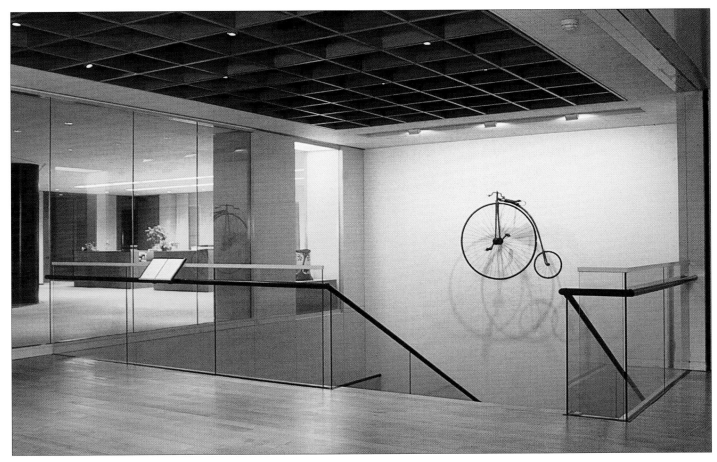

View of Fourth Floor staircase

painting, sculpture and photography. Today's curator of decorative arts has necessarily been schooled in programs deeply rooted in historic styles and values, rather than in applied or industrial design and thus lacks a thorough knowledge of the seminal 20th-century art movements which played a crucial role in the development of design. Little wonder so few design departments exist in our museums. Such value judgments shape our culture and are not easily changed[9]. It is just such a climate that initiated the first corporate collection devoted entirely to Modernism.

David Ryan
Director, Arts Program
Curator of Collections
Norwest Corporation
Minneapolis

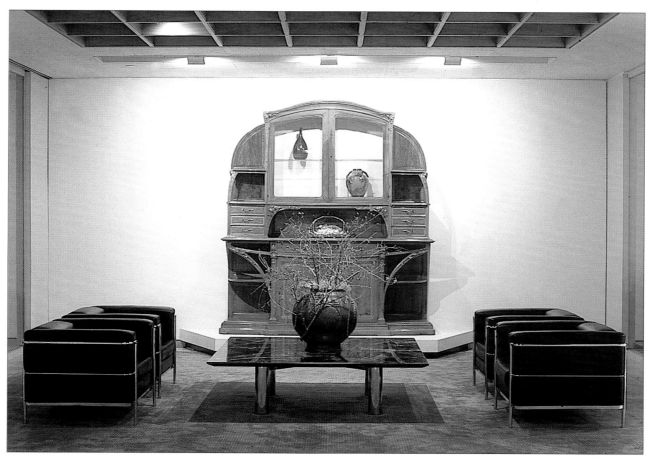

Executive Floor Reception showing Louis Majorelle buffet and Frank Lloyd Wright urn.

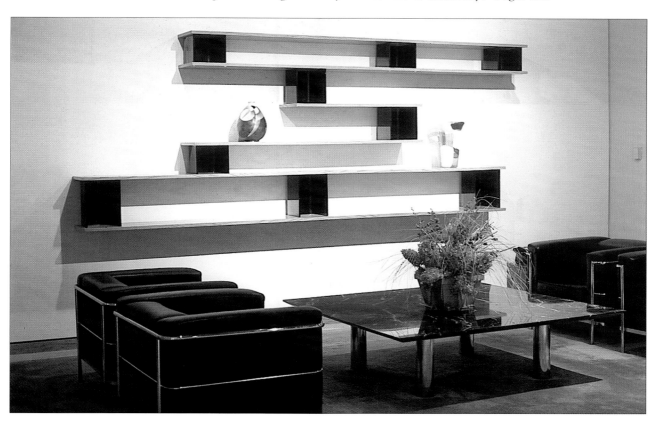

Executive Floor Reception showing Charlotte Perriand Bibliothèque.

Norwest exhibition brochures (refer to footnote 5).

NOTES:

1. In 1982, a Thanksgiving Day fire completely destroyed Norwest's headquarters, a sixteen-story building occupying half a city block in downtown Minneapolis. An early tentative assessment placed the damage at $75 million, the most costly fire in Minneapolis history. Although the landmark 1929 Art Deco structure was totally gutted, many of the architectural elements installed in the grand banking hall were rescued.

2. While these movements provide convenient classifications they are not absolute. As in all the arts, many artists and their works resist easy categorization. Where overlap occurs, works are assigned to that style in which it shares the closest affinities. Works executed by Viennese designers before 1903 when the Wiener Werkstätte opened or after 1933 when it closed, or by designers who were not officially members of the WW are grouped under the sub-category Vienna Moderne. The same has been done with De Stijl and the sub-category Dutch Modern and, likewise, to Bauhaus and the sub-category Deutsche Werkbund.

3. One of the difficulties underlying design appreciation and these respective movements is the issue of quality and connoisseurship. In many museum exhibitions and publications the emphasis has often been on representation rather than on curatorial selectivity, especially with Art Deco. Continuous evaluations over time in other disciplines such as painting, sculpture and prints have resulted in a well-grounded consensus by those closest to the field, but the natural process of selectivity has not been allowed to nurture with 20th-century decorative arts and design. More concerted efforts to make serious artistic judgments rather than encyclopedic overviews will help to establish standards of excellence for scholars, curators and collectors alike.

4. Another important feature of the Norwest collection is the manner in which Cesar Pelli's building, the appointed elements, and the vitrines are all careful integrated. Building and collection have, in fact, become one. In many corporate collections art works have been applied to inherited spaces like so many decals pasted to the wall. Today, more architects and artists are working in genuine partnerships on site-specific commissions just as Cesar Pelli and Siah Armajani did with the skyway bridge which connects Norwest Center to an adjoining building.

5. Norwest exhibitions:
Modernism at Norwest, 1989-90
Modernist Ceramics: 1880-1940, 1990-91
Modernist Lighting: 1900-1940, 1991-92
Women in Modernist Design: 1900-1945, 1992-93
The American Moderne: 1920-1940, 1993-94
Art Nouveau in Europe, 1994-95
Vienna Moderne: 1895-1930, 1995-96
Modernist Metalwork: 1900-1940, 1996-97
Scandinavian Moderne: 1900-1960, 1997-98
Fin de Siècle: 1900 & 2000, 1998-99

6. Emile Gallé (1846-1904); Louis Comfort Tiffany (1848-1933); Antoni Gaudí (1852-1926); Charles Rennie Mackintosh (1868-1928); Frank Lloyd Wright (1867-1956); Hector Guimard (1867-1942); and Josef Hoffmann (1870-1956) to name but a few. Not only was there an extraordinary number of gifted architects, artists, and artisans, their careers coincided with and often became inseparable from the phenomenal technological, scientific and commercial advances of their time.

7. Tradition vs. innovation; reactionary vs. visionary; honesty-to-materials vs. faux; unique (one-of-a-kind) vs. multiple; hand-made vs. machine-made; organic vs. geometric (curve vs. angle); naturaliste vs. abstraction; decorative vs. functional; ornament vs. form (form follows function); intuitive vs. cerebral.

8. The role of design in American museums is well articulated in *Modern Design in the Metropolitan Museum of Art, 1890-1990,* by R. Craig Miller, Associate Curator, 20th Century Department, from which these points have been extracted and paraphrased. The book was jointly published in 1990 by The Metropolitan Museum of Art and Harry N. Abrams, Inc., New York. Mr. Miller's points were expanded further in his article entitled *Unity and Renewal: Modern Design in American Art Museums* appearing in *NEOS,* the Journal of the Design Council, Denver Art Museum (Vol. 5, no. 1, 1995). Mr. Miller is presently Curator of the Architecture, Design & Graphics department, Denver Art Museum, administering one of the few such museum programs in America. Two additional sources for exploring the critical issues of design are: *By Design* by Ralph Caplan, St. Martin's Press, New York, 1982, and *Terence Conran on Design,* by Terence Conran, The Overlook Press, Woodstock/New York, 1996. Conran has made a lifetime commitment to design in both words and deeds in Great Britain.

9. The systematic dismantling of public arts education (including the Arts and Humanities Endowments), the American urge to democratize the arts and eliminate aesthetic distinctions and the increasing dominance of popular culture are having a dramatic effect on the arts in this country. It is dismaying that so little attention is given to design in its broadest sense, particularly in education, from public school through college, inasmuch as it affects everything we see and do. Moreover, two basic human needs: to add (the irresistible urge to embellish and enrich) and to subtract (the equally compelling need to achieve order, to simplify, to reduce) are the rudiments of design. They are likewise endemic to survival, the designing of one's life. Lastly, such pressing issues as the layout and functioning of our global communities and the survival of the planet are inextricably tied to design.

All dimensions given in inches (in) and centimetres (cm). Height (H) precedes width/length (W) precedes depth/diameter (D). On paperworks, image size precedes frame size.

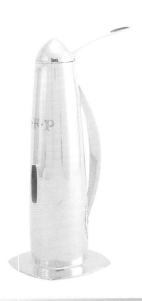

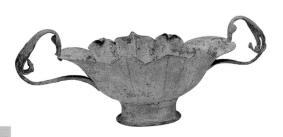

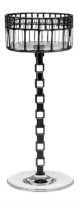

ARTS AND CRAFTS

The Arts and Crafts Movement began in Britain initially as a reaction to the de-humanizing effects of late 19th-century industrialization.

The movement's principal aims were to revive an artisan guild system aspiring to high standards of craftsmanship, and to return to simplified, honest forms using fine, natural materials. In America, the movement echoed these ideals, embracing further the virtues of hearth and home with spartan furniture designs which extended into the interiors of both the Mission Style and the Prairie School.

ART NOUVEAU

The *new art* became the first popular 20th-century style. Essentially European, it was fed initially by a widespread craze for *Japonisme*. A stultifying devotion to previous historical styles was totally replaced with organic form and decoration inspired largely by nature. Familiar motifs included curvilinear elements, sinuous contours and the use of tendrils and floral arabesques, whiplash lines and later, exaggerated embellishment. The fondness for Orientalism found its way to America, reaching its zenith in the stunning glasswork of Louis C. Tiffany.

WIENER WERKSTÄTTE

The Vienna Workshop was a direct offshoot from the fin-de-siècle Vienna Secession and was modeled principally on the British Guild of Handicraft.

In only two years, it engaged more than 100 artisans, its forte being handmade metalwork whose reductive style belied a dependence on handcrafts-manship. A marked change in style around 1915 led to more florid, organic elements, hints of what would soon follow in the Art Deco movement.

mode

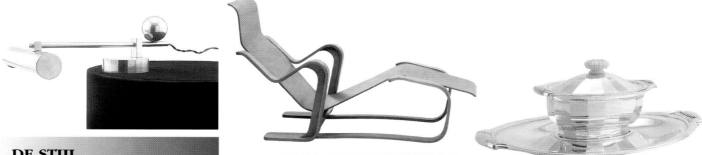

DE STIJL

Dutch for *The Style*, it is the name of a group of artists and architects who set out to create a universal style in architecture, the graphic arts and design, using squares and rectangles in flat planes of bold primary colors along with black, gray and white, all carefully orchestrated with straight lines. Much of the style's guiding principles were extremely theoretical. The painted furniture of Gerrit Rietveld has become a familiar emblem of De Stijl.

BAUHAUS

Founded by Walter Gropius in Weimar, Germany (later moved to Dessau), the Bauhaus School has come to represent the distillation of the Modern movement and the fundamentalist design ethic. Characterized by a "form follows function" idealogy, it was a logical extension of those principles established in the Arts and Crafts movement, except that it enthusiastically advocated the use of the machine in fabricating processes. The movement represents an important bridge between the decorative arts and industrial design.

ART DECO

Taking its name from the great Paris exposition of 1925, this highly eclectic style absorbed influences as diverse as Art Nouveau, Cubism, Bauhaus, Egyptology, Ballets Russes, primitive cultures and Hollywood. Exotic woods, exquisite finishes and precious materials were its hallmark. The later American phase (Art Moderne) is associated with both rectilinear forms and sleek, streamlined contours as well as synthetic materials and an infatuation with speed and aerodynamics.

ARTS
AND

1875-1915

ARCHIBALD KNOX (1864-1933) Scottish
Pitcher With Extended Lid Handle, 1901.
Sterling silver set with two long, narrow cabochons of jade.
Incised Celtic design (stylized knots motif) around handle.
Marks: inscribed initials: *HFP*. Stamped marks on underside
of base: *L. & Co* (maker's mark: Liberty & Co.); anchor image
(town mark: Birmingham); lion passant image (sterling mark);
(date: 1901) Cymric (Cymric line); and *S3017* hand engraved
registration number. Owing to the skill and time involved in
execution, script numerals were restricted to the larger, more
expensive pieces. Attributed to Archibald Knox.
Executed by Wm. Haseler & Sons for Liberty & Co., London.
H: 15in (38.1cm) x W: 8 ½in (21.6cm) (at lid handle)

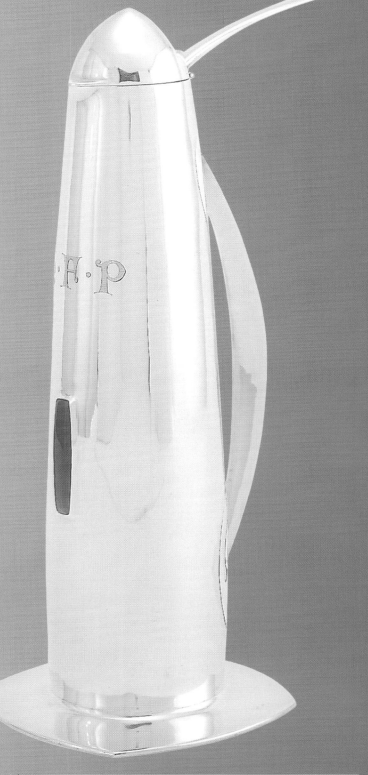

This rare and important pitcher – possibly the only one of its
kind – was a specially commissioned presentation piece. The
initials HFP are those of the recipient, who may have been an
owner or officer of Liberty & Co. The streamlined form and
spare decoration are extremely advanced for the time. Knox
produced similar designs in numerous variations but no others
of this size are known. The extended lid handle permits one
to hold the lid open while pouring with the same hand. Knox
became the principal silver and pewter designer for Liberty
of London. He created Celtic designs of the highest quality
introducing the Cymric (silver) and Tudric (pewter) lines.
His work serves as an important bridge between the British
Arts and Crafts and European Art Nouveau movements as
well as foreshadowing the silver work of the Bauhaus.

CRAFTS

The origins of the Arts and Crafts movement can be traced to a series of landmark events in 19th century England – including the 1836 publication of the Government Reports on design and industry, the world exhibitions of 1851 and 1862,[1] and the mediaevalism of three generations of social reformers who rallied against industry and its ever-tightening grip on the nation's economy and lifestyle. Yet many other less perceptible forces challenged the negative aspects of industrialization as the century progressed, including the growing awareness among the general populace that a nation's creativity reflected its moral values: if society could not produce a pure and uplifting form of art then the fault must lie in its ethical system. Art therefore served as a barometer of moral well-being.

Born in 1812, Augustus Welby Northmore Pugin is generally acknowledged as the precursor of the Arts and Crafts movement. The author of two works which profoundly influenced the next generation of society's watchdogs – *Contrasts* and *True Principles of Christian Architecture*, published in 1836 and 1841, respectively – Pugin was concerned with what he perceived as "the present decay of taste".[2] As part of his proposed remedy, he advocated that architecture should be "the expression of existing opinions and circumstances" rather than "a confused jumble of styles and symbols borrowed from all nations and periods".[3] In relating style in this manner to the spirit which had created it, Pugin settled on the Middle Ages as the optimum model for contemporary society. For him, Gothicism therefore became a social convention rather than an artistic one, one through which mankind could revive the Christian spirit that had existed before the Reformation. Mediaeval England had been Merry England, at least for the working class. Other styles could not serve as effectively to cure present-day England's ills. Classicism was singled out for special vilification as it was the expression of a pagan culture.

To the critic of *The Times*, the Crystal Palace exhibition of 1851 revealed an "absence of any fixed principles in ornamental design… it seems to us that the art manufacturers of the whole of Europe are thoroughly demoralised".[4] Blamed was the machine, which could now manufacture a flood of period cast-offs to meet the decorating whims of the upper classes and an expanding bourgeoisie. In part to redress such manifestations of bad taste, writers stepped forward to offer advice on the nature of design. Included were Owen Jones's *The Grammar of Ornament* (1856), which by 1910 had been reprinted nine times, and Sir Charles Eastlake's *Hints on Household Taste* (1868), which became a decorating bible of sorts, especially in America, where its wide use as a stylistic reference led to the generic term "Eastlake style" for a range of simple and sturdy wooden furnishings.

No doubt because in its initial implementation in the early 1800s the machine's potential for good outweighed its negative attributes, Pugin saw no reason to exclude it from the workplace if it was harnessed and confined to legitimate uses.[5] By the mid-century, however, such optimism amongst England's socialists and unionists had largely evaporated; mechanisation's impact on both artistry and worker morale was seen as deleterious. Leading the charge for change was John Ruskin.

Born in 1819, Ruskin advanced Pugin's belief in mediaevalism as the panacea for society's ills. Incapable of judging art without judging the society that created it, Ruskin built an entire structure of social, moral and educational theories in a lifetime of teaching, writing, and preaching at his countrymen. He concerned himself first with the nature of man and his personal needs, and then with the nature of his work, which was only viable when it expressed those needs. Embracing Pugin's belief that Christian architecture was superior to that of other cultures, Ruskin went further, insisting that architecture and artefacts should unashamedly reveal their man-made origins, which in turn would reflect man's essential humanity, with all his roughness and individuality. A precisely finished and symmetrical product, such as that generated by machine, represented therefore the denial of the human element. In the rapidly industrializing society of Victorian England, Ruskin voiced the concern of many of his countrymen, who agreed that art was an essential moral ingredient in the home environment, and that the loss of daily contact with hand-crafted

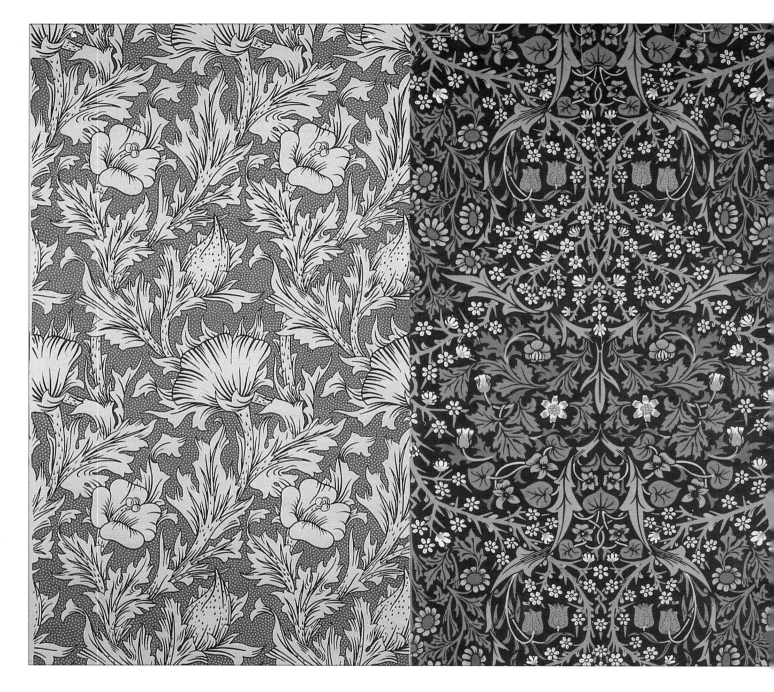

objects fashioned with pride, integrity and attention to beauty would diminish catastrophically the quality of life of the average citizen.

From around 1850, Ruskin saw himself increasingly as the custodian of his country's morals, and his forays into social criticism were greeted either with tolerance or indifference as the eccentricities of an eloquent spokesman for art. But in the 1860s he went further, launching an acrimonious attack on the current industrial system and the *laissez-faire* economy on which it was based. Special censure was reserved for the wealthy, who "not only refuse food to the poor; they refuse wisdom, they refuse virtue, they refuse salvation…". Ruskin's priestly dedication and oratory

drew many intellectuals to his cause, including William Morris, who read his *The Stones of Venice* (1853) while an undergraduate at Oxford. One chapter, entitled "The Nature of Gothic" was of particular political interest to young idealists such as Morris.

Born in Walthamstow in 1834, Morris was educated at Exeter College, Oxford, where he met Edward Burne-Jones, who became a life-long friend and business associate. In 1856 Morris joined the firm of G. E. Street with the intention of becoming an architect. Several career changes followed quickly until he found his true vocation in the field of pattern design, which included wallpapers, fabrics, tapestries and book decoration. One of his co-workers at G. E. Street

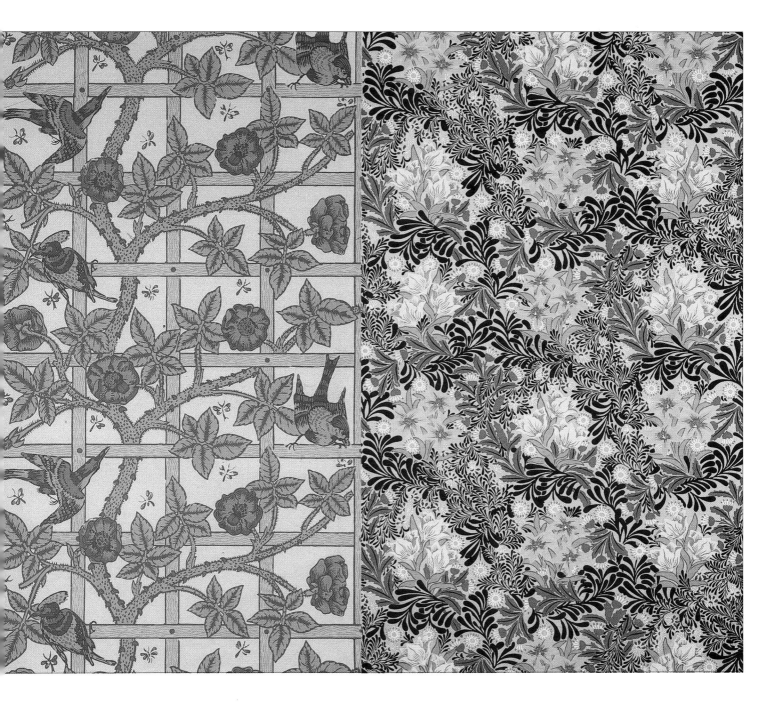

WILLIAM MORRIS (1834-1896) English
Wallpaper Sheets (left to right): *Horn Poppy*, 1885; *Blackthorn;*
1892; *Trellis*, 1864; *Bower*, 1877. Wood block print on paper.
Printed by Jeffery & Co., London.
H: 41in (104.1cm) x W: 22in (55.9cm) // H: 46in (116.8cm) x
W: 27in (68.6cm)

William Morris – designer, craftsman, theorist, father-figure of the
Arts and Crafts Movement and for 30 years the center of a group
of British architects, designers and artists – had a tremendous
impact on 20th-century design.
Morris was the first to champion such craft principles as *truth to
materials*, which became the basis of the Arts and Crafts
Movement. He admired simplicity in art and life and propogated
an ideal of rustic living. His utopian socialism and his affinity for
natural hand-crafted details made him the spiritual leader of the

Crafts Revival of the 20th century.
Morris excelled in the design of flat patterns, derived from organic
forms, particularly fruits, flowers and birds. He was especially
talented in designing carpets, fabrics, stained glass and wallpapers
and is credited with having created more than 600 designs during
the mid to late 1800s. In 1862 he founded the firm Morris,
Marshall & Faulkner (later Morris & Co.) making these new
designs widely accessible to London's middle-class homemakers.
A set of ten original wallpaper sheets are represented in the
Norwest collection. The most popular in its time, *Trellis* (above
left), was co-designed with his colleague, Philip Webb, who drew
the birds. Its popularity may well have resulted from its
atmospheric, see-through effect, a welcome relief to the flat, over-
decorated spaces so common to Victorian parlors where too much
was never enough. Today, the patterns are enjoying a renewed
appreciation as tastes turn increasingly to floral decoration in
fabric and fine paper designs.

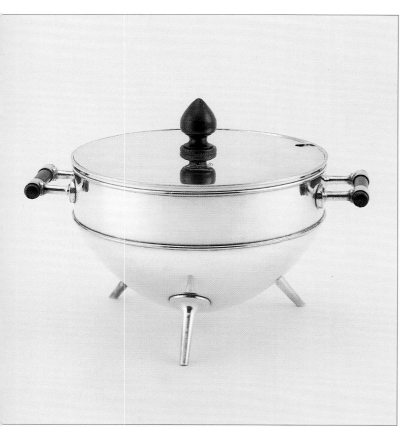

CHRISTOPHER DRESSER (1834-1904) English
Tureen, c.1880. Silverplate with ebonized stopper and handles.
Manufacturer: Hukin & Heath, London. Marks stamped on
bottom: *DESIGNED BY DR. C. DRESSER / H&H / 2123 /*
insignia */ KARTIN & CO., Cheltenham.*
H: 8in (20.3cm) x D: 9in (22.9cm) (at lid)

was Philip Webb, who later assisted in the design of
Morris's home, Red House (1859-1860), and in the
formation of his first commercial venture, Morris,
Marshall, Faulkner & Company (1861).[6] At the 1862
International Exhibition the firm's display included
pattern designs by Morris alongside furniture by Webb
and stained glass by the Pre-Raphaelites Rossetti, Ford
Madox Brown and Burne-Jones. Most items were
designed in the mediaeval style.

Like Ruskin, Morris was appalled by the wares
spewed out by those "inexhaustible mines of bad taste,
Birmingham and Sheffield… silver sunk to a mere
trade; glaring, showy, meretricious ornament…
(which) disgraces every branch of our art and
manufactures".[7] The remedy lay in an alternative
means of production to that of the factory, one that
would in effect constitute an entire philosophy of life
for the worker. For this, Morris endorsed Ruskin's
choice of the mediaeval craftsman's lifestyle as the best
means by which to implement social change, one in

GEORGE WALTON (1867-1933) Scottish
Cabinet, 1890. Quarter-sawn and stained oak with pewter inlay
and front up-and-pull latch. Manufacturer: Waring and Gillow.
Marks stamped into wood on verso: *4801 DESIGN / 2591/1.*
Attributed to George Walton.
H: 30 ⅛in (76.5cm) x W: 21 ½in (54.6cm) x D: 16in (40.6cm)

CHARLES ROBERT ASHBEE (1863-1942) English
Muffin Dish, c.1904. Hammered silver-plated copper with domed
lid capped with a wirework finial set with a cabochon
chrysoprase. Removable stopper on bottom side for warm water.
H: 6 ½in (16.5cm) x W: 9 ½in (24.1cm)

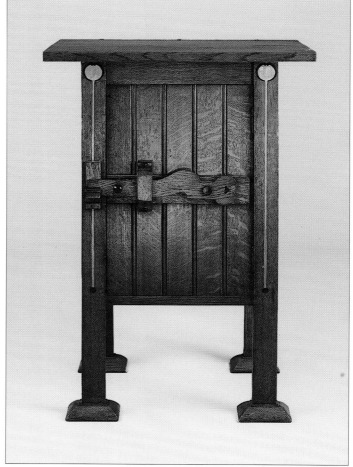

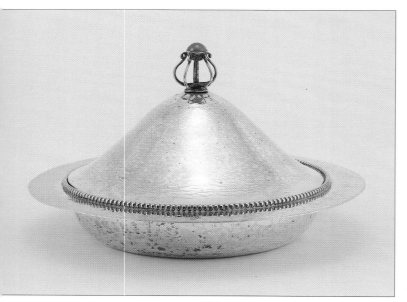

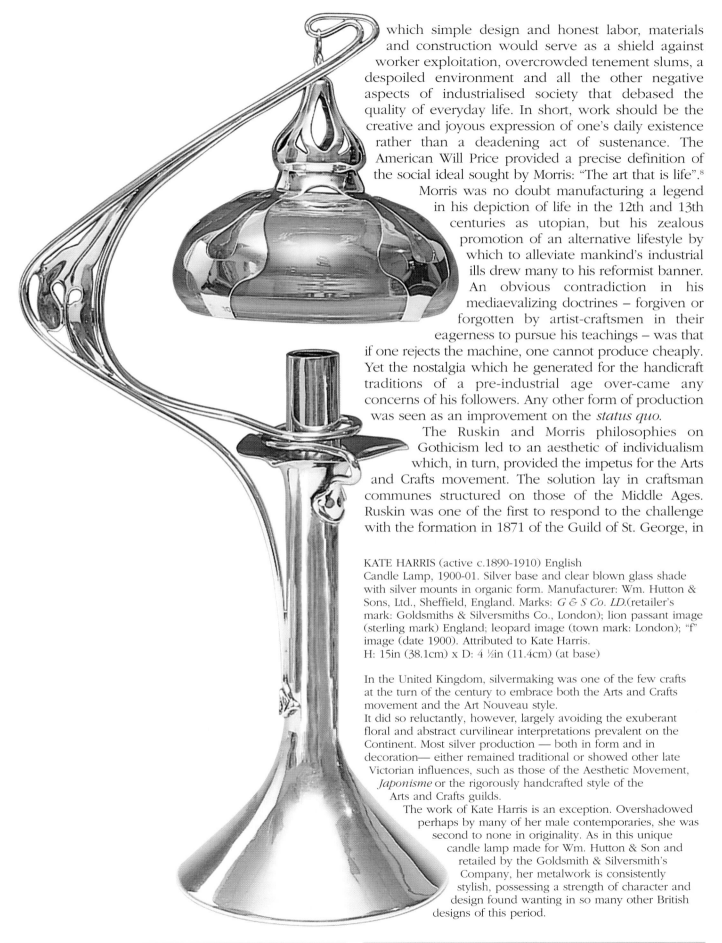

which simple design and honest labor, materials and construction would serve as a shield against worker exploitation, overcrowded tenement slums, a despoiled environment and all the other negative aspects of industrialised society that debased the quality of everyday life. In short, work should be the creative and joyous expression of one's daily existence rather than a deadening act of sustenance. The American Will Price provided a precise definition of the social ideal sought by Morris: "The art that is life".[8]

Morris was no doubt manufacturing a legend in his depiction of life in the 12th and 13th centuries as utopian, but his zealous promotion of an alternative lifestyle by which to alleviate mankind's industrial ills drew many to his reformist banner. An obvious contradiction in his mediaevalizing doctrines – forgiven or forgotten by artist-craftsmen in their eagerness to pursue his teachings – was that if one rejects the machine, one cannot produce cheaply. Yet the nostalgia which he generated for the handicraft traditions of a pre-industrial age over-came any concerns of his followers. Any other form of production was seen as an improvement on the *status quo*.

The Ruskin and Morris philosophies on Gothicism led to an aesthetic of individualism which, in turn, provided the impetus for the Arts and Crafts movement. The solution lay in craftsman communes structured on those of the Middle Ages. Ruskin was one of the first to respond to the challenge with the formation in 1871 of the Guild of St. George, in

KATE HARRIS (active c.1890-1910) English
Candle Lamp, 1900-01. Silver base and clear blown glass shade with silver mounts in organic form. Manufacturer: Wm. Hutton & Sons, Ltd., Sheffield, England. Marks: *G & S Co. LD.*(retailer's mark: Goldsmiths & Silversmiths Co., London); lion passant image (sterling mark) England; leopard image (town mark: London); "f" image (date 1900). Attributed to Kate Harris.
H: 15in (38.1cm) x D: 4 ½in (11.4cm) (at base)

In the United Kingdom, silvermaking was one of the few crafts at the turn of the century to embrace both the Arts and Crafts movement and the Art Nouveau style.
It did so reluctantly, however, largely avoiding the exuberant floral and abstract curvilinear interpretations prevalent on the Continent. Most silver production — both in form and in decoration— either remained traditional or showed other late Victorian influences, such as those of the Aesthetic Movement, *Japonisme* or the rigorously handcrafted style of the Arts and Crafts guilds.
The work of Kate Harris is an exception. Overshadowed perhaps by many of her male contemporaries, she was second to none in originality. As in this unique candle lamp made for Wm. Hutton & Son and retailed by the Goldsmith & Silversmith's Company, her metalwork is consistently stylish, possessing a strength of character and design found wanting in so many other British designs of this period.

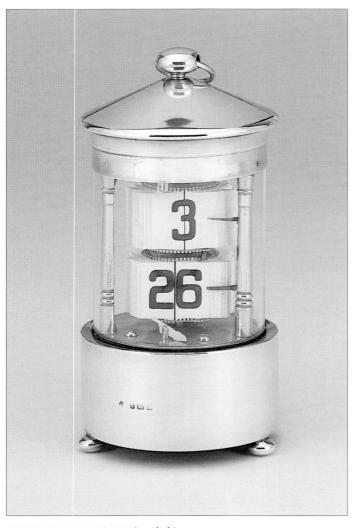

DESIGNER UNKNOWN (English)
Digital Clock, 1905. Silver mounted digital clock with
flickover numbers within cylindrical glass body. Hallmarked in
Birmingham, England, 1905; maker's mark: *C.S. Green*.
H: 6 ½in (16.5cm) x D: 3 ¼in (8.3cm)

founded in London in 1884 by members of the St.
George Art Society, a group of artists and architects in
the office of Richard Norman Shaw. These were soon
joined by another group of artists, architects, designers
and craftsmen sympathetic to the craft revival
movement which called itself "The Fifteen" and which
was led by Lewis F. Day and Walter Crane. The Arts
and Crafts Exhibition Society, an extension of the Art
Workers' Guild formed in 1888, provided a valuable
forum for the public in its exhibitions of Guild
members' works and as a platform for debates and
lectures by proponents such as Sedding, Voysey,
Mackmurdo, Ashbee, Shaw, Fry, Walton, and Lutyens.
Many of these were reviewed in *The Studio* and *The
Art Journal*, which served further to disseminate the
Arts and Crafts message. Also in 1888, the Guild of
Handicraft was founded in London by Ashbee and
three associates, with Ashbee as chief designer. Very
successful until around 1907, financial difficulties led
to its subsequent closure.

Noteworthy also at the time was the Birmingham
Guild of Handicraft, established in 1890 by admirers of
Ruskin and Morris, which later became a limited
company. In 1910, Arthur Dixon, the group's chief
designer and metalworker, amalgamated the guild
with the jewelry firm of E. & R. Gittins. A further Arts
and Crafts association, The Artificer's Guild, was
founded in 1901 by Nelson Dawson and Edward
Spencer.

One of Morris's most ardent publicists, Ashbee
revealed his versatility as a designer, silversmith and
jeweller in a long career that began and ended in

ERNEST ARCHIBALD (E. A.) TAYLOR (1874-1951) Scottish
Display Cabinet, c.1898. Mahogany. Two glazed doors separated
by a central panel decorated with a stylized floral motif in
marquetry of various colored woods inlaid with mother-of-pearl
and abalone shell, the brass door handles with circular enamelled
plaques. Original finish intact. Fitted with green velvet interior.
H: 68 ½in x W: 36in (91.4cm) x D: 17 ¼in (43.8cm)

The fifteenth of seventeen children, E. A. Taylor was born in
Greenock, Scotland. He was trained as a draftsman in the
shipbuilding yards of Scott and Co. Ltd., before attending the
Glasgow School of Art in the 1890s. Inevitably, he came under
the influence of the *famous four* – Charles Rennie Mackintosh,
J. H. MacNair and Frances and Margaret MacDonald. About 1900
he joined the well-established Glasgow cabinet-making firm,
Wylie and Lockhead Ltd., where he designed an entire drawing
room for their pavilion at the 1901 Glasgow International
Exhibition. He expanded his work to include stained glass
designs, receiving numerous medals and citations for design
excellence until his retirement in 1920.
This display cabinet was completed early in Taylor's career.
Immaculately crafted in maghogany with inlaid hardwoods,
abalone shell and enameled drawer pulls, it remains among his
most refined work. Typical of cabinetry designed by architect/
designers, the outside form appears to be a building in smaller
scale, particularly with the overhanging cornice. Its combined
proportion, exquisite craftsmanship and delicacy make it one of
the finest examples of high-style Arts and Crafts known to exist.

which the aim was nothing less than the reformation of
the existing social order and, thereby, the destruction of
industrial society. Planned was a system of masters and
servants, and artists and artisans, who would share a
mutual interest in the quality of life and work in their
communities.[9]

The Guild of St. George was an ill-fated venture, but it
was followed by others that, to varying degrees, were
more successful.[10] Amongst the first of these was the
Century Guild formed in 1882 by Arthur Heygate
Mackmurdo and Selwyn Image, in which decorative
works of all kinds, many designed by Mackmurdo, were
presented as a co-operative effort. An accompanying
magazine, *The Hobby Horse*, was published from 1884.
The guild flourished for another four years, and
although therefore short-lived, it exerted a considerable
influence on the craft revival movement.

Of similar importance was the Art Workers' Guild

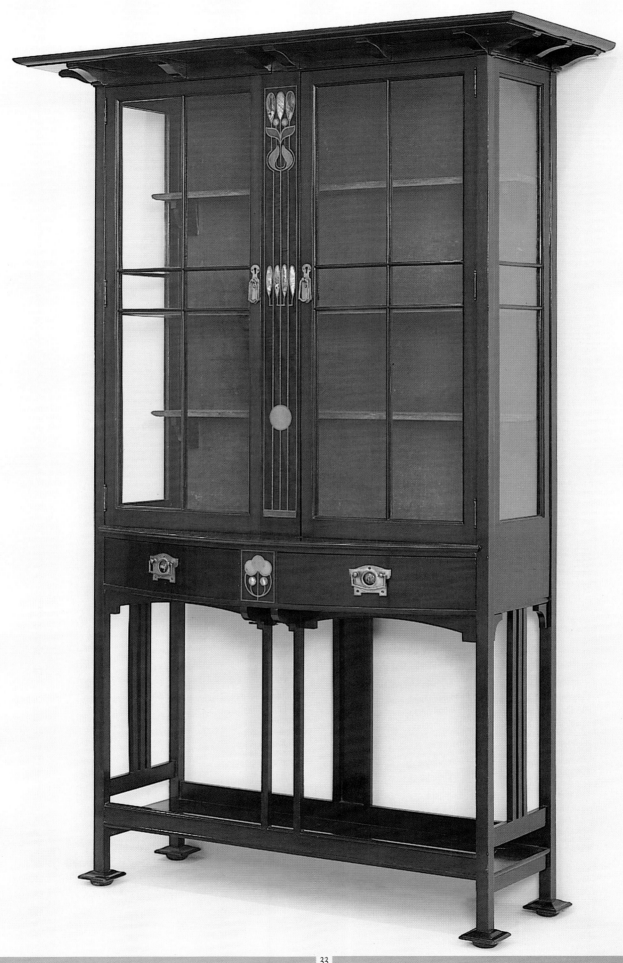

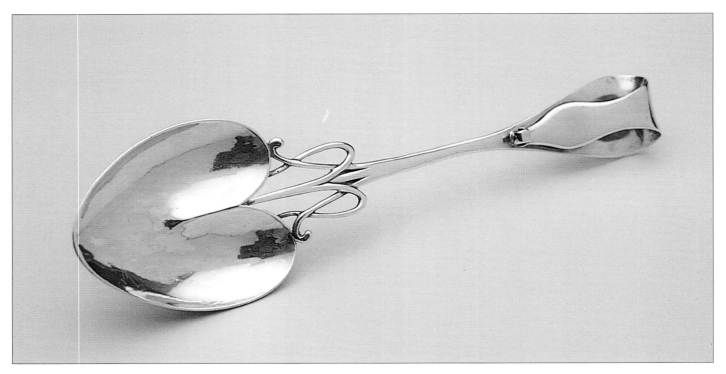

OLIVER BAKER (1859-1938) English
Spoon, 1903. Silver. Designed for: Liberty & Co., London. Original design, 1900. Marks: anchor, lion, *L & CO,d,* and *Cymric.*
L: 7 ¾in (19.7cm)

architecture. Educated at Cambridge and then articled in the east end of London, where he lived and later established the Guild of Handicraft, Ashbee enjoyed an international stature in the Arts and Crafts community surpassed only by that of Morris. Known especially for its metalware and jewelry, his guild was commissioned to produce the furnishings and other household appliances for the artist's colony, Mathildenhöhe, established by the Grand Duke of Hesse in Darmstadt in 1899.

Likewise an architect by profession, Ernest Gimson met Morris in 1884, and on his advice joined the London office of J. D. Sedding, where he learned about traditional crafts in his spare time. In 1890 he established Kenton and Company, furniture designers and manufacturers, with some associates, including William R. Lethaby, one of the architects from Norman Shaw's office who had helped to promote the formation of the Art Workers' Guild. When the Kenton firm collapsed two years later, Gimson set up a workshop near Cirencester in Gloucestershire, where he produced furniture and decorative plasterwork. For his part, Lethaby became the joint principal with George Frampton in 1896 of the London County Council School of Arts and Crafts.

The son of a minister banished from the Church of England for preaching against the doctrine of hell-fire, Charles Francis Annesley Voysey trained in the offices of J. P. Seddon and then George Devey before setting up his own architectural practice in 1882. Revealing an easy facility in his designs for decorative objects – notably fabrics, wallpapers and furniture – Voysey joined the Art Workers' Guild two years later. His simple linear style, in which virtually no accommodation was given to surface ornamentation, was soon widely copied in the "artistic" interiors of the period, some inspired directly by those in Voysey's own home, "The Orchard", in Chorley Wood, Hertfordshire, views of which were widely published at the time.[11]

The son of a Scottish laird, Mackay Hugh Baillie Scott trained as an architect before setting up his practice in 1889 in Douglas on the Isle of Man, where he met Archibald Knox at the local School of Art. Proficient in the decorative arts, Baillie Scott designed stained glass, iron and copper work, furniture and light fixtures for the interiors of his houses, collaborating on occasion with Ashbee, whose Guild of Handicraft executed several of his designs. Moving later to Bedford, Baillie Scott designed furniture with John White, some that was sold through Liberty's.

To the north, two Glaswegian architects – Ernest Archibald Taylor and George Walton – fell inevitably under the early influence of Charles Rennie Mackintosh before developing their own, less ornate and provocative, styles. Taylor, who had attended the Glasgow School of Art, joined a cabinetmaking firm in the city, Wylie and Lockhead, for whom he designed furnishings and stained glass windows. Walton, likewise an alumnus of the School of Art, created

CHRISTOPHER DRESSER (1834-1904) English
Double-Spouted *Sea Urchin* Vessel, 1879-82. Ceramic with
golden-brown and green glaze. Manufacturer: Linthorpe Art
Pottery, Middlesbrough, Yorkshire. Marks: *LINTHORPE Chr.
Dresser* (facsimile signature) / *312M*.
H: 7in (17.8cm) x W: 5 ½in (14cm) (to handles) x D: 5 ¾in (14.6cm)

JOHN WILLIAMS (dates unknown) English
Pot-pourri Casket, c.1900. Silver. Inscription reads "GATHER YE
ROSEBUDS WHILE YE MAY". Manufacturer: Patrick Roche. Marks
stamped on lid: *JW* / Lion Passant / *1* / Face of lion. Marks
stamped on bottom of casket: *JW* / Lion Passant / face of lion / *1*.
H: 5 ⅜in (13.7cm) x D: 6in (15.2cm) (at lid)

DESIGNER UNKNOWN (English)
Loop-handled Dish, 1903. Silver. Formed as footed shallow bowl with looping handles on either end which terminate in a heart shape.
Manufacturer: Murrle-Bennet & Co., London and Pforzheim. Marks: Makers mark: lion crescent /h/f/(shield).
H: 5 ¼in (13.3cm) x W: 5 ¼in (13.3cm) x D: 12 ½in (31.8cm)

numerous local interiors in a pared-down Arts and Crafts style before moving to London in 1897.

A fellow student of Morris and Burne-Jones at Oxford, William Arthur Smith Benson was articled in 1878 to the architect Basil Champneys. Opening his own studio in Hammersmith two years later, he initially concentrated on the fields of metalwork, wallpaper and cabinetmaking, some commissioned and executed by Morris and Co., of which he was appointed a director after Morris's death in 1896. Benson was drawn increasingly to metal household appliances for mass-production. A founder of the Art Workers' Guild and the Arts and Crafts Exhibition Society, his wares were frequently featured in *The Studio*.

All of the above – the guilds and the individual architects and designers – were instrumental to varying degrees in advancing the Arts and Crafts philosophy of "ethics and aesthetics" in England and in its dissemination abroad. The impact across the Atlantic was most pronounced.

English Arts and Crafts provided the primary inspiration for the corresponding movement in America, which reached its highpoint between 1890-1910, although Glaswegian, Viennese, and Parisian influences contributed also to the multiple manifestations of the movement in its adopted country. America's size contributed to the various regional interpretations that evolved, as did its own capitalist traditions. Whereas the Arts and Crafts philosophy travelled initially across the Atlantic through intellectual channels – disciples of Ruskin such as Charles Eliot Norton of Harvard, Oscar Lovell Triggs of the

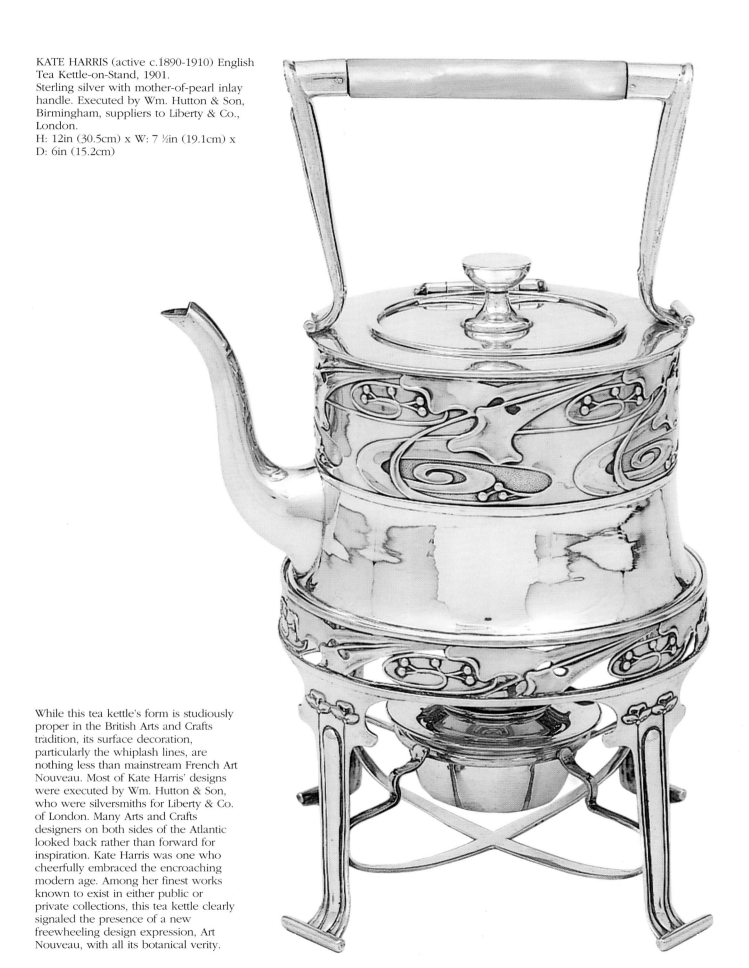

KATE HARRIS (active c.1890-1910) English
Tea Kettle-on-Stand, 1901.
Sterling silver with mother-of-pearl inlay
handle. Executed by Wm. Hutton & Son,
Birmingham, suppliers to Liberty & Co.,
London.
H: 12in (30.5cm) x W: 7 ½in (19.1cm) x
D: 6in (15.2cm)

While this tea kettle's form is studiously
proper in the British Arts and Crafts
tradition, its surface decoration,
particularly the whiplash lines, are
nothing less than mainstream French Art
Nouveau. Most of Kate Harris' designs
were executed by Wm. Hutton & Son,
who were silversmiths for Liberty & Co.
of London. Many Arts and Crafts
designers on both sides of the Atlantic
looked back rather than forward for
inspiration. Kate Harris was one who
cheerfully embraced the encroaching
modern age. Among her finest works
known to exist in either public or
private collections, this tea kettle clearly
signaled the presence of a new
freewheeling design expression, Art
Nouveau, with all its botanical verity.

University of Chicago, and Wallace Nutting, an ex-minister and proselytizer of the colonial lifestyle – it was not the advocates of English handcraftsmanship and social reform who in the end provided the catalyst for its successful transplantation and growth; for this, it owed its ultimate success in America less to the world of intelligentsia than to that of commerce.[12]

The early utopian experiments in communal living founded in the U.S. on the example of Ashbee's Guild of Handicraft,[13] such as Hull House in Chicago, which sought to improve the lives of laborers and immigrants, and the bucolic communities of Byrdcliffe Colony in Woodstock, New York, and Rose Valley, Pennsylvania, ultimately proved unsuccessful as they could not sustain themselves economically. Certainly, also, the host of Arts and Crafts organizations established across the country from the late 1890s to disseminate the movement's philosophies through exhibitions, periodicals and workshop instruction, served to familiarize the public with its philosophical goals and manner of technical implementation, but it was the movement's success in the marketplace, finally, that ensured its profitability and, thereby, its survival.

The success of the Arts and Crafts movement in America rested therefore on compromises that permitted it to adapt itself to the nation's free enterprise system.[14] To conceal this clear paradox from their customers, Arts and Crafts manufacturers cultivated the myth that they emulated the parent movement in England, which they did by reiterating the latter's rhetoric on such themes as the unification of art, work and life. To further this end, the applied arts were presented as fine art handwrought by individual craftsmen, despite the fact that most products were

CHARLES ROBERT ASHBEE (1863-1942) English
Biscuit Barrel, 1900. Sterling silver, enamel and blister pearl. Cylindrical form with heart-shaped leaves and berries motif (cut-outs) with domed lid in crimson enamel. The finial is sterling wirework with a blister pearl set in a besel. Marks: *CHARLES ROBERT ASHBEE / GUILD OF THE HANDICRAFT, LONDON, 1900.*
H: 7 ⅛in (18.1cm) x D: 5 ¼in (13.3cm)

GEORGE LOGAN (1866-1939) Scottish
Ewer and Basin, c.1905. Ceramic with transfer print of a Scottish rose decoration with black-and-white checkered rim. Designed for and executed by Wedgwood & Co., Staffordshire, England. Marks: *IMPERIAL*, crown, *WEDGWOOD CO. LTD., ENGLAND* (on basin); crown, *WEDGWOOD CO. LTD., ENGLAND* (on ewer). Atttributed to George Logan.
H: 5 ¼in (13.3cm) x D: 15 ½in (39.4cm) (basin)
H: 11 ½in (29.2cm) x W: 9 ¾in (24.8cm) x D: 6 (ewer)

actually made on assembly lines by a combination of artisans and machines. Purists argued that this deception invalidated the artistic value of the finished piece; pragmatists countered that never had so many American consumers enjoyed such a high level of design in their homes; the creation of a mass-market for affordable, artistically-conceived goods increased the average home-owner's awareness of, and therefore appreciation for, fine hand-craftsmanship, quality construction, simple and sturdy materials, design dedicated to function, and environmental harmony. Left unspoken in such promotion of the Arts and Crafts lifestyle was the fact that the manufacturer was the ultimate beneficiary, in monetary terms.

In their packaging of the Arts and Crafts ideal, most American makers – individual artisans, guild-like associations and larger manufacturers alike – adhered to the movement's requisite tenets of functional design, simple materials, etc., but where possible they standardized styles and used machinery and the division of labor to minimise costs. This embrace of industry's *modus operandi* to create "handcrafted"

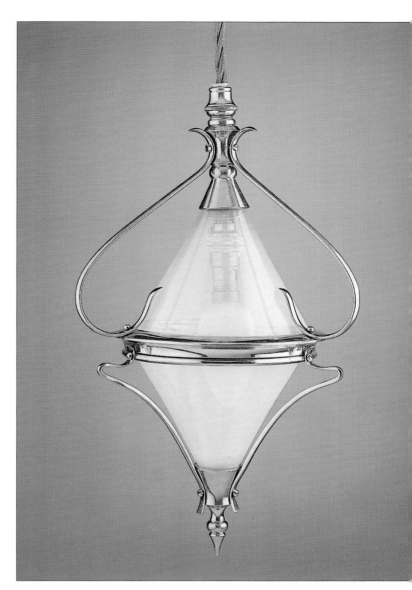

WILLIAM ARTHUR SMITH BENSON (1854-1924) English
Hanging Lantern, c.1895. Opalescent glass shade with brass fittings.
H: 11in (27.9cm) x D: 6 ½in (16.5cm)

goods was, of course, profit-oriented and therefore hypocritical as it overrode directly Ruskin's concerns for the worker's well-being and his crusade for labor reform. Yet most Arts and Crafts makers brought a far greater humanitarian sensitivity to the workplace than conventional industrialists, in part because their product promoted itself as part of a superior living environment to that mass-produced in dirty and overcrowded sweatshops. This concern for humane working conditions helped the Arts and Crafts employer avoid direct confrontation with local labor unions. Charles Limbert, for example, moved his Arts

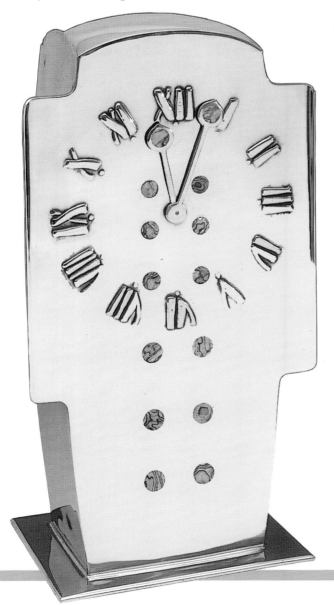

ARCHIBALD KNOX (1864-1933) Scottish
Mantel Clock, c.1902. Pewter with inlaid abalone shell.
Designed for Liberty & Co., London. Marks: Tudric (on base).
Attributed to Archibald Knox.
H: 13 ½in (34.3cm) x W: 7 ½in (19.1cm) x D: 3 ¾in (9.5cm)

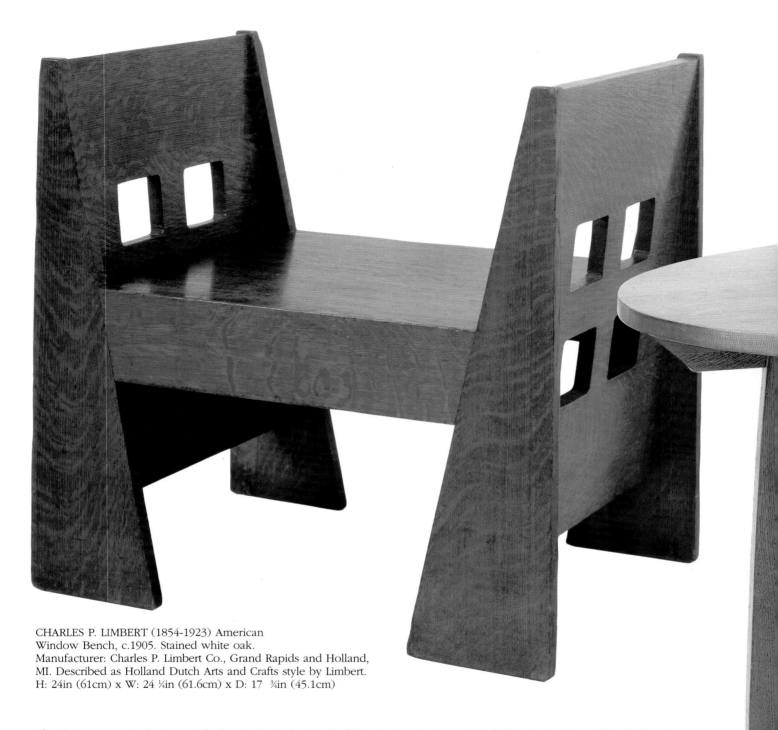

CHARLES P. LIMBERT (1854-1923) American
Window Bench, c.1905. Stained white oak.
Manufacturer: Charles P. Limbert Co., Grand Rapids and Holland,
MI. Described as Holland Dutch Arts and Crafts style by Limbert.
H: 24in (61cm) x W: 24 ¼in (61.6cm) x D: 17 ¾in (45.1cm)

After thirteen years in business, Charles Limbert advertised a fully developed Arts and Crafts line in the *Grand Rapids Furniture Record* for July 1902. His new line of furniture became known as *Holland Dutch Arts and Crafts* modeled after similar lines established by Gustave Stickley and Elbert Hubbard's Roycrofters. No less than his contemporaries, Limbert championed the virtues of handmade craftsmanship, simplicity of line, unadorned surface, and fumed oak, but unlike them, he frankly acknowledged his debt to European designers, particularly the Scotsman, Charles Rennie Mackintosh.
Many of Limbert's chairs are line-for-line copies of those Mackintosh designed for the Willow Tearooms in Glasgow in 1904.
A familiar motif, the square cutouts in a window-pane configuration as seen in this table's stretchers and on the side panels of the bench, is generally attributed to Mackintosh. The table top is joined by legs that taper dramatically giving the form a strong Vienna Secessionist flavor. Today, it is regarded as Limbert's finest design, well on its way to becoming a timeless example of blending between turn-of-the-century European and American sensibilities.
The wood seat, as it was labeled, was listed in the Chas. P. Limbert & Co. sales catalogue priced at $14 with a leather cushion and $9 without. Observing the Arts and Crafts formulae, the wood was quarter-sawn and fumed, then assembled with mortise and tenon or with exposed dowel joints. A complex finishing process involving repeated sanding, polishing and waxing was used. In addition to the cutouts, Limbert's bench is joined by endpieces that taper dramatically from top to bottom giving the form a Germanic or Austrian look. The resulting silhouette energizes the otherwise relentlessly straightforward Arts and Crafts style associated with Gustave Stickley.

CHARLES P. LIMBERT (1854-1923) American
Double Oval Table, c.1910. Stained oak.
Stretchers formed by reticulated squares.
Manufacturer: Charles P. Limbert Co. (1902-44),
Grand Rapids and Holland, MI.
H: 29in (73.7cm) x W: 47 ½in (120.7cm) x D: 36in (91.4cm)

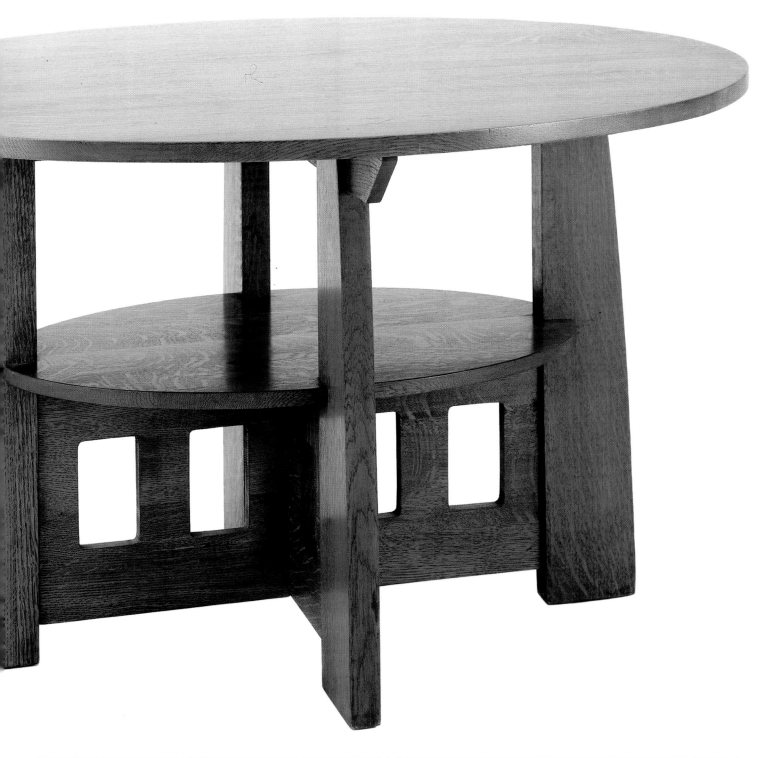

WILLIAM D. GATES (1852-1935) American
Monumental Vase, c.1905-10. Glazed earthenware. Buttress vessel
form shape #416. Attributed to William D. Gates for *Teco* ware
line. Manufacturer: Gates Potteries, Terra Cotta, IL. Marks: signed
with impressed block (four markings).
H: 18in (45.7cm) x W: 10 ½in (26.7cm) (base)

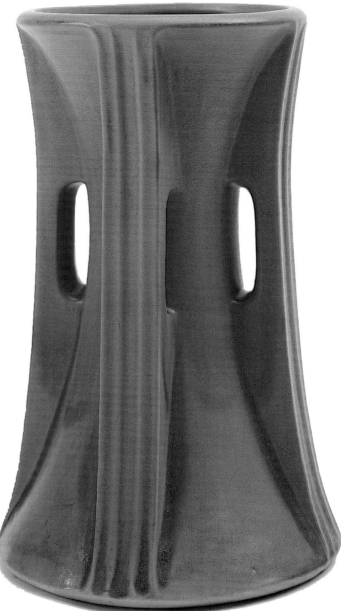

and Crafts factory from Grand Rapids, Michigan, the
hub of the nation's furniture-making industry, to a lake
near the small town of Holland to provide his workers
with a healthier environment.

The tastemaker and standard-bearer of the American
Arts and Crafts movement was Gustave Stickley, who
through his factory – initially named the United Crafts
Workshop and then, from 1904, the Craftsman
Workshop – promoted and extended Morris's principles
in both an artistic and socialist sense. Appointing
himself the spokesman for "the great middle class,
possessed of moderate culture and moderate material
resource", Stickley called for an art conducive "to
plain living and high thinking, to the development of
the sense of order, symmetry and proportion".[15]
Sprinkled with quotes by Morris, Stickley's populist
message targeted the average American homeowner,
whose limited budget called for a subtle marketing
ploy that offered "to substitute the luxury of taste for

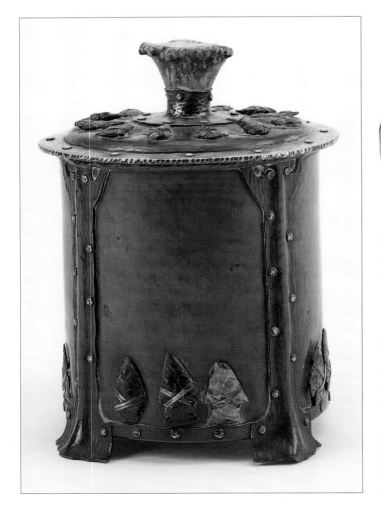

the luxury of costliness; to employ only those forms
and materials which make for simplicity, individuality
and dignity of effect".

Central to Stickley's commercial success was his
magazine, *The Craftsman*, published monthly from
1901, which became the mouthpiece through which he
could legitimize, and thereby publicize, his line of
wares.[16] Articles by influential guest writers on such
issues as style, home decoration, residential architecture
and landscaping, assured readers of the journal's
validity as an arbiter of taste.

MARCUS & COMPANY (American)
Humidor, c.1915-20. Copper and silver with American Indian
arrowheads and bone handle. Marks (inscribed on bottom):
maker's insignia / *MARCUS & CO.* / *COPPER AND SILVER*.
H: 8in (20.3cm) x W: 6 ¼in (15.9cm)

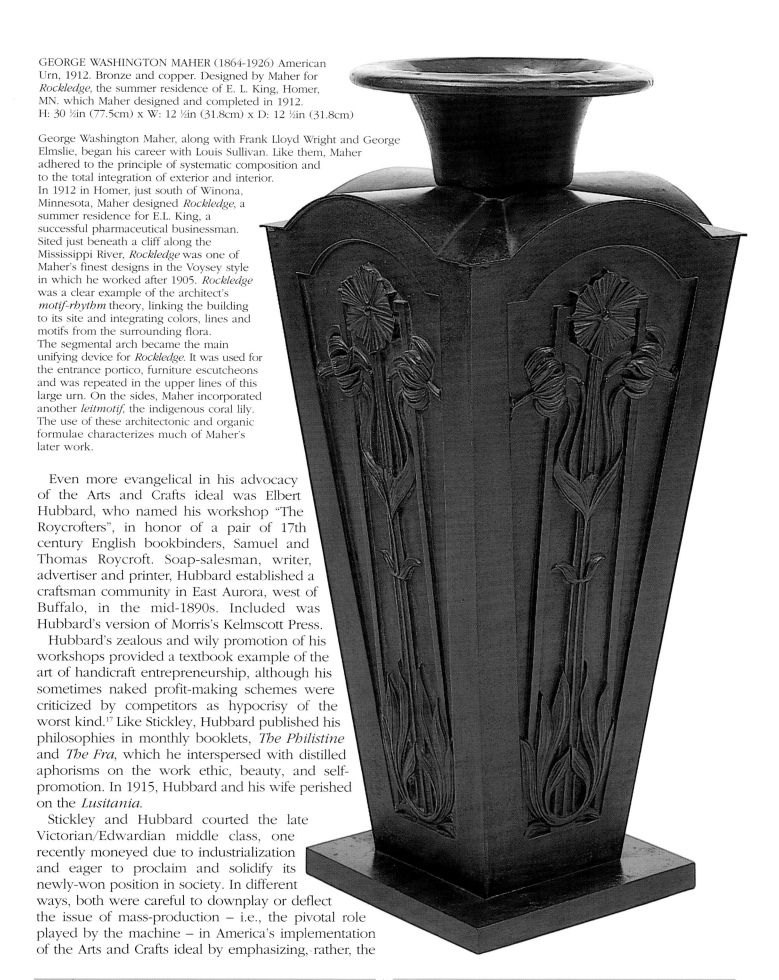

GEORGE WASHINGTON MAHER (1864-1926) American
Urn, 1912. Bronze and copper. Designed by Maher for
Rockledge, the summer residence of E. L. King, Homer,
MN. which Maher designed and completed in 1912.
H: 30 ½in (77.5cm) x W: 12 ½in (31.8cm) x D: 12 ½in (31.8cm)

George Washington Maher, along with Frank Lloyd Wright and George
Elmslie, began his career with Louis Sullivan. Like them, Maher
adhered to the principle of systematic composition and
to the total integration of exterior and interior.
In 1912 in Homer, just south of Winona,
Minnesota, Maher designed *Rockledge*, a
summer residence for E.L. King, a
successful pharmaceutical businessman.
Sited just beneath a cliff along the
Mississippi River, *Rockledge* was one of
Maher's finest designs in the Voysey style
in which he worked after 1905. *Rockledge*
was a clear example of the architect's
motif-rhythm theory, linking the building
to its site and integrating colors, lines and
motifs from the surrounding flora.
The segmental arch became the main
unifying device for *Rockledge*. It was used for
the entrance portico, furniture escutcheons
and was repeated in the upper lines of this
large urn. On the sides, Maher incorporated
another *leitmotif,* the indigenous coral lily.
The use of these architectonic and organic
formulae characterizes much of Maher's
later work.

Even more evangelical in his advocacy
of the Arts and Crafts ideal was Elbert
Hubbard, who named his workshop "The
Roycrofters", in honor of a pair of 17th
century English bookbinders, Samuel and
Thomas Roycroft. Soap-salesman, writer,
advertiser and printer, Hubbard established a
craftsman community in East Aurora, west of
Buffalo, in the mid-1890s. Included was
Hubbard's version of Morris's Kelmscott Press.

Hubbard's zealous and wily promotion of his
workshops provided a textbook example of the
art of handicraft entrepreneurship, although his
sometimes naked profit-making schemes were
criticized by competitors as hypocrisy of the
worst kind.[17] Like Stickley, Hubbard published his
philosophies in monthly booklets, *The Philistine*
and *The Fra*, which he interspersed with distilled
aphorisms on the work ethic, beauty, and self-
promotion. In 1915, Hubbard and his wife perished
on the *Lusitania.*

Stickley and Hubbard courted the late
Victorian/Edwardian middle class, one
recently moneyed due to industrialization
and eager to proclaim and solidify its
newly-won position in society. In different
ways, both were careful to downplay or deflect
the issue of mass-production – i.e., the pivotal role
played by the machine – in America's implementation
of the Arts and Crafts ideal by emphasizing, rather, the

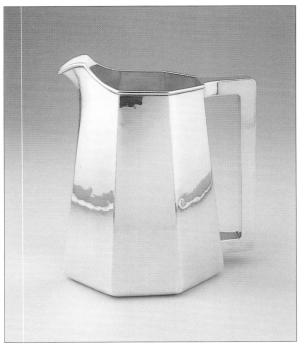

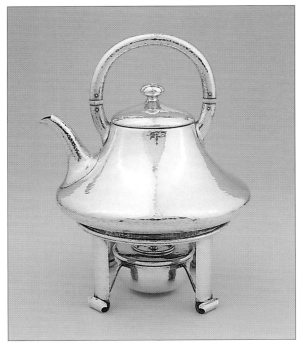

CLARA BARCK WELLES (1868-1965) American
Pitcher, 1916. Sterling silver. Panel form pitcher.
Manufacturer: Kalo Shop, Park Ridge, IL. (founded by
Welles in 1900). Marks: *April 27, 1916 / STERLING /
HAND WROUGHT AT THE KALO SHOPS / CHICAGO
AND NEW YORK /18.*
H: 8in (20.3cm) x W: 10 ¼in (26cm)

SHREVE & COMPANY (1852-1967) American
Kettle on Stand, 1911. Hand-hammered silver and
ivory. Maker: Shreve & Company, San Francisco.
Marks on kettle: monogram inscribed on side; maker's
insignia / *FEB.15.1911 / 2 PINTS / 3309* inscribed on
bottom. Maker's insignia inscribed on bottom of stand.
H: 10in (25.4cm) x D: 7 ½in (19.1cm)

FRANK LLOYD WRIGHT
(1867-1956) American
Urn, c.1903. Molded and
hand-hammered sheet
copper. Executed by:
James A. Miller &
Brothers Chicago for
an anonymous
commission. Of
spherical form,
worked in
repoussé with
four circular
designs with
crenellated
edge, within
elliptical and
lozenge frame
borders, raised
on four
spreading
rectangular feet.
This urn is one of
approximately eight
in two patterns known
to exist, all believed to
be designed between 1895
and 1903. It is identical to
the urn designed for the Susan
Lawrence Dana House in
Springfield, IL.
H: 18 ¾in (47.6cm) x D: 19 ½in
(49.5cm)

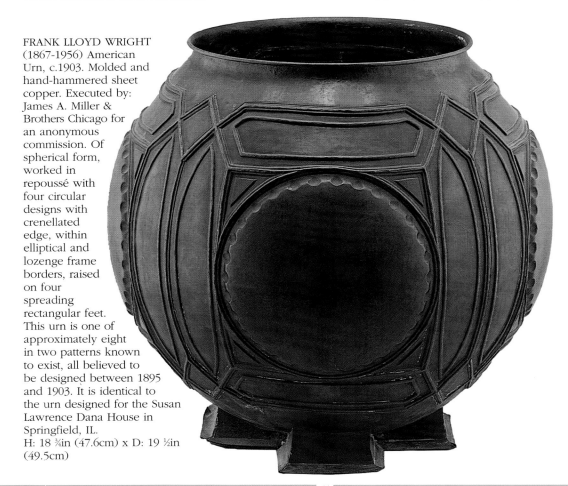

GEORGE E. OHR (1857-1918) American
Vase, c.1900. Glazed earthenware. Quatrefoiled form consisting of four pinched inverted triangles, together with a globular four-leafed clover effect, ending at the top. Over-all silver crystals on a black glazed ground. Marks: signed with the impressed George Ohr monogram early block signature on the underside of base.
H: 6 ½in (16.5cm) x W: 5 ½in (14cm)

moral and spiritual legacy of their handcrafted products. In this, the pronouncements of Ruskin and Morris helped to shore up the movement's message, even as it was being contradicted. Stickley, especially, frequently quoted Morris's definition of art as "the expression of man's joy in his work". Shifting the emphasis slightly on occasions, he stressed also "not the work itself, so much as the making of the man; the soul-stuff of a man is the product of work, and it is good, indifferent or bad, as is his work".[18]

In defense of such seemingly duplicitous sales-manship by Stickley and Hubbard (and others), it should be noted that the burgeoning consumer culture in America around 1900 pitted Arts and Crafts manufacturers not only against each other, but also against an avalanche of other household wares offered through department stores such as Marshall Field in Chicago, John Wanamaker's in Philadelphia, Jordan Marsh in Boston, and Macy's in New York. For the

GEORGE R. PRENTISS KENDRICK (1850-1919) American
Monumental Vase, c.1898-1900. Glazed earthenware decorated with stylized leaves and buds on dark green matt glaze. Executed by Grueby Faience Co., Boston. Marks stamped on bottom: circular insignia *(GRUEBY FAIENCE CO., BOSTON, U.S.A.)* with leaf motif in center. One of only three vases of this size known to exist. Attributed to George R. P. Kendrick.
H: 30in x W: 12 ⅝in (32.1cm)

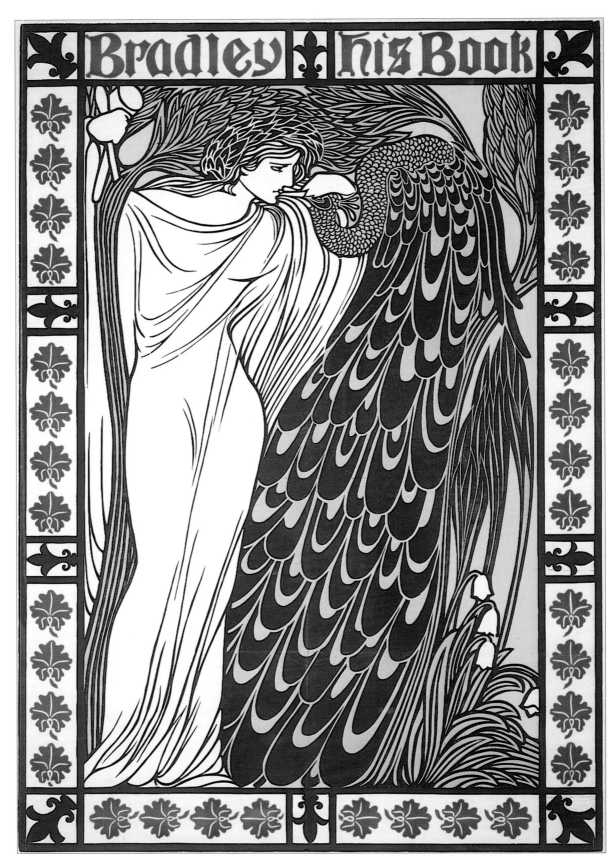

WILLIAM (WILL) H. BRADLEY (1868-1962) American
The Kiss from *Bradley: His Book*, 1896. Color woodcut and lithograph.
Publisher and Printer: The Wayside Press, Springfield, MA.
H: 39 ¹⁵⁄₁₆in (35cm) x W: 27 ¹⁄₁₆in (68.7cm) // H: 49 ½in (125.7cm) x W: 37in (94cm)

homeowner, there were in addition the mail-order services of Montgomery Ward and Sears, Roebuck and Company from which to make one's selection. Competition was fierce; to the point that debate amongst Arts and Crafts adherents on the moral viability of the machine quickly became redundant; no other means of production existed by which expeditiously to meet the surge in consumer demand.

For those Arts and Crafts manufacturers whose designs tended to be stark and functional, such as Stickley and his many imitators, the machine provided the further advantage that the simpler the task, the better it performed, and the better it performed in comparison with the manual worker. Conversely, the more elaborate an object's ornamentation, the more labor-intensive its required means of manufacture and, therefore, the less efficient a machine for this purpose. By this argument, the more pure the form of an object, the more powerful the reason to make it by machine. It required only the convoluted logic of its publicists to link the "pure" or rectilinear contours of a machine-made object to the language of rectitude espoused by the movement's social reformers in England and, thereby, to bring legitimacy to their cause.[19]

Proponents of the machine received the valued support of Frank Lloyd Wright, who forcefully defended its artistic integrity and, where necessary, modified his designs to exploit its capabilities. As he stated in his famous speech, entitled "The Art and Craft of the Machine", to the Chicago Society of Arts and Crafts in 1901, "Machine technology made 'obsolete and unnatural' the old handcraft tradition of 'laboriously joined' structural parts; it compelled the artist to become 'the leader of an orchestra, where he was once a star performer'".[20] Wright's opinion was shared by most manufacturers in the field: the machine relieved the craftsman from the drudgery of monotonous and repetitive work, which permitted him to concentrate his skills on the more important, i.e. creative, aspects of production. In short, mechanization needed to be guided and controlled in the workplace, not banned from it.

In a final analysis of the machine's role in production, it should be noted that the Arts and Crafts manufacturer's battle for America's middle class was largely won because of it, at least in what could realistically be expected in terms of a national market share. The movement's social message – the work ethic, the common man, the simple life, etc. – appealed especially to those who scorned the upper class's ostentation and excesses. And whereas this segment of society could not afford unique works of art (nor could it be argued that it was sufficiently knowledgeable to judge or appreciate such works could it have afforded them), its acceptance of a range of standardized home furnishings – invariably handsome, practical and comfortable, though in no way grand – assured its members of a tasteful lifestyle enjoyed by many at the same income level. This attitude reflected a departure from the traditional trend of the middle class to ape the rich, a fact which Stickley and others were able to exploit commercially.

It was the furniture-maker who received the lion's share of the American Arts and Crafts market, and around whose products craftsmen in ancilliary disciplines, such as ceramics, lighting and metalware, established their respective businesses and reputations in the movement's joint propagation of the concept of the unified home environment.

Arts and Crafts furniture was characterized by simplicity and cleanliness of form and proportion, honesty of construction, attention to detail, and a love of materials naturally expressed. Durability was emphasized; each piece was made to be used and made to last. The value of handcraftsmanship was especially stressed. Mortises and tenons, and dowelling, replaced the nail and the screw. Superfluous ornament was assiduously avoided; an object's structural elements, such as projecting tenons and keys, and slats or spindles, became its main source of decoration.

The movement's premier cabinetmaker was Gustave Stickley, whose Craftsman Workshop was based in Eastwood, New York. Gustave's brothers, Leopold and John George, operated a rival workshop in Fayetteville from 1902. Another branch of the family's cabinetmaking business, the Stickley Brothers Company, was founded in Grand Rapids in 1891. Of significance also within the movement were The Shop of the Crafters in Cincinnati, and the Charles C. Limbert Company. All offered a selection of "Mission" furniture, the generic name at the time for the American version of Arts and Crafts furniture.

Stickley placed great emphasis in his furniture on massive proportions, strength and durability, a philosophy to which he adhered as he constantly reviewed and modified his designs as a means to effect cost-cutting. Only for one brief period, between 1903-04, when the architect-designer-illustrator Harvey Ellis joined the Craftsman workshops, did Stickley deviate from his severe style. Ellis introduced refinements that lightened the visual heaviness of Stickley's furniture, primarily through the application of metal inlays of plant motifs that showed his grasp of contemporary developments in Glasgow, London, and Vienna. These small concessions to adornment, as Stickley explained in an article in *The Craftsman* in 1904, were "to make interesting what otherwise would have been a too large area of plain, flat surface. It, in any case, emphasizes the structural lines, accenting in most instances the vertical elements, and so giving a certain slenderness of effect to a whole which were otherwise

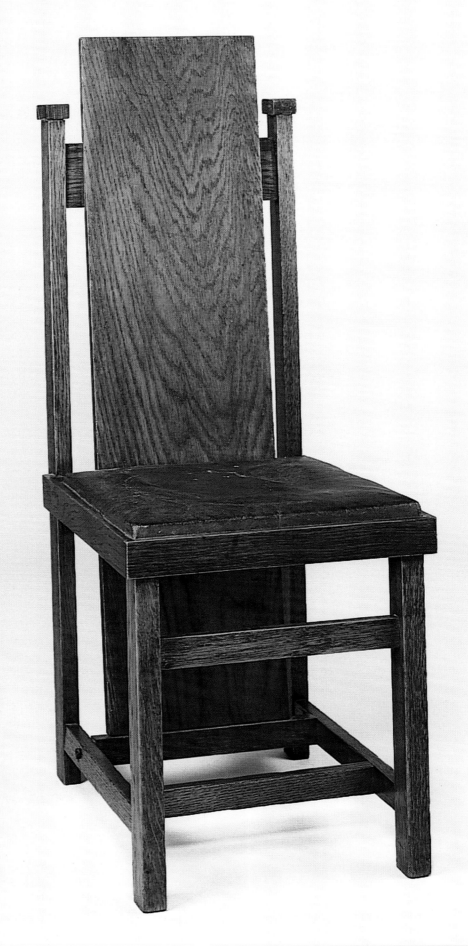

FRANK LLOYD WRIGHT (1867-1956) American
Plate, 1914. Glazed porcelain, designed for the Midway Gardens,
Chicago. Marks in underglaze on bottom of plate: *New York,
Chicago, Bauscher, Weiden (Germany), 1914.*
H: 6 ¼in (15.9cm) x W: 9 ¾in (24.8cm)

too solid and heavy".[21]

In his all-too-brief sojourn in Eastwood, Ellis introduced arching curves and other understated forms of ornamentation that softened the sharp rectilinear quality of the workshops' repertoire of furniture, textiles and graphics. His modifications to Stickley's furniture, in particular, brought a grace and poetic quality to models which might otherwise have become increasingly monumental and ponderous in Stickley's relentless pursuit of honesty and simplicity. Ellis's untimely death in 1904 brought an abrupt end to such experimentation.

Stickley's preference for American white oak was shared by most of his competitors. As he wrote, "Oak is to Craftsman furniture what mahogany was to the French, English and Colonial furniture of the 18th century – a wood perfectly adapted to the use made of it – and in addition to this, it has a natural quality which I can best express by the term 'friendly', that is, a certain strength of fiber and grain and a mellowness of color and surface which seems to offer itself to everyday use and wear".[22]

The founding of the Roycroft Furniture Shop in 1901 was due to a request for furnishings by guests of the

FRANK LLOYD WRIGHT (1867-1956) American
Side chair, c.1904. Oak with original leather-covered slip-seat.
Provenance: Hillside Home School, Spring Green, WI.
H: 39 ¼in (97.2cm) x W: 15in (38.1cm) x D: 19 ¼in (48.9cm)

DESIGNER UNKNOWN (American)
Bud Vase, c.1910. Sterling silver (hand-beaten) with glass tube.
Executed by Lebolt & Co., Chicago. Marks: *LEBOLT / Hand
Beaten / Sterling 804.*
H: 13in (33cm) x W: 3 ½in (8.9cm) x D: 3 ½in (8.9cm)

community's inn. The models were heavy and simple, drawing their inspiration from the currently popular Mission style. An article in *House Beautiful* the same year described one of the chairs as "honest and simple enough in construction, but somewhat too austere in design, and altogether too massive to be pleasing". Although refinements were introduced, the principal qualities of Roycroft's furniture remained its robust handcrafted structure which, combined with the bold lettering of the signature, exemplified the pride and diligence which the shop placed in its workmanship, which the idealistic Elbert Hubbard described in one of his epigrams as "made the best we know how".

The principal furniture designers at Roycroft were James Cadzow and William Roth, although neither

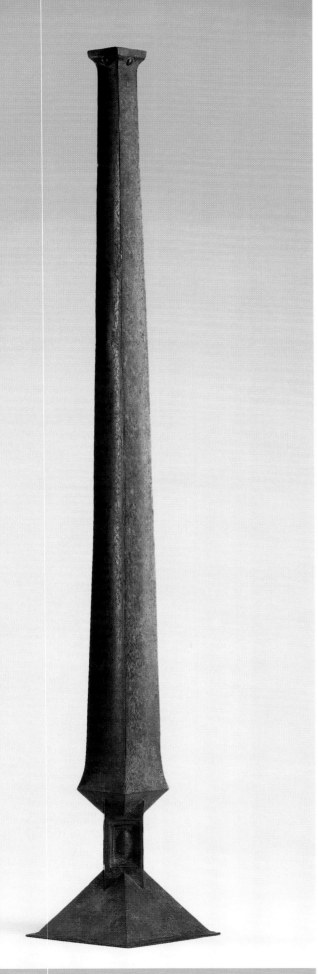

FRANK LLOYD WRIGHT (1867-1956) American
Weed Holder, c.1895-1900. Copper with original patina.
Executed by James A. Miller and Brother, Chicago.
H: 28in (71.1cm) x W: 4 ¼in (10.8cm) D: 4 ¼in (10.8cm)

The first of Frank Lloyd Wright's copper weed holders was
probably designed shortly after 1893, at the start of his
independent architectural practice. The vases were made by
James A. Miller in response to Wright's displeasure with the
bric-a-brac so often brought into the interior of his new homes
by clients yet to be properly indoctrinated. He subsequently
included the model in several of his interiors, including the
octagonal library in his own studio in Oak Park and later, the
dining room of the Dana house in Springfield, Illinois. Today,
there are approximately ten weed-holders in private and public
collections. Wright developed an organic approach to architecture
which openly expressed the interrelationship of exterior and
interior, down to every detail, from furniture (often built-in) to
such elements as this weed holder (and its complement, a large
bulbous urn also in the Norwest collection, see page 44). His
penchant for a sophisticated simplicity is apparent in this piece
as it is throughout his early work.

Wright's affinity for repoussé copper echoed Arts and Crafts taste,
but he saw little common ground between his own carefully
calculated effects and the "plain barn door" simplicities of
Gustave Stickley and the Roycrofters. Wright sought to achieve
the effect found in Oriental metalwork that he so revered, a hand-
applied, weathered patina. It's likely Miller experimented with the
patina over the years in close consultation with Wright.

ROYCROFT SHOPS (1895-1938) American
Side Chair (model no. 031), 1900-05. American white oak, quarter
sawn. Three back slats flanked by tapering square supports above
a flaring square seat. Manufacturer: Roycroft Shops, East Aurora,
NY. One of four known existing examples. Marks: *Roycroft*,
carved on front of rail; orb carved on front of seat.
H: 47 ½in (120.7cm) x W: 17 ⅜in (43.7cm) x D: 18 ¹⁵⁄₁₆in (48.2cm)

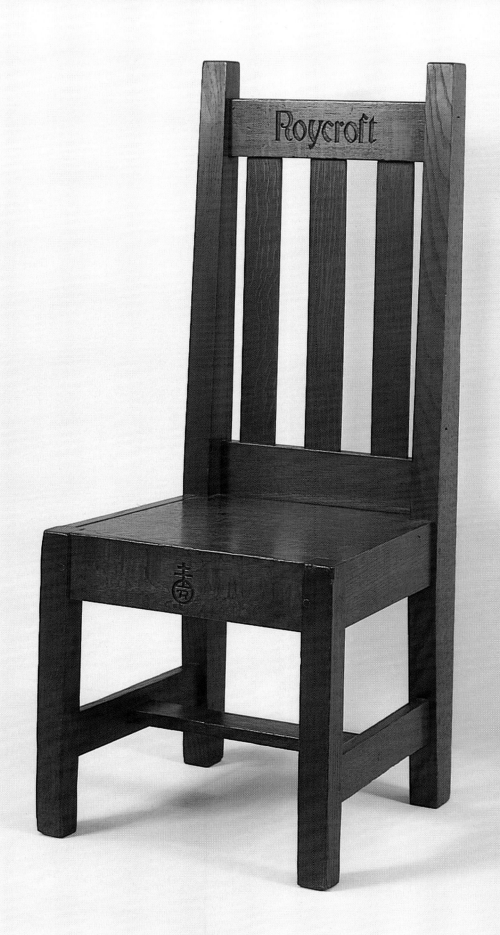

they nor the other designers were allowed individual credit by Hubbard. Also on the staff was Dard Hunter, who following a trip in the early 1900s to Vienna, where he visited the Wiener Werkstätte, replaced the conventional Roycroft organic motifs in his decorative repertory with a rigid checkerboard matrix of design.

Like Stickley, the furniture-maker Charles Rohlfs showed a preference for indigenous oak and ash due to their distinctive grains, which often determined the fanciful motifs with which he embellished the wood's surface. Having moved in Buffalo in 1885, Rohlfs later began in his free time to design and manufacture a range of furniture for his home in the prevailing Mission style. This avocation soon blossomed into a home industry which in 1902 afforded him an invitation to the World's Fair in Turin and by 1909 an expanded workshop comprised of eight fulltime artisans.

Unlike Stickley, Rohlfs brought an exuberant idiosyncratic style to his furniture designs, one that found its mature expression in complication rather than simplicity. Although the European influences are obvious – the sinuous Art Nouveau whiplash convolutions of Belgian and French Art Nouveau, such as those of Horta, Guimard and Mucha – his work showed an energetic blend of whimsy, functionalism, and solid handcrafting that was unmistakably his own. Some of his motifs, in their compact and tangled luxuriance, echo the architectural ornamentation on Sullivan's Guarantee Insurance building in downtown Buffalo. Rohlfs is seen today as neither a pioneer nor a full disciple of the Arts and Crafts movement, but as an excellent craftsman with a refreshing originality.

In the mid-West two exponents of the region's Prairie style, both architects and former employees and protegées of Sullivan, Frank Lloyd Wright and George Grant Elmslie, designed furnishings (and a full range of household accessories) in the Arts and Crafts style for both residential and commercial commissions. Of the two, the most gifted and celebrated was Wright.

Wright conceived of the decorative arts as interior architecture, each object contributing to a unified scheme of design that constituted the "grammar" of the house. As he noted, "everything has a related articulation in relation to the whole and all belongs together because all are speaking the same language".[23] Virtually all of his furniture was therefore intended for use in the specific house for which it was designed, although a great deal of it – such as

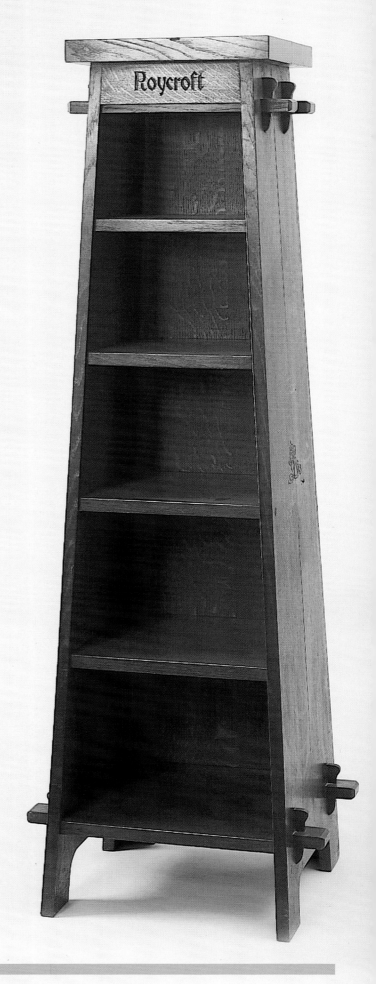

ROYCROFT SHOPS (1895-1938) American
Magazine Pedestal, c.1902. Stained oak. Standing pedestal with series of open shelves supported by dowling with tenon-and-key side locks on top and bottom. Embellished with carved maple leaves. Manufacturer: Roycroft Shops, East Aurora, NY. Marks: *Roycroft* inscribed in gothic script.
H: 63 ¾in (161.9cm) x W: 17 ¼in (43.8cm) (at base) x D: 17 ½in (44.5cm) (at base)

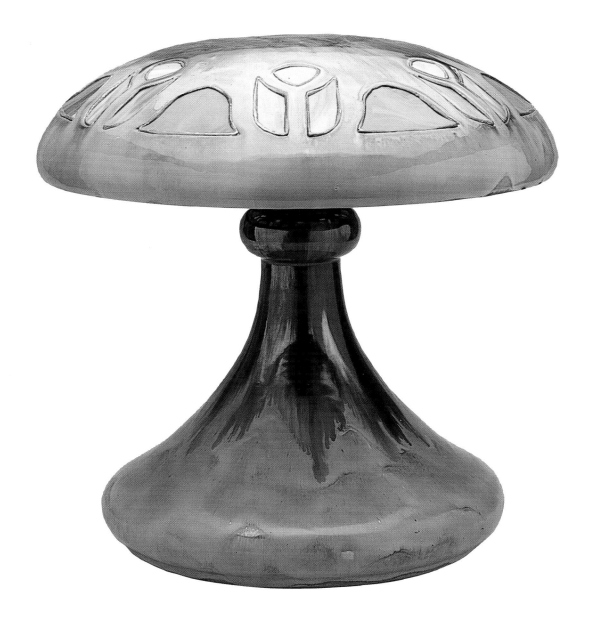

FULPER POTTERY COMPANY (c.1805-1930) American
Mushroom Lamp, c.1910. Stoneware with green crystalline and *flambé* glaze and inset panels of multicolored stained glass.
Manufacturer: Fulper Pottery Co., Flemington, NJ. Marks: signed with ink stamp monogram on underside of base.
H: 18in (45.7cm) x D: 17in (43.2cm) (at shade)

The Fulper Pottery Company had its roots in the Samuel Hill Pottery, possibly founded as early as 1805 for the manufacture of drainage tiles and other industrial products. It was not until 1909, however, that Fulper introduced his Vasekraft line and entered the American art pottery market. For the next two decades, this New Jersey pottery produced outstanding wares in the Arts and Crafts tradition, with emphasis on unusual forms and glazes.
Advertisements in Arts and Crafts periodicals of the time, such as Elbert Hubbard's *The Fra* and Gustave Stickley's *The Craftsman*, extolled the virtues of Vasekraft pottery, especialy the Fulper Vasekraft lamps, first introduced in 1910. One advertisement called the lamp "the very latest in interior decoration, adding beauty to every home". Another remarked on its "originality and beauty of design, and wonderful workmanship". Fulper's Vasekraft pottery was considered an ideal accompaniment to the sturdy Arts and Crafts furniture manufactured by Gustave Stickley's Craftsman shop.

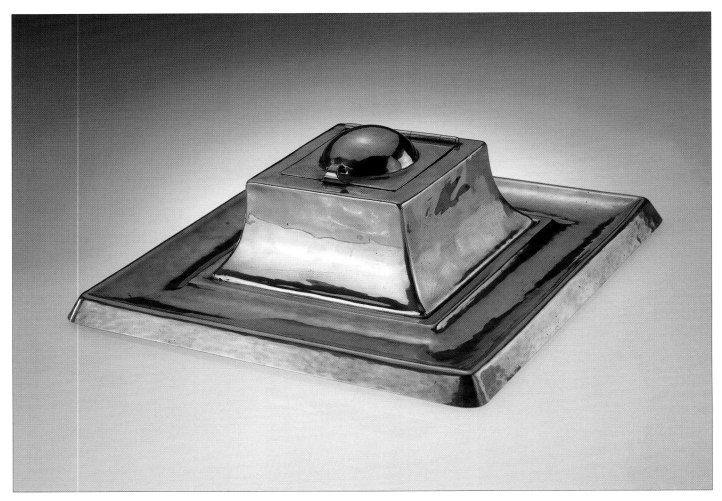

CHARLES FRANCIS ANNESLEY VOYSEY (1857-1941) English
Inkwell and Pen Tray, 1900. Brass with glass insert. Executed by R. LL. B. Rathbone, Birmingham.
Marks: 673 (model number) / Rathbone, 1900 (date mark).
H: 3 ½in (8.9cm) x W: 10in (25.4cm) x D: 10in (25.4cm)

cabinets, bookcases, and benches – was built-in.

Wright never came to terms fully with the Mission furniture of the Stickleys, Limbert, and others, even though it was not incompatible with his interiors. Yet he felt intellectually superior to it; in its rudimentary construction it was conceptually a remnant of the 19th century, whereas his, which was unapologetically machine-made, belonged firmly to the present and future. Some observers today speculate on the discomfort that must have been endured by the original occupants of Wright's seat furniture, as their sharp rectilinearity showed no concession to the human anatomy.

Scottish by birth, Elmslie joined the Chicago firm of Adler & Sullivan in 1889 as a draughtsman and in 1896 was promoted to chief designer. He left in 1909 to join William Gray Purcell and George Feick, the latter left the partnership four years later. Elmslie and Purcell enjoyed an extremely close collaborative relationship for 15 years (only seven of which were spent directly together). The

two pursued a perpendicular architectonic style in which abrupt contours, tight compositions and a virtual lack of ornamentation identifies the majority of their furniture designs. Most of their commissions were undertaken in Minnesota and Wisconsin. Important clients included Edward W. Decker of Minneapolis and the Merchants Bank of Winona.[24]

Another noted mid-West architect, George Washington Maher, opened his own office in Chicago in 1888. By the turn-of-the-century his office was handling a significant number of commissions, most of them residential. His most important client was the J. R. Watkins Company of Winona, for whose president, Ernest L. King, Maher designed *Rockledge*, a large Prairie School residence situated at the base of a limestone bluff on the west bank of the Mississippi River. The commission provided Maher ample opportunity to incorporate his motif-rhythm theory of decoration, the fundamental principle of which he described as "to receive the dominant inspiration from

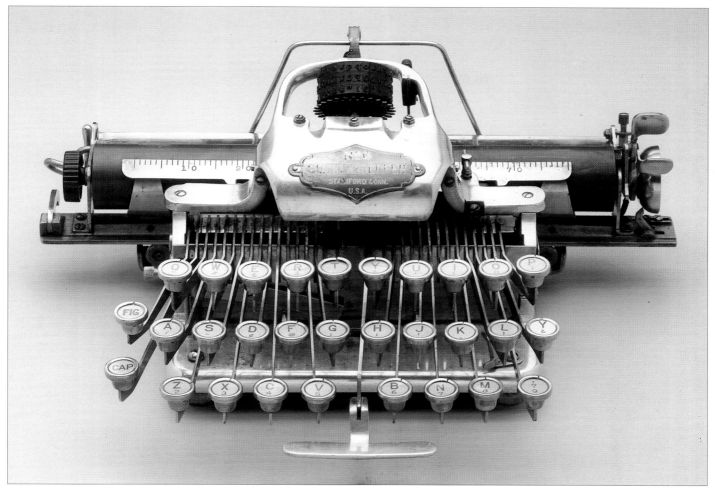

GEORGE C. BLICKENSDERFER (-1917) American
Blickensderfer 6 Typewriter, c.1890. Aluminum "portable" typewriter with original wood carrying case.
Manufacturer: Blickensderfer Manufacturing Co., Stanford, CN.
H: 5in (12.7cm) x W: 12in (30.5cm) x D: 8 ½in (21.6cm) (typewriter)
H: 7in (17.8cm) x W: 13in (33cm) x D: 9 ½in (24.1cm) (carrying case)

the patron, taking into strict account his needs, his temperament, and environment, influenced by local color and atmosphere in surrounding flora and nature. With these vital impressions at hand, the design naturally crystallizes and motifs appear which being constantly utilized will make each object, whether it be of construction, furniture, or decoration, related…" In the *Rockledge* house, various decorative motifs recur throughout the architecture and furnishings as the means to unify it thematically; in particular, an indigenous coral-colored lily which was repeated in its fabrics, stained glass panels and light fixtures (see page 41).[25]

On the West Coast, the excitement of the furniture made by Charles Sumner and Henry Mather Greene – its design, execution and choice of ebony as a contrasting inlay – drew the praise of Charles Ashbee during his visit in 1909 to their Pasadena workshop. He wrote of "the best and most characteristic furniture I have seen in this country. There were beautiful

cabinets and chairs of walnut and lignum-vitae, exquisite doweling and pegging, and in all a supreme feeling for material, quite up to the best of our English craftsmanship".[26] The Greene brothers created furniture of this calibre for the bungalow-style houses which they designed for their most important clients, including Robert R. Blacker of Pasadena. The house for David B. Gamble, which followed shortly, solidified their reputation as pioneers of a highly distinctive native American architecture achieved in large part by its exuberant Arts and Crafts cabinetry, which was executed by John Hall, California's most accomplished furniture-maker.

In San Francisco, Arthur Mathews formed the Furniture Shop in 1906, in association with John Zeile, in part to meet the demands for furnishings by the wealthy in the wake of the earthquake and fire which leveled the city earlier that year. Comprised of skilled artisans, carvers, cabinetmakers and decorators, the Shop ranged in number from 20 to 50, matching the

flow of work. Mathews was assisted amongst others by his wife, Lucia Kleinhaus Mathews, a painter and former pupil. Whereas a significant part of the business was geared to relatively plain furniture for commercial usage, it did indulge its prized clientele with a selection of lavishly crafted pieces adorned with imagery drawn readily from Renaissance, Bourbon and William Burges' Victorian revival prototypes. The degree of ornamentation on these special order works shows a preoccupation with aesthetics that gave full interpretation to Morris's doctrine, "Have nothing in your home which you do not know to be useful or think to be beautiful". Typical of what became known as the California Decorative Style, this type of furniture by Mathews represented a dimension of the American Arts and Crafts movement far removed in spirit from the robust functional idiom of Stickley and Hubbard.[27]

The field of Arts and Crafts ceramics in the U.S. fell broadly into two categories: that of the large commercial manufactories such as Rookwood, Fulper, Grueby, Gates, and the Tiffany Studios, which searched for a financially viable union of art and industry; and the single potter or small studio, such as George Ohr, Hugh Robertson, Adelaide Alsop Robineau and Theophilus Brouwer, who remained true to the potter's art and craft. The former concentrated largely on the faithful reproduction of a given design. Only very narrow degrees of variance could be allowed, as part of their business was generated by mail order catalogs, which included an illustration, with specifications of each object. Uniformity was therefore essential, even in the floral and landscape decorative imagery generated at Rookwood and Newcomb, where only small latitude in detail was permitted for artistic interpretation. Such issues of standardization were of no consequence to the individual potter: for him or her, the search for novel glaze formulae and firing effects were paramount.

Amongst the larger manufactories, the Rookwood Pottery in Cincinnati was renowned for its "standard" glaze. Introduced in 1884, the technique was distinguished by its background of muted tones, usually chocolate or chestnut browns, ocher yellows, willow greens, and cherry reds, which blended into each other as the vessel was rotated. These colors provided the ground for sprays of flowers, cereals or portraits applied in slip clay in warm complementary hues beneath a high gloss overglaze. Other glazes developed by the firm included its "Iris" and "Sea-green" varieties.

A former decorator at Rookwood, Artus Van Briggle was exposed to the fledgling Art Nouveau style while an art student in Paris in the mid-1890s. On returning to Cincinnati, he became increasingly preoccupied with glaze experimentation, which included an attempt to rediscover the secret of the Ming dynasty's "dead" or mat glazes, which he applied to vases decorated with rampant Belle Epoque imagery. Forced to leave Ohio due to ill-health, van Briggle moved to Colorado Springs where he continued his experimentation with local clays and glazes. His vessels were made in molds, which were dried, then biscuit-fired, glazed and refired.

The Grueby Faience Company in Boston, the Gates Potteries in Terra, Illinois, and the Fulper Pottery Company in Flemington, New Jersey, were much larger enterprises which likewise sought to develop new glazes for application to molded vessels. At Grueby, for example, experimentation led to a mat green "cucumber" glaze that became the firm's hallmark, its appeal lying both in the rich monotone of its coloring and its velvety yet glossless surface, qualities considered at the time unique to American pottery (Stickley, for example, incorporated many of Grueby's wares into his Craftsman room settings). Until then, dull finishes had usually been obtained by sandblasting or by the immersion of the piece in an acid-bath. Although Grueby introduced a range of other colors – blue, yellow, brown, ochre, plum and mustard – none was considered comparable within the Arts and Crafts community to the mat green variety.[28]

In contrast, high-fire tests were conducted at studios such as the Weller Pottery in Zanesville, Ohio; the Dedham Pottery in Dedham, Mass; the Chelsea Keramic Art Works near Boston; the Middle Lane Pottery in East Hampton; and the Grand Feu Pottery in Los Angeles. In these, intended glaze effects included iridescent, lustered, or mirrored finishes achieved at high kiln temperatures. At the University City Pottery in Ohio, the visiting legendary potter, Taxile Doat, briefly (1910-1915) shared his formulae for *flambé*, crystalline and metallic glazes with his host, the American Women's League, before returning to his native France. For a glorious moment, University City boasted some of the most prestigious names in the medium: Doat, Robineau, Frederick Rhead, and Dahlquist.

Perhaps the most celebrated exponent of the Arts and Crafts movement in ceramics – and certainly its most bizarre and flamboyant – was George Ohr, who established his pottery in Biloxi, Mississippi, in 1893. Ohr's technical virtuosity grew rapidly as he personally threw, glazed and fired all of his works. The search for new shapes and glazes led to his much-vaunted claim of "No two alike". Ohr's dexterity with the potter's wheel led to the creation of a fanciful range of manipulated shapes that were crushed, twisted, folded, dented, pleated or pinched with apparent ease and abandon (see page 45). To these he applied a kaleidoscope of high-gloss glazes, many experimental and sponge-applied to achieve variegated, splotched or spattered effects.

The American metalworker of the Arts and Crafts movement drew his initial inspiration from his mediaeval counterpart. The craft remained firmly

DESIGNER UNKNOWN (American)
Chestnut Pillow, c.1910. Hand embroidered linen with cutout design.
17in (43.2cm) x 15 ½in (39.4cm) x 5 ¾in (14.6cm)

bound to fundamentals: only the hammer and essential chasing tools were considered legitimate, their stroke marks left proudly on the metal's surface as proof of its maker's manual dexterity. Structural elements, such as chamfered rivets, were frequently left exposed to provide a small decorative fillip. The movement's silver industry, both the single smith and larger shops, embraced the same philosophy, though greater public demand for silverware led to the widespread use of machinery, such as stamping presses, to expedite production. The relative simplicity required in working with metal or silver, and the small amount of space necessary to do so, spawned a wide "cottage" industry.

Chicago became a hub of the movement in this field,

in part because of the influence of Ashbee, where a display of his jewelry and silver was staged in the city's inaugural Arts and Crafts exhibition in 1898. Two years later, during his tour of the U.S., Ashbee's lecture at the Art Institute generated further publicity for his Guild of Handicraft and its Art and Crafts ideals.

Clara Barck Welles opened her Kalo Shop in Chicago in 1900, its name taken from the Greek word for beautiful. An energetic woman known as a fair employer, teacher, and promoter of women's causes, Welles oversaw the production of a wide range of copper, brass, and silver household wares manu-factured under her supervision by a team of craftswomen in a workshop behind her Park Ridge home that she and her husband named the Kalo Art-

Craft community.[29] Emphasis was placed on simple forms with lightly hammered finishes expressive of the metal, which was given a decorative finish accented on occasion by colored stones reminiscent of Ashbee's Cymric and Tudric wares for Liberty & Co. With the number of staff growing to 25, Kalo Shops became the leading producer of silverware for more than three generations of Chicagoans (see page 44).

Also in Chicago, the retail jewelry firm of Lebolt & Co. was established in 1899, and a metalshop was added around 1912. The owner, J. Myer H. LeBolt developed a series of distinctive hand-hammered tea and coffee services and flatware patterns to supplement the firm's jewelry. A staff of roughly 25 designers and artisans – silver and goldsmiths, polishers, chasers, stone-cutters and setters – were retained. Styles ranged from the traditional (for example, Gothic, Louis XVI and Georgian) to a selection of unadorned Arts and Crafts pieces heightened only with a lightly hammered surface finish.[30]

Born of Scottish parents, Robert Jarvie moved to Chicago, where an interest in lighting led him by 1900 to a serious part-time career as a metalworker. The slender fluid forms of his candlesticks set them apart from those of the imitators who quickly emerged.[31] As orders increased, Jarvie commissioned two local foundries to execute some of his designs, and in 1904 resigned his job and opened a shop in the city's Fine Arts Building. Soon his output included 16 different candlestick models, plus lamps and miscellaneous household metalware.

Items were cast or spun, the former process preferred for tall forms and the latter for a selection of shorter, trumpet-shaped sticks. Items in copper are most easily spun as the metal's softness and malleability are well-suited to the formation of tapered or domed shapes. Brass, however, is better cast as its heavier gauge and specific gravity require continual annealing during spinning to prevent friction and the subsequent possibility of cracking.

In San Francisco, Shreve & Co. began as a jewelry store in 1852 and by degrees established itself as a leading producer of hollow-ware, trophies and souvenir spoons. Around 1900, the firm began to experiment with hand-hammered surfaces used in conjunction with cut-out designs, which were soldered on to the body of the vessel rather than riveted, as the imitation bosses make it appear (see page 44) . The technique shows the Arts and Crafts exponent's compromise: the marriage of the trade's traditional types of decoration – with an evocation of its craft techniques and archaic construction – and a time-saving method of assembly. This compromise was forced increasingly on the late Victorian silversmith as the machine transformed his cottage industry into a

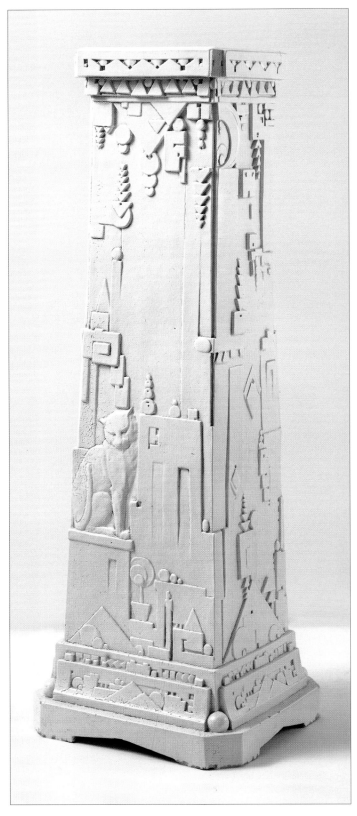

FERDNAND CESAR AUGUSTE BERNARD JAMES MOREAU (1853-1920) French-American
Pedestal, c.1911. Glazed terra cotta. Cast with a faux-Egyptian cityscape, replete with geometric motifs, stylized cat and owl. Designed for a model lamp designed by Fritz Albert. Executed by: Northwestern Terra-Cotta Co. (Norweta), Chicago.
H: 38 ½in (97.8cm) x W: 13in (33cm) x D: 12in (30.5cm)

commercial enterprise.

Dutch by birth, Dirk Van Erp was employed in the naval shipyards on Mare Island near San Francisco when he began to experiment in metalwork as a hobbyist. He never shook off his early, somewhat rudimentary and self-taught, style, but he had a fine sensitivity to form and proportion. In 1908, he opened his Copper Shop in Oakland, from where he moved shortly to San Francisco. Van Erp's metalware is characterized by a vigorous *martelé* decorative finish achieved by the application of alternative hammer strokes to its inside and outside surfaces. His copper table lamps, which he mounted with mica shades, are his most prized creations.

In 1905, Stickley established a metalwork department in Eastwood to supplement his cabinetshop. The stamped hardware that he had first used did not suit the solid, handcrafted appearance of his furniture, so a blacksmithy was set up to forge handwrought hinges, key escutcheons and handles. Lamp fixtures, fireplace furniture, chafing dishes, coal buckets, and other objects were soon in production, as well as accessories in copper, brass, and wrought-iron. At Roycroft, artist-craftsmen such as Dard Hunter and Karl Kipp oversaw the creation of a similar range of Arts and Crafts metalware appliances.

It is fair, in conclusion, to note that the leaders of the Arts and Crafts movement masterminded the acceptance of their products in mainstream America by heralding the concepts of fine craftsmanship. Yet with few exceptions the standard achieved was undistinguished compared to that of the pre-industrial era, as most objects were at least partially made by machines or molds to established designs, which reduced their creativity. The artistic legacy of most American Arts and Crafts objects therefore lies less in their technical virtuosity than in their level of design. A final central irony of the American movement was that, while philosophically opposed to industrialization, it was able by utilizing the latter's markets and methods to flourish more than in its country of birth, the United Kingdom.

The Great War sounded the death knell for many Arts and Crafts pursuits in America: wartime realities intruded on the nation's nostalgic preoccupation with the craftsman lifestyle. And whereas many workshops continued with some success throughout the 1920s, the Depression effectively drained the movement of its vitality. Its legacy has been more enduring, however, as it survives in our present attitudes to domestic environments, craft as art, and the artistic value of the decorative arts in general. Thanks in part to the resurgence in interest in the Arts and Crafts movement in the 1980s, art now enjoys a broader definition in society, and a broader spectrum of society enjoys art.

NOTES

1. For a summary of the 1851 Crystal Palace exhibition, see Gillian Naylor, *The Arts & Crafts Movement*, 1971, pp.20-22.

2. See also A. W. N. Pugin, *An Apology for the Present Revival of Christian Architecture in England*, London, 1843.

3. Ibid.

4. "Universal Infidelity in Principles of Design", *The Times*, reprinted in *The Journal of Design*, vol. V, 1851.

5. Pugin, op.cit., p.41.

6. For a discussion on the formation of the firm, see Philip Henderson (ed.), *William Morris: His Life, Work and Friends*, London, 1967.

7. As quoted in Naylor, op.cit., p.14.

8. See the covers of *The Artsman*, the journal of Will L. Price's Rose Valley community in Pennsylvania, published between 1903 and 1907.

9. See E. T. Cook & A. Wedderburn (eds.), *The Collected Works of John Ruskin*, London, 1903-12, vol. XXX.

10. For a comprehensive review of the English Arts and Crafts guild system, see Isabelle Anscombe & Charlotte Gere, *Arts & Crafts in Britain and America*, 1978, p. 109 ff.

11. A selection of Voysey interiors is illustrated in Duncan Simpson, *C. F. A. Voysey: An Architect of Individuality*, 1979.

12. For a discussion on the initial cross-fertilisation of Arts and Crafts ideals between proponents in the U.K. and America, see Wendy Kaplan (ed.), *"The Art that was Life": The Arts & Crafts Movement in America 1875-1920*, exhibition catalogue, Boston, 1987, pp. 57-58.

13. Ashbee's second trip to America in 1900-01, during which he delivered a series of lectures in 14 States on behalf of the National Trust, contributed greatly towards the growth of the Arts and Crafts movement in the U.S. For a summary of Ashbee's tour, see C. R. Ashbee, "A Report by C. R. Ashbee to the Council of the National Trust for places of historic interest and natural beauty", October MDCCCC – February MDCCCCI, Essex House Press. Further information on the trip is included in the biography by Alan Crawford, *C. R. Ashbee: Architect, Designer, and Romantic Socialist*, 1985.

14. See Eileen Boris, "Dreams of Brotherhood and Beauty", *The Social Ideas of the Arts & Crafts Movement*, "The Art that was Life..." op.cit. p. 208 ff.

15. G. Stickley, "Thoughts Occasioned by an Anniversary", 1905, p. 53.

16. For discussion on *The Craftsman*, see Leslie Greene Bowman, *American Arts & Crafts: Virtue in Design*, 1990, p. 36.

17. Bowman, ibid., p. 42.

18. G. Stickley, "Als Ik Kan, Art True and False", *The Craftsman* 8 (August 1905), pp. 684-686.

19. Carl Schorske, "Observations on Style and Society in the Arts & Crafts Movement", Record of the Art Museum, Princeton University, vol. 34, no. 2 (1975), p. 42, as quoted in Robert Judson Clark & Wendy Kaplan, *The Art that was Life...*, op.cit., p 78.

20. See Edgar Kaufmann, Jr. and Ben Raeburn, *Frank Lloyd Wright: Writings & Buildings*, 1960 (reprinted 1974), for a discussion on Wright's speech to the Chicago Society of Arts & Crafts.

21. G. Stickley, *The Craftsman*, January 1904, pp. 394-396.

22. Quoted in *Catalogue of Craftsman Furniture*, firm's booklet, 1909, p. 8.

23. Sharon S. Darling, *Chicago Furniture: Art, Craft & Industry 1833-1916*, New York, 1984, p.257.

24. For a biography on Elmslie, see Brian A. Spencer, *The Prairie School Tradition*, 1979, p. 120; for ones on Elmslie and Purcell, see David Gebhard, "Purcell and Elmslie, Architects", *Prairie School Review*, July 1965, pp. 5-13.

25. The leitmotifs in Maher's work are discussed in Clark & Kaplan, *The Art that was Life...*, op.cit., pp. 94-95.

26. Quoted in Marion Page, *Furniture Designed by Architects*, 1980, p. 118.

27. For information on Arthur and Lucia Mathews see, for example, Harvey L. Jones, *Mathews: Masterpieces of the California Decorative Style*, Salt Lake City, 1980.

28. See *Boston Sunday Globe*, March 1901, for a discussion on Grueby's standard green glaze.

29. For a biography on Welles and the Kalo Shops, see Sharon S. Darling, *Chicago Metalsmiths*, 1977, pp.45-55.

30. Darling, ibid., p. 105-110.

31. Jarvie's metalware repertoire is discussed in Anon, "Work of Robert Jarvie", *The Craftsman*, December 1903, p. 273.

ART NO

1880 - 1910

Central to an examination of the Art Nouveau movement and of whether the work of an individual or school qualified stylistically as part of it, must be an attempt to define the movement clearly and narrowly. No single artist-designer-craftsman or architect epitomised the "New Art"; each sought to settle his account with historicism in his own way. The movement evolved differently in different countries in the late 19th century with the single purpose of defeating the status quo within the fine and applied arts. Nor did its exponents embrace it with equal enthusiasm and success, or for an equal amount of time: some chose to drop out soon after it had been launched in the early 1890s, others at the height of its success at the triumphal 1900 Exposition Universelle in Paris, and others after its rapid demise five years later. All were in revolt against a century of mediocrity and pastiche, yet each was free to express his opposition as he chose. As a contemporary critic noted in 1902 of the fledgling Art Nouveau movement in America, there was little agreement amongst its adherents beyond "an underlying character of protest against the traditional and the commonplace".[1]

The Victorian pre-occupation with a cluttered eclecticism – its *horror vacui* and outmoded taste – opened the door in the early 1890s to the concepts of modern interior design through which Art Nouveau advanced its cause. The average 19th century interior was solemn and tedious, with little air and less light. Every conceivable surface and space was used to create the dissonant and fusty mix of furniture, bric-a-brac, wall hangings and textiles that came to characterize home-ownership in the Victorian age. The Art Nouveau solution, exemplified for the public in the modern *ensembles* displayed at the turn-of-the-century

MARIE ZIMMERMANN (1878-1972) American
Centerpiece Bowl, c.1910. Handwrought copper, patinated in a verde green. Looping handles with foliate-organic details.
Marks: logo stamped on bottom.
H: 7 ½in (19.1cm) x
W: 19in (48.3cm) x
D: 8in (20.3cm)

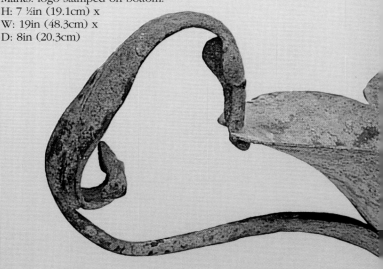

Although widely exhibited and recognized in her own time, Marie Zimmermann is largely unfamiliar to contemporary audiences. Her polygenetic designs drew upon sources as diverse as Chinese, Celtic and Persian traditions and she produced a wide range of objects from jewelry, flatware and tea sets to furniture and architectural ornaments. However, it is her metalware designs that are most revered today.

This hammered bowl, like many of her works, is based on Chinese forms popular during the T'ang Dynasty. Chemically antiqued patinas fascinated metalworkers, but few could approximate the broad range of color and textural effects that Zimmermann achieved.

While she worked comfortably in silver, gold, iron and brass, it is in copper that she was to create her *naturaliste* works, forms inspired by close studies of nature. The bowl's elegant restraint is in the Arts and Crafts tradition, but its foliate form, particularly the tendril-like handles, echo the lines and spirit of Art Nouveau. Among Zimmermann's finest work, it alone reaffirms her place as a pre-eminent American metalsmith.

UVEAU

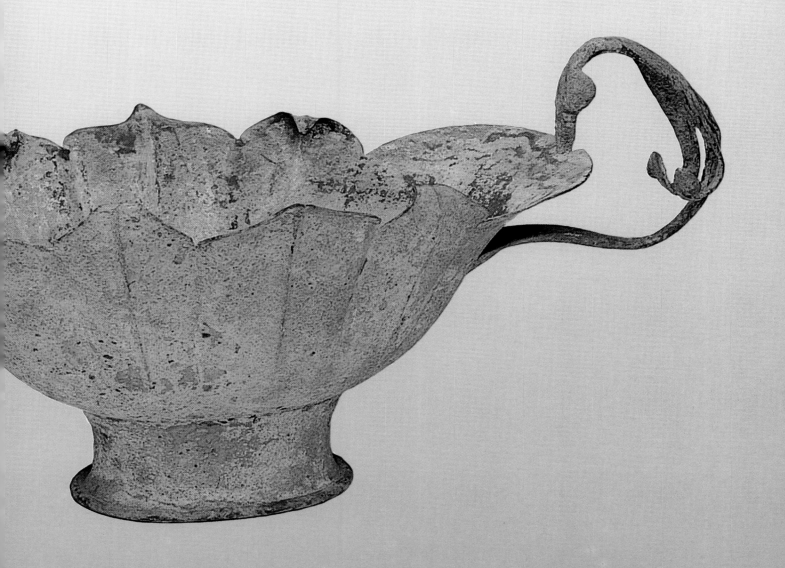

HENRY VAN DE VELDE (1863-1957) Belgian
Salad Bowl, 1904. Hard paste porcelain with underglaze blue
decoration. Manufacturer: Meissen Porcelain Factory. Marks on
underside: Meissen crossed swords in blue; *van de Velde*
signature impressed.
H: 4in (10.2cm) x W: 8 ¾in (22.2cm) x D: 9in (22.9cm)

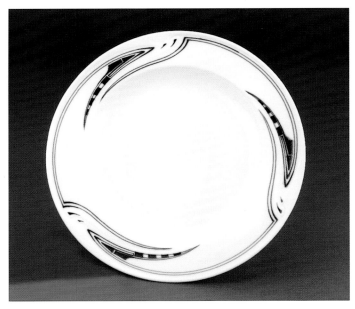

HENRY VAN DE VELDE (1863-1957) Belgian
Dinner Plate, 1904. Hard paste porcelain with underglaze blue
decoration. Manufacturer: Meissen Porcelain Factory, from the
same dinner service as the salad bowl, left.
D: 10 ½in (26.7cm)

by department stores and at the annual Salons in the French capital, was to synchronize every element of a room, from its general color scheme to the smallest detailing of its smallest object, such as the key escutcheons and hinges on its furniture. Everything had to be *en suite*, in sharp contrast to the typical *recherché* interiors of the time. Today, nearly all those Art Nouveau interiors have disappeared, their wallpapers and upholstery dispersed within families or at auction. Yet enough has survived to show that in this aspect of design, at least, the new movement offered a radical improvement on the prevailing taste in interior design.

It was to William Morris that Art Nouveau owed its single greatest debt. Far earlier, and far more stridently, than any one else, it was Morris who challenged mid-19th century aesthetic values and the manner in which they affected society as a whole. Like John Ruskin before him, Morris did not always practise what he preached, but it was what he preached that mattered and which led, ultimately, to the climate of changing expectations that swept the United Kingdom and Europe in the 1880s and 1890s. In its most exuberant manifestations, Art Nouveau certainly over-reached the revolution in household design for which Morris had striven, yet his teachings continued to serve and guide the movement.

The Industrial Revolution provided the focus of Morris' discontent. Through it, mankind had lost its soul and become engulfed in a morass of inexpensive mass-produced wares imitative of other ages and cultures that deadened its sensibilities, while cheapening life itself. Morris condemned any use whatsoever of the machine, and also the excessive division of labor that it entailed. Mankind needed an environment conducive to both physical and spiritual well-being, and to Morris, therefore, the machine was innately evil as it destroyed beauty and debased civilization. In search of a model lifestyle by which to remedy the situation, Morris chose the Middle Ages, whose work ethic became the refrain of the crafts movements spawned through his exhortations first in England and then in Europe and the United States.

Another source of incalculable impact on Art Nouveau's evolution was *Japonisme*, which became the rage in fashionable Western society following the treaty between the United States and Japan drawn up by Commodore Matthew C. Perry and the shogun in 1854. Western artists and decorators drew inspiration from a host of Japanese art works, including *Ukiyo-e* prints, woodcuts and lacquerware by such masters as Hokusai (1760-1849), Hiroshige (1797-1858) and Utamaro (1753-1806). In particular, Hokusai's *Mangwa* print album became a primary source for Japanese decorative motifs and their interrelationship within a composition. Likewise, images from Japanese fans, ceramics, enamelwares, masks, screens, and kimonos were drawn on as such wares flooded Europe from the mid-1850s. By the time of the 1862 London Exposition, this orientation – literally – was in full swing throughout Europe.

Of further influence to Western artists were the

compositional devices employed by their Japanese counterparts, including the two-dimensional picture frame, flattened perspectives (often from a bird's eye view), block colors and silhouetting. The rage for *Japonisme* extended even to the use by some artists, such as Toulouse-Lautrec, Whistler, and Gallé, of Japanese-styled cartouches and calligraphy as the means by which to sign their works. The Japanese artist's traditional affinity for Nature was likewise quickly assimilated by Western painters and craftsmen into their work. Bamboo, carp, wisteria, cherry blossoms and waterlilies gained prominence in the West's decorative repertoire, as did the Japanese artist's predilection for a muted palette and emphasis on the poetic quality of Nature. In an Art Nouveau context, countless imitators of Japanese art emerged, to the point that a profound Orientalism is discernible in virtually every one of its disciplines.

Any classification of Art Nouveau must be built in part around the movement's pre-occupation with Nature, which dominated its artistic expression for the full ten years that it remained rampantly in vogue. It was Nature which stood as the style's pre-eminent thematic inspiration. Art Nouveau was, in fact, a Paean to Nature in its re-creation of all of its myriad forms and colors. There was hardly a horticultural species, however humble in origin or evolutionary development, that was not transformed briefly into an imaginative, and usually functional, work of art. Life's order seemed, in fact, momentarily reversed; for a brief moment, at least, it was the lowliest of farmyard plants – cow parsley, cereal crops, etc. – that commanded

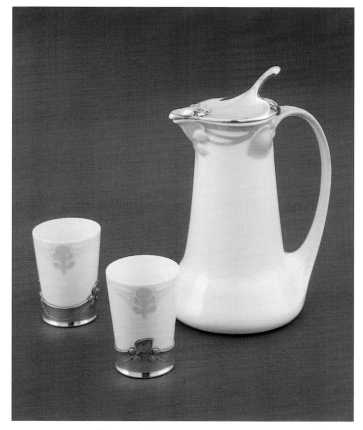

MAURICE DUFRÊNE (1876-1955) French
Chocolatier Set, 1901-02. Porcelain with relief decoration of glazed blue and pink; silver hinge on pot and silver mount on two matching cups. Probably designed for La Maison Moderne, Paris. Marks incised on bottom: *M. Dufrène.*
Pot: H: 8 ⅜in (21.3cm) x W: 4 ½in (11.4cm); Cups: H: 3in (7.6cm) x W: 2 ⅛in (5.4cm)

Art's centerstage. Further artistic stimulus was found in a strange and creepy menagerie, including the world of entomology – insects such as dragonflies, moths, beetles and ants – and the murky realm of the sea and its mysterious denizens, which Jules Verne romanticised in *Twenty Leagues under the Sea.*

The line became the second major motif of the Art Nouveau decorative vocabulary of ornament. Its earliest master was the Englishman Aubrey Vincent Beardsley, whose brief career resembled that of the movement itself, springing up suddenly and brilliantly, then moving through a variety of modifications before ceasing as abruptly as it had begun. By the age of 20 Beardsley had become an accomplished draftsman in complete control of line and concept. His illustrations for Oscar Wilde's *Salome* showed his advanced

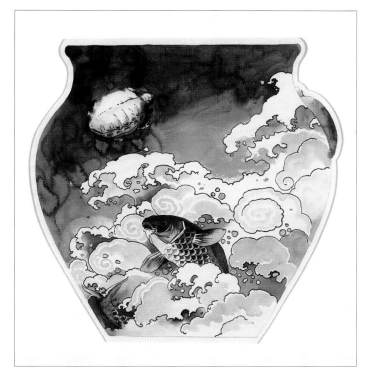

AMÉDÉE DE CARANZA (dates unknown) Turkish-Italian
Vase Design, n.d. Watercolor gouache with traces of crayon on tracing paper (?) mounted on paperboard. Produced for La Manufacture Viellard, Bordeaux, France. Attributed to Amédée de Caranza.
H: 38in (96.5cm) x W: 30in (76.2cm) // H: 42 ¼in (107.3cm) x W: 34 ½in (87.6cm)

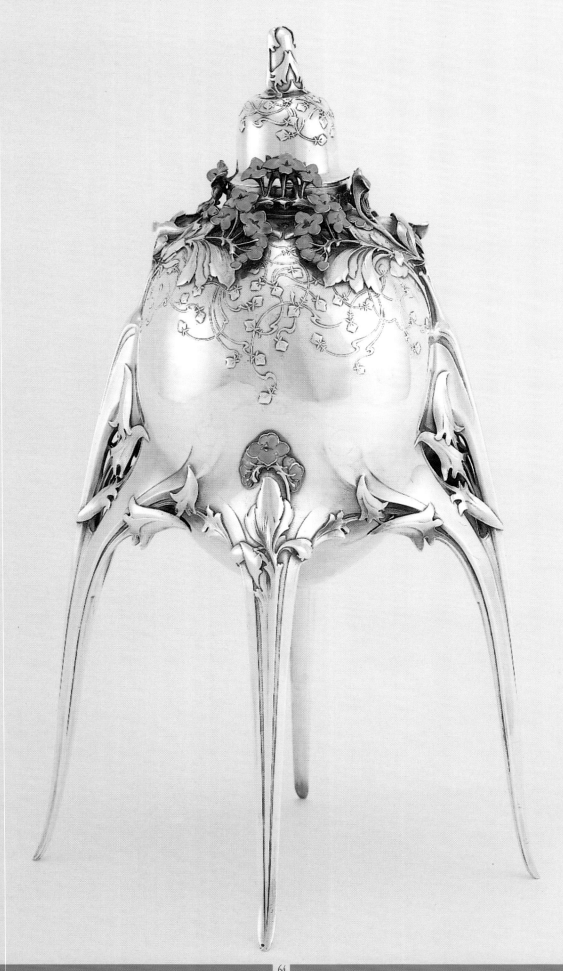

JULES AUGUSTE HABERT-DYS (1850-1924) French
Caviar Server, 1905. Silver with inlaid enamel work (*champlevé*)
and engraved decoration. Removable cap with metal tube insert.
Marks: inscribed signature/date (*J. Habert-Dys-1905*) on inside leg.
H: 13 ½in (34.3cm) x D: 5 ¼in (13.3cm)

Silver manufacturers at the turn of the century opted for the
known over the unknown. Orthodoxy prevailed, even in an
industry overhauled by modern technological advances. A
notable exception was Jules Habert-Dys, one of the several
metalworkers of distinction at the Salons between 1900 and 1910
who took organic decoration to heart, investing his eccentric
forms with life-like qualities. Insects were especially an inspiration.
On first glance this caviar-server-creature seems to be inching its
way forward. It was designs of this style that elicited *Ornament
und Verbrechen* (Ornament and Crime) an essay by Vienna
architect/designer Adolf Loos who advocated the elimination of
all decoration, equating ornament to a spiritual and moral
weakness. The enamel decoration at the top is hinged so the cap
may be removed. Inside, a metal tube (for the caviar) sits atop a
pin allowing space for crushed ice to be inserted along the sides.

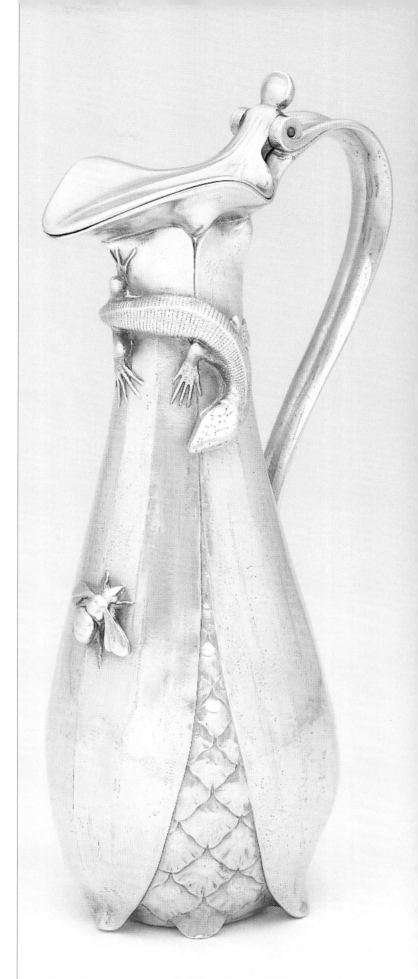

M. LUCIEN HIRTZ (1864-1928) French
Pitcher, c.1900. Silver-gilt. Possibly designed for Frédéric
Boucheron's presentation in the 1900 Exposition Universelle de
Paris. Attributed to Lucien Hirtz.
H: 10 ½in (26.7cm) x W: 5 ½in (14cm) (at handle) x D: 3 ½in
(8.9cm)

Lucien Hirtz was a prolific artist whose career extended over a 40-
year period. Today, his name is synonymous with the finest Art
Nouveau jewelry and silverwork. As early as 1889 Hirtz began
participating in the Paris Expositions as a collaborator with Leon
Bakst and the Falize House of Jewelry. Four years later, Frédéric
Boucheron engaged Hirtz as one of his principal designers, a close
collaboration which lasted 35 years.
This solid silver pitcher was designed by Hirtz for the Boucheron
line featured in the silver section of the French Pavilion in the 1900
Paris Exposition Universelle. Boucheron won the gold medal for
his commissioned designs, including this fine example. Its seed-
pod or plant-husk form serves as surface for *naturaliste* elements –
a lizard and a bumble bee – and the profile of the lid and spout
further suggest a lizard-like creature. The integration of form and
decoration reached its zenith with French Art Nouveau designs,
this being a superlative example of the style.

understanding of how to balance the flat, black areas of his compositions with the negative white spaces between them. A delicate, yet bold and dynamic, network of lines writhe or sweep across his graphic compositions, engulfing and unifying neighboring forms. So effective was Beardsley in the use of this device that it is often difficult for the eye to differentiate between what he drew and what he left out.

The Belgian architect Victor Horta was another Art Nouveau exponent effectively to integrate the line into his designs.[2] In his *hôtel particulier* (private residence) for the prosperous Brussels engineer and industrialist, Emile Tassel, Horta provided spatial continuity and fluidity between floors by a coiled line, which unified the building's interior and furnishings. Charged with power and grace, and as light as air, this line became Horta's famous *imprimatur*, the common denominator in all his subsequent Art Nouveau buildings. The Tassel house made its greatest impact in Paris, where the architect Hector Guimard was quick to adapt its serpentine configurations into his own highly distinctive grammar of ornament. The result was an important body of work rendered in a luxurious and plastic organic style, of which the entrances to the Paris Métro stations and the Castel Béranger (1894-98), Paris, are the most identifiable.

The painter Edvard Munch likewise showed his understanding of the line's ability powerfully to convey his message in preference to descriptive or

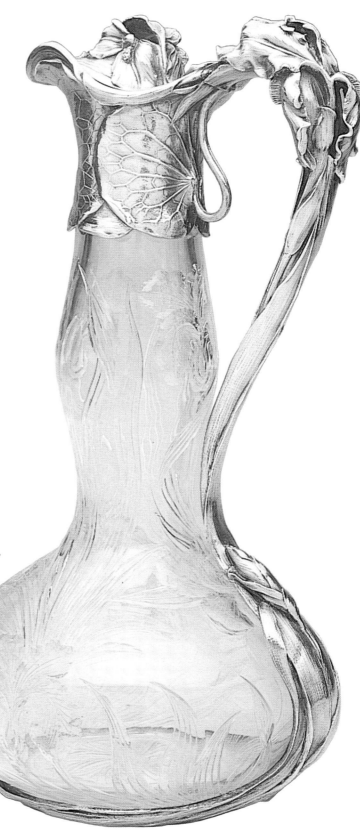

JACOB (JAC.) JONGERT (1883-1942) Dutch
Van Nelles Tabak (Van Nelles Tobacco), 1920. Poster / color
lithograph. Printed by Immig & Son, Rotterdam.
H: 39in (99.1cm) x W: 25 ½in (64.8cm)// H: 45 ½in (115.6cm) x W:
32 ⅛in (81.9cm)

WILLIAM DURGIN (1833-1905) American
Decanter, c.1900. Crystal with gilt sterling mounts. Metalwork by:
William Durgin & Son, Concord, N.H. Glass by: T. G. Hawkes & Co.,
Corning, NY. Marks: stamped *STERLING* and script *"D"* on bottom.
H: 12 ⅝in (30.1cm) x W: 6 ½in (16.5cm) (at handle) x D: 6in
(15.2cm)

Like many works of the American Art Nouveau style, this
decanter bridges the more opulent and patterned objects
of the mid-19th century with the increasingly simplified
designs of the 20th century. William Durgin was well
informed of the new movement's stylized floriations
through the many European publications and
imported works entering the American market at the
turn of the century; in fact, he named one of his
patterns *New Art*. The curvaceous form of the crystal
decanter is engraved with a composition of iris blooms
(a favorite motif with Durgin). The *naturaliste* elements
(flowers, clinging vines, tendrils and leafage) common to the
School of Nancy, the movement's epicenter in eastern France,
are respectfully rendered in the gilt repoussé mounts. Such works
are based on a thorough analysis of plant morphology and are
intended as celebrations, if not exaltations, of nature.

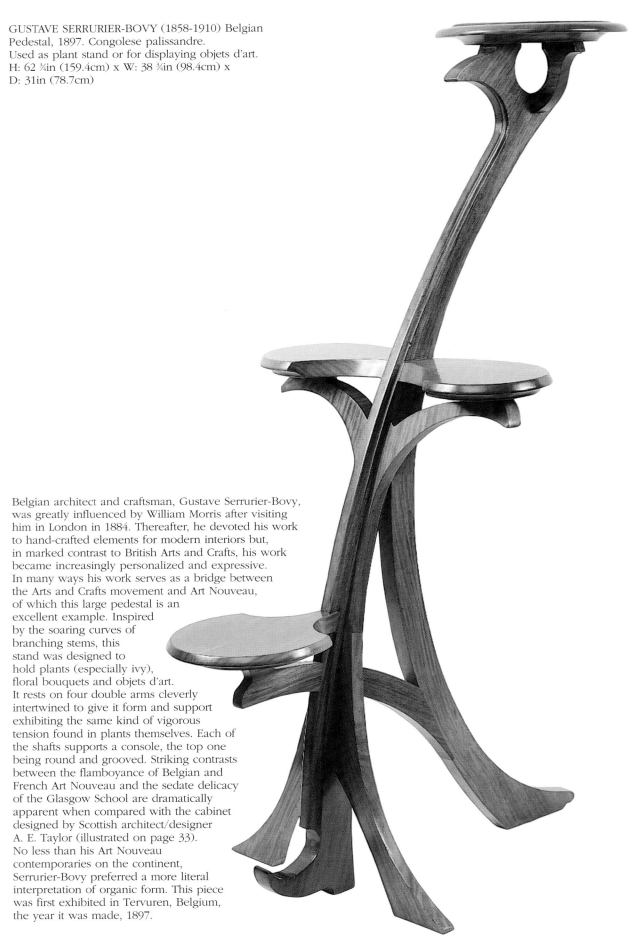

GUSTAVE SERRURIER-BOVY (1858-1910) Belgian
Pedestal, 1897. Congolese palissandre.
Used as plant stand or for displaying objets d'art.
H: 62 ¾in (159.4cm) x W: 38 ¾in (98.4cm) x
D: 31in (78.7cm)

Belgian architect and craftsman, Gustave Serrurier-Bovy,
was greatly influenced by William Morris after visiting
him in London in 1884. Thereafter, he devoted his work
to hand-crafted elements for modern interiors but,
in marked contrast to British Arts and Crafts, his work
became increasingly personalized and expressive.
In many ways his work serves as a bridge between
the Arts and Crafts movement and Art Nouveau,
of which this large pedestal is an
excellent example. Inspired
by the soaring curves of
branching stems, this
stand was designed to
hold plants (especially ivy),
floral bouquets and objets d'art.
It rests on four double arms cleverly
intertwined to give it form and support
exhibiting the same kind of vigorous
tension found in plants themselves. Each of
the shafts supports a console, the top one
being round and grooved. Striking contrasts
between the flamboyance of Belgian and
French Art Nouveau and the sedate delicacy
of the Glasgow School are dramatically
apparent when compared with the cabinet
designed by Scottish architect/designer
A. E. Taylor (illustrated on page 33).
No less than his Art Nouveau
contemporaries on the continent,
Serrurier-Bovy preferred a more literal
interpretation of organic form. This piece
was first exhibited in Tervuren, Belgium,
the year it was made, 1897.

RAOUL-FRANÇOIS LARCHE (1860-1912) French
Table Lamp, c.1900. Gilt bronze. Single bulb lamp depicting
American dancer Löie Fuller. Bulb concealed in the billowing
folds of the robe. Marks: signed *Raoul Larche M441* with
foundrymark.
H: 13in (33cm) x W: 7in (17.8cm) (at base)

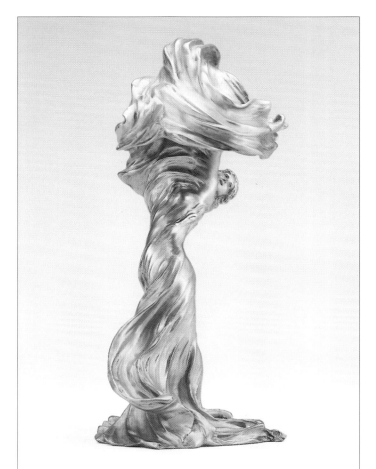

narrative elements. As the critic Peter Selz described
the Norwegian's most celebrated work, *The Cry*, of
1893, "A writhing figure emerges from the picture
plane, and its convoluted form is repeated throughout
the landscape in the sinuous line of the shore and the
equivalent rhythm of the clouds. The curved line is
strongly emphasised by its contrast to the straight,
rapid diagonal cutting through the imaginary space of
the painting. The cry that the central figure seems to be
uttering pervades the landscape like a stone creating
centrifugal ripples in water. Munch has painted what
might be called sound waves, and these lines make the
human figure merge with the landscape to express a
total anxiety that evokes an immediate response from
the observer".[3] Certainly, no other Art Nouveau artist
applied the line to his work with such intellectual
impact. In Munch's hands, the line became a genuine
expression of deep psychological involvement.

Art Nouveau's decorative vernacular included also a
limitless bevy of languid and nubile maidens with long
entwined and trailing tresses, who served in full or bas-
relief in porcelain, bronze and pewter as supports for a
host of *bibelots* and other household appurtenances –
including garnitures, pin trays, *bonbonnières*, and
toiletry wares – or as the proud Fairy Electricity
brandishing aloft an electrified torchère to symbolize
the invention of the incandescent filament bulb and, by
projection, the triumph of Science over Mechanics, of
the new century over the old. "Woman", in fact, became
representative of all that the Belle Epoque and *Les
Années Insouciantes* stood for. Freed of the real-life
metal and whalebone harnesses into which fashion had
locked her, and freed also from her equally stifling
respectability, woman threw caution, clothes and
corsets to the winds. That, at least, is how Art Nouveau
artists and sculptors depicted her in her many guises on
objets d'art at the annual Parisian Salons. Often she was
combined with flowers to form a hybrid *femme-fleur*,
the blossoms in her outstretched arms concealing light
sockets or the cover of an inkwell.

If Morris was the theoretician whose beliefs more
than those of others initiated the Art Nouveau
movement, it was Arthur Heygate Mackmurdo, the
English architect, graphic designer and craftsman, who

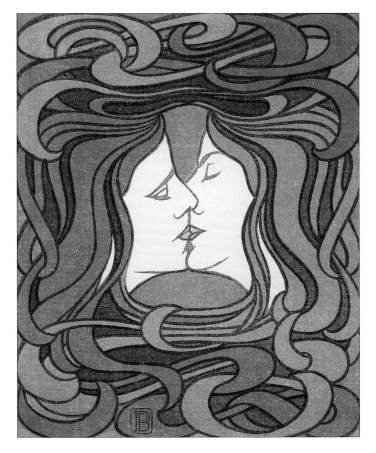

PETER BEHRENS (1868-1940) German
The Kiss, c.1900. Color woodblock print. Signature: PB
(intertwined, lower center).
H: 10 ¼in (26cm) x W: 8 ½in (21.6cm) // H: 21 ¼in (54cm) x W: 18
⅛in (46cm)

PETER BEHRENS (1868-1940) German
Dinner Plate, 1900-01. Hard-paste porcelain with stencilled
geometric design. Manufacturer: Porzellanfabrik Gebrüder
Bauscher, Weiden, Germany. Designed for use in Behrens' home
at Darmstadt. Marks on bottom: impressed numeral or artist's
monogram, Meissen crossed swords mark in underglaze blue,
#91 in underglaze blue.
D: 10in (25.4cm)

EDOUARD COLONNA (1862-1948) French-American
Dinner Plate, from *Canton* service, 1900. Porcelain. Manufacturer:
Gernard, Dufraisseix and Abbot, Limoges, France. Marks on
bottom: *GDA, FRANCE* in underglaze.
D: 9 ⅝in (24.5cm)

RICHARD RIEMERSCHMID (1868-1957) German
Plate, c.1904-05. Stoneware. Manufacturer: Merkelbach.
D: 9 ¾in (24.8cm)

provided its earliest practical implementation in the
field of design. Two elements, in particular, established
him as an unprecedented talent: his pursuit of linear
simplicity and his asymmetrical compositions rendered
in boldly contrasting colors, such as black and white.
His choice of plant motifs, and the manner of their
abstraction, likewise set him apart from his
contemporaries. Mackmurdo's revolutionary chair-
back of 1883 precipitated the *fin-de-siècle* decorative
movement.[4] The fretwork splat, comprised of a row of
slender tendrils tossed by the wind, is today readily
perceivable as a pivotal Art Nouveau influence. The
interplay between the apparent movement in the
foreground and the stationary background creates a
trompe-l'œil effect that provides the composition with
perpetual rhythm and motion, like seaweed caught in
opposing currents. The combination of rigorously flat
surfaces, undulating plant forms, and contrasting colors
anticipated Art Nouveau's mature graphic syntax by
fifteen years and is today indistinguishable from it.

Mackmurdo exposed the readers of his *Hobby Horse*
journal to the works of an even earlier precursor of Art
Nouveau, the poet and illustrator William Blake (1757-
1827), whose wood engravings and temperas for
Songs of Innocence revealed his smoothly flowing and
undulating linear style of ornamentation and the

HERMANN GRADL (1869-1934) German
Plate from the *Fish* service, c.1899. Porcelain. Hand-painted
marine life in the Art Nouveau style. Manufacturer: Königlich-
Bayerische Porzellan-Manufaktur Nymphenberg. Established 1747.
Marks in underglaze on bottom: *insignia, Nymphenberg, 624, xx1.*
D: 9 ½in (24.1cm)

manner in which he integrated it with the text and then
both within the margins of the page, a technique
which clearly established him as *the* proto-Art
Nouveau artist-designer. In various typographic works,
Blake revealed a vigorous organic style of decoration
in which the simplified and flattened forms also
showed his familiarity with Japanese printmaking.

The English designer and book illustrator Walter
Crane was another to provide inspiration to the Art
Nouveau movement in its seminal years in his designs
for objects across a broad spectrum of the decorative
arts, including ceramics, fabrics, wallpapers,
embroidery and stained glass, which he produced
from the late 1860s. Crane's illustrations for children's
books of nursery rhymes and fairy tales were
composed in a fanciful and lively pictorial style
dominated by floral motifs that are today seen as a
direct antecedent to the Art Nouveau vocabulary of
decorative ornament. Crane's flat rendering and choice
of harmonious colors also showed his affinity for
Japonisme, a further bond linking his works to that of
the Art Nouveau graphic artist.

FRANZ BÖRES (dates unknown) German
Pokal (covered presentation cup), c.1910. Silver. Executed by: P.
Bruckmann & Sons, Heilbronn, Germany.
H: 12in (30.5cm) x W: 3 ⅜in (8.6cm) (at base)

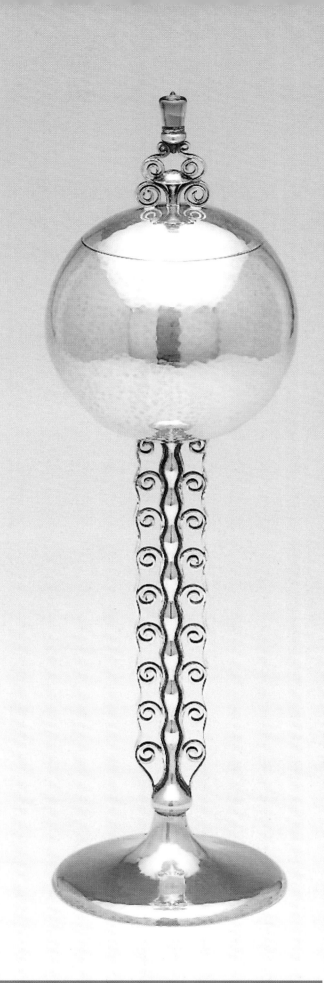

An ardent proselytizer of Japanese art and artefacts, Arthur Lasenby Liberty was in the mid-1870s a London merchant destined later to play a giant role in the dissemination and marketing of Art Nouveau. When his employer, Farner & Rogers, closed in 1874, Liberty acquired the firm's outstanding inventory of Japanese silks, linens and printed cottons, which drew the attention, amongst others, of the progressive English artist community. By the early 1890s, Liberty's fabrics, to which he added a trendy selection of household products, had become a status symbol for Europe's fashion elite that propelled his store to fame while helping greatly to establish the international appeal and legitimacy of the new movement.

The American expatriot, James Abbott McNeill Whistler, was another to influence the growth of the Art Nouveau movement in England, in part through his adoption in the early 1860s of Japanese woodcut techniques, especially that of the interplay of space and outline to generate a sophisticated simplicity. Too much of an individual to be part of any circle, Whistler was nevertheless friendly with the Pre-Raphaelites, with whom he shared his enthusiasm for orientalism. Beardsley, too, was greatly influenced by Whistler. His Peacock Room of 1876-77, commissioned by the shipping magnate F. R. Leyland to house his porcelain collection in his London residence, brought Whistler wide acclaim for its sumptuous exoticism.[5] The room was remarkable both for its anticipation of the

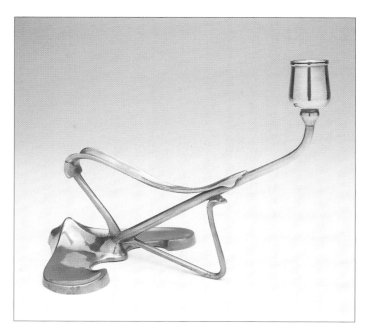

RICHARD RIEMERSCHMID (1868-1957) German
Chamberstick, c.1898. Brass. Executed by: Vereinigte Werkstätte, Berlin.
H: 7 ½in (19.1cm) x W: 11in (27.9cm) x D: 7in (17.8cm)

JOHANNES (JAN) EISENLÖFFEL (1876-1957) Dutch
Tea Kettle on Floor Stand, c.1906. Solid brass construction.
H: 30 ½in (77.5cm) x D: 11in (27.9cm)

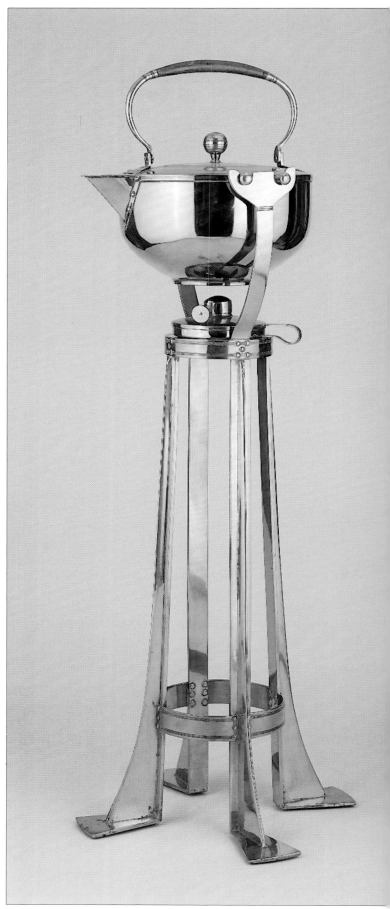

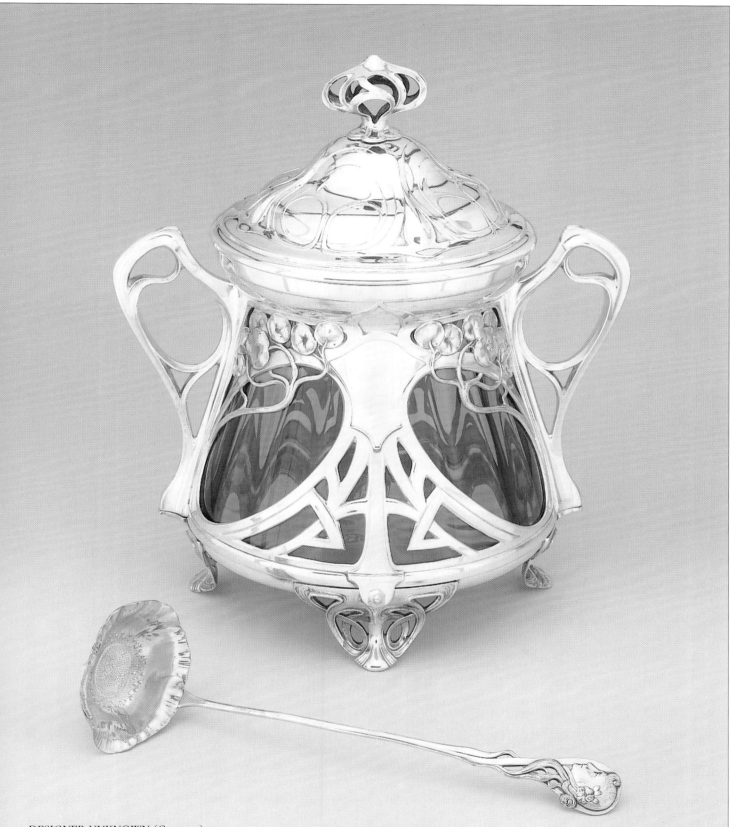

DESIGNER UNKNOWN (German)
Punch Bowl, c.1900. Silvered metal framework with lid and green glass liner.
En suite with silvered metal ladle and gilt bowl. Made by Württembergische Metallwaren Fabrik (WMF),
Geislingen, Germany. Marks: stamped *WMFN I/O* on ladle handle; stamped *WMF I/O 3.5* on bowl leg.
H: 18in (45.7cm) x W: 16in (40.6cm) (to handles) x D: 11in (27.9cm); Ladle: L: 15in (38.1cm) x W: 4 ⅝in (11.7cm)

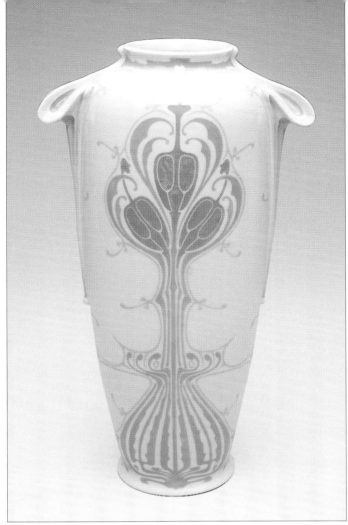

EDOUARD COLONNA (1862-1948) French-American
Vase, 1900-02. Porcelain. Designed for retail by L'Art Nouveau
Bing, Paris. Manufacturer: Leuconde, France. Marks: *E Colonna*
and *ANB* within squares and *LEUCONDE* in underglaze green,
impressed *520*. Without cover.
H: 11 ¾in (29.8cm) x D: 2 ⅝in (6.7cm) (at opening)

TAXILE-MAXIMIN DOAT (1851-1938) French
Gourd Vase, c.1900. Porcelain with relief decoration in salmon,
white, green with blue overflow. Executed by Sèvres. Marks:
TDoat (T and D intertwined) and *Sèvres* painted in salmon
underglaze.
H: 7 ¼in (18.4cm) x D: 3in (7.6cm)

universal popularity that the peacock enjoyed as a decorative motif around 1900, and for its strong vertical emphasis, adopted later by the Viennese Secessionists.

Despite being able to lay such indisputable claims to Art Nouveau's antecedence in so many disciplines – including, as discussed, the creations of Blake, Morris, Mackmurdo, Whistler, Beardsley, Crane, and others – the generation of English architects and artist-designers who came to maturity around 1900 rejected the movement's floral or linear exuberances almost entirely. Progressive design in England aligned itself more with the indigenous Arts and Crafts movement, settling on a decorative style that was eminently reasonable, moderate and simple, in which the triumphs of a revived handcraftsmanship were emphasized. To the north, however, the movement could boast one significant adherent in Glasgow, Charles Rennie Mackintosh, who electrified the emerging modernist schools in Austria and Germany

with his attempts to revise the Scottish baronial style.[6]

Mackintosh's designs for the Glasgow School of Art (1896-1909), four tearooms for a Miss Cranston (1897-1904), and Windyhill in Kilmalcolm (1900-01), amongst others, reveal his attempt not only to develop a matrix of new architectural concepts, but also to unify the exteriors of his buildings with a modernist style of decoration on their interiors, the latter which he designed in collaboration with an associate, Herbert MacNair, and the MacDonald sisters, Frances and Margaret. Had Mackintosh restricted his experimentation to the buildings themselves – in particular, to his search for a novel asymmetrical system of massing and fenestration – he would have avoided the antipathy of the English critics. His choice of ghost-like visions of attenuated young women enveloped by abstracted sprays of pink roses and apple pips, with which he adorned his friezes and furniture, was found by many to be weird and disquieting (Mackintosh and his three Glaswegian

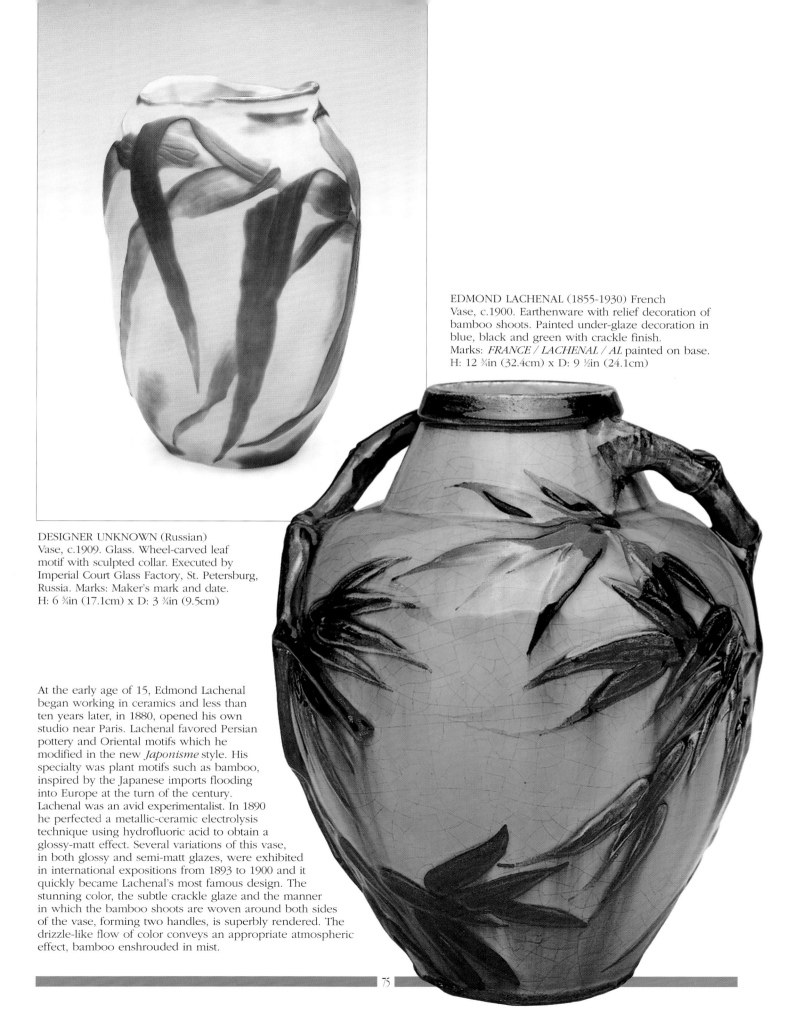

EDMOND LACHENAL (1855-1930) French
Vase, c.1900. Earthenware with relief decoration of
bamboo shoots. Painted under-glaze decoration in
blue, black and green with crackle finish.
Marks: *FRANCE / LACHENAL / AL* painted on base.
H: 12 ¾in (32.4cm) x D: 9 ½in (24.1cm)

DESIGNER UNKNOWN (Russian)
Vase, c.1909. Glass. Wheel-carved leaf
motif with sculpted collar. Executed by
Imperial Court Glass Factory, St. Petersburg,
Russia. Marks: Maker's mark and date.
H: 6 ¾in (17.1cm) x D: 3 ¾in (9.5cm)

At the early age of 15, Edmond Lachenal
began working in ceramics and less than
ten years later, in 1880, opened his own
studio near Paris. Lachenal favored Persian
pottery and Oriental motifs which he
modified in the new *Japonisme* style. His
specialty was plant motifs such as bamboo,
inspired by the Japanese imports flooding
into Europe at the turn of the century.
Lachenal was an avid experimentalist. In 1890
he perfected a metallic-ceramic electrolysis
technique using hydrofluoric acid to obtain a
glossy-matt effect. Several variations of this vase,
in both glossy and semi-matt glazes, were exhibited
in international expositions from 1893 to 1900 and it
quickly became Lachenal's most famous design. The
stunning color, the subtle crackle glaze and the manner
in which the bamboo shoots are woven around both sides
of the vase, forming two handles, is superbly rendered. The
drizzle-like flow of color conveys an appropriate atmospheric
effect, bamboo enshrouded in mist.

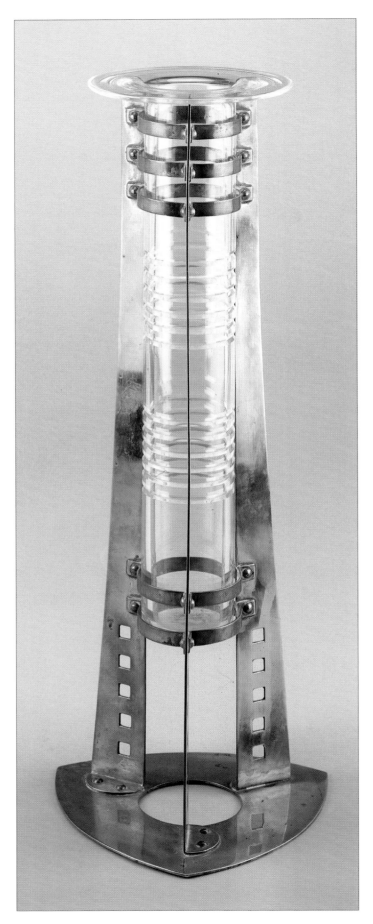

colleagues became known as "The Spook School" because of their preference for such imagery). An anonymous contributor to *Our Homes and How to Beautify Them* expressed the typical English attitude to Mackintosh's designs, "the Scotto-Continental 'New Art' threatens in its delirious fantasies to make the movement for novelty a target for the shafts of scoffers and a motive for the laughter of the saner seven-eighths of mankind".[7] Notwithstanding such censure, Mackintosh's impact on 20th century design was phenomenal, and out of all proportion to his brief career, even though his architectural *œuvre* was virtually forgotten for another 40 years.

In the United Kingdom, silvermaking was one of the few crafts at the turn-of-the-century to embrace the Art Nouveau idiom. It did so reluctantly, however, largely avoiding the exuberant floral and curvilinear interpretations that emerged on the Continent. Enamels and semi-precious stones were chosen as the optimum means to express modernist impulses, along with an enchanting Celtic Revival iconography. Of the few English firms and individual silversmiths who committed all or part of their output to the new movement, Liberty & Company was the most successful. Its lines of silver and pewter, introduced under the trade names Cymric and Tudric respectively, included porringers, christening sets, biscuit barrels, muffin dishes and egg coddlers, in addition to costly gifts such as sporting trophies and punch bowls. The most ambitious of these were accented in bright enamels and/or encrusted with a range of gem-set cabochons and materials such as turquoise, lapis lazuli, agate, malachite and blister pearl. Of the firm's stable of designers, Archibald Knox emerged as the most gifted. Born on the Isle of Man, he developed a

GUSTAVE SERRURIER-BOVY (1858-1910) Belgian
Vase, c.1905. Brass frame with glass insert.
H: 16in (40.6cm) x W: 6in (15.2cm) x D: 6in (15.2cm)

Belgian architect and craftsman Gustave Serrurier-Bovy studied architecture at the Fine Arts Academy in Lüttlich, where he was born. He was greatly influenced by William Morris after visiting him in London in 1884 and thereafter devoted his work to handcrafted elements for modern interiors. In marked contrast to British Arts and Crafts, however, his work became increasingly personalized and expressive. After returning to Lüttlich he founded a furniture firm which, like Liberty in London and S. Bicy in Paris, enjoyed an active trade with the Far East.
Serrurier-Bovy's visit to the new Künstlerkolonie Darmstadt in 1901 had a dramatic effect on his later work, evident in this 1905 vase. As with Joseph Maria Olbrich and Peter Behrens, founders of the artists' colony, Serrurier-Bovy's artistic efforts turned towards the reconciliation of art and industry. In this piece, a glass form suggesting a laboratory test-tube is fitted between three brass flanges and a triangular base. The etched rings of the vase echo the brass rings which hold it in place and the small square cut-outs recall the work of Charles Rennie Mackintosh and the Wiener Werkstätte.

fanciful grammar of decorative ornament based on remote Celtic and Manx designs drawn from the island's crosses, grave memorials, and its runic monument. Another stylistic influence evident in Knox's work is *The Book of Kells*.

The revolutionary stylisations of Morris, Beardsley and Whistler first crossed the Channel to Brussels, where they drew the admiration of the city's community of avant-garde artists, who exhibited jointly from 1884 through *Les Vingt*, which had been formed by a local lawyer, Octave Maus, to seek out progressive works of art as the means to counteract historicism in Belgian art. *Les Vingt* provided a forum for those whose works were barred by the juries who monitored entries to the traditional annual Salons. Included amongst the society's charter members were Toorop, Ensor, Knopff, van de Velde and van Rysselberghe, all who contributed to the period's movement away from conventionalism in art.

In Brussels, Henry van de Velde's versatility manifested itself in his designs for book illustrations, typography and posters. Particularly notable was his 1899 design for the Toorop company, a food concentrate manufacturer, of a poster which consists of an arrangement of repeating abstract linear forms that rise from the bottom of the composition to meet a maze of rectangular lines that contain the single word "Tropon" written in a formalized type face (see page 104). The design's novelty lies in the fact that it is purely graphic; there are no pictorial elements whatsoever, a device he probably learned from his familiarity with progressive German posters, such as that of Behrens, whose *The Kiss,* of 1898 (see page 69) provided a superior example of the medium: the two almost classical profiles are enveloped in a dense arabesque of

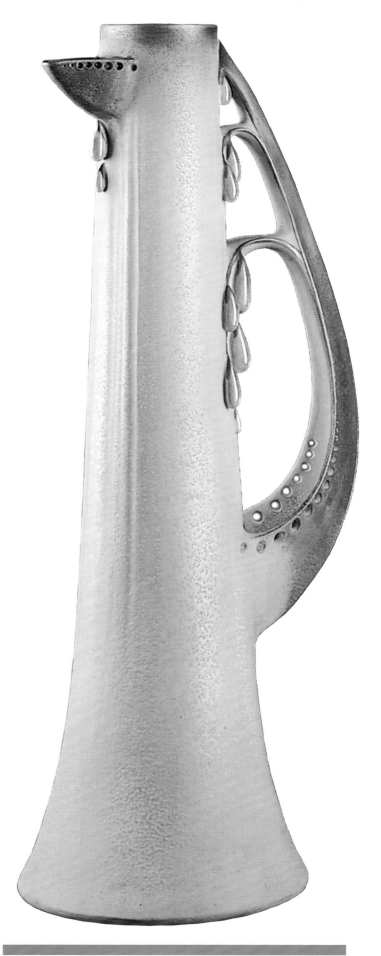

PAUL DACHSEL (active: 1904-1910) Czechoslovakian
Pitcher, c.1905. Ceramic with applied decoration. Marks: artist's mark: (interlocking PD */TURN - TEPLITZ / Made in Austria / No. 680.*
H: 17 ⅜in (44.8cm) x D: 5 ¾in (14.6cm) (base)

While many are familiar with the word Amphora, few know the details surrounding one of the most productive ceramic firms ever. Its formal title is Riessner, Stellmacher & Kessel Amphora Werke, founded in Turn-Teplitz, Austria in 1892. The discovery of coal deposits near the Bohemian twin cities fueled a prodigious development in Austrian ceramic manufacturing. In 1897, the company began to produce vases that were *im Amerikanischen genre* inspired by Grueby and Rookwood. It received awards at international expositions throughout Europe and by 1907, the company had grown to 300 employees. At least 90% of Amphora's product was exported and it is estimated that 60 to 70% came to America.
The two most important known designers of ceramic forms were Paul Dachsel and Alfred Stellmacher. Dachsel designed many pieces for Amphora before leaving to form his own firm in 1904. His designs were Successionist inspired, but invariably injected with his personal touches. He was one of the few Amphora designers who relied entirely on abstract elements rather than figurative designs, or the popular type of *portrait* vases.

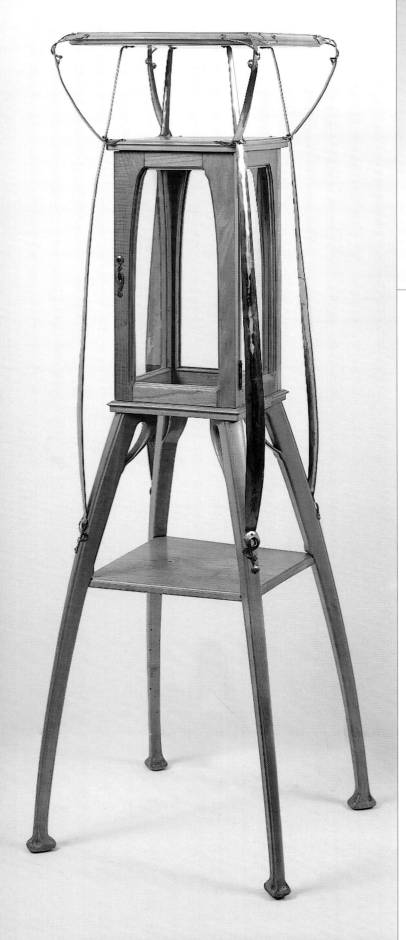

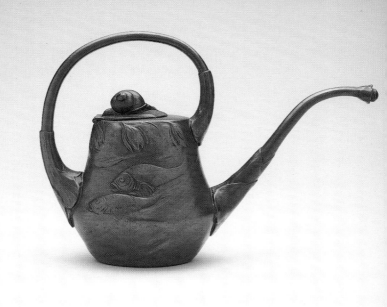

HUGO LEVEN (1874-1956) German
Water Sprinkler, c.1898. Pewter. Designed by Hugo Leven and
Herman Fauser for J. P. Kayser und Söhn, Krefeld, Germany.
Marks on bottom: impressed name of manufacturer
(*KAYSERZINN, 4205*).
H: 8 ¾in (22.2cm) x W: 5in (12.7cm) x D: 12in (30.5cm)

interlacing lines, i.e., hair, that draws them into, and
finally unifies, the composition.

Van de Velde showed his easy facility with the
concepts of Art Nouveau in a number of
characteristically abstract curvilinear designs for
ceramics and other household accessories executed
both in his workshops in Ixelles, a Brussels suburb,
and by the Staatliche Porzellan-Manufaktur at Meissen
in Germany.

A member of *Les Vingt* and a Liège furniture-
manufacturer by profession, Gustave Serrurier-Bovy
launched his career as a decorator at the inaugural
Salon of *La Libre Esthétique*, in 1894. His interiors were
characterized by the use of brightly colored ceilings
and walls *au pochoir*, hand-blocked floral curtains,
tiled faience chimney surrounds and stained glass
windows that offset the provincial plainness of his
wood furnishings. These combined a rustic solidity
with sweeping Art Nouveau curves.

In nearby Amsterdam, the Dutch artists Toorop and
Thorn-Prikker included posters in their artistic
repertoire. Toorop's 1895 design for Delftsche Slaolie
(see page 66) is especially noteworthy in its
transformation of long hair and plant organisms into
complex linear patterns that animate the poster's entire
surface.[8] Thorn-Prikker's graphic style was also two-
dimensional, but less ornamental; his posters for the

LÉON BENOUVILLE (1860-1903) French
Sellett, c.1900. Sycamore with mounted brass elements.
H: 57 ¼in (145.4cm) x W: 19in (48.3cm) x D: 19in (48.3cm)

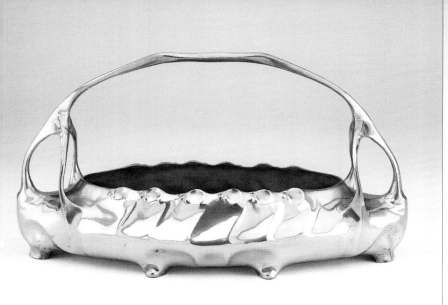

HUGO LEVEN (1874-1956) German
Jardinière (floral basket), 1902-03. Pewter. Designed by Leven for
J. P. Kayser und Söhn, Krefeld, Germany. Marks: impressed
"*Kayserzinn*" and *#4529.*
H: 9in (22.9cm) x W: 15in (38.1cm) x D: 8in (20.3cm)

NEWCOMB COLLEGE POTTERY (Founded 1885) American
Plate, c.1900. Ceramic. Hand-thrown by Joseph Fortune
Meyer with incised and painted decoration by Sadie Irvine
for Newcomb College Pottery, New Orleans.
D: 7 ½in (19.1cm)

Revue Bimestrielle pour l'Art Appliqué of 1896 reveal
the tendency towards Expressionism that he pursued
later in his career.

The Low Countries provided Art Nouveau also with
a varied production of ceramics, most notably those of
the Rozenburg works, near The Hague, where in 1899
a wafer-thin "egg-shell" porcelain was developed on to
which delightful designs evocative of Java in the Dutch
East Indies were painted. The Zuid-Holland
manufactory in Gouda likewise flirted briefly with the
Art Nouveau idiom.

Around the time of the 1889 Exposition Universelle
in Paris, the infant Art Nouveau movement found its
way from Brussels to two French cities, Nancy and
Paris, where it took root and bloomed. Historically and
geographically removed from the mainstream of
French art, Nancy is the industrial hub and railhead of
Alsace-Lorraine. The city's pre-eminence in the French
decorative arts in the late 19th century was therefore
dependent less on tradition than on the individual
achievements of its artists, particularly Emile Gallé,
who came to prominence in the early 1880s. Gallé
aspired to an alliance of the region's industrial arts, and
following his success at the 1889 Exposition
Universelle, during which his stylistic and technical
innovations in glass and furniture production were
greeted with international acclaim, Gallé became the

FRIEDRICH ADLER (1878-1942) German
Umbrella Stand, 1900-01. Ceramic with pewter mount in tri-
footed cylindrical form. Mount designed for Walter Scherf,
Nuremberg, Germany. Marks: The ceramic insert made at the
Zsolnay Art Pottery, Pécs, Hungary. Marks: *OSIRIS #664.*
H: 21 ⅝in (54.9cm) x D: 11 ¼in (28.6cm)

ABEL LANDRY (1871-1923) French
Vase, c.1905. Glazed stoneware with iridescent glaze depicting the *Four Seasons*. Manufacturer: Limoges, France. Marks (signed on the side): *Abel Landry*. Stamped markings on the bottom. H: 17in (43.2cm) x W: 8 ½in (21.6cm) x D: 8 ½in (21.6cm)

Architect-designer Abel Landry studied at the École des Arts Décoratifs in his home town of Limoges and later at the École des Beaux-Arts in Paris. Initially a landscape painter and architect, he turned to interior design after studying with William Morris in London. Upon returning to Paris, Landry became actively involved with *La Maison Moderne*, the firm and showroom which executed most of his designs, including this rare, four-sided vase. Like many architects of the period, Landry preferred creating total ensembles, from wallpaper, curtains and carved panelling, to the art works on the walls.
In this vase, Landry's earthbound architectonic form functions as a facade for the ethereal painterly effects on its four panels, each depicting a floral motif identified with the four seasons. The iridescent glaze – a miracle of modern chemistry as much as creative invention – is generally associated with two other French ceramicists, Clément Massier and Jacques Sicard. Seldom is it seen in a work so finely executed and, rarer yet, in a work by Abel Landry.

catalyst for his fellow Nanceien artisans. This loosely knit group presented a united front to the 1900 Exposition Universelle, where its triumphs were legion, under the banner of the Ecole de Nancy. The School was formally, and somewhat belatedly, incorporated the following year. Gallé was elected President and Victor Prouvé, Louis Majorelle and Antonin Daum vice-presidents.

Under Gallé's stewardship, glass became a protean art form. Until then a static and colorless material that was painted or engraved with pictorial or narrative images, it was now transformed into a medium of simulated movement and infinitely blended colors, with complex internal patterns and surface textures. Gallé's range of ornamentation, and its manner of application to the vitreous mass, was even more innovative. Techniques such as marquetry-de-verre, *intercalaire* (inter-layered decoration), wheel-engraving, etching with hydrofluoric acid, patination, enamelling and the application or encrustation of pieces of glass, were mixed *ad infinitum* in the pursuit of the perfect creation, most requiring additional trips to the furnace for the application of each new element of decoration. Further aspects of Gallé's work, such as the poetic verses with which he adorned many of his vessels and his *vases hyalites* and *vases de tristesse*, contributed to what had become, by the time of his premature death from leukemia in 1904, the most comprehensive compendium of techniques in the history of the medium.

Like all of his colleagues in the Ecole de Nancy, Gallé's primary focus was Nature, which provided him with an inexhaustible source of creative inspiration. Flora of every species, many indigenous to Alsace-Lorraine, were portrayed in their entirety or in microcosm, such as the details of a calyx, pistil or corolla.

Gallé's overwhelming impact on his medium – both artistic and commercial – was quickly noted by other glasshouses, which began with varying success to generate a similar repertory of wares. The most imposing of these was the neighboring Daum works, which opened in Nancy in 1892. Mixing a range of techniques and naturalistic images similar to those of Gallé, the Daum *frères* created numerous works of high aesthetic and technical merit amongst a huge commercial output. The firm's light fixtures, many made in partnership with the cabinetmaker Majorelle, who manufactured their metal armatures, were distinctive and refined.

Majorelle was the undisputed master of Art Nouveau furniture. Blessed with superb design sense and technical virtuosity, he was simultaneously artist and artisan, designer and technician. His most fertile years were from 1898 to 1908, when piece after piece of breathtaking quality in sumptuous exotic woods such as amaranth and purpleheart came on to the market.

OTTO ECKMANN (1865-1902) German
Vase, c.1898. Ceramic with bronze mounts by Otto Schulze (1848-1911). Manufacturer: Königliche Porzellan-Manufacktur (KPM), Berlin. Marks: artist's monogram (*OE)* inscribed on mount. H: 20 ¼in (51.4cm) x W: 8in (20.3cm) x D: 6in (15.2cm)

Many of his most graceful and luxuriant creations challenged the works of the great 18th century *ébénistes* who served the Bourbon monarchy.[9]

Unlike Nancy, Paris did not have its own school or principal group. The city was simply too large and

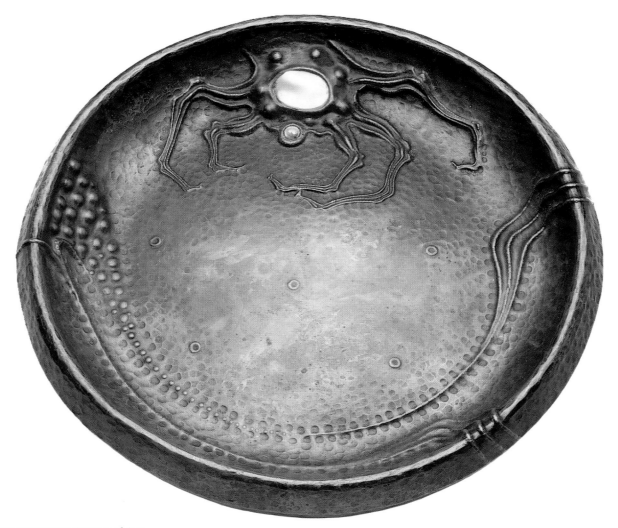

LUDWIG VIERTHALER (1875-1967) German
Bowl, 1906. Copper with repoussé design of a sea creature and naturaliste / abstract motifs with inset mother-of-pearl.
Manufacturer: J. Winhardt & Co., Munich. D: 12in (30.5cm)

Munich-born Ludwig Vierthaler first came to prominence around 1906 as a designer for metalwork companies in the city. He worked for various firms, including a brief stint with Tiffany & Company in New York. He is best known perhaps for the color effects obtained from his copper vases, jardinières, urns and bowls, all treated in such a way that subtle color effects provided an atmospheric backdrop for surface decorations based on underwater plant and animal forms. As with this remarkable bowl, they were often inset with semi-precious stones and mother-of-pearl. J. Winhardt & Company's "artistically superior patinations" were sold under the registered trademark EOSIN, but it was Vierthaler who executed them.

In this exercise in marine life ornament, a crab-like creature's body occupies one side. Another creature's arms seem to be curling around the other side, conveniently leaving the central area free. The choice of this extraordinary surface decoration was inspired by Ernst Haeckel's *Kunstformen der Natur* (Art Forms in Nature), the first installments of which had appeared in 1899.

diverse to be dominated by a single decorative philosophy. Most Art Nouveau exponents, however, opted for an abstract organic style in which the various elements of the plant were stylized – i.e. suggested – rather than realistically defined, as in Nancy. The annual Salons afforded local cabinetmakers with an incomparable opportunity to display their latest works. In fact, the Salons became *de rigueur:* the critics seldom strayed beyond the Champs-de-Mars or the Grand Palais, and their published opinions could dictate commercial success or oblivion. Amongst the capital's most noted modernist furniture designers and

manufacturers around 1900 were Eugène Gaillard, Abel Landry and Léon Benouville.

Many French ceramicists were drawn to the Art Nouveau movement at the height of its fashionableness. Included were two basic groups: the individual potter and small *atelier*, on the one hand, and the large commercial manufacturer, such as the National Manufactory at Sèvres, on the other. The former group tended to specialize in glaze formulae and sculpting (or modeling); the latter on painted forms of decoration. On many occasions, of course, two or three techniques were used by both groups in concert.

Single potters rejected conventional china painting techniques of decoration in favor of ancient Persian, Turkish and Far Eastern pottery, in which the interaction of the clay and glaze – of their often unpredictable fusion by fire – was preferred to the medium's traditional European pictorial or narrative form of imagery. Theodore Deck is generally credited with extricating ceramics from the clutches of historicism from around 1860. Deck was joined in his early experimentation by Félix Bracquemond, the engraver and lithographer, and then by several ceramicists who came to maturity at the *fin-de-siècle*, including Edmond Lachenal, who founded his own studio in Chatillon-sous-Bagneux, where he perfected a process of gilding on faience. Several other gifted potters were drawn to the pursuit of the perfect glaze, including Ernest Chaplet and Emile Decœur, the latter a student of Lachenal for whom the only importance of the clay body was that it provided the surface to which he could apply his glaze formulae. To this end, the standard household vase became the perfect vehicle as it could serve as a functional container while masquerading as a work of art.

Another glaze exponent, Pierre-Adrien Dalpayrat was drawn to sumptuous high-fired Chinese glazes, particularly those of the Ming and Ch'ing dynasties. His special interest lay in a range of thick liver-red *rouge flambé* glazes imitative of *sang-de-bœuf*, which became his signature color, and a range of marble-ised and crystalline glazes that he poured in two-color combinations to create dynamic chromatic effects.

A virtuoso ceramicist, Taxile Doat became famous for his mastery of the *pâte-sur-pâte* technique that he developed in partnership with Marc-Louis Solon at Sèvres. A legendary figure within his field by 1900, Doat showed his versatility in his production of a heterogeneous range of *flambé*, crystalline, crackled and metallic glazes, which he shared with the industry

FRANZ RINGER (dates unknown) German
Planter-on-Stand, 1904. Glazed pottery. Executed in a bold graphic *Darmstadt Style*. Manufacturer: Villeroy & Boch, Audun-le-Tiche, Germany. Marks on bottom: Villeroy and Boch monogram / #2908. Attributed to Franz Ringer.
H: 39in (99.1cm) x D: 10 ½in (26.7cm)

Most of the German ceramic and porcelain manufacturers were markedly hesitant about wading into Jugendstil at the sacrifice of their mainstream output. Typically, at Villeroy & Boch, in the Saar, a less pronounced interpretation of modernism was marketed under the firm's brand name, Mettlach. Two other German manufactories, Rosenthal in Sleb, and Swaine & Co. in Huttensteinach, shared this tentative approach.
Characteristic of the Mettlach line, this planter and stand are decorated in a highly stylized interpretation of Jugendstil design with flat, monochromatic tones. The two matching pieces are executed in a bold graphic Darmstadt style with a swirl pattern animating the design. At this time planters were very much in vogue, meant to accommodate large ferns.

NILS EMIL LUNDSTRÖM (1865-1960) Swedish
Vase, c.1897-1910. Porcelain with underglaze
painting. Reticulated vase form with design of
Easter lilies modeled by Alf Wallander (1862-
1914); decorated by Nils Lundström. Made by
Rörstrand Pottery and Porcelain Factory
(founded 1725), Stockholm, Sweden.
Provenance: Rörstrand Company Collection
Museum (bears an identifying paper label
attached to the interior of the vessel).
Condition: a firing hairline fissure
appears on side.
H: 17in (43.2cm) x D: 8 ¾in (22.2cm)

At the turn of the century, the artists of the
Swedish Rörstrand Porcelain Factory created
some of the most beautiful decorative objects
of the Art Nouveau period. Led by a
formidable technical director, Robert
Almström, and his hand-picked artistic
director, Alf Wallander, they took nationalistic
pride in turning native flora and fauna into
elegant three-dimensional objects. Painting
and sculpture were artfully realized in
reticulated openwork tinted with a soft palette
of muted, pastel shades, ranging from a satiny
pink to an atmospheric gray-green. Typical of
Scandinavian designs, they conveyed an
impression of order and rational nature, of
poetic restraint rather than passionate
choreography. At the Paris 1900 Exposition
Universelle, the delicate porcelains of
Rörstrand were among the most celebrated
works to be exhibited, winning over an
enormous international audience.
This vase, formerly in the collection of the
Rörstrand Museum, was modeled by Alf
Wallander and painted by Nils Lundström.
Four Easter lilies are depicted, one on each
side with a painted stem and four sets of
calligraphic-like leaves extending into a fully
reticulated blossom.

CHRISTIAN NEUREUTHER
(1869-1921) German
Tray, 1904. Ceramic tile inset in oak frame of natural
finish with brass handles. Manufacturer: Wächtersbach
Steingutfabrik, Königstein, Germany. Marks: signed *KAW* logo and *CN.*
H: 3 ⅛in (7.9cm) x W: 20 ⅝in (52.4cm) x D: 13in (33cm)

in his 1905 book, *Grand Feu Ceramics*. His designs were as varied as his glazes, and included fruit- and vegetable-formed vessels such as the colocynth (bitter apple) and gourd, plus masks, plaques, bottles and portrait medalions. In Nancy, Ernest Bussière and the Mougin *frères* modelled a similar range of organic vessels to those by Doat.

In sharp contrast to the individual potter, France's large manufactories preferred the Victorian painterly form of decoration to that of the glaze, which was subject to the accidental effects of the kiln and therefore too random to meet the precise standards of quality required in serial production. At Sèvres, Vincennes and Haviland in Limoges, therefore, wares in the Art Nouveau idiom tended to be decorated with painted images, especially of flora and fauna, rendered in a soft naturalistic palette often with a strong Japanese interpretation.

In the Sèvres *genre* were the porcelain wares created around 1900 for Siegfried Bing's vanguard modernist Parisian gallery, the Maison Art Nouveau Bing, by two of its in-house designers, Edouard Colonna and Georges de Feure. Both applied a refined Art Nouveau organic style rendered in delicate pinks, powder-blues and greens to a range of toiletry items, table top accessories, tea services and figurines manufactured for the firm by Gérard, Dufraisseux & Abbot (G.D.A.) of Limoges. A matching line of porcelain was designed by Bing's rival store, La Maison Moderne, by three of its designers: Maurice Dufrêne, Paul Follot, and Abel Landry.

The four annual Paris Salons attracted the foremost artist-craftsmen in the nation, including those in the related fields of *orfèvrerie* (silversmithing and other precious materials) and jewelry. Several participants – most notably, René Lalique, Eugène Feuillatre, and

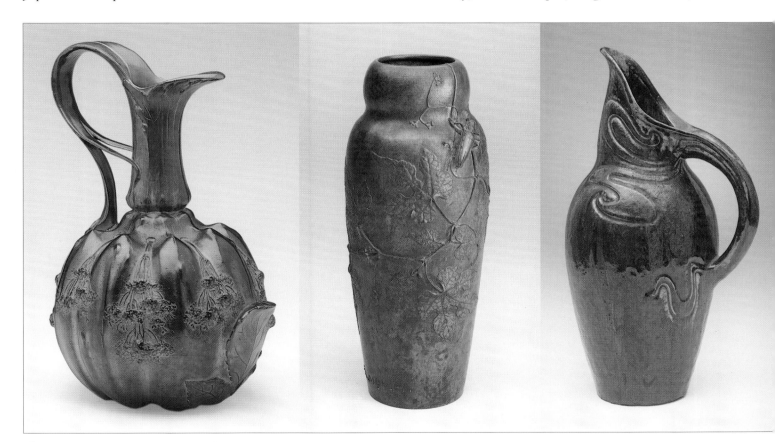

LÉON KANN (dates unknown) French
Pitcher, c.1900. Bronzed metal with gilt surface. Designed as organic ewer form.
H: 13 ⅛in (33.3cm) x W: 9in (22.9cm) x D: 8in (20.3cm)

HUGO C. M. ELMQUIST (1862-1930) Swedish
Vase, c.1908. Bronze. Patinated with relief of life-size beetle and trailing vine with leaves. Vessel likely cast in Florence, Italy.
Marks: *HUGO ELMQUIST;* (stamped on bottom of vase) with artist's insignia. Signature also incised on side.
H: 10in (25.4cm) x D: 4 ⅛in (10.5cm)

PIERRE-ADRIEN DALPAYRAT (1844-1910) French
Pitcher, c.1900. Stoneware with incised decoration and *rouge flambé* glaze. Vessel incised with whiplash tendrils at top and bottom points of handle. Signed: Dalpayrat (painted on bottom).
H: 16in (40.6cm) x W: 7in (17.8cm) x D: 9in (22.9cm)

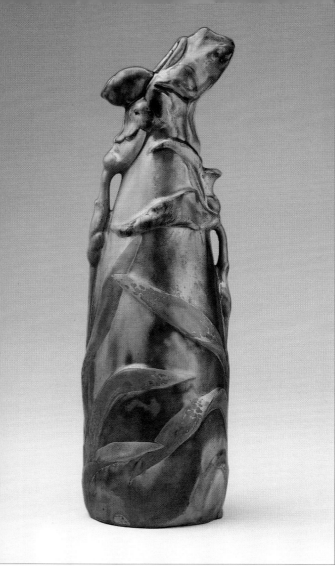

ERNEST BUSSIÈRE (1863-1913) French
Vase, c.1900. Ceramic with metallic-lustre glaze.
Executed by Keller and Guérin, Luneville. Marks:
KG/Luneville with Bussière signature.
H: 13 ¼in (33.7cm) x D: 3 ½in (8.9cm)

MAX LÄUGER (1864-1952) German
Vase, 1899. Earthenware. Executed by Tonwerke, Kandern,
Germany. The model was exhibited in the German section of the
1900 Exposition de Universelle, Paris, the 1902 Turin Exposition,
and the 1904 St. Louis Exposition.
H: 8 ½in (21.6cm) x D: 6 ½in (16.5cm)

Lucien Gaillard and the Maisons Vever, Falize, Boucheron, Aucoc, and Cardeilhac – presented works in both categories.

In its resistance to change, the French silver and jewelry industries adopted Art Nouveau imagery tentatively. Orthodoxy prevailed, even in a field overhauled by modern technological advances. Most members chose to offer a limited selection of Art Nouveau inspired objects of vertu within a broad repertory of traditional, and therefore proven, styles. They were generally more adventuresome, however, in their introduction of novel materials into their creations, a practice initiated by Lalique in the mid-1890s with his use of horn, ivory, enamels, tortoiseshell, etc., in place of the medium's stock-in-trade of diamonds and other precious gemstones.

Lalique was the unique talent of his age, generating works of stupefying originality, penetrating beauty and technical virtuosity in the fields of both jewelry and objects of vertu. Many monographs have been written on his achievements, so it is sufficient here to note that he was the true initiator of the French revolution at the *fin-de-siècle* in his areas of specialty and their dominant force.[10]

Lucien Gaillard was another to apply himself as both *bijoutier* and *orfèvre*. Drawing strongly on entomological and zoological themes, Gaillard transformed Nature's humblest, and sometimes ugliest, creatures – rhinoceros beetles and praying mantis amongst a multitude of bugs, snakes, and other reptiles – into a graceful selection of vases, humidors, and other domestic utensils. Part of Gaillard's genius lay in his mastery of a wide range of materials, including metals, woods, horn and patinations, which

ANTONIUS HENDRICUS LIMBURG (1887-) Dutch
Vase, c.1905. Fayence. Rozenburg form designed for Zuid-
Holland, Gouda, Holland. Marks: *Made in A.L. ZUID. HOLLAND
5008* etched on bottom.
H: 16 ½in (41.9cm) x D: 4 ⅛in (10.5cm)

FREDERICK HURTEN RHEAD (1880-1942) English
Ewer, 1898. Earthenware. *Intarsio* line designed by Rhead for Foley
Company, Staffordshire, England. Marks on bottom: *THE FOLEY /
manufacturer's monogram / I NTARSIO, ENGLAND, R.N. 330302.*
H: 12 ⅛in (31.1cm) x D: 5 ½in (14cm)

he blended effortlessly.

Amongst the other metalworkers of distinction at the Salons were Jules Habert-Dys, Lucien Hirtz (who worked for the Maison Boucheron), Georges Bastard, Lucien Bonvallet (who worked for the Maison Cardeilhac), Henri Husson, and Valery Bizouard.

In the graphic arts, there was an interdependence and easy alliance between the Art Nouveau movement and the poster world, in which both clearly owed a great debt to an earlier influence: the Japanese printmaker. In France, the medium was well-established by the late 1880s, in large part due to Jules Chéret, who had opened his lithography workshop in Paris as early as 1866. Chéret produced many of his more than 1,000 recorded poster designs in the modern style in the promotion of such consumer products as Saxoleine combustion fuel, Job cigarette papers and Dubonnet. Chéret mastered the medium's methodology in his subtle integration of the lettering into the composition as a whole, and the use of silhouetted images and strong color harmonies.

Another artist with a highly personal graphic style, Henri de Toulouse-Lautrec produced a total of 32 posters, many for the cabaret entertainers and music-halls of Montmartre. Most of his designs are classics, with powerful, essentially two-dimensional, images that are easily read from a distance. Most importantly, they convey the special persona of the client or product by portraying them where necessary in caricature, which Lautrec achieved by the clever modulation of his subject's silhouette to suggest his or her individual character or mood. Under his hand, the line became an almost independent carrier of the emotion.

ZSOLNAY ART POTTERY (Hungarian)
Grand Vase, 1899.
Earthenware with iridescent metallic-lustre *Eosin* glaze. Swollen baluster form
with applied leaves and tulip blossoms. Made by Zsolnay Art Pottery, Pécs, Hungary.
Model featured in the Hungarian Section of the 1900 Exposition Universelle, Paris.
Marks: *Wafer* (raised) signature mark, *1899* H: 15 ½in (39.4cm) x D: 11in (27.9cm)

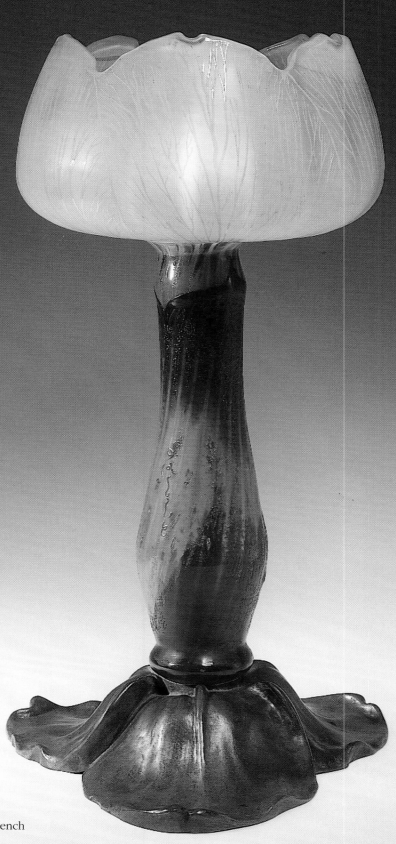

ÉMILE GALLÉ (1846-1904) French
Corolla Lamp c.1900.
Cameo art glass formed as an open lotus-like
blossom with a long throat set into a bronze socle of leafage.
Marks: Signed in the glass *Gallé* with the artist's Japanese style signature.
H: 18 ½in (47cm) x D: 10in (25.4cm) (at base)

A generation younger than Chéret, Alphonse Mucha became the most celebrated Art Nouveau poster artist, in part through his association with Sarah Bernhardt, for whom he created several of his most memorable works. Pushed by his entrepreneurial employer, the lithographer Champenois, Mucha generated a prodigious volume of work, including posters, menus, calendars, and *panneaux décoratifs*. In 1902, partly to meet the demand of an insatiable public, Mucha published two volumes of graphic designs, *Documents décoratifs* and *Figures décoratives*.[11]

Eugène Grasset was another noted graphic artist in Paris to respond to the modern idiom, although with some hesitancy: his posters and book illustrations reveal clear English stylistic antecedents, especially those of the Pre-Raphaelites and mediaevalism.

The formation of an artist's colony in Darmstadt in 1899 helped to consolidate and legitimise the new movement in Germany, which became known as *Jugendstil* ("Youth Style") after the Munich magazine, *Jugend*, that promoted Art Nouveau. Inspired by the English Arts and Crafts movement, with whose manifesto he had become acquainted during his association with Mackay Hugh Baillie Scott, who designed furniture for him, Grand Duke Ernst Ludwig of Hesse invited seven German and Austrian artists, including Peter Behrens and Joseph M. Olbrich, to form a permanent community for artists, called Mathildenhöhe, in Darmstadt.

Although his infatuation with *Jugendstil* was short-lived – in 1904 he rejected the curve entirely from his designs – Behrens was influential in spreading its initial appeal, although with an interpretation far less exuberant than that in France and Belgium. His designs in the new idiom for furniture, for example, like those by his countrymen August Endell, Richard Riemerschmid, Otto Eckmann and Bernhard Pankok, incorporated restrained and rational shapes that borrowed an occasional volute or scroll from the Art Nouveau vocabulary.

Metalware production in Germany around 1900 was concentrated around Berlin, Darmstadt, Dresden, and Munich. Manufacturers outside these centers included P. Bruckmann und Söhne in Heilbronn and the Württembergische Metallwaren Fabrik (WMF) in Geislingen. To ensure that they remained *au fait* with progressive design concepts, some manufactories, such as the Vereinigte Werkstätten, situated both in Berlin and Munich, retained accomplished designers such as Bruno Paul and Riemerschmid to submit modernist designs to supplement their standard editions of metalware.

In addition to the production of silver, several German factories applied a charming selection of floral and curvilinear motifs to pewterware. Notable in this category were Walter Scherf & Company, which marketed its wares under the tradename "Osiris", and J. P. Kayser und Söhne, in Krefeld, for whom the versatile Hugo Leven submitted designs for domestic accessories such as claret and water jugs, tea caddies, beakers and candlesticks.

In Berlin, the conservative State-owned Königliche Porzellan-Manufaktur (KPM) embraced *Jugendstil* tentatively from 1902 with a selection of curvilinear and floral patterns applied to porcelain tableware services and vases. The Staatliche Porzellan-Manufaktur at Meissen followed their lead, retaining outside designers, such as van de Velde and Behrens, to provide it with state-of-the-art modernism. To the south, in Bavaria, the Nymphenburger Porzellan-Manufaktur produced a similar line of modernist porcelain tablewares under the supervision of Hermann Gradl, while at Villeroy & Boch, in the Saar, an understated modernist vernacular was marketed under the firm's brand name, Mettlach. The firm of Rosenthal, in Selb, applied a similar range of graceful botanical patterns to its porcelain output. Few independent German potters embraced *Jugendstil* with the same enthusiasm as the large factories, with the notable exception of Max Läuger, a mixed-media artist-craftsman, who produced a range of *Jugendstil* earthenware vessels at his studio in Kandern in the Black Forest.

Across the Atlantic, the development of modernist trends within American architecture around 1900 bore some resemblance to those in Europe, but the relationship remained complex and in some ways

LOUIS COMFORT TIFFANY (1848-1933) American
Mandarin (Lotus Leaf) Leaded Glass and Bronze Lamp, c.1900-05. Executed in shades of green and white mottled and striated stained glass panels set within a ribbed pattern. Base formed in a tall, elongated root-style with a double-folded ribbed platform. Shade signed with a small bronze tag: *Tiffany Studios New York*. Base impressed on the underside: *Tiffany Studios New York 28749* with the early cross-key monogram (an indication this lamp was one of the earliest designs executed at the Tiffany Studios). The price list published by Tiffany Studios in 1906 described the shade as "model #1524, 25 inch Lotus, Pagoda", and the base as "model #373, Library standard, Mushroom, 6-8 c.p. lights, shade #1524".
H: 31 ½in (78.7cm) x D: 24 ½in (62.2cm) (at shade) x D: 12in (30.5cm) (at base)

It is in the medium of glasswork that Louis Comfort Tiffany is acknowledged as a genius and innovator of the American Art Nouveau style. In doing so, he was among the first to eliminate the age-old distinctions between the fine arts and the decorative arts. Moreover, he forever cut the ties that bound American decorative art to Europe, forging a new American aesthetic. Tiffany devoted his life to the production of glassware, stained glass windows and lamps for the purpose of beautifying home interiors. While there have been untold numbers of lamps produced by Tiffany Studios, this work remains one of the purest examples. Its refinement and abstract quality are a refreshing antidote to the heavy decoration prevalent in many Tiffany lamp designs.

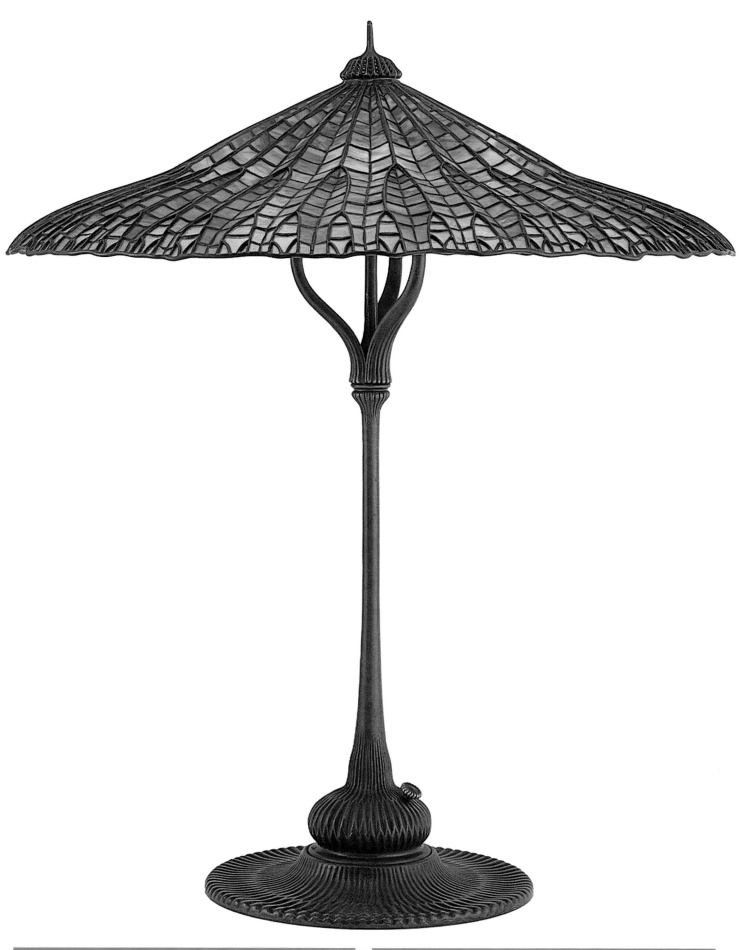

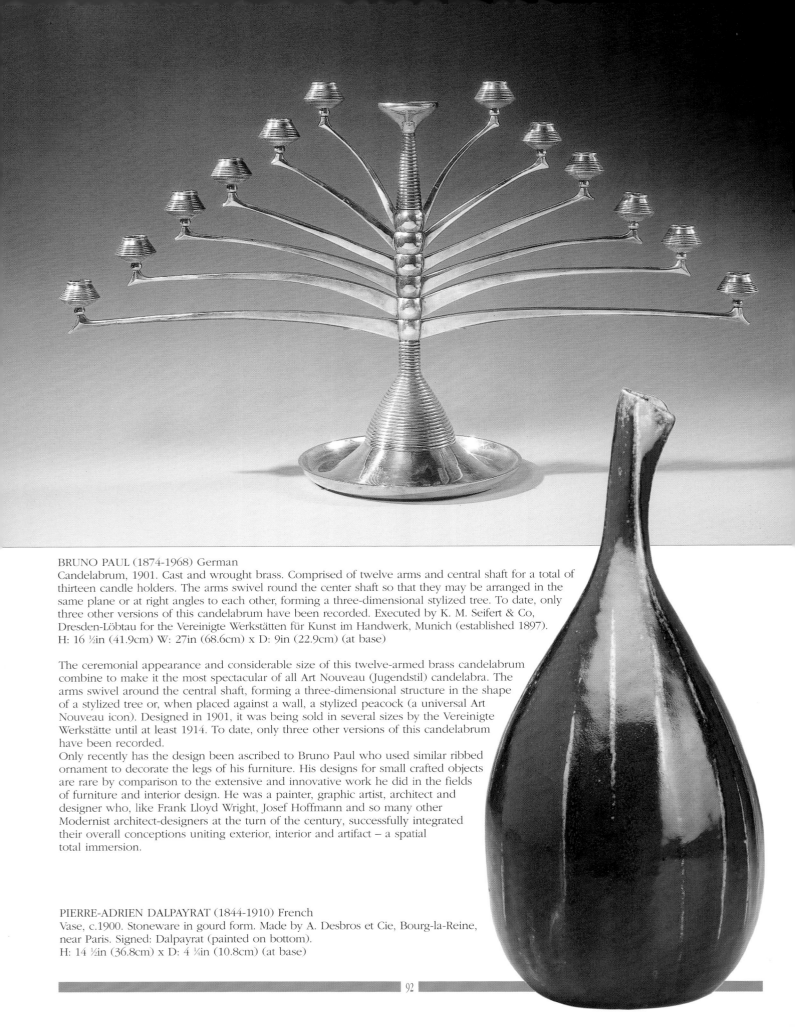

BRUNO PAUL (1874-1968) German
Candelabrum, 1901. Cast and wrought brass. Comprised of twelve arms and central shaft for a total of thirteen candle holders. The arms swivel round the center shaft so that they may be arranged in the same plane or at right angles to each other, forming a three-dimensional stylized tree. To date, only three other versions of this candelabrum have been recorded. Executed by K. M. Seifert & Co, Dresden-Löbtau for the Vereinigte Werkstätten für Kunst im Handwerk, Munich (established 1897).
H: 16 ½in (41.9cm) W: 27in (68.6cm) x D: 9in (22.9cm) (at base)

The ceremonial appearance and considerable size of this twelve-armed brass candelabrum combine to make it the most spectacular of all Art Nouveau (Jugendstil) candelabra. The arms swivel around the central shaft, forming a three-dimensional structure in the shape of a stylized tree or, when placed against a wall, a stylized peacock (a universal Art Nouveau icon). Designed in 1901, it was being sold in several sizes by the Vereinigte Werkstätte until at least 1914. To date, only three other versions of this candelabrum have been recorded.
Only recently has the design been ascribed to Bruno Paul who used similar ribbed ornament to decorate the legs of his furniture. His designs for small crafted objects are rare by comparison to the extensive and innovative work he did in the fields of furniture and interior design. He was a painter, graphic artist, architect and designer who, like Frank Lloyd Wright, Josef Hoffmann and so many other Modernist architect-designers at the turn of the century, successfully integrated their overall conceptions uniting exterior, interior and artifact – a spatial total immersion.

PIERRE-ADRIEN DALPAYRAT (1844-1910) French
Vase, c.1900. Stoneware in gourd form. Made by A. Desbros et Cie, Bourg-la-Reine, near Paris. Signed: Dalpayrat (painted on bottom).
H: 14 ½in (36.8cm) x D: 4 ¼in (10.8cm) (at base)

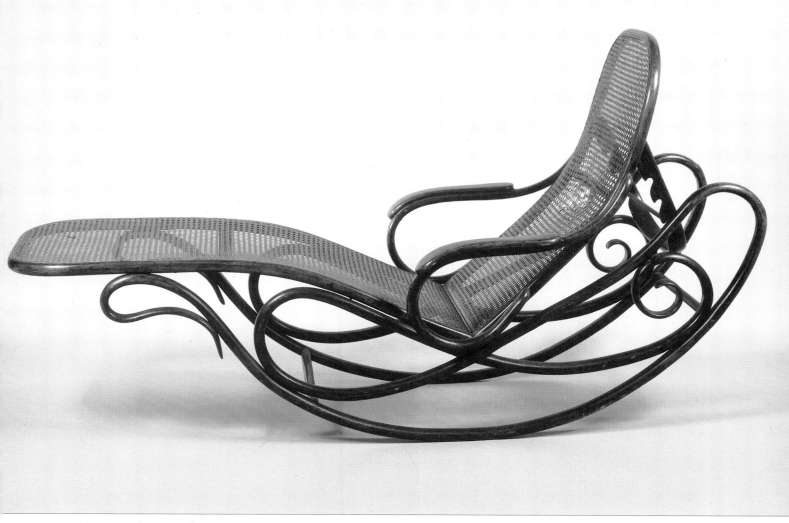

AUGUST THONET (1829-1910) Austrian
Rocking Chaise, c.1880-83. Model no. 7500. Bent and turned beechwood with walnut stain and original
caning (in back rest). Made by Gebrüder Thonet, Vienna. Attributed to August Thonet.
H: 32in (81.3cm) x W: 68 ¾in (174.6cm) x D: 26 ½in (67.3cm)

Indelibly identified as classics of modern design, the remarkable bentwood furnishings of Gebrüder Thonet continue to turn heads
more than a century later. While the history of bentwood furniture dates back centuries, it was Michael Thonet (1796-1871), an
enterprising cabinetmaker from Boppart-am-Rhein in Germany, who propelled the notion of bending woods (and subsequently,
tubular metal) into the 20th century.
Thonet began experimenting in the 1830s with the bending and laminating of wood, first producing delicate and lightweight
Biedermeier designs, forerunners of the familiar Vienna café chairs. Under the patronage of Prince Metternich, Thonet moved to Vienna
and was granted a patent for his new bentwood process in 1842. In the 1850s he set up two factories near beech forests in Moravia (the
present Czech Republic), which he handed over to his five sons in 1853. With diminishing supplies of timber, the factory was relocated
in Hungary. At one time the firm employed 6000 people worldwide and produced 5000 pieces of bentwood furniture daily.
Thonet's economical and logical use of beechwood represented important breakthroughs in the manufacturing process, enabling
production for mass markets in Europe, America and South America. His genius was most brilliantly achieved in his early designs such
as the rocking chaise (schaukefauteuil) designed in the late 1880s and intended for affluent households who could both afford it and
had ample space to comfortably accommodate its considerable size. An Anglo-American invention, the rocking chair was not
enthusiastically embraced in Western Europe until a rocking chair design appeared in the Thonet catalogue in 1862. The design was
further modified into a chaise-longue rocker, its sweeping curves capturing the spirit and signature whiplash line of the Art Nouveau
movement perfectly. Thonet's fluid grammar of motion in this piece suggests movement even when the chair remains stationary.
The elongated rods of bent wood that form its sides appear to be single 20ft (609.6cm) elements, but are in fact constructed from two
separate pieces spliced near the intersection of the arms at the side rail. No other example of Thonet furniture used such long lengths
of wood. Borrowed from the Morris Chair (named for the British designer, William Morris) the adjustable back anticipates Josef
Hoffmann's Sitzmaschine by a quarter of a century.

WILLIAM (WILL) H. BRADLEY (1868-1962) American
Complete Set of *Chap-book* Posters, 1894-95.
Poster/lithographs. Series includes: *The Twins* (May 1894) H:
19 ½in (49.5cm) x W: 13½in (34.3cm); *The Blue Lady*
(December 1894) H: 18 ⅞in (48cm) x W: 13 ¼in (33.7cm);
May (May 1895) H: 20 ½in (52.1cm) x W: 13 ⅞in (35.3cm);
Pegasus (September 1895) H: 20in (50.8cm) x W: 13 ⅝in
(34.6cm); *The Pipes* (June 1895) H: 20 ¾in (52.7cm) x W: 14
⅜in (36.5cm); *The Poet and His Lady* (January 1895) H: 20in
(50.8cm) x W: 13 ⅜in (34cm); and *Thanksgiving* (November
1895) H: 19 ⅝in (49.8cm) x W: 13 ⅜in (34cm). Published by
Stone and Kimball, Chicago and Boston. All works framed
the same size: H: 26 ¾in (67.9cm) x W: 20 ¼in (51.4cm)

Will Bradley began his career at twelve as a printer's devil
for a Michigan newspaper. His mother had moved there after
the death of his father, a Boston cartoonist, in 1874. In 1887,
he moved to Chicago to accept a position as a designer; he
was completely self-taught. In 1894 Bradley's book and
theatre posters and series of covers for *The Inland Printer*
and *The Chap-Book* marked the beginning of Art Nouveau in
America.
The seven posters in this collection were designed as
advertisements for the separate issues of *The Chap-Book*, a
monthly anthology of verse, short stories and illustrations by
noted authors and artists, published between 1894-95.
Bradley's individual posters are represented in many public
and private collections but few complete sets are known to
exist.

LOUIS COMFORT TIFFANY
(1848-1933) American Vase,
c.1900. Hand-blown glass with
wheel-carved cameo Favrile
surface depicting attenuated
leaves in deep green over a
white glass ground.
Cylindrical form, swollen at
the shoulder.
Marks: inscribed
L.C. Tiffany Favrile 4572B,
accession no. *87-277*.
H: 13 ¾in (34.9cm) x
D: 5in (12.7cm)

The genius governing Louis
Tiffany's energies over a 30-year
period took form in the most
intoxicating range of glassware
in the annals of the craft. His
contributions as colorist, naturalist
and as innovator have only recently
been properly documented and
appreciated. In 1894 Tiffany
patented *Favrile* glass (from the
Latin word *faber*, meaning *artisan*),
inspired by ancient iridescent
techniques produced by exposing
hot glass to metallic fumes and
oxides. The technique soon became
a trademark for Tiffany and could
never be matched for brilliance of
color, fantasy of form or quality
of workmanship. The graceful
silhouette of this hand-blown vase
with delicate wheel-carved leafage
applied over a translucent ground
is among the artist's quietest, yet
most successful compositions.
Tiffany's restraint in both color and
motif has resulted in a work of
soothing tranquillity.

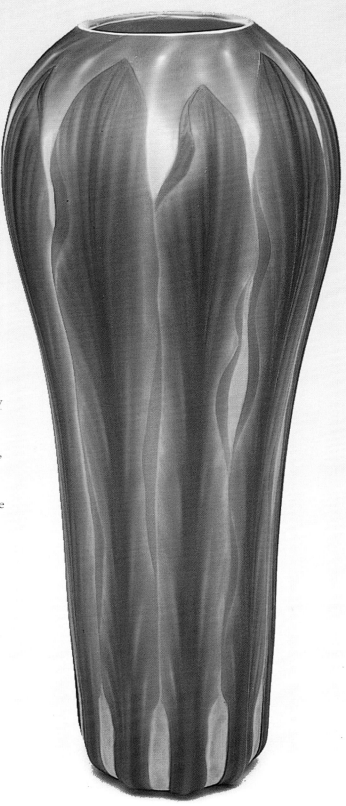

LOUIS COMFORT TIFFANY
(1848-1933) American
Floriform Vase, c.1900.
Favrile blown glass.
Provenance: Edgar Kaufman,
Jr. Collection.
H: 21 ⅞in (55.2cm) x
D: 5 ¼in (13.3cm) (base)

The name of Louis C. Tiffany has long
been synonymous with leaded-glass
lamps of undisputed beauty. Today,
Tiffany might be dismayed, as they
were essentially of commercial
purpose, a convenient way to use up
the several tons of glass chips and
shards remaining from his monumental
windows. There remains, however,
little dispute in the fundamental
talents which governed his energies –
those of a colorist and naturalist – nor
of his spectacular innovations as a
glassmaker. With the opening of a
new glassworks at Corona, Long
Island in 1892, Tiffany soon patented
his *Favrile* glass. His decoration
tended towards the abstract in its
depiction of organic forms, as with
this rare Egyptian onion flower-form
vase, its fluid silhouette simplified and
elongated into a plant-like stem and
flower. In this work alone (its unique
iridescent colors the result of exposing
the molten glass to the fumes of
vaporized metals) Tiffany is seen as a
decorative artist of unparalleled
ability, vision and accomplishment.

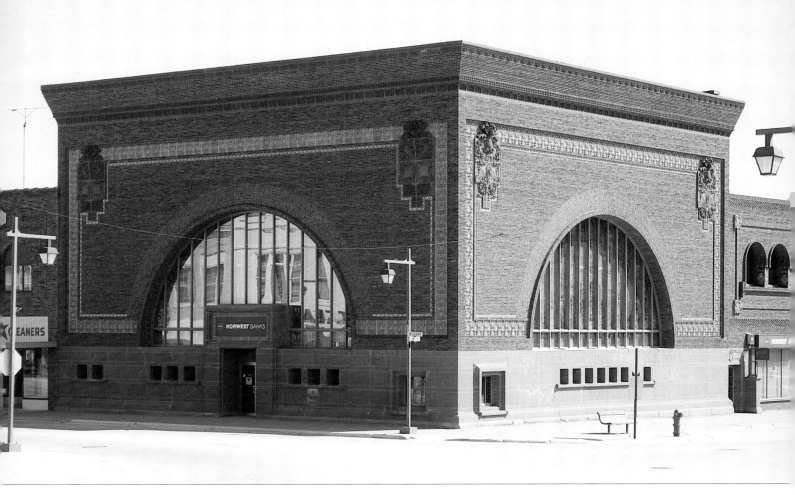

LOUIS H. SULLIVAN (1856-1924) American
Norwest Bank Owatonna (formerly The National Farmers' Bank), 1906-08. George Grant Elmslie (1871-1952) Chief Draftsman and Ornamentalist

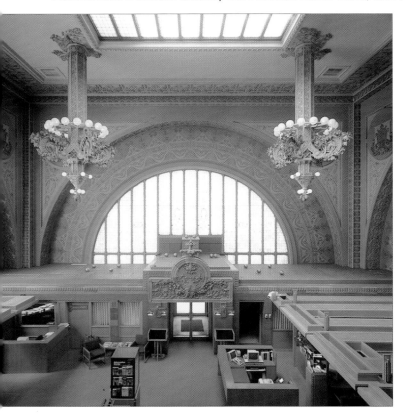

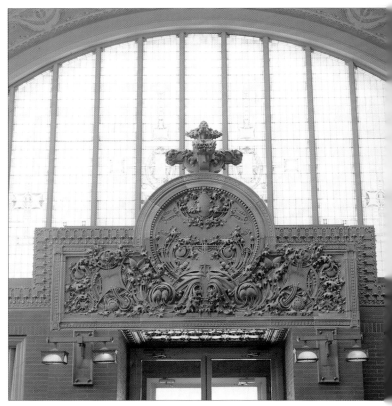

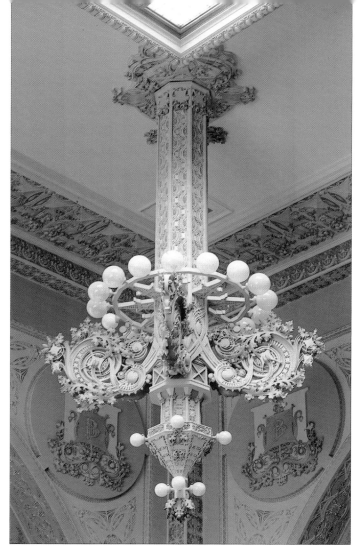

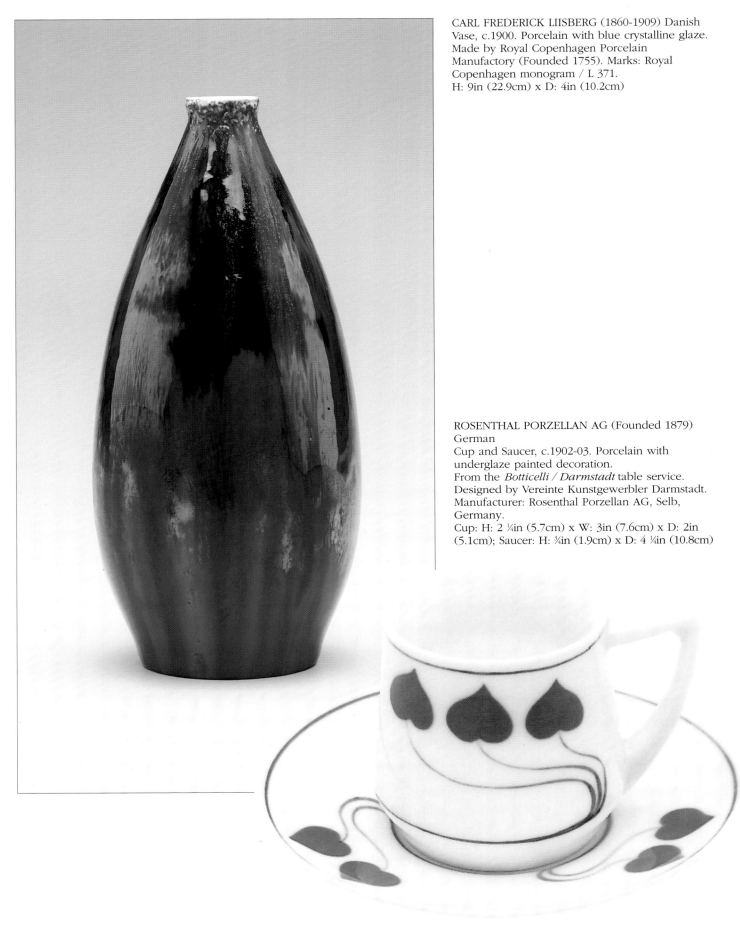

CARL FREDERICK LIISBERG (1860-1909) Danish
Vase, c.1900. Porcelain with blue crystalline glaze.
Made by Royal Copenhagen Porcelain
Manufactory (Founded 1755). Marks: Royal
Copenhagen monogram / L 371.
H: 9in (22.9cm) x D: 4in (10.2cm)

ROSENTHAL PORZELLAN AG (Founded 1879)
German
Cup and Saucer, c.1902-03. Porcelain with
underglaze painted decoration.
From the *Botticelli / Darmstadt* table service.
Designed by Vereinte Kunstgewerbler Darmstadt.
Manufacturer: Rosenthal Porzellan AG, Selb,
Germany.
Cup: H: 2 ¼in (5.7cm) x W: 3in (7.6cm) x D: 2in
(5.1cm); Saucer: H: ¾in (1.9cm) x D: 4 ¼in (10.8cm)

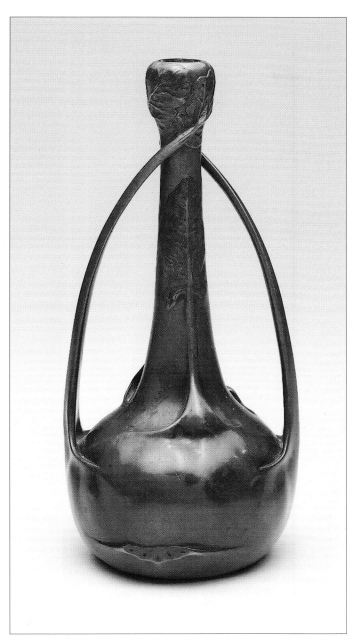

LUCIEN GAILLARD (1861-1933) French
Vase, c.1900. Patinated bronze. Executed in the form and leafage
of the turnip.
H: 8in (20.3cm) x W: 3 ½in (8.9cm) x D: 2 ¾in (7cm)

THEODORE HANFORD POND (1872-1933) American
Vase, c.1910. Handwrought copper in the form of the wildflower,
jack-in-the-pulpit. Marks: *Pond* imprint stamped on bottom.
H: 17 ½in (44.5cm) x W: 4 ¼in (10.8cm) (at base)

ROOKWOOD POTTERY,
Cincinnati, Ohio (1880-1940)
American
Vase, 1901. Ceramic with *Sea
Green* glaze. Decorated with
carved tulip motif and sea
green glaze by Sturgis
Lawrence for Rookwood
Pottery. Exhibited at the St.
Louis *Louisiana Purchase
Exposition, 1904;* awarded a
medal for artistic merit.
Original paper label affixed to
underside of base. Marks:
signed underside of base with
Rookwood Pottery's
impressed monogram, date,
design *#907B,* artist's full
signature and Exposition
paper label.
H: 16 ⅞in (42.9cm) x
D: 6 ⅜in (16.2cm)

JACQUES SICARD
(1865-1923) French
Monumental Vase, 1902.
Glazed earthenware. Marks
inscribed on surface within
the glaze: *Sicard Weller.*
H: 24in (61cm) x
D: 14in (35.6cm)

obscure. Whereas Louis Sullivan's choice of a highly condensed and luxuriant vegetal grammar of ornament with which to dress his new buildings bears close comparison with the work of Guimard and Xavier Schoellkopf, amongst others, it was applied to structures of rectilinear form. In his choice of texture, pattern and color, Sullivan qualified as an Art Nouveau adherent; in the strictly traditional massing of his buildings, he did not. Unadorned, these structures are not "new art" at all, even though their lower reaches were covered with an exquisite skein of colorful foliage. The ornamentation therefore appears detached and superficial, as on his Guarantee Building (1894-95), Wainwright (St. Louis, 1890-91), Chicago Stock Exchange (1893-94), and the delightful National Farmers' Bank in Owatonna, the first of eight rural banks that Sullivan designed in the twilight of his career (1906-19).[12] A fortuitous collaboration between Sullivan, his chief draftsman Elmslie, and the banker Carl K. Bennett, resulted in a box-like structure

that was softened, if not totally disguised, by a range of compact botanical embellishments generated by Elmslie in terra cotta, stained glass, iron and wood in a palette of soft greens, gold and rust set off against the earthy red-browns of the building's brickwork. Sullivan saw the commission as the opportunity to create a "color symphony" and "color tone poem".

In the graphic arts, Americans took their inspiration from vanguard developments in the United Kingdom and Europe, as they always had. William Bradley emerged as the nation's premier draftsman, illustrator and poster designer in the Art Nouveau idiom. In addition to the large body of work that he produced for the *Chicago Tribune*, *Echo*, and *The Inland Printer*, Bradley published several of his own magazines, including *Bradley: His Book*, which contained examples of his own illustrative designs and those of others who showed progressive tendencies. Some of his compositions today appear indistinguishable from

HENRY VAN DE VELDE (1863-1957) Belgian
Tropon, 1898. Poster / color lithograph. Full-size version. Printer: Hollerbaum & Schmidt, Berlin.
H: 44 ¾in (113.7cm) x W: 30 ¾in (78.1cm) // H: 45in (114.3cm) x W: 31in (78.7cm)

JOSEF SATTLER (1867-1931) German
Pan, 1895. Poster / color lithograph. Printer: Kunst-Austalt V. Albert Frisch, Berlin.
H: 13 ½in (34.3cm) x W: 10 ½in (26.7cm) // H: 23 ¼in (59.1cm) x W: 18in (45.7cm)

LOUIS MAJORELLE (1859-1926) French
Chicorée Style Buffet, c.1902. Black walnut.
H: 100 ½in (255.3cm) x W: 88 ½in (224.8cm) x D: 22in (55.9cm)

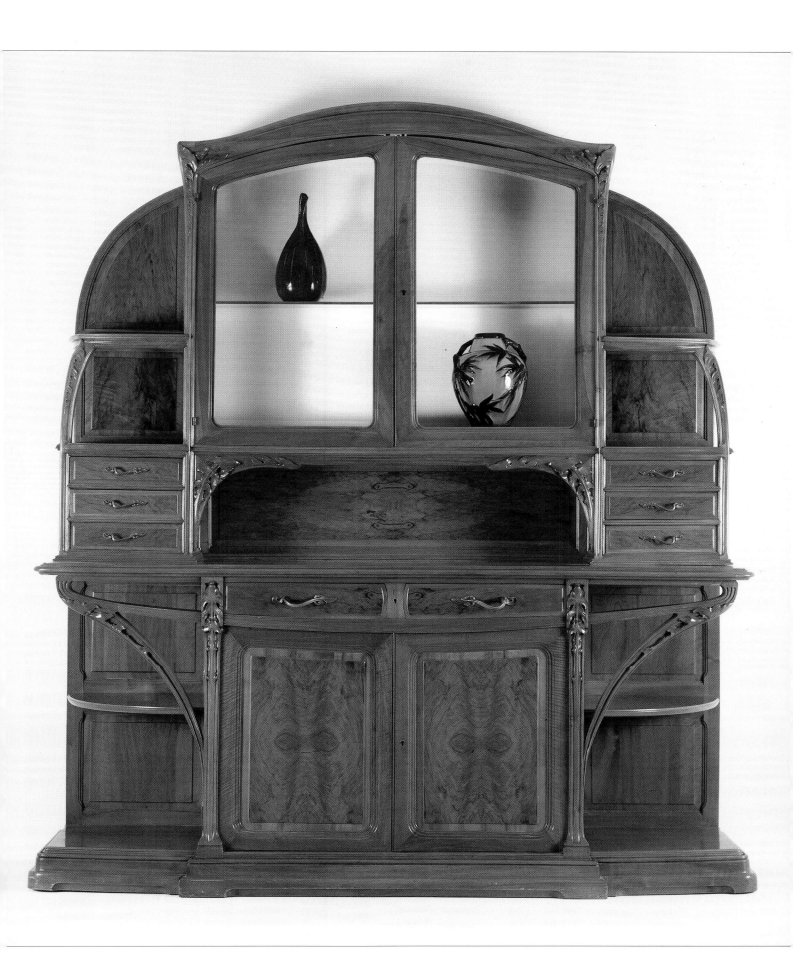

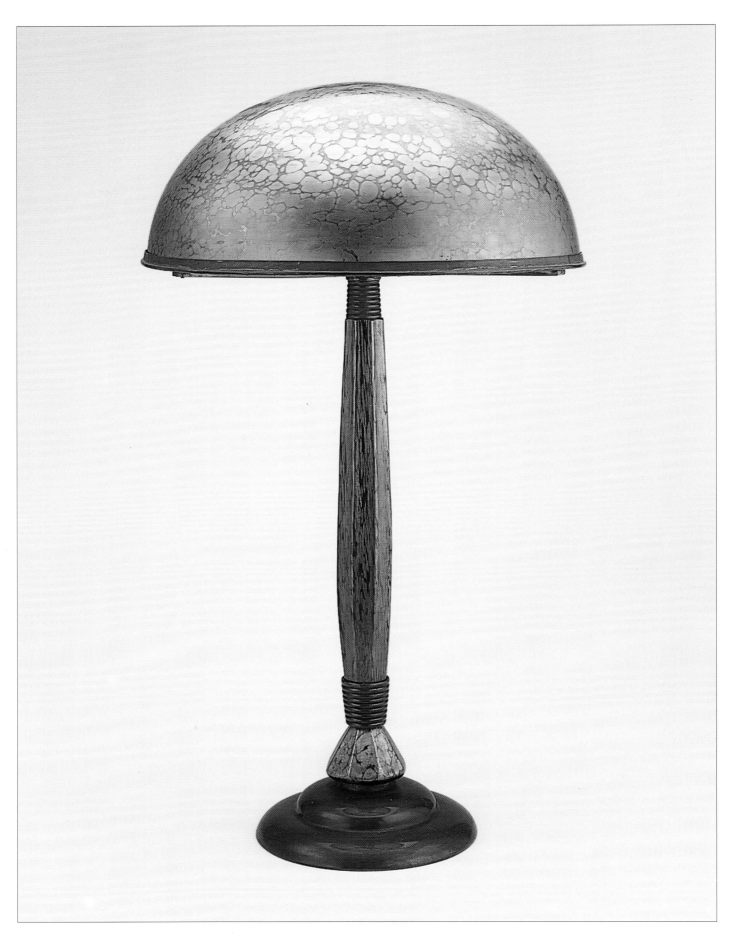

images generated by his counterparts in Belgium and France at the time.

Louis John Rhead, who had emigrated to America in 1883, following a career as a ceramicist and china-painter in England, designed bookbindings for the New York binder William Matthews before turning his hand in 1894 to poster design. Edward Penfield was another to design Art Nouveau-inspired posters, many for *Harper's*, in a style reminiscent of Théophile Alexandre Steinlen.

Around 1900, the American ceramic industry was divided roughly along the lines of its French counterpart; individual potters and studios explored recent glaze formulae innovations, while the larger factories opted for a painterly, and commercially more viable, decorative style. Today's historians tend to classify the industry within the category of "Arts and Crafts" rather than "Art Nouveau", a distinction that is followed in these pages.

The world of American art glass at the turn-of-the-century was dominated – if not monopolised, in the view of most critics – by Louis Comfort Tiffany. As with Gallé, the magnitude of Tiffany's achievements in the medium far exceeded those of his compatriots. Although his interpretation of Nature varied significantly from that of the Europeans – he preferred to portray it realistically, in contrast to the stylistic abstractions that evolved on the Continent – his pre-occupation with the outdoors placed him squarely within the modern movement. More than any other factor, it was the creation in 1893 of a glass furnace at his Corona workshops that enabled Tiffany to extend his business beyond that of the creation of liturgical objects for his principal client, the Church, to the manufacture of a diverse selection of household appurtenances. Of these, it is his inimitable glassware, such as his flowerform vases and leaded lamps, that are most prized by today's connoisseurs for their giddy range of blended and mottled hues that simulate Nature's ever-changing moods and palette. On the death of his father in 1902, Tiffany took on the responsibilities of Art Director of Tiffany & Company in addition to his supervision of the giant output of industrial art wares generated by his own workshops.

Isolated rumblings against Art Nouveau-inspired works of art – in particular, their persistent disregard for the fundamental principle of good design, i.e., that an item's ornamentation must always remain subservient to its function – began in the late 1890s, and became a passionate outcry by 1905. Soon, a roving band of self-appointed critics formed to police the annual exhibitions in Paris, Brussels, Nancy and Munich, with the mission of curbing the movement's ill-considered exuberance. Logic, it was argued, was being sacrificed on the altar of Beauty. Contributing to the movement's rapid downfall was the fact that it had been promoted in large part by brilliant individualists – Horta, Gaudí, Mucha, Lalique, Gallé, and Tiffany – to name just a few of its most gifted exponents. Its momentum had been fueled more by independent achievements, geographically dispersed and often isolated, than by a formal system of tuition, such as that provided by the Ecole des Beaux-Arts in Paris, which would have ensured a degree of stylistic continuity and standardization. The movement's very essence, its spontaneity and unbridled eccentricity, could neither be taught to the rank and file, nor copied by them with impunity.

By 1910, the movement was effectively over, its death as much self-induced as brought about by extraneous factors. The Salons were largely filled now with nondescript designs, sterile evocations of past styles, such as "Louis Quinze". The First World War formally brought the curtain down on the *fin-de-siècle* epoch. For later critics, it also provided a neat division between 19th- and 20th-century decorative design. Art Nouveau is now perceived as a Victorian movement which, although it straddled the two centuries, was out of step with progressive design concepts and developments, and was therefore part of the earlier one.

NOTES
1. For opinions by contemporary critics on the huge fashionability of the Art Nouveau movement around 1900, see Henry F. Lenning, *The Art Nouveau*, The Hague, 1951, pp.117-121.
2. For a comprehensive review of the major surviving commission by Horta in his characteristic Art Nouveau style, see Yolande Oostens-Wittamer, *Victor Horta L'Hotel Solvay The Solvay House*, 2 vols., 1980.
3. Peter Selz, *Art Nouveau*, exhibition catalogue, The Museum of Modern Art, New York, 1960.
4. For an illustration of Mackmurdo's seminal chair design, see, for example, Gillian Naylor, *The Arts & Crafts Movement*, 1971, Illust. no. 28.
5. The Peacock Room was exhibited at the Freer Gallery of Art, Washington, D.C., in May, 1995; see *House Beautiful*, May 1995, p.54 ff.
6. The most comprehensive study of Mackintosh's work is incorporated in the catalogue accompanying the traveling 1996-97 exhibition on his work; see Wendy Kaplan (ed.), *C. R. Mackintosh*, 1996.
7. Quoted in Alastair Duncan, *Art Nouveau*, London, 1994, p.32.

8. For another poster which illustrates Thorn-Prikker's graphic poster style, see John Barnicoat, *Posters*, London, p.93.
9. For biographical information on Majorelle, see Roseleyne Bouvier, *Majorelle*, Paris, 1991; and Alastair Duncan, *Louis Majorelle Master of Art Nouveau Design*, London and New York, 1991.
10. The definitive work on Lalique's jewelry is Sigrid Barten, *René Lalique Schmuck und Objets d'Art 1890-1910*, Prestel, 1977.
11. The original editions of *Documents Décoratifs* and *Figures Décoratives* are today hard to locate. For a reprint of *Documents Décoratifs*, including illustrations of the original 72 plates and a translation of the foreword by Gabriel Mourey, see *The Art Nouveau Style*, Dover, 1980.
12. For a discussion on the National Farmers' Bank in Owatonna, see *An Architectural Symphony*, Norwest Corporation publication, Minneapolis, 1981; for a review of rural banks designed by Sullivan, see "Eight small-town Midwestern banks are 'Little Gems' of architect Sullivan", *Minneapolis Star and Tribune*, Travel Section, January 25, 1987, p.1E ff.

LEOPOLD BAUER (1872-1938) Austrian
Lamp, c.1905. Bronze foot and mounts with paneled glass stem and dome-shaped art glass (*papillon* technique) shade.
Manufacturer: Johann Loetz-Witwe Glassworks, Klostermühle, Austria. Attributed to Leopold Bauer.
H: 29in (73.7cm) x D: 16 ½in (41.9cm)

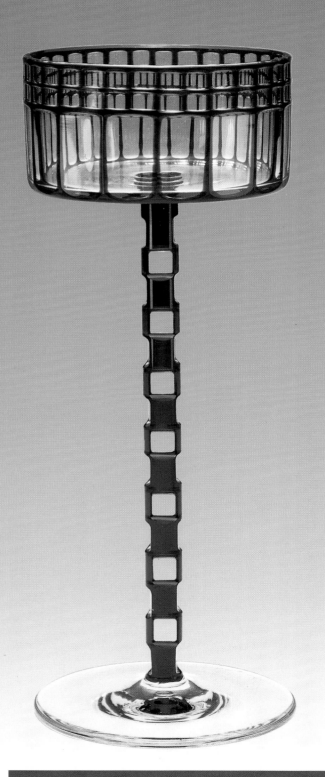

OTTO PRUTSCHER (1880-1949) Austrian
Wine Glass, c.1912. Clear crystal overlaid with cobalt blue
(cut out to expose the clear). Sold by E. Bakalowits & Sons,
Vienna. Probable manufacturer: Adolphshütte, Winterberg.
H: 8 ¼in (21cm) x D: 3 ¼in (8.3cm)

While Otto Prutscher is well known for his jewelry and silver
work, he designed some of the finest glass ever. Marketed by
both E. Bakalowits and the Wiener Werkstätte, his stemware
suites made from crystal and overlaid with deep colors utilizing
the "paper-chain" method provide an especially dramatic effect
in clear glass.

Using a traditional Austrian and Bohemian form of decoration,
the glass was *flashed* with a single color and then carved and
polished to form a checkered motif which became Prutscher's
hallmark. Colors range from rose-pink and yellow to purple and
deep cobalt blue. The precariously long, thin stem is likewise a
signature element. For stability glass makers invariably preferred
the foot of a wine-filled glass to be wider than the upper bowl.
Prutscher apparently enjoyed living on the edge, or encouraging
others to do so, often making the foot smaller in circumference.
His bowl forms vary from the traditional rounded cup to a flat
bottom. This model is considered one of his most advanced in
both color and form.

RKSTÄTTE

The head of the school of architecture at the Vienna Academy of Fine Art, Otto Wagner became the *éminence grise* of the modern movement in Austria both by his pioneership of the Secession and by the example of his own architectural work, which had a profound and lasting influence on his students, including Josef Hoffmann, Richard Neutra and Rudolph Schindler, the last two who established their reputations in California. Wagner's most celebrated building in Vienna was the Postal Savings Bank of 1904-06, a startling harbinger of the modern functionalist aesthetic. Clad in thick slabs of white marble held together by aluminum bolts that made the viewer aware of its assembly, the building presented cubic structural concepts in sharp contrast to the ponderous revival-style facades of its neighbors on the city's leafy new boulevard, the Ringstrasse. The main hall on the interior of the building was likewise radical: its air of stripped-down practicality achieved by a vast suspended ceiling, steel supporting columns, and a novel glass brick floor that transmitted light to the basement levels. Most interiors at the time followed the formula of Viennese high-Victorian, known as the "Makart Style", after the neo-Baroque painter, Hans Makart, who gave his name to the studied and affected residential opulence fashionable in central Europe towards the turn-of-the-century.

To counter the pervasive influence of this type of deadening Victorian eclecticism in architecture and interior design, the most progressive lights of Vienna's art world accepted the earlier leadership role of English designers in the fight to combat the glut of goods generated by the Industrial Revolution and the latter's stultifying impact on society as a whole. Austria was in fact around 1900 in the midst of an almost exaggerated Anglomania. The decorative arts magazine *The Studio* was devoured in the capital's cafes, and English fashion, sport and (astonishingly) food were debated endlessly. This infatuation could be traced back to the foundation in 1864 of the Austrian Museum für Kunst und Gewerbe (Museum of Art and Industry), created on the model of the South Kensington Museum (now the Victoria & Albert). Here a collection of commercially handmade goods of high quality was assembled to spur local craftsmen to emulate Morris' Art Workers Guild and Ashbee's Guild of Handicraft. The goal was for a new anti-industrial form of art workshop dedicated to craftsmanship and individual creativity, with the shared noble ideal of equality between artist and artisan. In 1867, a Kunstgewerbeschule (Academy of Applied Art) was added to the museum, where many members of the Secession movement and the Wiener Werkstätte later received their education in the arts. The demarcation between the three institutions was, in fact, readily crossed. In many cases, the same artist was active in all three; at the Kunstgewerbeschule as a teacher, in the Secession (from 1897) as an exhibitor, and at the Wiener Werkstätte (from 1903) as a designer.

In turn-of-the-century Vienna, the hoped for happy marriage of art and industry had failed to materialize; the hallmark of most machine-made wares remained their inferior design and quality of manufacture. Within the art community a system of small communal workshops was thought best to remedy the situation, by which the individual craftsman could appeal directly to private patronage without official or industrial intervention. With this concern for survival, the major and minor arts became increasingly linked, for better or worse, in their common search for reform. It was this notion of collaborative design which became the heart of the Secession's program, which led in turn to the concept of *Gesamtkunstwerk*, or "total work of art".

Led by Gustav Klimt, a group of primarily young Viennese artists – painters, sculptors and architects – elected, in March 1897, to secede from the establishment's prestigious Kunsterhaus (Artist's House) organization in resistance to its conservatism and rigidly blinkered exposition policies. The goal of these artists was to give modern trends an airing in the capital through a more progressive organization.

Known formally as the Society of Austrian Artists, the Vienna Secession was founded the next month. The dissidents included the nucleus of the nation's most gifted architects and artists, such as Wagner, Hellmer, Klimt, Engelhart, Moll, Olbrich, Hoffmann and Moser. The group's first exhibition, staged in March 1898 in

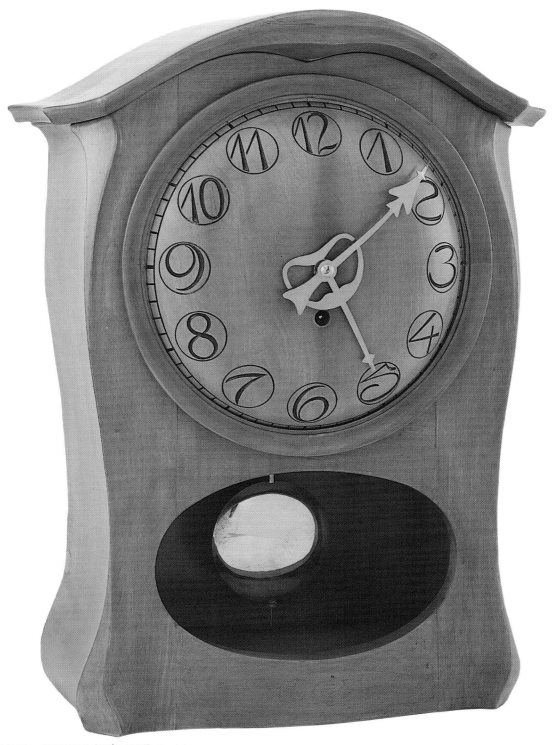

JOSEPH MARIA OLBRICH (1867-1908) Austrian
Mantel Clock, c.1899. Pearwood with applied metallic numerals. Designed for the apartment of Dr. Frederick V. Spitzer, Vienna.
H: 20in (50.8cm) x W: 15in (38.1cm) x D: 7 ½in (19.1cm)

In turn-of-the-century Vienna, Otto Wagner and his gifted students, Josef Hoffmann and Josef Olbrich, led the attempt to modernize architecture and interior furnishings. All three were founding members of the Vienna Secession which broke away from the ultra-conservative Künstlerhaus in 1897. Olbrich was chosen to design their celebrated exhibition hall (*kunsthalle*), renowned for its large spherical cupola of openwork leaves. Completely restored, the building is still used for art exhibitions and has become a famous Vienna landmark.
Although undulating, Olbrich's early style (1898-1904) is unfailingly anchored in solid architectural forms as seen in this mantel clock. Its curvaceous lines, distinctive numerals and oval pendulum opening are his familiar hallmarks. The clock was but one element of a totally harmonized interior created for the apartment of Dr. Frederick Spitzer in Vienna. As with his contemporaries, especially Hoffmann, Frank Lloyd Wright and Charles Rennie Mackintosh, Olbrich aspired to a unified integration of an interior and its furnishings.

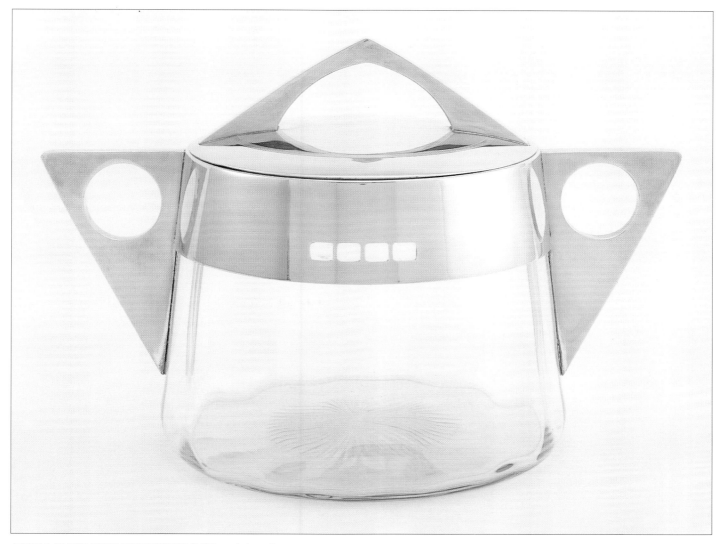

GISELA FALKE VON LILIENSTEIN (1871-) Austrian
Covered Tureen, c.1902. School of Kolomon Moser. Cut glass bowl with brass lid and handles. Executed by Argentor, Vienna. Marks:
Argentor 429.
H: 12in (30.5cm) x W: 17 ¾in (45.1cm) (to handles) x D: 10 ⅞in (27.6cm)

Baronesse von Lilienstein took an active part in the activities and development of the Wiener Werkstätte at the turn of the century. She studied with Josef Hoffmann among others and her work was exhibited in several Secessionist exhibitions as well as important international expositions in Europe and America. She designed works in several disciplines including ceramics, glassware, lighting and some furniture, though few pieces have survived.
The commanding presence of this tureen is difficult to ignore and must have been quite at odds with *fin-de-siècle* furnishings. Its highly assertive form, especially the angular handles with their bold circular cutouts, and the paneled glass bowl contrasts greatly with the scale and delicacy of many domestic designs of this era. Its only concession to period style is the cut-glass star pattern on the bottom. The four cut-out squares in the brass mount anticipate the gridlike *gitterwerk* baskets of Hoffmann and Koloman Moser to follow in the next several years.

the Gartenbau-halls, marked the start of a new artistic era in Austria, their aim to present and promote the sale of their own works, plus those of foreign avant-garde artists and architects. Deeply conscious of their ideal of an artistic renewal to be carried into all fields of human activity, the group moved quickly to establish itself. A headquarters building was designed by Joseph Maria Olbrich and constructed within six months in the shadow of the venerable Academy of Fine Arts. The inscription above the entrance stated the Secessionist credo, "To each century its art, to art its freedom". The building's gold-painted ironwork cupola, designed as a reticulated garland of laurel leaves, gave it the nickname of the gilded cabbage, which remained the talking point of the city for some time.

The first issue of the movement's magazine, entitled *Ver Sacrum* (Sacred Spring), appeared in January 1898, with the lofty goal of "steering the blustering spring gale of the new art on the continent through the dense grove of Austrian art", and to correct the

JOSEF HOFFMANN (1870-1956) Czechoslovakian-Austrian Table Vase, 1899. Polished wood and brass mount with Loetz glass vase insert. Retailed by Bakolowits & Son, Vienna. H: 18 ½in (47cm) x D: 7 ¾in (19.7cm)

impression that Vienna was in any way a German satellite.[1] The magazine's format and typography bore clear witness to the Secessionists' modernist ambitions in its crisp and harmonious linear quality and preference for an elegant mix of geometric ornamentation. In this, the graphic skills of Berthold Löffler and Koloman Moser were readily evident, as in the posters designed for the group's exhibitions. Moser, especially, created a taut and racy decorative vernacular of checkered or circular patterns that found its fullest expression in his later designs for furniture and appliances at the Wiener Werkstätte.

The Viennese early modern movement drew a great deal of its inspiration from progressive contemporary design in England and Scotland. The city's art community was galvanized especially by Mackintosh, who with his wife and the MacNairs displayed a range of architectural and furniture designs in the VIIIth Secessionist exposition in 1900 and again, the following year, in a German competition, *Haus eines kunstfreundes*. This assimilation of outside influences was selective, however; whereas Mackintosh's elongated linearity was readily received in the Austrian capital, his heavy, sometimes sentimental, decorative imagery was not. Preference was given to a spare and achromatic form of indigenous ornament that showed traces of the Biedermeier and Empire styles. Rejected outright were the Art Nouveau whiplash curves and contours of France and Belgium, their nervous serpentine convolutions transformed by the Secessionists into a unique formula of restrained, primarily symmetrical and geometric, patterns.

Ashbee's display of handwrought silverware and jewelry at the 1900 Secessionist exposition had a similar impact on local artist-craftsmen to that of the Glasgow Four on the city's architects and artists. His philosophies on art and society, and of their interdependence, were absorbed shortly into the work program of the Wiener Werkstätte.

No discussion of Viennese art at the turn-of-the-century, including the achievements of the Secession

In 1900, inspired by the work of Scottish architect-designer, Charles Rennie Mackintosh, Josef Hoffmann began replacing Jugendstil emphasis on organic form and exaggerated ornamentation with angularity and spare detailing. In this early departure from his previous designs he retained a warm wood finish and a gentle curvilinearity, qualities adopted simultaneously by his colleague, Joseph Olbrich.

This rare table vase was conceived of *in the round*. There are no front or backsides, and the see-through perforated slats in oval form foreshadow the breakthroughs yet to come in the work of such modernist sculptors as Henry Moore and Barbara Hepworth. The glass vase was made by Johann Loetz Witwe located in Klostermühle in western Bohemia. Their iridescent glassware was of exceptionally high quality and closely resembled that of Tiffany for the latter to initiate litigation in 1901 to prevent unsigned Loetz pieces from being imported into North America. Fortunately, each firm inspired the other to even greater heights of creativity.

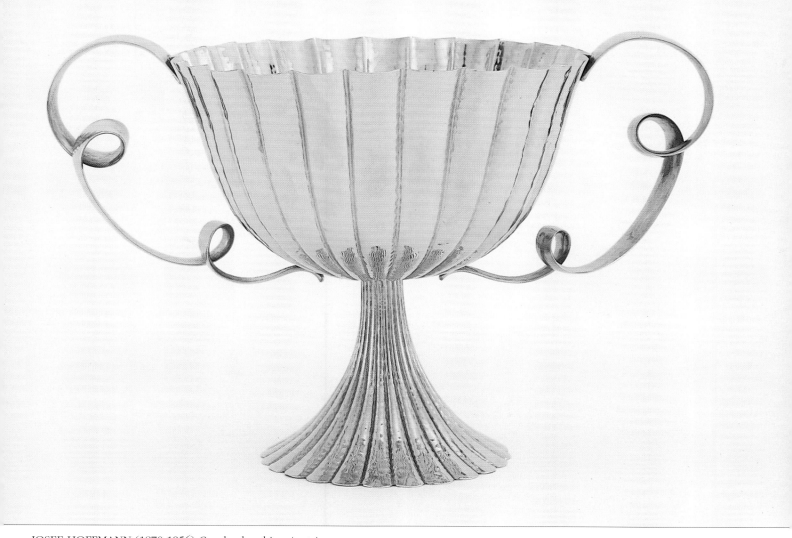

JOSEF HOFFMANN (1870-1956) Czechoslovakian-Austrian
Centerpiece Bowl, 1924-25. Hammered brass. Executed by: Wiener Werkstätte. Model exhibited
in the 1925 Paris Exposition Universelle. Marks stamped on outer rim: *WIENER WERKSTATTE,
JH* in monogram and *MADE IN AUSTRIA* within a square.
H: 7 ⅛in (18.1cm) x W: 12in (30.5cm) (with handles)

Josef Hoffmann is acknowledged as among the first of Viennese form-givers to evolve a new modernism at the turn of the century, one based initially on reductivism (the elimination of unnecessary ornament) and on geometry. Spanning a 50-year career, however, Hoffmann's work is far too diverse to be easily classified. His forms range from an austere linearity to the baroque. As a master assimilator, intuitive and endlessly inventive, Hoffmann produced a wide variety of styles which confirm his eclectic genius.
In this Art Deco centerpiece bowl Hoffmann adds to two neoclassical fluted forms a Viennese verve: the *unnecessary* arabesque of handles. The two ribbon-like elements may have been inspired by the widespread use of ribbons and streamers long familiar to a Viennese culture proud of its festive, celebratory traditions, and one likewise distinct from their more sober German neighbors. The loops seem to function, if at all, as an insolent provocation of ornament at a time when the purist tenets of the avant-garde held sway.

and the Wiener Werkstätte, can omit mention of Gustav Klimt, whose brilliant individualism dominated the era. Through his creations, the capital could boast of one, if not THE quintessential Art Nouveau artist. Certainly no other artist's work embodied the movement more fully in terms of such issues as the art of surface decoration, flowing curves and rich ornamentation, ephemeral beauty and symbolic feminine imagery tinged with decadence. Klimt is best known for his allegorical portraits of voluptuous young women set against sumptuously textured backgrounds. His use of appliqués, such as sequins, probably inspired by Byzantine mosaics, in some ways anticipated today's collage. Like the Nabis, Klimt moved easily from canvas to other surfaces, creating between 1900-03 large murals for three faculties at the University of Vienna, which were greeted at their unveiling with severe censure because of the radical character of their symbolism.[2] His landscapes and floral compositions, rendered in a kaleidoscopic and compact curvilinear imagery, mixed representational elements with freely invented geometric ornaments.

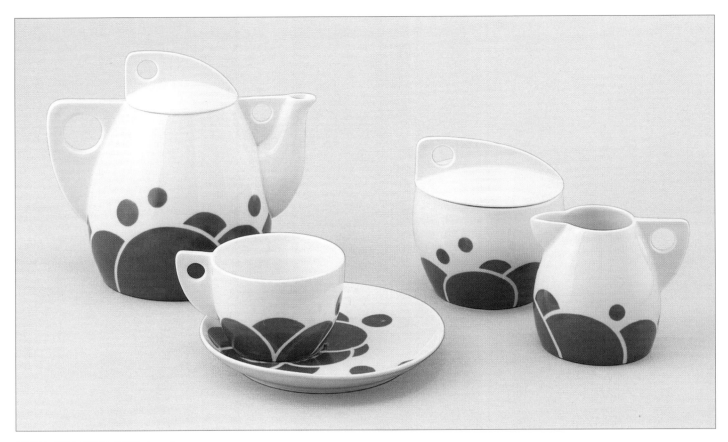

JUTTA SIKA (1877-1964) Austrian
Tea Service, c.1901-02. Ceramic with stencilled red-orange decoration on white ground. Manufacturer: Wiener Porzellan-Manufaktur, Josef Böck, Vienna. Marks in glaze on bottom: *Schule Prof. Kolo Moser / 501/a /* manufacturer's insignia.
Teapot: H: 6 ¾in (17.1cm) x W: 7 ½in (19.1cm) x D: 5in (12.7cm)
Sugar bowl: c.1902. H: 4 ½in (11.4cm). Creamer: H: 3 ½in (8.9cm)

The co-founders of the Wiener Werkstätte, Josef Hoffmann and Koloman Moser, gave young ceramicists formal instruction, who, in turn, executed designs produced by Moser's and Hoffmann's regular students. Moser was especially active in forming ties with the ceramics industry, and his students. Jutta Sika, among others, reaped the benefits of these connections. Before long, the mark *Schule Prof. Kolo Moser* (School of Moser) became a very exceptional mark of quality. The firm of Josef Böck, in particular, demonstrated an unusual willingness to pursue the best in modern design.
The early *Schule Moser* ceramics drew their strength from exceedingly pure geometric forms, decorated with equally severe patterns. Jutta Sika's tea service represents the epitome of this *moderne* phase. The flanges with circular holes and complementary stenciled circle motif are typical *Schule Moser*. Note how the teacup sits at the saucer's edge to accommodate a pastry, and the way the stencil design of the cup continues on to the saucer anticipating Russian avant-garde designs a decade later. The service looks as contemporary today as it must have appeared at the turn of the century.

The Secession enjoyed considerable success in its early years. Following the fanfare afforded the VIIIth exhibition in 1900, which concentrated on the applied arts, the group staged an exhibition under Hoffmann's direction two years later in celebration of Beethoven, in which the concept of *Gesamtkunstwerk* was fully explored.[3] Klimt's resignation from the group in 1905, following tensions arising from a disagreement on fundamental issues, led to the departure of other members sympathetic to him. The association remained at the center of Viennese artistic life even after its defining years of 1898-1905, however, and is still active today.

Friendships formed prior to the Secession's VIIIth exposition by Hoffmann and Moser with the Glasgow group and with Ashbee, initiated a trip by the two to Scotland and England. It was their visit to Essex House, Ashbee's Guild of Handicraft in the east end of London, that fomented the idea of the creation in Vienna of a similar association of cooperative workshops where artists and craftsmen would work side-by-side to manufacture fashionable, and therefore commercially exploitable, items for the city's well-to-do. The final steps towards this goal were taken in May, 1903, with the collaboration of Fritz Waerndorfer, the anglophile scion of a wealthy textile-manufacturing family. Already a patron of both Mackintosh and Hoffmann,[4] Waerndorfer offered to finance the venture. The Wiener Werkstätte (Viennese workshops) was formally established the following

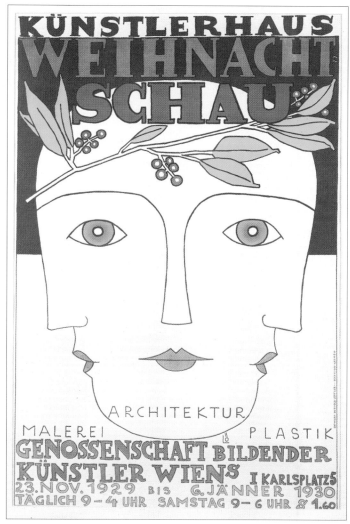

BERTHOLD LÖFFLER (1874-1960) Austrian
Künstlerhaus Weihnacht Schau, 1930. Poster / color lithograph.
H: 37in (94cm) x W: 23in (58.4cm) // H: 47in (119.4cm) x
W: 33¼in (84.5cm)

JOSEF MARIA AUCHENTALLER (1865-1949) Austrian
Vienna Secession, 1900. Poster/color lithograph. Printer: A.
Berger, Vienna.
H: 61in (154.9cm) x W: 27in (68.6cm) // H: 77in (195.6cm) x
W: 43in (109.2cm)

month, with Waerndorfer in charge of management, and Hoffmann and Moser of artistic direction.

Senior in experience, Hoffmann's appointment in 1898 to the faculty of the Kunstgewerbeschule preceded that of Moser by one year. Recognised as a talented and progressive architect, Hoffmann forged his way to the forefront of the modernist movement in Vienna with his facades for the Apollo candle shop and the Haus auf der Berghöhe (both 1899), and his interior for the Vienna School of Handicraft's pavilion at the 1900 Exposition Universelle in Paris, all of which showed the influence of Olbrich in their colorful intimacy and curvilinearity. After 1900, however, Hoffmann pursued an increasingly severe architectural style, as in his designs for the Purkersdorf sanatorium west of Vienna (1904-05), and the villa Beer-Hoffmann

BERTHOLD LÖFFLER (1874-1960) Austrian
Kunstschau Wien, 1908. Poster / color lithograph. Printer: Albert Berger, Vienna.
H: 14 ⅜in (36.5cm) x W: 19 ⅝in (49.8cm) // H: 21 ¼in (53.9cm) x W: 26 ½in (67.3cm)

JOSEF HOFFMANN (1870-1956) Czechoslovakian-Austrian
Seven Ball Sidechair, c.1906. Model no. 371. Beechwood and stained mahogany.
Maker: Jacob & Josef Kohn, Vienna.
H: 43 ½in (110.5cm) x W: 17 ⅞in (45.4cm) x D: 19 ⅝in (49.9cm)

(1906), on both of which his earlier ornamental elements were sharply curtailed, to the point almost of elimination.

Hoffmann's revolutionary pared-down concepts of design had a striking impact on his students at the Kunstgewerbeschule, whom he invited to collaborate on the creation of minimally-ornamented, totally 20th century, objects in glass, ceramics and metal. In functional design and splendid materials lay the craftsman's salvation from industrialization. Inspired by the crisp verticality of Mackintosh's designs, yet rejecting totally the Glasgwegian's heavy poesie and decorative vernacular – especially the symbolist rose and attenuated virginal maidens – Hoffmann sought to develop a quintessentially Viennese modernist decorative idiom based on simplified shapes and an honest use of materials. His early designs to this end were comprised of slender architectural forms with unbroken surfaces, which between 1903-06 underwent the transition to a more sophisticated

stylization in which geometric patterns, including the checkerboard matrix, became his preferred form of decoration for a host of household accessories. Hoffmann's persistent use of the grid pattern in his designs led to the nickname *Quadratl*, or little square, coined by his colleagues.

When applied as adornment to silver or painted metal objects produced by the Wiener Werkstätte, the centres of the squares in the checkerboard matrix were perforated to form a screened pattern (*gitterwerk*). At once utilitarian and decorative – and an instant success with customers – the checkerboard matrix became the most identifiable image associated in the public's mind with the workshops, its repetition of tiny squares combining clarity with a diaphanous pattern of voids and solids. Perceived as an entirely new form of design adaptable to mass-production, it was reproduced on daily appliances such as vases, lamps, jardinières, baskets and trays.

In his search for a marriage of simplicity and subtlety,

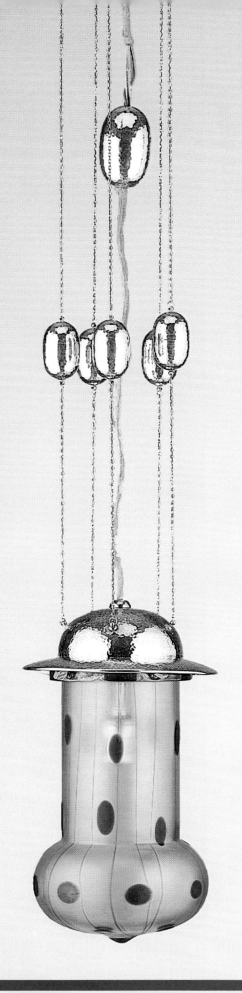

ALFRED ROLLER (1864-1935) Austrian
Embroidery Design, 1901. Block print on paper.
Verlag Anton Schroll & Company, Vienna. No. 1. Lithographer: A.
Druck, A. Berger, Vienna.
H: 24 ¼in (61.6cm) x W: 31 ¾in (78.1cm)

Hoffmann's designs for furniture were equally novel.
His earliest models, illustrated in a 1901 essay, "Simple
Furniture", reveal a predictable Mackintosh influence,
but with an emphasis on functionalism that soon
superceded the Scotsman's aestheticism. The critic A.
S. Levitus noted the evolution in a 1906 review of
Hoffmann's most recent furniture, "Utility is the first
condition, but there is no reason why the simplest
articles should not be beautiful. The value does not lie
only in the material, but in the right thought and
treatment of the material, and its power to convey that

KOLOMAN MOSER (1868-1918) Austrian
Chandelier, c.1905. Silvered-metal in two sections together with a
cylindrical glass shade with cushion-form base washed in opal
iridescence and decorated with azure dots and tendrils. Attributed
to Koloman Moser.
H: 56 ½in (39.4cm) x W: 8 ½in (21.6cm)

Few artists contributed as much as Koloman Moser to the flavor
and style of *fin-de-siècle* Vienna. In painting, and in the graphic
and decorative arts, Moser, together with Gustav Klimt and Josef
Hoffmann, defined the shape and course of the Viennese
Secession.
While most of both Hoffmann's and Moser's designs for objects,
interior elements and furniture were based on geometric forms,
Moser occasionally designed works inspired by Art Nouveau
sensibilities, like this chandelier. Moser, more than Hoffmann,
would enrich his relatively spare forms with a sensual surface
ornamentation, using rich materials such as Loetz glass and
original color patterns. This chandelier, with its hanging chains
and silver spheres, recalls the elegant necklaces Moser designed
for production by the Wiener Werkstätte.

MARIA LIKARZ-STRAUSS (1893-1956) Austrian
Evening Bag, c.1925. Glass beads and kid leather. Executed by:
Wiener Werkstätte.
H: 7 ½in (19.1cm) x W: 5 ½in (14cm)

thought to the mind of others…"

Two of Hoffmann's most important interior design commissions generated some of his finest furniture. The first was the Purkersdorf sanatorium (1904), for which he created a variety of elegant side and dining chairs with pierced oval backrests and splats. Included in the commission was the prototype, painted in blue and white, of Hoffmann's *Sitzmaschine* (Sitting machine), which in its 1908 version represents to many connoisseurs his most ingenious chair design.

JOSEF MARIA OLBRICH (1867-1908) Austrian
Schnapps Decanter, 1901. Pewter (original finish). Abstracted peacock form. Executed by Metallwarren-Fabrik E. Hueck, Lüdenscheid, Germany. Marks on bottom: stamped monogram, stamped manufacturer's mark / 1901 *(Edelzinn, E. Hueck, 1865)*.
H: 13 ¼in (33.7cm) x W: 3 ⅝in (9.2cm) x D: 4 ¼in (10.8cm)

The 1871 proclamation of the King of Prussia as German Emperor unified that country's numerous principalities and led to its rapid industrialization. Economic growth brought prosperity and with it a burgeoning bourgeoisie who sought precious objects as a measure of their elevated status within society. Jugendstil was especially fashionable in southern Germany, particularly in Munich and Darmstadt, where both Peter Behrens and Josef Olbrich applied it conceptually to the houses they designed around 1900 for the Mathildenhöhe Colony. The most advanced metalware to emerge during this period was a severe geometrical style developed by Olbrich and his fellow Vienna Seccessionists. This decanter in pewter has long been a favorite design – almost icon – of their style. It is one piece of a schnapps service comprised of six cordials and a tray Olbrich designed in a stylized Peacock pattern.

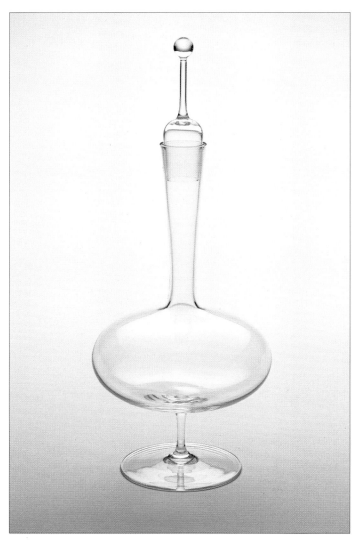

OSWALD HAERDTL (1899-1959) Austrian
Decanter with Stopper (which also functions as cordial), c.1930-40. Glass. From the *Ambassador* service, no. 240. Designed by Haerdtl for Lobmeyr Glassworks, Vienna.
H: 12 ¼in (31.1cm) x D: 4 ¾in (12.3cm)

Designed specifically for patients, this recliner draws its inspiration from the English Morris model which employed a similar moveable rod mechanism to determine the angle of the back. Yet it is the crisply machined and functional appearance of Hoffmann's chair that provides it with clear design leadership in this century. Mention should be made here also of another significant, yet apparently undocumented, Hoffmann side-chair that resembles the model which he designed for the Purkersdorf sanatorium. It is referred to today as the "Seven Ball" model, due to the vertical band of spheres that unites the two arched sections of its open back-rest.[5]

KOLOMAN MOSER (1868-1918) Austrian
Sherry Krug, c.1900. Heliotrope glass with silvered metal mounts designed by Moser. Retailed by Bakalowits, Vienna.
H: 10in (25.4cm) x W: 7 ½in (19.1cm) x D: 6 ½in (16.5cm)

Hoffmann's second important interior, in 1907, was the Cabaret Fledermaus, a favorite watering hole of fashionable Vienna. Here, Hoffmann's designs for the interior were dazzlingly neat and uncluttered; utilitarian tables and chairs with ball joints painted in spartan black and white, a combination which at first seemed chilly, but which was felt to be a refreshing contrast to the all-too-familiar warmth of the traditional upholsterer's art. Opening with Kokoschka's *The Spotted Egg*, the playhouse was soon frequented more by design students than theater buffs. Today, the black-and-white Fledermaus chair is considered an icon of 20th century design, in part because it pre-figured similar experiments in color by the De Stijl group.

Closely associated with Hoffmann since they were students together under Wagner at the Academy of Fine Art, but unlike him an artist-turned-designer, Koloman Moser brought first-hand knowledge of diverse craft skills and commercial art experience to the pair's design responsibilities at the Wiener Werkstätte. Moser's special graphic talent and sense of rhythmic proportion proved a providential match for, and counterbalance to, Hoffmann's rigid architectural logic. The result was a harmonious and highly fruitful working collaboration in which it is now often difficult to distinguish one man's work from the other's. Both must be credited with the architectural vocabulary of modular geometric design that became pervasive in Viennese design from 1900, one which had the ability to give small objects monumentality and large ones an almost precarious lightness. A metal plantstand could therefore have the look of a visionary skyscraper and

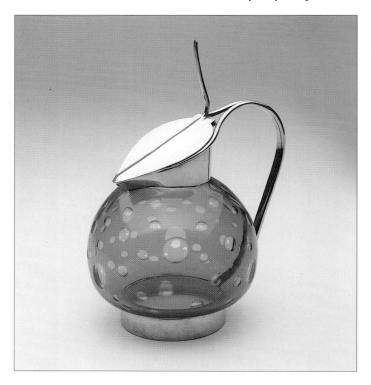

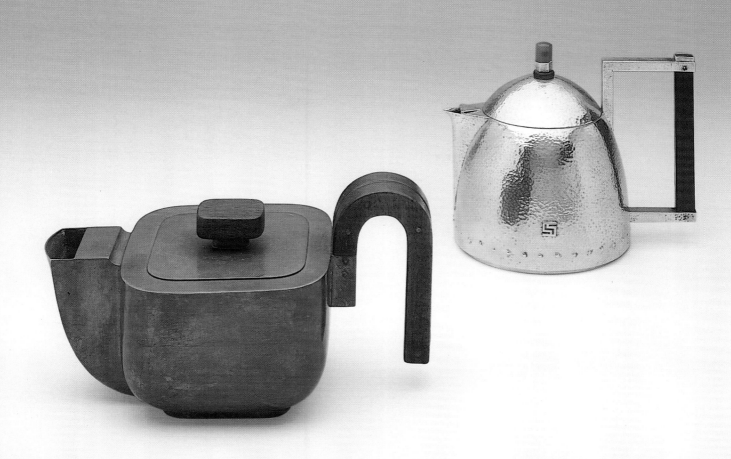

JOSEF HOFFMANN (1870-1956) Czechoslovakian-Austrian
Teapot, 1929-30. Handmade brass with teakwood finial and handle. Executed by Wiener Werkstätte.
H: 5 ⅛in (13cm) x W: 9 ¼in (23.5cm) x D: 5in (12.7cm)
Teapot, 1903. Hand-hammered silver (900) with carnelian finial and ebony handle. Executed by Wiener Werkstätte.
H: 6in (15.2cm) x W: 7in (17.8cm) x D: 5in (12.7cm)

Illustrating the range in the work of architect-designer Josef Hoffmann are these two teapots representing a time span of three decades. The first, executed in hand-hammered silver in 1903, was made the same year the Wiener Werkstätte was co-founded by Hoffmann and Koloman Moser. Among the earliest pieces to be produced by the Werkstätte, its form and delicate refinement contrast sharply with Hoffmann's teapot design produced almost 30 years later.

Such art movements as French Cubism, Dutch Neo-plasticism, Russian Constructivism and the German Bauhaus were to have a significant influence on European applied arts through the '20s. Endlessly inventive, Hoffmann not only assimilated these influences, he modified them into his own signature style. Representing a decided mood swing from his 1903 design, the later teapot possesses a muscularity directly related to applied designs of the thirties. Both teapots are extremely rare examples.

yet at the same time have a gauze-like airiness and weightlessness. The common denominator in this was the square, which when applied in miniature in repeating patterns along the surface of a cube-shaped object, served to provide it with a chic modern look sharply at odds with conventional forms of embellishment.

Moser's designs for furniture ranged from inexpensive bentwood models executed in large editions by J. & J. Kohn, to royal commissions such as the sumptuous desk in elm veneered in rosewood, mother-of-pearl and ivory that he designed for Charlottenlund Palace, the residence of Queen Louisa of Denmark.[6] He also designed dining-room suites in mahogany and sycamore inlaid with brass, and white-

painted chairs in beechwood with aluminum shoes. Smaller household items, such as his stepped square metal plant-stands and candlesticks, are often indistinguishable from those of Hoffmann.

The Wiener Werkstätte's financial difficulties towards the end of 1906 contributed to Moser's decision to leave. He realised that it was impossible to reconcile the extravagant production costs at the workshops with prices that did not go even halfway to covering these costs. As he noted, "Nobody can live that way – except in terms of creating art for the benefit of posterity".[7] On his resignation in 1907, he returned to teaching at the Kunstgewerbeschule and to his career as a painter.

The pre-occupation within the Wiener Werkstätte

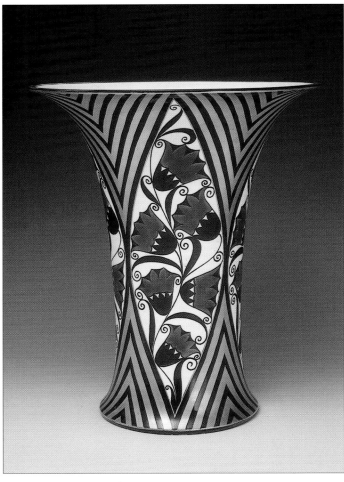

KARL KLAUS (1889-) Austrian
Vase, c.1912. Hand-painted fayence.
Executed by the firm of Ernst Wahliss, Vienna.
Marks: SERAPIS-FAYENCE (stamped) /9646 (etched under glaze).
H: 11in (27.9cm) x D: 9in (22.9cm)

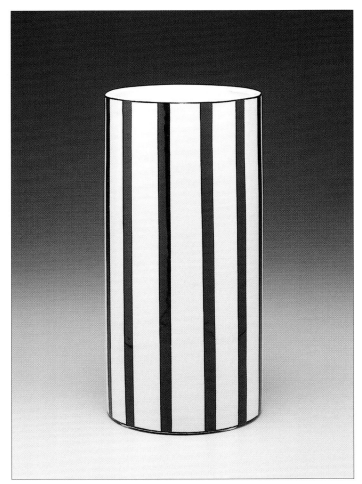

MICHAEL POWOLNY (1871-1954) and BERTHOLD LÖFFLER (1874-1960) Austrian
Vase, c.1906. Glazed ceramic. Designed by Powolny and Löffler for Wiener Keramik/Gmunder Keramik. Marks: Wiener Keramic under glaze.
H: 8 ½in (21.6cm) x D: 4in (10.2cm)

with geometric forms gradually lost momentum after 1905, and by the arrival of Eduard Wimmer in 1912 and Dagobert Peche in 1915 it had virtually disappeared. It was replaced by a less focused range of floral and pictorial ornamentation which had frustrated Moser and contributed to his departure. As he later commented, "To my mind, activities became too diversified, and too dependent on the taste of the patron. Yet mostly the public was not even sure what exactly it did want. These impossible desires of the clients, and certain other differences of opinion, caused me to leave the Wiener Werkstätte…".[8] It was no doubt difficult to try to influence, let alone criticize too severely, the taste of the customers to whom Moser referred; most came from the artists' own circle of enlightened, progressively-minded and financially-secure upper-middle class, the same group to which the workshops later turned for assistance when their financial situation deteriorated further.

Hoffmann and Moser were the co-authors of a work

JOSEF HOFFMANN (1870-1956) Czechoslovakian-Austrian
Sitzmaschine Reclining Armchair, c.1905. Model no. 670. Beechwood and metal. Early example in rare two-tone original finish with adjustable reclining back and cushions. Maker: Jacob & Josef Kohn, Vienna. Marks: original label of J. & J. Kohn on underside.
H: 43 ½in (110.5cm) x W: 32 ⅛in (81.6cm) x D: 25 ¼in (64.1cm)

In 1904 Josef Hoffmann was commissioned to design the Purkersdorf Sanatorium (a nursing home) near Vienna. Purposely designed for patients, this early recliner has both seat and back cushions (the latter removed in order to show the open-square pattern on the hinged back). The cant of the back support may be easily adjusted by a moveable rod which fits between the knobs on the side-pieces. Hoffmann's use of a ball element to strengthen the joints appeared later as a decorative motif in both metalwork and furniture designs. The *Sitzmaschine* was first exhibited in the Vienna Kunstschau in 1908. Several examples are in museum collections, but this model is extremely rare due to its early date and the fact that it was executed in a two-tone finish. Today, the chair is regarded as a modern icon, a timeless fixture of Viennese culture.

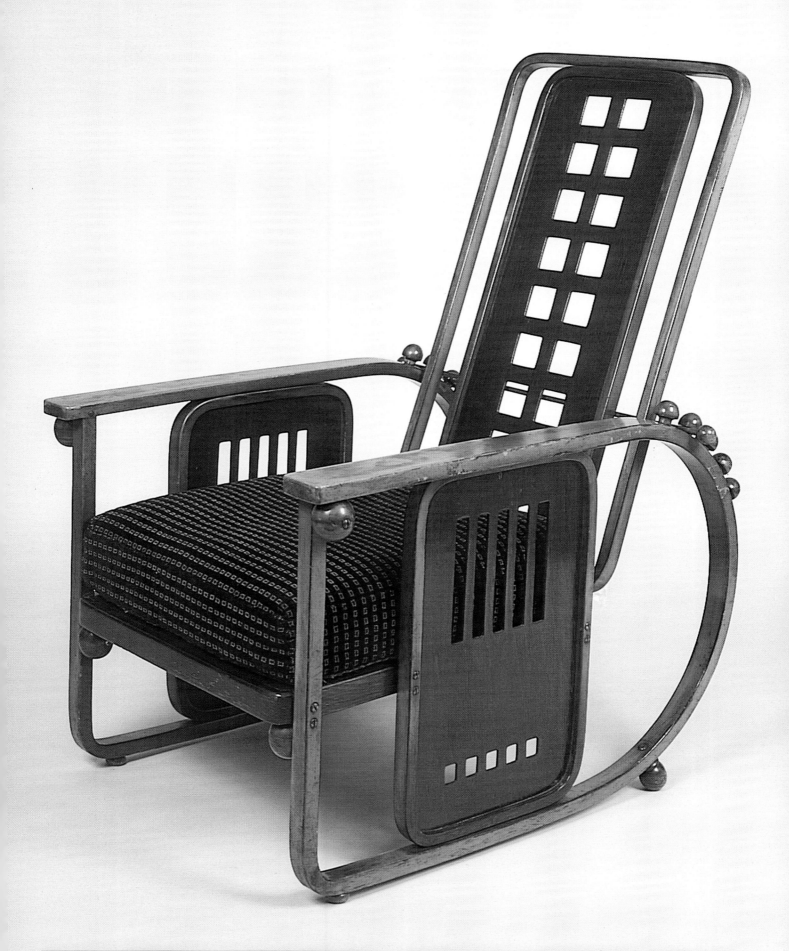

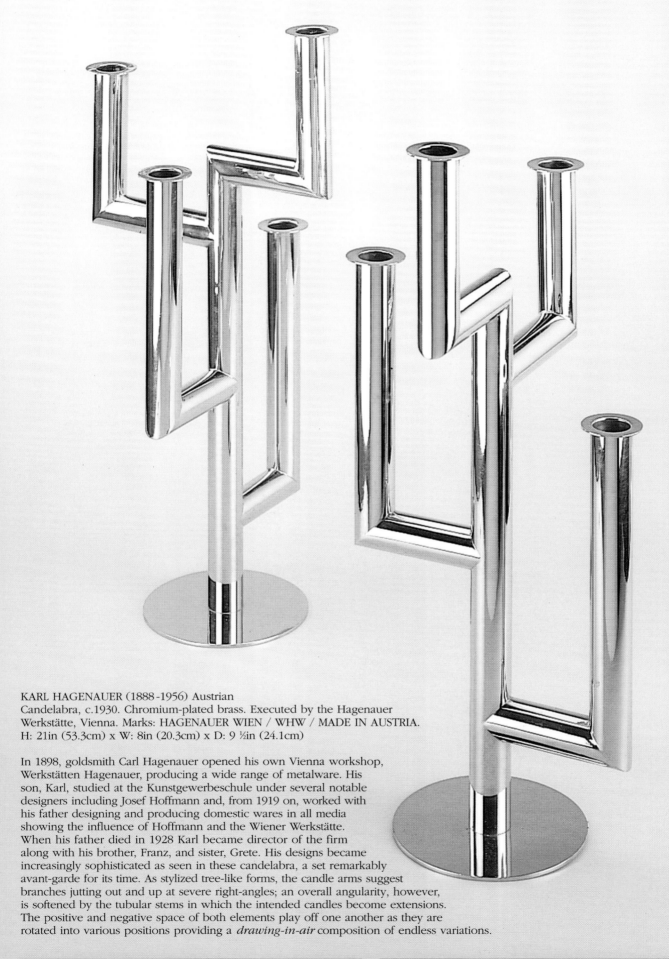

KARL HAGENAUER (1888-1956) Austrian
Candelabra, c.1930. Chromium-plated brass. Executed by the Hagenauer
Werkstätte, Vienna. Marks: HAGENAUER WIEN / WHW / MADE IN AUSTRIA.
H: 21in (53.3cm) x W: 8in (20.3cm) x D: 9 ½in (24.1cm)

In 1898, goldsmith Carl Hagenauer opened his own Vienna workshop,
Werkstätten Hagenauer, producing a wide range of metalware. His
son, Karl, studied at the Kunstgewerbeschule under several notable
designers including Josef Hoffmann and, from 1919 on, worked with
his father designing and producing domestic wares in all media
showing the influence of Hoffmann and the Wiener Werkstätte.
When his father died in 1928 Karl became director of the firm
along with his brother, Franz, and sister, Grete. His designs became
increasingly sophisticated as seen in these candelabra, a set remarkably
avant-garde for its time. As stylized tree-like forms, the candle arms suggest
branches jutting out and up at severe right-angles; an overall angularity, however,
is softened by the tubular stems in which the intended candles become extensions.
The positive and negative space of both elements play off one another as they are
rotated into various positions providing a *drawing-in-air* composition of endless variations.

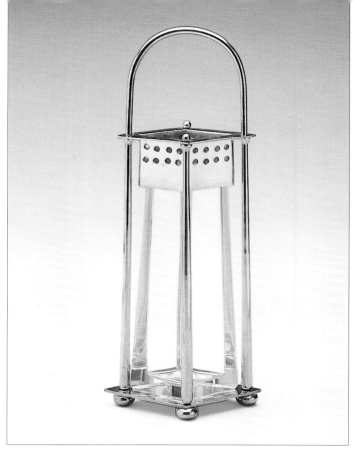

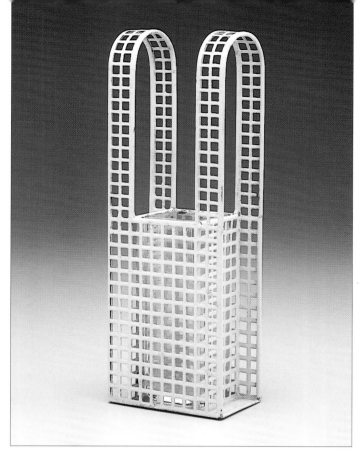

HANS ÖFNER (1880-) Austrian
Budvase, c.1905. Silverplate with glass-panel insert. Executed by
Argentor, Vienna. Marks: *ARGENTOR / WIEN*. Attibuted to Öfner.
H: 9in (22.9cm) x W: 3 ½in (8.9cm) x D: 2 ½in (6.4cm)

KOLOMAN MOSER (1868-1918) Austrian
Bud Vase, c.1904-06. *Gitterwerk* painted metal with glass insert.
Executed by Wiener Werkstätte. Marks: stamped Wiener
Werkstätte on bottom.
H: 8 ½in (21.6cm) x W: 3in (7.6cm) x D: 2in (5.1cm)

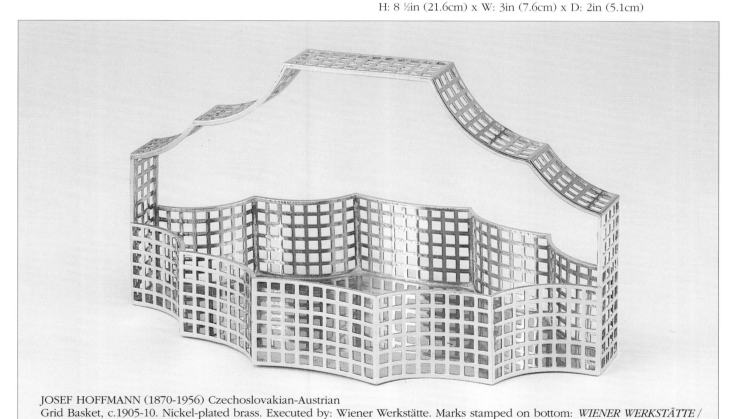

JOSEF HOFFMANN (1870-1956) Czechoslovakian-Austrian
Grid Basket, c.1905-10. Nickel-plated brass. Executed by: Wiener Werkstätte. Marks stamped on bottom: *WIENER WERKSTÄTTE /*
artist's initials / monogram.
H: 6in (15.2cm) (to handle) x W: 10 ¼in (26cm) x D: 5 ½in (14cm)

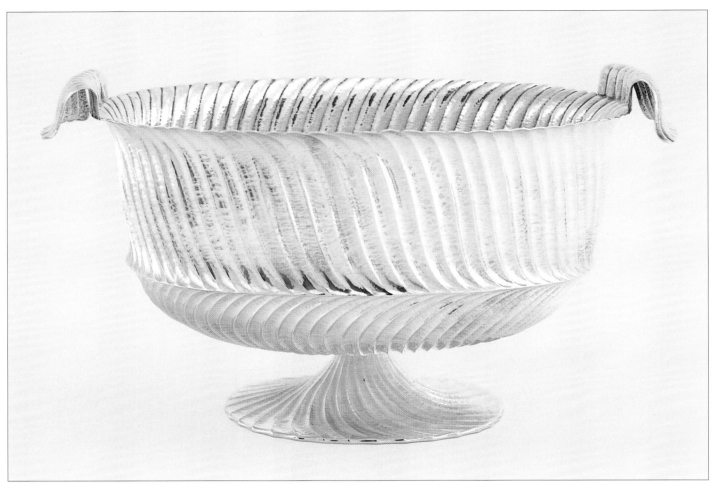

DAGOBERT PECHE (1886-1923) Austrian
Centerpiece Bowl, c.1920. Silver. Manufacturer: Wiener Werkstätte. Marks stamped on base: *Made in Austria / Wiener Werkstätte / DP /*
Silver mark */ 900 / WW / 'rosenmarke'.*
H: 6 ¾in (17.2cm) x W: 11in (28.0cm)

program (manifesto) published in 1905 which stated that the goal of the Wiener Werkstätte was to make work by fine craftsmen equivalent to that of fine artists. In a tone as much a sermon as a sales pitch, the text warned, in part, that:

> "The boundless evil caused by shoddy mass-produced goods, and by uncritical imitation of earlier styles, is like a tidal wave sweeping across the world. We have been cut adrift from the culture of our forefathers and are cast hither and thither by a thousand desires and considerations. The machine has largely replaced the hand and the businessman has supplanted the craftsman. To attempt to stem this torrent would seem like madness. Yet for all that we have founded our workshop. Our aim is to create an island of tranquillity in our own country, which, amid the joyful hum of arts and crafts, would be welcome to anyone who professes faith in Ruskin and Morris".[9]

One of the firm's primary objectives was the translation of the innate moral strength of good design and craftsmanship into one of commercial appeal. At issue was the belief that avant-garde design and middle-class values were partners rather than adversaries. The booklet itself, in its sharp oblong format, typography and graphics, served to impress upon the reader that the workshops were on the cutting-edge of the modern movement.

Although Hoffmann and Moser provided the leadership in design at the Wiener Werkstätte in its early years, they were in effect part of a large and skilled inter-disciplinary team of artist-designer-craftsmen, many of whose achievements have remained unrecognized. Between 1903-06, the workshops were comprised of roughly 100 artisans of whom 37 were masters who were permitted to sign their work. Now difficult to identify, many of these participated also between 1900-14 in the Secessionist movement and/or were associated with the Kunstgewerbeschule.

THÉRÈSE TRETHAN (1879-) Austrian
Tureen, c.1902-03. Glazed porcelain. Manufacturer: Josef Böck, Vienna. Marks on base: *Schule Prof. Kolo Moser.*
H: 7in (17.8cm) x W: 10 ½in (26.7cm) (to handles) x D: 7 ¼in (18.4cm)

In 1900 a course in ceramic techniques was added to the curriculum of Vienna's Kunstgewerbeschule (School of Applied Arts) formally acknowledging the importance of ceramic design and its application to industry. Soon, its active program was instrumental in forging ties between artists and industry through the exhibition of exemplary works and by fostering collaborations between student designers and ceramicists. In fact, the school's chemistry laboratory complemented the artistic innovations of its design department with technical research. Josef Hoffmann and Koloman Moser provided formal instruction; the ceramicists, in turn, executed designs produced by their students such as Thérèse Trethan. Moser was especially active in forming ties with the ceramics industry, and his students reaped the benefits of these connections. Before long, the mark: *Schule Moser* (School of Moser) became something of a brand name and a sign of distinction. The firm of Josef Böck, in particular, showed an unusual willingness to pursue the best in modern design as this tureen clearly demonstrates.

Whereas Hoffmann and Moser provided the designs for the vast majority of the wares produced by the workshops at the time, there were others at various stages of its existence who contributed to its highly distinctive modernist and Austrian look, albeit with less celebrity than their two illustrious peers. Included were Berthold Löffler, Otto Prutscher, Mathilde Flogl, Jutta Sika, Maria Likarz-Strauss, and Thérèse Trethan, who all displayed remarkable interdisciplinary skills. In the 1920s, ceramic production was enhanced on occasion by a trio of gifted designers: Gudrun Baudisch, Susi Singer and Vally Wieselthier.

The diversity of its technical staff permitted the workshops to manufacture works of art in a wide range of materials, including silver, gold and metalware (household appliances and accessories, deluxe goods, and jewelry); graphics (stationery, postcards, posters, wallpapers and books); leather (bookbindings and bags); and textiles (clothes and theater costumes). Objects which the workshops were themselves not set up to manufacture were commissioned out; for example, furniture to the cabinetmakers Thonet or J. & J. Kohn; glass to Julius Bakalowits, Lobmeyer or Meyr's Neffe, and porcelain to Josef Bock's Wiener Porzellan-Manufaktur. The wares of an affiliated pottery cooperative, the Wiener Keramik, founded by Powolny and Löffler in February, 1906, were included in subsequent Wiener Werkstätte

BERTHOLD LÖFFLER (1874-1960) Austrian
Wallpaper Design, c.1908. Color lithograph. Unused sheet.
H: 35in (88.9cm) x W: 19 ½in (49.5cm) // H: 41 ½in (105.4cm) x W: 26in (66cm)

Early Viennese wallpaper design was a natural outgrowth of fabric design requiring a similarly repetitive application of a two-dimensional pattern. Fabrics themselves had, in fact, been used as wall coverings in early Wiener Werkstätte interiors and all of the artists who contributed to the wallpaper collections also designed fabrics. Though wallpaper design was very much part of the British Arts and Crafts revival, it was taken up rather slowly by the Austrians, who considered paper wall coverings lower class. Importantly, wallpaper had a natural bearing on the development of the *Gesamtkunstwerk* (total design) as it related to interior design. This wallpaper sheet of stylized berries and tulips was one of several designed by Berthold Löffler.

sales catalogues.

The Wiener Werkstätte's most spectacular commission, executed between 1904-11, was for a wealthy young Belgian, Adolphe Stoclet, who gave Hoffmann carte-blanche to create a sumptuous modern residence on the Avenue de Terveuren in the Brussels suburbs. Hoffmann spared nothing in providing a showcase for the new workshops. The result was a formal and austere mansion of square block construction sheathed in marble accentuated at the angles with embossed copper moldings. Fine materials and relentless perpendiculars were shown to be as suitable for a dwelling as for a business building. For the interior of the building (which has survived in its original state), Hoffmann deployed the full range of the workshops' design and technical skills. Klimt's dining-room murals, executed in mosaics of marble, gold and semi-precious gems, set the tone for the mood of lavish refinement sought throughout. Other participants included Carl Otto Czeschka, Leopold

DAGOBERT PECHE (1886-1923) Austrian
Kunsthandlung Gustav Nebehay, c.1920. Poster / color lithograph. Marks (signed in print): *D. Peche.*
H: 32 ½in (82.6cm) x W: 20 ⅛in (54cm) // H: 34in (86.4cm) x W: 22 ½in (57.2cm)

Dagobert Peche was appointed manager of the Artist's Workshop for the Wiener Werkstätte in 1915. He had met Josef Hoffmann in 1911, the same year he graduated from Vienna's Academy of Fine Art, and from the start impressed everyone with his creative energy. Contrasted to the studied order of Josef Hoffmann, Peche favored and freely exercised his private fantasies, reviving an appreciation for baroque exuberance. Many of his metalware designs appear as if they had been abandoned in a jungle overgrown with wild vines and exotic fruits. He eagerly explored all areas of design: graphics, the applied arts as well as fashion and theater costumes. This poster was commissioned by Gustav Nebehay, a Viennese art dealer, purposely to announce the posthumous exhibition of Gustav Klimt's working drawings for the famous friezes he later executed for the Palais Stoclet in Brussels.

Forstner,[10] Michael Powolny, Franz Metzner and Richard Luksch.

The Palais Stoclet was the crowning Wiener Werkstätte *gesamtkunstwerk*, the culminating point of the Art Nouveau style in its Viennese incarnation, and one greatly admired subsequently by younger European architects such as Le Corbusier and van der Rohe. Proving conclusively that the Jugendstil movement in architecture was not dependent for its legitimacy on curves, the house provided perfect stylistic unity, a triumph of the geometric principle in its interplay of flat surfaces and delicate proportioning and in the unified furnishings and decoration of its interior.

Following the split in the Secession in 1905, the most progressive wing of Viennese art was left without a regular exhibition space. A solution for this was found in 1908 with the group's decision to participate with the Wiener Werkstätte in the giant year-long Kunstschau exposition. Designed entirely by

Hoffmann in a series of gardens and adjacent buildings, the exposition was intended as an art lesson for the Viennese on how to beautify every aspect of their lives. Shown were the works of 179 artists in 54 rooms, which included displays devoted to theater arts, art for and of children, and a broad selection of the newest creations of the Wiener Werkstätte. The latter revealed clearly that new stylistic influences were coming to the fore at the workshops in the wake of Moser's resignation the previous year. Less prevalent now was the checkerboard symmetry of the early years, its static neutrality supplanted as a source of design inspiration by a fragmented mosaic of densely enriched surface decoration which drew on influences such as embroidered folk art and illuminated mediaeval manuscripts. And whereas this shift was implemented gradually, its impact was clearly noticeable at the Kunstschau exposition to the critics, some who expressed concern that the workshop was now scattering its energies too widely and trivially to win over fashionable clientele.

The transition from the earlier stylistic austerity of Hoffmann and Moser to a new romantic and eclectic individualism was apparently sanctioned by Hoffmann, whose own designs began to blend his previously mannered elegance with decorative accents more compatible with the chubby charm of Powolny's gaily colored Baroque revival ceramic cherubs and Czeschka's phenomenal silver showcase, the latter a technical and artistic *tour de force* encrusted with ivory, lapis-lazuli and other gemstones that took two full years to complete.[11]

The most gifted of the new generation of Wiener Werkstätte designers, Czeschka applied his tightly woven stylizations of sharp-ended curlicues and looping whorls to a wide range of disciplines with mixed success. Whereas his complex compositions for flat works – for example, page layouts and jewelry – were invariably cohesive, these were sometimes too lavish and heavy in their translation on to three-dimensional household objects, where their application was sculptural. Nevertheless, Czeschka created numerous works of arresting beauty in which western logic seemed to yield to a quasi-oriental splendor. In his designs, pattern was an all-consuming gratification of the senses, a progressive and liberating impulse against the ascetic severity of Teutonic classicism. Perhaps bored or frustrated by the respectability now afforded his earlier style, Hoffmann followed suit, although tentatively, in a range of works in which his standard dialogue of surface plane and structural form was abandoned for a more precious and chic (some would say frivolous and banal) grammar of ornament.

The Kunstschau extravaganza marked the end of the first epoch of the Wiener Werkstätte. Thereafter the minor arts in Austria began again to be minor, responding increasingly to bourgeois taste rather than defining it. Yet the firm continued to extend its international reach after 1908 with expositions in Rome, Cologne, Leipzig and elsewhere, and by the participation in its domestic exhibitions of the Deutsche Werkbund, which brought with it German press coverage. In 1914, the year that Waerndorfer left Austria on a one-way ticket to the United States, it became a limited company. Much of the new funding was provided by the firm's customers, who therefore also became shareholders and debtors in a precarious and ever-tightening financial noose.

The arrival in 1915 of Dagobert Peche, at age 29, provided the workshops with fresh impetus and a further stylistic departure. Imbued with an idiosyncratic temperament refined to a point of nervous perversity, Peche's effervescent spiky style became the hallmark of the Wiener Werkstätte look in the teens in poster, textile and exhibition design. His urge to unleash ornament, irrationality and caprice found an advocate in Hoffmann, already under the influence of Czeschka in his search for more elaborate forms of embellishment after a decade of suppressing them. It was Peche, though, who provided the leadership in the new design team in his creation of lacy forms that evoked feminine luxuriance and fairytale imagery, including ivory pagodas, bell-shaped flowers, gushing fountains and forests inhabited by trembling fawns. Peche's style was essentially a mode of filigree best worked on paper, fabrics or jewelry, yet he also concocted objects of supreme rococo whimsicality that in their French flavor and abstract detailing prefigured the high-style Art Deco imagery of the Paris Salons in the early 1920s.

OTTO WAGNER (1841-1918) Austrian
Armchair, c.1902. Model no. 718 F/B. Ebonized beechwood with aluminum sabots and leather.
Made by Jacob & Josef Kohn, Vienna.
H: 30 ⅝in (77.8cm) x W: 22 ½in (57.2cm) x D: 22in (55.9cm)

Yet to receive the full credit he deserves, Otto Wagner was the Nestor of Viennese modernity. Among his students were Adolf Loos, Josef Maria Olbrich, Josef Hoffmann and Leopold Bauer to name a few. By 1900, his architectural office employed a staff of 70, realizing such landmark structures as the *Am Steinhof* church, buildings for the city rail network, the *Die Zeit* Telegram Office and the famous Österreichische Postsparkasse (Imperial Austrian Postal Savings Bank). For the bank, Wagner created an exterior and interior (including all furnishings) which continue to exude modernity.
This chair precedes a variant armchair (1904-06) designed for the bank's boardroom. In the later version, horizontal splats and a wooden seat panel replace the upholstered back and seat. Aluminum strips were also applied to the armrests for added enhancement and protection. The chair form was subsequently produced commercially in several variations by J. & J. Kohn and the rival firm Gebrüder Thonet which likewise produced furnishings for the Savings Bank.

The events that ignited the hostilities of 1914, initiated six years earlier by Austria's annexation of the obscure Balkan states of Bosnia-Herzegovina, caught the nation off-guard and brought to a dramatic halt the prosperity enjoyed in the capital. The death in 1916 of the ageing Emperor Franz Josef served further to stress the fact of an era not merely past but irrevocably destroyed. And within two years the Hapsburg monarchy ceased to exist, leaving Vienna at the head of a drastically shrunken nation, restructured beyond recognition. At war's end, Vienna was the traumatised capital of a new country in the raw, one that had no time to apply itself to anything but survival and reconstruction. In a brief span, a whole world of certainties and new energies had disappeared. The impact on the art community was correspondingly severe. The deaths in 1918 of four modernist giants – Gustav Klimt, Otto Wagner, Egon Schiele, and Koloman Moser – served further to signify the end of Vienna's brilliant stewardship of early 20th century culture.

Inevitably, the Wiener Werkstätte became a casualty of events as demand for its wares fell to a trickle. Yet production rebounded even before the cessation of hostilities, with women filling the place of the male staff who had been mobilized into the military, especially in the fashion cutting rooms. The firm's establishment in 1922 of a New York showroom, under the direction of Joseph Urban, and participation in the 1925 Exposition Universelle in Paris, helped later to restore its international reputation to a pre-war level. Yet quality standards continued to decline and unmistakable elements of kitsch and commercialism marked too many of its wares in the 1920s, even before Peche's resignation in 1923. The firm announced its closure in 1932, at roughly the same time that the initial Bauhaus school and the De Stijl movement passed into history.

In retrospect, it is difficult to call the Wiener Werkstätte a success in the terms that it initially set for itself, that of a marriage of art and industry at the highest level. Citing Ruskin and Morris, its founders envisioned an alliance between collaborative artists dedicated to the notion that handwork was morally fulfilling and an educated and sophisticated cosmopolitan clientele who would value enduring quality over fickle fashion. As such, the goal was the creation of functional objects of grace and quality affordable to a broad spectrum of society. Yet, while the workshops' finest efforts were reserved for one-of-a-kind lavish commissions, the enterprise allowed itself at the other end of the design spectrum to dilute the authority of its *imprimatur* by the production of a considerable volume of trivia.

From a financial point of view, as noted, matters at the Wiener Werkstätte were never particularly rosy. Hoffmann, in particular, incurred significant cost overruns on many projects which he corrected by dipping into the firm's capital resources. The result was that actual production costs on many objects bore no economic relation to market forces. Yet philanthropic art connoisseurs such as Stoclet, Waerndorfer and the Wittgenstein family remained in short supply, leaving the workshops always in search of a new milch-cow to underpin them financially. In comparison with the basic Bauhaus philosophy – that of the creation of good prototype designs for mass-production – the Wiener Werkstätte appeared wed to the concept of the unique handcrafted work of art, an ideal which is risky at the most prosperous of times, but which has no chance at all when pursued during the economic and political upheavals suffered by Austria at the time.

NOTES
1. For a discussion on the *Ver Sacrum*, which made its debut in January 1898, and was in publication for nine years, see *Vienna Moderne: 1898-1918*, exhibition catalogue, Sarah Campbell Blaffer Gallery, University of Houston, Texas, 1979, p.21 ff.
2. Klimt's three murals – Philosophy, Medicine and Jurisprudence – which received widespread censure in part because of their nudity, were bought back from the university by Klimt in 1905.
3. The Beethoven exhibition was the Secession's 14th show. It included a frieze by Klimt and a bust by Klinger of the composer in an installation by Hoffmann.
4. Waerndorfer had commissioned a music room from Mackintosh and a dining room from Hoffmann for his new villa.
5. Hoffmann's Purkersdorf chair (1904) and the "7-Ball Chair" (1905) were manufactured by J. & J. Kohn. For an illustration of the two, see Siegfried Wichmann, *Jugendstil Art Nouveau: Floral & Functional Forms*, Boston, 1984, p.165.
6. The desk is now in the Silverman collection, New York. Illustrated in *Das Interieur* 4, 1904, pp.94-95; and in Alastair Duncan, *Fin de Siècle*

Masterpieces from the Silverman Collection, New York, 1989, pp.168-169.
7. In a letter from Moser to Hoffmann on February 3, 1907, quoted in Werner J. Schweiger, *Wiener Werkstätte Design in Vienna 1903-1932*, London, 1984, p.68.
8. Koloman Moser, "Mein Werdegang", *Velhagen und Klasings Monatsheftie*, Bielefeld & Leipzig, 10, 1916; quoted in *Vienna Turn of the Century Art & Design*, exhibition catalogue, 1979-1980, Fischer Fine Art Ltd., London, p.7.
9. Published in *Vienna Moderne: 1898-1918*, op. cit., pp. 87-89.
10. Biographical information on Leopold Forstner has recently become available; see *VIENNA 1900-1930 ART IN THE HOME*, exhibition catalogue, 16 October 1996 – 18 January, 1997, Historical design, Inc., New York, pp.9-19.
11. The display case is now in the Silverman collection; see *Fin de Siècle Masterpieces from the Silverman Collection*, op.cit., pp.157-162. For views of it at the 1908 Kunstschau Wien exhibition, see Kirk Varnedoe, *Vienna 1900: Art, Architecture & Design*, exhibition catalogue, The Museum of Modern Art, New York, 1986, p.97.

EMMANUEL JOSEF MARGOLD (1888-1962) Austrian
Biscuit Box, c.1925. Painted tin with lithographed design. Marks: stamped *Made in Germany* on bottom.
H: 4 ½in (11.4cm) x W: 8 ¼in (21cm) x D: 5in (12.7cm)

Before joining the Darmstadt artists' colony in 1911, Emmanuel Josef Margold served as an assistant to Josef Hoffmann in the department of architecture at Vienna's Kunstgewerbeschule (School of Applied Arts) where he enjoyed considerable success as an architect-designer. From 1912, he created packaging, window displays and shop fittings for the Hermann Bahlsen biscuit factory in Hanover. His graphic designs were typical of the Viennese decorative style of '20s, many inspired by local flora and fauna.
One of his most striking designs, this biscuit box reflects Margold's early training and experience in architecture. Its silhouette recalls Austrian building contours at the turn of the century, particularly chalets. The all-over applied graphics provide a dazzling rhythmic counterpoint to its stolid architectonic form. Berries, tendrils, flames and chevrons are interwoven into bright patterns inspired by Czechoslovakian and Hungarian peasant motifs of the period.

DE STIJL

1917-1928

The circumstances surrounding the formation of De Stijl were more fortuitous than orchestrated. Above all else, Holland's neutrality during the First World War provided an overriding precondition, as did the fact that Mondrian was stranded there between 1914-19; had he remained in Paris during the hostilities, as he had wished, it is unlikely that the movement would have materialized. In the circumstances, crucial meetings held in 1916 between Mondrian and van der Leck, the friendship that blossomed between van Doesburg and Antony Kok, the poet who became a theorist in De Stijl's cause, and the fact that Vantongerloo happened to be in the Netherlands at the time only because he was a Belgian war refugee, were amongst the random events that coalesced around 1917 to create an atmosphere favorable to the birth of the movement in Holland.

The loosely-knit confederation of artists and architects who merged to form De Stijl shared the same deep-rooted principles concerning art and society, whose union they believed would lead to the ever-elusive goal of a world at peace with itself. From the start, however, the movement was composed of individuals with distinct yet sometimes antithetical viewpoints, who found it mutually advantageous to exchange ideas in a public forum. And although predominantly Dutch and located in the nearby cities of Leiden-Hague and Laren, members were hardly ever in direct contact with each other, relying rather on the group's magazine of the same name to keep them abreast of their colleagues' opinions and developments. From its inception, therefore, De Stijl lacked cohesion and homogeneity: there was no single tenet to which everyone subscribed. It was, rather, a

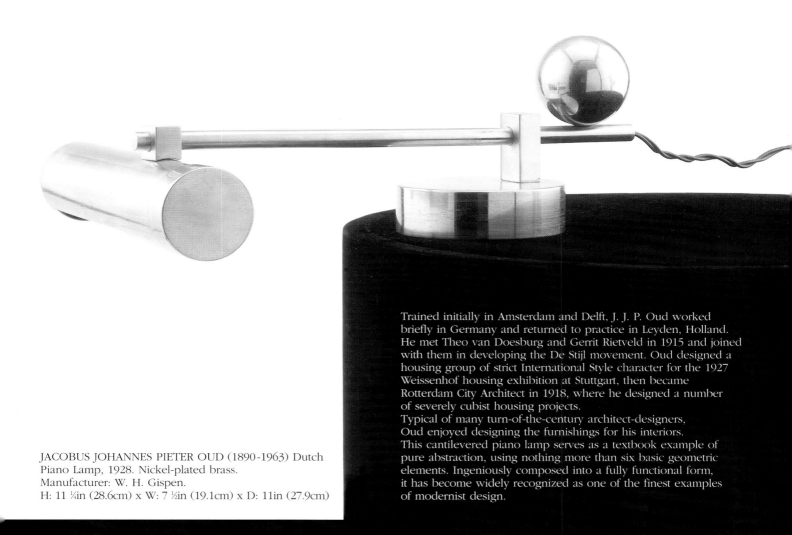

JACOBUS JOHANNES PIETER OUD (1890-1963) Dutch
Piano Lamp, 1928. Nickel-plated brass.
Manufacturer: W. H. Gispen.
H: 11 ¼in (28.6cm) x W: 7 ½in (19.1cm) x D: 11in (27.9cm)

Trained initially in Amsterdam and Delft, J. J. P. Oud worked
briefly in Germany and returned to practice in Leyden, Holland.
He met Theo van Doesburg and Gerrit Rietveld in 1915 and joined
with them in developing the De Stijl movement. Oud designed a
housing group of strict International Style character for the 1927
Weissenhof housing exhibition at Stuttgart, then became
Rotterdam City Architect in 1918, where he designed a number
of severely cubist housing projects.
Typical of many turn-of-the-century architect-designers,
Oud enjoyed designing the furnishings for his interiors.
This cantilevered piano lamp serves as a textbook example of
pure abstraction, using nothing more than six basic geometric
elements. Ingeniously composed into a fully functional form,
it has become widely recognized as one of the finest examples
of modernist design.

movement in a state of constant flux which evolved over time in a manner that reflected the different backgrounds and changing viewpoints and interests of those involved. Not surprisingly, for this reason, it was a relatively short-lived venture, one that remained an active force for barely fourteen years – roughly the same length of time survived by the Bauhaus – in large measure only through the manipulations of its founder and chief protagonist, van Doesburg, an art critic-turned-painter and self-taught architect. In reality, the De Stijl ideal was propelled largely by the work and philosophies of only three principals: van Doesburg, Mondrian and Rietveld. The rest were marginal players in a changing cast.

De Stijl was officially formed in 1917, its founding membership comprised of Piet Mondrian, Theo van Doesburg, Vilmos Huszar (Hungarian painter, ty-pographer and graphic designer), Robert van't Hoff (architect), Bart van der Leck (abstractionist painter), J. J. P. Oud (Rotterdam's chief architect, who however never wholeheartedly associated himself with the group), Georges Vantongerloo (Belgian abstract artist and sculptor), and Jan Wils (architect, who like Oud distanced himself from the group despite an early collaboration with Huszar).[1] Van der Leck, who did not sign the group's first manifesto in 1918, was the first to leave in a disagreement with van Doesburg over the issue of whether architects should be permitted to contribute to the group's magazine. Van't Hoff withdrew the following year, and Oud, Wils and Vantongerloo in 1921. New membership was provided in 1919 by Gerrit Rietveld and in the early 1920s by Cornelius van Eesteren, a Prix de Rome recipient and later chief architect of Amsterdam.

ANTONIUS (ANTOON) KURVERS (1889-1940) Dutch
Tentoonstelling van Nederlandsche Gemeentewerken (Exhibition
of Dutch Municipal Works), 1926. Poster / color lithograph.
Printer: Van Leer, Amsterdam.
H: 38in (96.5cm) x W: 31in (78.7cm) // H: 41 ¼in (104.8cm) x
W: 33 ⅝in (85.4cm)

HENDRIKUS THEODOROUS WIJDEVELD (1885-1987) Dutch
Economisch-Historische, 1929. Exhibition of International
Economic History, Pictures, Miniatures, Tapestries, Documents,
Models, Graphics; City Museum of Amsterdam. Dates are listed.
Poster / color lithograph. Printer: Druk de Bussy, Amsterdam.
H: 42 ¼in (108cm) x W: 30 ⅝in (77.8cm) // H: 29 ½in (74.9cm) x
W: 26in (66cm)

Entitled *De Stijl* (i.e. "The Style") the group's
magazine was inaugurated in October, 1917, in Leiden,
with van Doesburg as editor. Published monthly, it
remained the vehicle by which van Doesburg
propagandized the movement, and ceased only after
his death in 1931 (a commemorative issue, edited by
his widow, appeared in 1932).[2] The fact that the title of
the magazine was prefaced by the word *De,* i.e, *The*
Style, suggests an assertive quality, or moral
imperative, that indicates that its members felt that the
movement was the best, if not the only, means by
which to fuse art with life and, thereby, to effect a
means of social reform.

It is important to note at this point that the utopian
vision pursued by the De Stijl movement often varied
little, if seemingly at all, from those espoused by other
vanguard art movements at the time. Often, only
obscure differences in emphasis, perhaps cultural or
political, distinguished the goals for society of one

GERRIT RIETVELD (1888-1964) Dutch
Red-Blue Chair. Original design, 1917-18. Deal wood and
plywood with ebony aniline dye. Back, seat and terminals
lacquered in red, blue and yellow. Executed by: G.A. van de
Groenekan (fabricator of original design), c.1974. Marks branded
(underneath seat): *H.G.M. / G. A. v.d. GROENEKAN / DE BILT
NEDERLAND.*
H: 40in (101.6cm) x W: 20 ½in (52.1cm) x D: 27in (68.6cm)

The earliest version of this chair, made in 1917-18, was unpainted
and included side panels. It was conceived on a grid pattern with
a basic unit of ten centimeters and reportedly was the first
documented object to embody the principles of the De Stijl
movement. Soon after designing the prototype, Rietveld altered
its scale by reducing the lintels and removing the side panels; he
also applied the colors which give the chair its name.
Of approximately 75 objects within Rietveld's oeuvre, the *Red-
Blue* chair undoubtedly ranks among the most original, and
certainly is the most well known. The design stands as a three-
dimensional realization of the philosophy of the De Stijl
movement. Today it has become, along with the paintings of
fellow countryman Piet Mondrian, an icon of modernity.

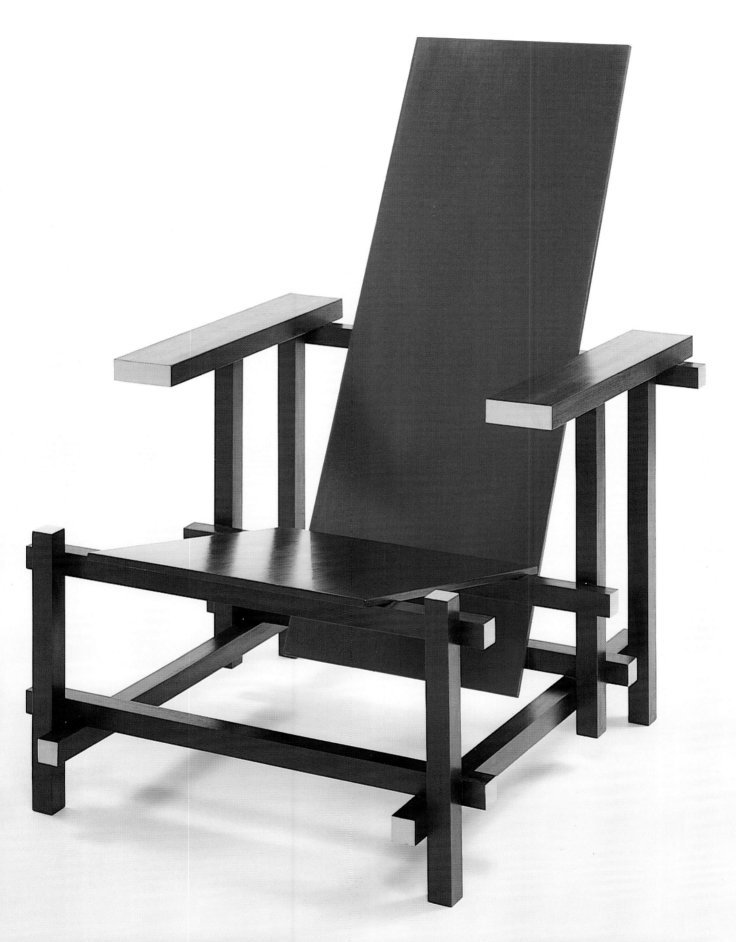

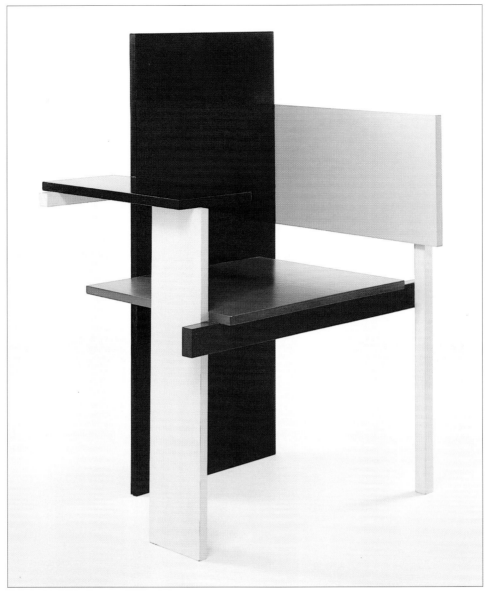

GERRIT RIETVELD (1888-1964) Dutch
Berlin Chair. Original design, 1923. Mahogany plywood, linden ash. Painted black, white
and three shades of gray. Executed by: G.A. van de Groenekan (fabricator of original
design), c.1974. Marks branded (underneath seat): *H.G.M. / G.A. v.d. GROENEKAN / DE
BILT NEDERLAND*.
H: 42in (106.7cm) x W: 28 ¾in (73cm) x D: 23in (58.4cm)

group from another. The De Stijl manifesto therefore drew the allegiance of a host of European fellow travellers, if only fleetingly, each with his own interpretation of how best to create universal harmony in the wake of the social upheaval generated by the First World War and the nascent Russian Revolution. In the perception that capitalism and bourgeois individualism were at an end lay the hope for a new egalitarian start for mankind.

Notable amongst those with related tendencies to De Stijl, and whose careers touched at some point on the movement, were the Italian Futurist Gino Severini, the German Dadaist Kurt Schwitters and Expressionist Bruno Taut, the Dutch graphic artist Piet Zwart, the Austrian architect-sculptor Frederick Kiesler, and the Russian Supremacist El Lissitzky, the last-mentioned who in the early 1920s created PROUN, an acronym for Pro Unovis, i.e., the unification of art and life.[3] In a non-political context, the impact of Frank Lloyd Wright's architecture likewise provided De Stijl architects with a profound seminal influence following the publication in 1910 and 1911 of the two Wasmuth volumes on his work. Van't Hoff and Wils, in particular, showed a strong Wrightian influence in the manner in which they approached the concept of spatial continuity in their interiors.

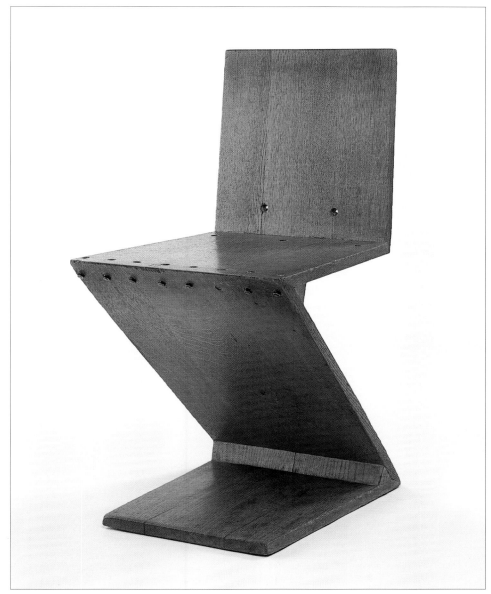

GERRIT RIETVELD (1888-1964) Dutch
Zig-Zag Sidechair, 1939. Original design, 1934. Natural oak with brass fittings. Executed by:
G.A. van de Groenekan (fabricator of original design) for private commission.
H: 27 ¾in (70.5cm) x W: 14 ⅝in (37.1cm) x D: 14 ⅝in (37.1cm)

The De Stijl movement existed for roughly fourteen years, during which it underwent three basic phases of evolution; those of 1917-21, 1921-25, and 1925-31.

In the initial stage, the De Stijl painter found himself subordinate to the architect, his contribution in joint projects limited to the introduction of color to highlight or camouflage surfaces already defined by the architect. The architect's traditional dominance therefore infringed on the painter's freedom to define the form and dimensions of his compositions, a disparity which the painter blamed on the *retardaire* traditions of architecture compared to modern painting. The same restrictions applied, of course, to

projects in stained glass and mosaics. The issue, which was rigorously and endlessly debated in correspondence between members of the group and in its magazine, was never resolved fully to either side's satisfaction. Vantongerloo felt it necessary even to remind readers that he was an artist, not a housepainter *per se*!

The balance shifted in the early 1920s as painters recognized their ability to effect a new kind of abstract space through the use of color. 1921-25 became the group's period of maturity, one in which many of its most significant projects were realized, both individually and in collaboration. The 1923 exhibition

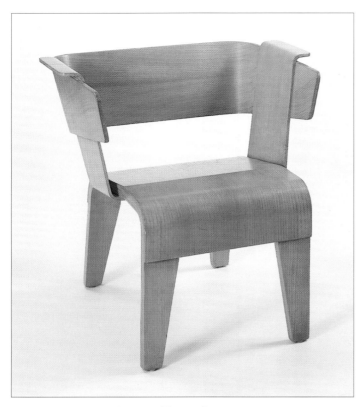

GERRIT RIETVELD (1888-1964) Dutch
Danish chair, c.1949-50. Birch-faced molded plywood and
chromium-plated steel glides. Manufacturer unknown.
H: 24in (61cm) x W: 25 ⅜in (63.6cm) x D: 21 ½in (54.6cm)

in Paris by van Doesburg and van Eesteren at Leonce
Rosenberg's Galerie de l'Effort Moderne served, in its
dynamic asymmetrical arrangement of articulated
elements and colors, to signify for the international art
community the legitimacy of the group's neoplastic-
architectonic manifesto.

The final phase, 1925-31, saw the alienation of
architects and painters and the subsequent disavowal
by both of the validity of collaborative work. De Stijl
architects stressed the functional aspect of their
profession, often prohibiting any color at all. Painters,
conversely, tended to disregard physical structure
while concentrating on color as the means to
formulate their abstract concepts of environmental
design. By the late 1920s the original notion of De Stijl
as a group of like-minded professionals ceased to have
any significance; surviving members began to sever
their ties to the movement and its magazine and editor.
And soon the designs of Huszar, van der Leck and
Zwart, amongst others, were only tangentially related
to their earlier abstract work. Ultimately, however,
rejection came from the public itself, which was

BART VAN DER LECK (1876-1958) Dutch
Shopping Bag, c.1935. Two-color lithograph. Designed for Metz &
Co., Amsterdam and The Hague.
H: 9 ¼in (23.5cm) x W: 9 ¼in (23.5cm) // H: 18 ¾in (47.6cm) x
W: 18in (45.7cm)

unable ever fully to comprehend or tolerate the
austere and esoteric conceptions inherent in the De
Stijl doctrine, especially those relating to the challenge
of merging moral and aesthetic ideals to attain a
perfect modern urban environment.

To the movement's detractors, De Stijl's designs were
of an uncompromisingly severe purity, calling for
drastic changes in society as a whole, while stifling the
self-expression of the individual who, amongst other
adjustments to his lifestyle, would have to endure the
conformity of De Stijl living and work spaces. As
agents of social reform, therefore, the movement's
goals remained both unrealistic and unrealized.

The ultimate disintegration of De Stijl came on the
death of van Doesburg, at age 48, in a sanatorium in
Davos, Switzerland. Of the original group, only
Mondrian continued to paint in a De Stijl-like manner,
although he had formally withdrawn from the group in
1926 in protest after van Doesburg introduced
diagonals into his compositions.

At this point consideration must be given to the word
"Neoplasticism", which originated from a term coined
by the Dutch theosophist, Dr. M. H. J. Schoenmaekers,
in his article "The New Image of the World" published
in 1915, "Gradually art is purifying its plastic means
and thus bringing out the relationships between them
(i.e., between figurative and non-figurative). Thus in
our day two main tendencies appear: the one
maintains figuration, the other eliminates it. While the
former employs more or less complicated and
particular forms, the latter uses simple and neutral
forms, or, ultimately, the free line and pure color…
non-figurative art brings to an end the ancient culture
of art… (therefore) the culture of particular form is

approaching its end. The culture of determined relations has begun".[4] Applying the theosophic idea that reality is comprised in essence of a series of opposing forces, Schoenmaekers emphasized the polarity of horizontal and vertical elements, and the importance of primary, i.e., pure, colors within the whole. For mankind to achieve equilibrium in the midst of these opposing forces, he prescribed "a controllable precision, a conscious penetration of reality, and exact beauty".[5]

Schoenmaekers' article, and another that he wrote the following year entitled "Principles of Plastic Mathematics", served to formulate the neoplastic theory defined first in the De Stijl context by Piet Mondrian, in his work during his forced sojourn in Laren in 1915-16.[6]

For Mondrian, neoplasticism represented the reconciliation of the opposing forces at the structural heart of the universe. In order to resolve this duality and thereby to achieve perfect harmony, a neoplastic work could be realised by "the position, dimension, and value of the straight line and rectangular (color) plane".[7] How best to achieve this equilibrium in their work was fiercely debated at the time by Mondrian and like-minded artists. Mondrian expressed his viewpoint in an essay later published in *De Stijl*, "Neoplasticism in Painting", in which he explained his stylistic preference for overlapping color planes over those of van Doesburg and van der Leck, who employed narrow bars of color on a white field.[8]

Central to De Stijl's search for life's essential truths, Mondrian's theories on color and space became the basic methodology and preferred means of artistic expression. Prerequisite was the complete elimination of any reference to objects in nature: compositions had to be unhampered by associations with objects in the real world. Representation had therefore to be banished from art and replaced by an abstract geometric grammar of ornament. Taking the abstractions of Cubism and Futurism to a new non-figurative level, Mondrian opted for a matrix of orthogonal (i.e. right-angled) compositions that were arranged in horizontal and vertical planes, and enhanced by isolated, juxtaposed or overlapping blocks of pure color.

Van Doesburg explained Mondrian's neoplastic credo in the second issue of *De Stijl*: "The modern artist does not deny nature… but he does not imitate it. He does not portray it. He creates a different image of it. He uses it and reduces it to its elemental forms, colors and proportions in order to achieve a new image. The new image is the work of art."

To Mondrian all art, including the De Stijl interpretation, was a stop-gap measure on humanity's road to universal harmony. As he noted, "Art is only a substitute while the beauty of life is still deficient. It

BART VAN DER LECK (1876-1958) Dutch
Horseman, 1919. Poster / color lithograph on paper with stripped-in typography. Possibly printed by the artist. Note knight on horseback as central image.
H: 45 ⅝in (115.9cm) x W: 22in (55.9cm) // H: 53in (134.6cm) x W: 28 ½in (72.4cm)

J. KUYKENS (dates unknown) Dutch
Floor Lamp, c.1930. Six thick glass slabs electrically illuminated
from within and supported by an inverted U-shaped chromed
tubing set into a glass plinth base.
H: 69 ¼in (175.9cm) x W: 15 ⅜in (40cm)(at base) x D: 10in
(25.4cm) (at base)

With the perfection of the incandescent bulb in the 1920s, lighting
became increasingly scientific. Lamp forms as pure abstract
elements began to emerge. That some lighting designers became
known as illuminating engineers is evident in this striking floor
lamp designed by J. Kuykens. Its brazen modernity, both in form
and materials, must have been eyed with some suspicion: Is it an
untold device meant for the scientific laboratory or intended for a
domestic setting?
Echoing the horizontal layered elements of De Stijl and
International Style architects, its tubular steel standards support
solid glass slabs which emit a deep red glow when lit by the central
bulb. It is clearly intended to provide ambient or atmospheric
illumination rather than a directed beam of light. Little to date is
known about the Dutch designer, including his first name, though
several models of this lamp are documented.

will disappear in proportion as life gains in equilibrium".
Today, such a prediction seems naive, at least.[9]

Dr. Schoenmaekers' reference, above, to
"controllable precision" as one of the essential ways
for mankind to achieve harmony, addressed a
philosophy that has always been at the core of the
Dutch attitude to life. The neat network of rectilinear
fields and straight roads, canals and dikes that
intersects the nation's landscape shows the same
preoccupation with fastidiousness and cleanliness as
that enunciated in the De Stijl manifesto. In Holland,
geometric precision has been the means by which
human spirit and inventiveness has triumphed over
nature's caprices and, thereby, achieved for its citizens
an optimum life style. For the exponents of De Stijl,
linear precision provided a similar methodology
through which to control the visual message in their
art. And only through such precision could harmony be

GERRIT RIETVELD (1888-1964) Dutch
Hogestoel, Highback Chair. Original date of design, 1919. Beech,
painted white and blue. Executed by: G. van de Groenekan
(fabricator of the original design), 1955. Marks branded on
underside of seat: H.G.M.G.A v.d. Groenekan De Bilt Nederland.
H: 36in (914cm) x W: 25 ½in (64.8cm) x D: 24in (61cm)

The Hogestoel appeared in print for the first time in the Dutch
publication, De Stijl, no. 12, 1920 as part of a decor designed by
Theo van Doesburg, dated 1919. The same chair was later placed
by Rietveld in a clinic at Maarssen (1920) but without the two
original side panels.
This particular model was said to have been shown at the seminal
Bauhaus exhibition of 1923, though there is some controversy
surrounding the matter. Most scholars today believe that though it
had been promised for the show, it was never sent. In any case,
there are many analogies which may be drawn between De Stijl
philosophies and the basic tenets on which the Bauhaus
movement was founded. The chair's form also has many affinities
with Russian Constructivism, characterized by planar elements
seemingly floating in space.

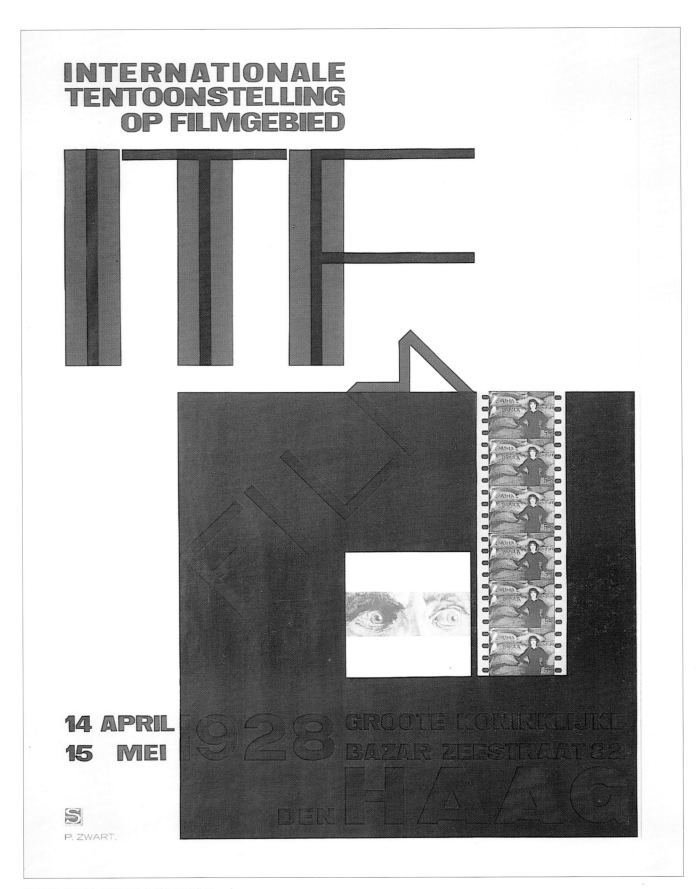

PIETER (PIET) ZWART (1885-1977) Dutch
ITF, 1928. Poster / color lithograph. Printer: M.V. / J.S. Strang & Co., Drukkerijen, The Hague.
H: 42 ⅛in (107.3cm) x W: 30 ⅝in (77.8cm) // H: 48in (121.9cm) x W: 36 ¼in (92.1cm)

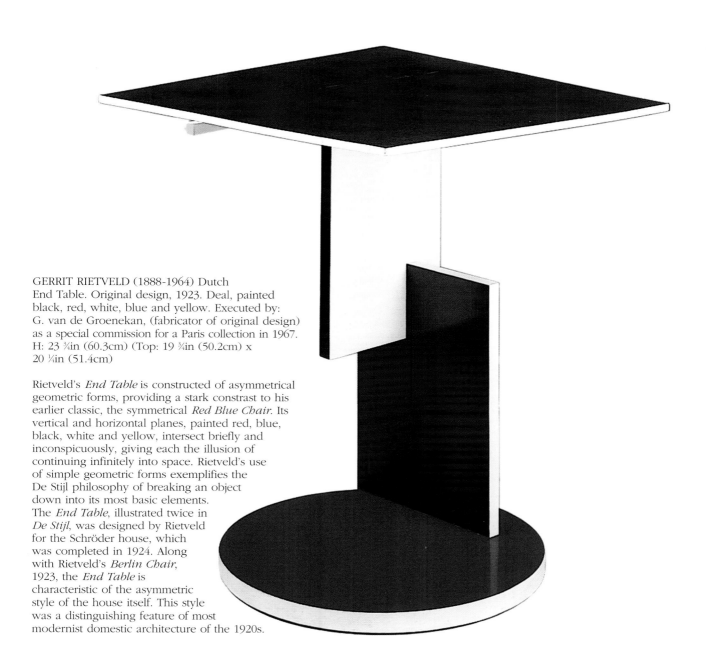

GERRIT RIETVELD (1888-1964) Dutch
End Table. Original design, 1923. Deal, painted
black, red, white, blue and yellow. Executed by:
G. van de Groenekan, (fabricator of original design)
as a special commission for a Paris collection in 1967.
H: 23 ¾in (60.3cm) (Top: 19 ¾in (50.2cm) x
20 ¼in (51.4cm)

Rietveld's *End Table* is constructed of asymmetrical
geometric forms, providing a stark constrast to his
earlier classic, the symmetrical *Red Blue Chair*. Its
vertical and horizontal planes, painted red, blue,
black, white and yellow, intersect briefly and
inconspicuously, giving each the illusion of
continuing infinitely into space. Rietveld's use
of simple geometric forms exemplifies the
De Stijl philosophy of breaking an object
down into its most basic elements.
The *End Table*, illustrated twice in
De Stijl, was designed by Rietveld
for the Schröder house, which
was completed in 1924. Along
with Rietveld's *Berlin Chair*,
1923, the *End Table* is
characteristic of the asymmetric
style of the house itself. This style
was a distinguishing feature of most
modernist domestic architecture of the 1920s.

achieved; images of representational art had shown themselves to be ineffective in this pursuit. To contemporary critics, the movement's artistic purity was therefore readily perceived to be synonymous with Dutch puritanism.

From its inception, the main irreconcilable issue within De Stijl was that of the relationship intended in the group's manifesto between architects and painters.[10] Van der Leck, in an early collaboration with Berlage, the leader of the Amsterdam school of architecture, noted that the two disciplines performed essentially different functions, and that they should not therefore infringe on each other's domains. At the beginning, at least, it was the painters who felt subordinate as they were dependent on the architects for adequate flat wall spaces, which they felt were invariably denied them. Architects, predictably, saw themselves as the masters of

the spaces they created. In attempting to contain the skirmishes that arose continually between the two factions, van Doesburg exhorted antagonists that no discipline – architecture, painting, stained glass, mosaics, rugs, or whatever – was subservient to another. The goal was the collective effort, the synthesis of every discipline. All were equal in the pursuit of the total work of art, which, in turn, would serve as the blueprint for social reform. Few cared to listen, however; not least Mondrian, who remained committed to easel paintings in the belief that they were independent of their surroundings and therefore of the buildings which housed them.

To protect himself against the possibility that he might have to compromise his work in a collaborative venture, an event in which he felt that the architect would inevitably manipulate the outcome, Mondrian in the

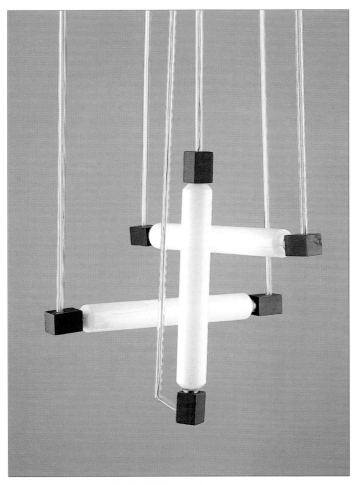

GERRIT RIETVELD (1888-1964) Dutch
Hanging Lighting Fixture. Original design, 1920. Incandescent
glass bulbs and oak base plate painted black. Manufacturer: G.
van de Groenekan (fabricator of original design) as a special
commission for a private collector in Amsterdam, 1976. Marks
(branded stamp on base plate): *H G M v d Groenekan De Bilt
Nederland.*
Hanging size: H: 53in (134.6cm) (adjustable);
Plate: 15 ¾in (40cm) square

early 1920s began to transform his Paris atelier into his
own Neoplastic environment. By attaching movable
pasteboard rectangles of primary and neutral colors to
the walls, he could organize the room into areas of color
and conduct his experiments free of the architect's
propensity to meddle and dominate. The addition of
furniture, likewise painted in primary and neutral
colors, allowed Mondrian to create an entire
environment comprised of a complex, albeit balanced,
grid of colors and planar forms.

The other De Stijl painters likewise experimented
independently with the concepts of neoplasticism, in
most part through the creation of maquettes and
renderings. Yet most, however reluctantly, had to form
unions with architects in order to participate in the
creation of a real environment. In all, a few dozen
painter-architect liaisons came to fruition, most in the
early 1920s. Surviving photographs reveal a host of

similar coloristic and spatial treatments by different
painters in their attempt to assimilate the different
elements of an interior. The intended color
composition on the walls and ceilings had to anticipate
the placement of the furniture within the room to
ensure an integrated and harmonious whole. The
colors on one surface had also to interact satisfactorily
with those on adjacent ones. These and other
considerations, such as the interaction of horizontals
and verticals and of color associations across space,
were analyzed and then revised as the architect
inserted his prerogatives into the equation. As Huszar
explained the process in his article "On the Modern
Applied Arts" (*Over de Moderne Toegepaste Kunsten*),
"plasticising is arranging the spaces and functions
rhythmically and at the same time practically".[11]

Interiors were the embodiment of the De Stijl ideal,
yet in spite of all pretensions by van Doesburg to its
universality, the ironic fate of the De Stijl interior was
that it existed mostly for exhibition purposes and was
subject therefore to much the same treatment as the
movement's easel paintings, which could be taken off
the wall and stored as the need arose. Unlike the latter,
however, most of the interiors that were realized were
dismantled or destroyed when tastes or circumstances
changed. So with rare exceptions these interiors are
today known only through contemporary descriptions,
black and white photographs, preliminary sketches, or
recent reconstructions.

One of the first De Stijl collaborative interior ventures
was between van Doesburg and Oud for the "De
Vonk" holiday residence that the latter was
commissioned to build in Noordwijkerhout in 1917. In
addition to the designs of a series of glazed ceramic
brick mosaics on the exterior facade of the house, van
Doesburg created tiled brick floor patterns and a
different sequence of colors for each of the ten
wooden doors on the upper floor. For these,
combinations of white, gray and black were
interchanged to define the structural elements of each
differently, including its central flat plane and bands of
outside moldings. In the same year, van Doesburg
collaborated on the De Lange townhouse designed by
Wils in Alkmaar. Here, van Doesburg contributed a
triptych stained glass panel with flat planes of color
inspired by a theme from a Bach fugue, which he had
calculated to be a mathematical mode of musical
expression corresponding precisely to his own
rectilinear graphic style. The window was comprised
of a palette of primary and secondary colors (violet,
green and orange), plus black, in an asymmetrical but
balanced pattern which contained subtle variations in
color and composition that bore comparison to the
rhythmic cadence of a fugue. Utilized in this manner,
stained glass was perceived by De Stijl members as a
medium midway between painting and architecture,

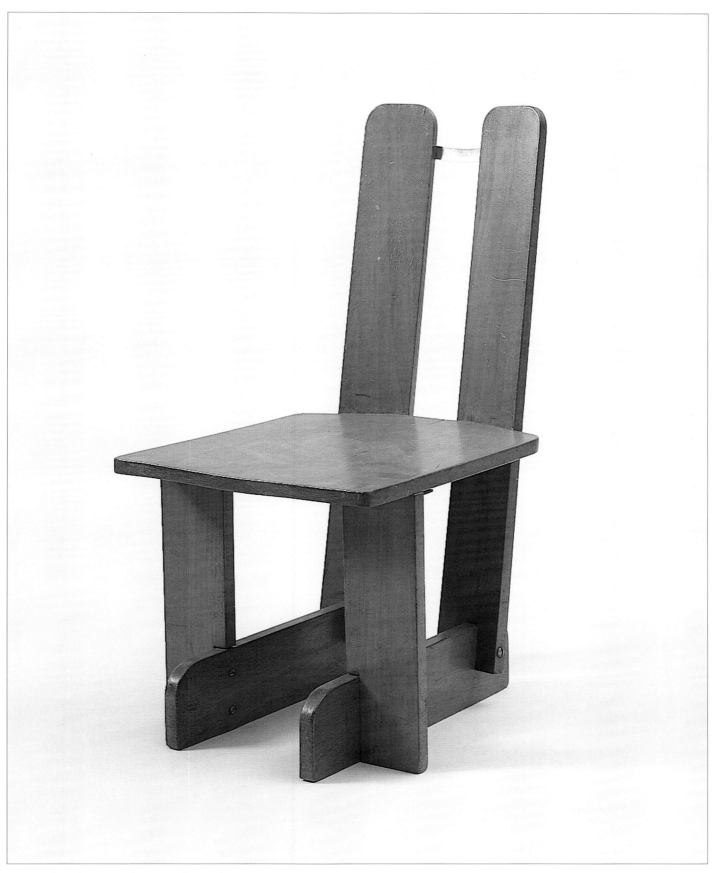

PIETER (PIET) ZWART (1885-1977) Dutch
Chair, 1935. Wood with metal clasp strengthener. Designed for Montessori School, Wassenaar, Germany.
H: 26in (66cm) x W: 12½in (31.8cm) x D: 14in (35.6cm)

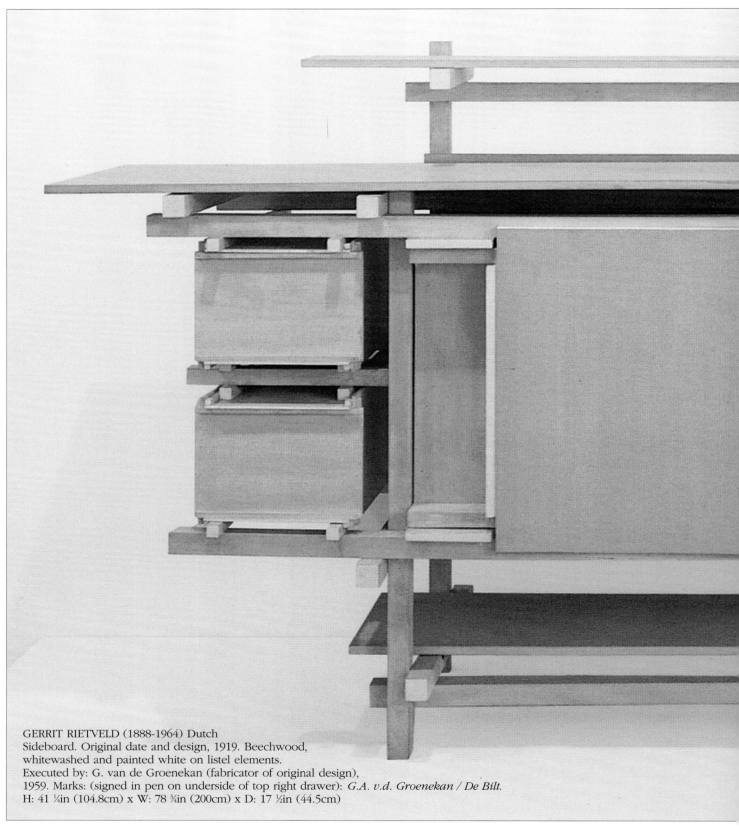

GERRIT RIETVELD (1888-1964) Dutch
Sideboard. Original date and design, 1919. Beechwood,
whitewashed and painted white on listel elements.
Executed by: G. van de Groenekan (fabricator of original design),
1959. Marks: (signed in pen on underside of top right drawer): *G.A. v.d. Groenekan / De Bilt.*
H: 41 ¼in (104.8cm) x W: 78 ¾in (200cm) x D: 17 ½in (44.5cm)

One of the most important works to be identified with the De Stijl movement, this sideboard regrettably survives only in a series of subsequent issues. The original, thought to have been executed in oak, was destroyed in a fire. It was first purchased by the architect, Piet Elling, who was an admirer of Rietveld's work.
As a composition in the planar elements, the sideboard was designed along more traditionally functional lines than Rietveld's more familiar chairs. Even so, the overall design was no less revolutionary and still looks fiercely modern in its starkness. In this piece, especially, Rietveld achieves the De Stijl edict of *weightlessness* by the masterful use of open spaces and by highlighting the listel ends

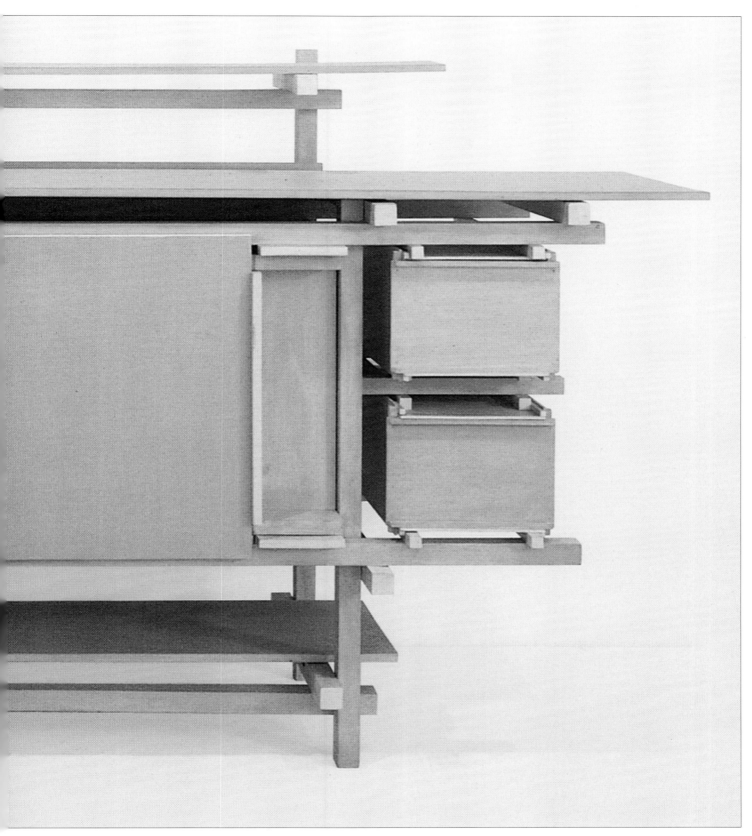

with white. The form appears to float, space seems to continue through it rather than being blocked by its presence. Its strong horizontal emphasis, symmetry and rectilinearity are the very ingredients which Frank Lloyd Wright, among others, incorporated into prairie school architecture.

Approximately ten sideboards were executed by van de Groenekan, who made all of Rietveld's furniture – most were done in the 1960s. His first attempt to duplicate the original was executed with Rietveld's assistance, and is in the collection of the Stedelijk Museum, Amsterdam. This sideboard was the second to be completed.

PIETER (PIET) ZWART (1885-1977) Dutch
Homage to a Young Girl, 1925. Edition of 50. Letterpress. A typographical experiment: composition based on the four
letters of the artist's first name, Z for Zwart, and the date. Marks: signed, lower right.
H: 9 ½in (24.1cm) x W: 6 ⅝in (16.8cm)

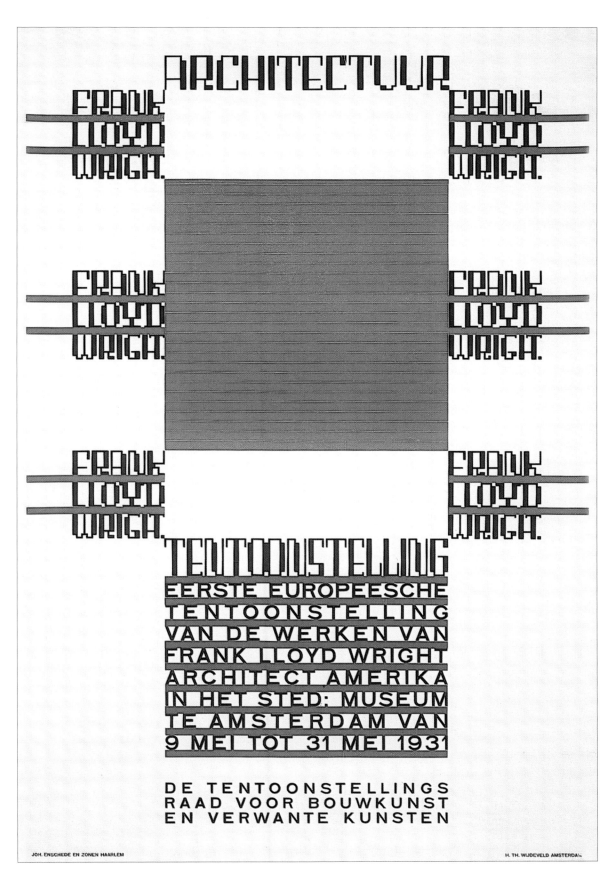

HENDRIKUS THEODOROUS WIJDEVELD (1885-1987) Dutch
Architectuur / Frank Lloyd Wright, 1931. Poster / color lithograph. Printer: Joh Enschede en Zonen, Haarlem.
H: 30 ½in (77.5cm) x W: 19 ¾in (50.2cm) // H: 37in (94cm) x W: 25 ½in (64.8cm)

one that incorporated conventional elements of both.

The Schröder house on the outskirts of Utrecht is the only extant De Stijl structure. Designed in 1924 by Rietveld for Mrs. Truus Schröder-Schrader, the building stands at the pinnacle of the movement's mature architectural style, one whose identity is determined by a carefully managed interplay of spaces, planes and colors. The most conspicuous aspect of the house is the independence of its various parts, which is achieved by sliding panels that enable the inhabitant to determine the preferred sizes and shapes of each living space. For example, the only set rooms on the upper floor are the bathroom and stairwell; the rest of the space is comprised of a large open area that can be subdivided into a series of rooms to meet the specific needs of the home-owner. Linear combinations of primary colors, accented with neutral white, gray and black, help to delineate and enhance the interior's spatial and planar elements. The house's open transformable plan served to exemplify many of the elements in the 16-point program which van Doesburg outlined in "Towards a Plastic Architecture":[12] the goal of a new form of architecture with open skeletal construction free of encumbering walls, one that was elementary, functional and without precedent.

A collaboration completed in 1928 between van Doesburg and Sophie Taeuber-Arp and the sculptor Jean Arp produced another definitive expression of De Stijl aesthetic principles, that of the cafe L'Aubette in Strasbourg (destroyed shortly afterwards). Van Doesburg's contribution was a series of astounding colorist interiors that had to be fitted into the building's 18th century floor plans, a feat perceived by some of his peers as a clear victory for the painter over the architect. A year later, the house which van Doesburg designed for himself in Meudon, France, provided another landmark De Stijl commission in its formation of the interior into a spatial continuum. Van Doesburg's most ambitious project, but one unrealized, was his expansion plan for the city of Amsterdam, between 1928-34, in which he applied the principles of De Stijl to urbanism.

Enshrined today in furniture-making's pantheon for his design of one particular chair, Gerrit Rietveld (1888-1964) began his apprenticeship in his father's cabinetry shop at age eleven, i.e., on the eve of the new century. At the time, most cabinetmakers in Holland preferred a pre-industrial style and manner of furniture construction, with emphasis given to simply expressed rectilinear forms made of modest but solid materials. Rietveld was one of many Dutch artisans greatly influenced at the time by the English Arts and Crafts movement, and he remained essentially an artist-craftsman throughout his career, rather than an artist-as-intellectual, like most of the other De Stijl members.

At age 20, Rietveld attended architectural night classes, supplemented later with courses under P. J. C. Klaarhamer, an associate of H. P. Berlage. In 1911, he set up his own cabinetry shop in Utrecht, but there was little in these formative years to anticipate his startlingly innovative chair design of 1917, the prototype of the so-called Red/Blue chair (*Rood/Blauwe stoel*), which underwent modifications in form and color in the next several years as Rietveld pared away superfluous components, including the original side panels. Historians have speculated at length on the motivation for the chair's radical form, some feeling that the seeming drive to self-destruction by mankind during the First World War served in part as a catalyst for Rietveld who, like others, sought drastic solutions within his field – extreme times call for extreme measures – as a remedy for civilization's ills. Even so, the chair's seminal design caught the art community entirely off guard. The scholar Sigfried Giedion later noted its impact, "as in painting and architecture, it was necessary temporarily to forget everything and begin afresh, as if no chair had ever before been built".[13]

Composed of thirteen equilateral struts (described variously in De Stijl literature also as lintels, listels, lathes, and spars) that touch but do not intersect, and of two broad planks set diagonally within them, the Red/Blue chair is essentially a De Stijl treatise on the displacement of space, a concise intellectual interpretation in open three-dimensional form of Mondrian's philosophy on neoplasticism. Left unpainted until after 1919, the final version contained a red backrest, blue seat and black lacquered struts with bright yellow squared-off terminals. Rietveld later described the chair conceptually as "made of two boards and a number of lathes... made to the end of showing that a thing of beauty, e.g. a spatial object, could be made of nothing but straight, machined materials".[14]

Although criticized by some observers as severe and uncomfortable, the chair's simple repertory of shapes and colors belies its daring originality, one which quickly propelled it into the hierarchy of early 20th century design classics. Suddenly, furniture, a member of the minor decorative arts, was elevated from its subsidiary role in design to one of parity with architecture.

Rietveld designed roughly 75 pieces of furniture, most between 1917 and 1934. Several of these, in addition to the Red/Blue chair, warrant mention for their attempt to reach a satisfactory balance of abstract structural components.

The beechwood sideboard (*dressoirtjie*) of 1919 (see pages 148-149) is a more ambitious architectural work than the Red/Blue chair, in which the designer was confronted with a new set of spatial concepts – ones at

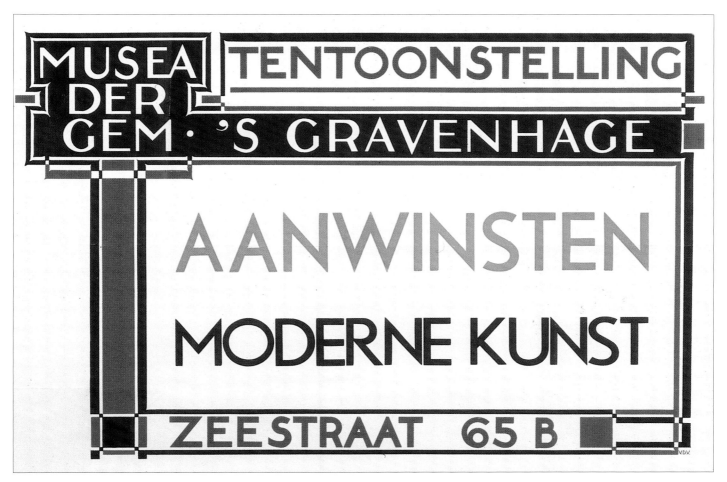

DESIGNER UNKNOWN (Dutch)
Moderne Kunst, 1925. Poster/color lithograph. Printer: V.D.V.
H: 19in (48.3cm) x W: 25in (63.5cm) // H: 25 ¾in (65.4cm) x W: 32in (81.3cm)

once more complicated and difficult to accommodate as the piece does not lend itself to linear elements alone, but to considerations of both mass and volume. Rietveld's solution lay in a series of cantilevered horizontal planes that, like the chair, bears his unmistakable stylistic *imprimatur* in its search for a logical breakdown of three-dimensional space. The piece's strong horizontal emphasis, with its exaggerated overhangs and post-and-lintel construction, finds a ready comparison in Wright's Prairie-school houses of the early 1900s.

Rietveld's Berlin chair (*Berlijnse stoel*) of 1923 was conceptually far more sophisticated than the sideboard (see page 138). Designed for the model room which Huszar and he displayed at the Greater Berlin art exhibition that year, the chair represents the designer's most abstract and compact composition, one composed only of three asymmetrical planar elements: the large black panel that serves both as a backrest and rear leg; the broad black horizontal armrest supported by a slightly narrower white leg panel; and a high pale grey vertical side panel. The chair's architectonic form

evokes the rectangular planes of the Schröder house completed the following year.

Also in 1923, Rietveld designed an end table (*divantafeltjie*) for the living room on the upper floor of the Schröder house. Comprised of five pieces of pineboard painted in five different colors, the table's compatibility with its surroundings was noted by Scott Burton in a 1980 article in *Art in America*: "… it is so satisfying formally, with its slight but sharp displacements, and coloristically. Notice its subtle concentricity of square and circle, its splitting of the vertical support into two not quite equal-size parts, its confinement of primary colors to top and bottom, its simultaneous expression and concealment of structure in the blue rectangle painted over the dovetail joining top and support… Here is a maximally considered object".[15] Like other examples of Rietveld's furniture designs, the end table would be understood best – both visually and intellectually – if viewed in its original integrated setting. Nevertheless, its sharp angularity and delineations of color provide an excellent example of the De Stijl concept in isolation.

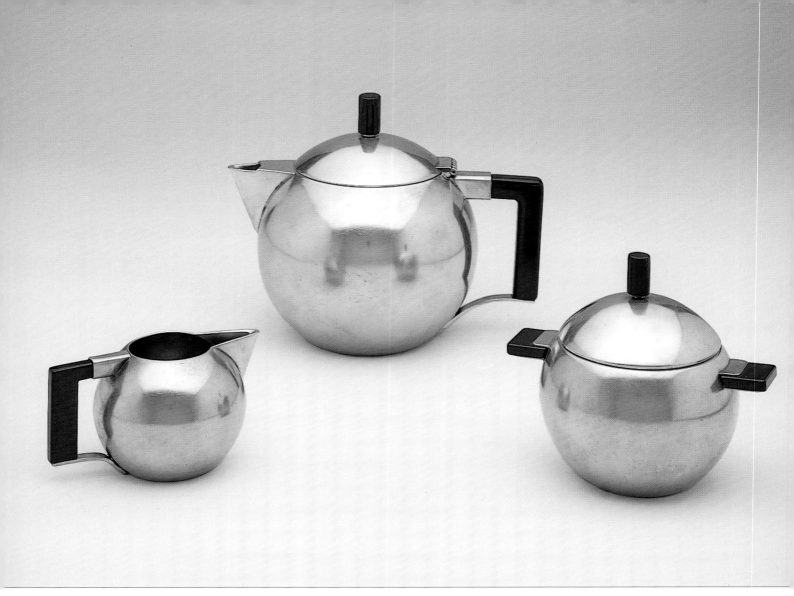

THEODORE HOOFT (1918-1965) Dutch
Teapot with Creamer and Covered Sugar Bowl, c.1930. Pewter. GERO.
Teapot: H: 6in (15.2cm) x W: 7 ¼in (18.4cm) x D: 5in (12.7cm) Sugar Bowl: H: 4 ⅝in (11.7cm) x W: 5 ⅛in (13cm) x D: 4in (10.2cm)
Creamer: H: 2 ½in (6.4cm) x W: 4 ¼in (10.8cm) x D: 3in (7.6cm)

In 1900, the Dutch variant of Art Nouveau (*Nieuwe Kunst*) featured an exotic blend of organic decoration inspired by nature and far-off cultures (Dutch East Indies, Orient and the Middle East) as well as folk art embellishments. In less than fifteen years, a dramatic reversal occurred in The Netherlands with the introduction of stark, planar elements by Gerrit Rietveld and members of the De Stijl movement. It was a rational, intellectual approach to design in which form, proportion and clarity were the hallmarks.

In 1918, a Copenhagen manufacturer producing silverplate and pewter was bought out by Gero, a Dutch firm located in Zeist. Th. Hooft joined the firm that same year and soon became director of the design laboratory. His designs were typically without ornamentation, cost productive and invariably presented few technical demands. At the time this tea set was produced (c.1930), the economy was in decline worldwide. The unadorned, dull patina and squared-off handles were produced at minimal cost – stylistic purity on a shoestring budget – aimed at a deflated market. Quite likely, few sets were produced as it presumably found little favor with a public still preferring Empire and rococo-inspired designs.

The last chronologically of Rietveld's distinctive furniture designs, the Zig-Zag chair of 1934 (see page 139) lacks the abstractions of the Red/Blue and Berlin models, yet its aspiration appears to be the same; once again, to deconstruct the conventional chair.[16] In this, the model's pure sculptural form seems to react against the proliferation of tubular steel and bentwood functionalist designs generated by the International School in the late 1920s, which by 1934 were commonplace, if not hackneyed. G. A. van der Groenekan, a longtime employee in Rietveld's cabinetry shop, who fabricated most of his original designs, reproduced many models of the "Z" chair for private collectors long after they had made their debut

during the De Stijl era. The chair has also been produced since 1971 by Cassina of Milan.

A further Rietveld innovation, one which inspired a host of imitations in Europe throughout the decade, was the hanging lamp (*Hanglamp*) which he designed for the consulting room of Dr. A. M. Hartog, of Maarssen, in 1920. Comprised of four standard Philips tubular incandescent bulbs (a later variant included only three bulbs) suspended on electrical cords in an arresting spatial composition defined by parallels and perpendiculars, the fixture served as the prototype for the model designed three years later by Walter Gropius for his office at the Weimar Bauhaus. In Paris, in the late 1920s, Jacques Adnet applied a similar spartan interplay of lines and angles to a series of hanging and table lamps comprised of frosted tubular bulbs housed in chromium-plated mounts.

Today's observer can view the De Stijl movement with a respect tempered by incredulity. It is now difficult to comprehend the disastrous events surrounding the Great War and the sense of futility and despair that the ensuing political and economic chaos engendered in most Europeans. Certainly it was honorable to search for a panacea for mankind's ills, yet to do so in such an implausible manner – by the promotion of a universal visual language that would subordinate the individual's social and spiritual needs to those of the greater whole – now seems at the very least romantic and ideologically far-fetched. De Stijl was, in effect, like a tiny religion with a proselytizing spirit and core of the faithful. That it was tolerated, even briefly, in such calamitous times indicates that it did not present a threat to the status quo in a tolerant Holland, unlike the Bauhaus, which was perceived in neighboring Germany as an innately subversive entity. Yet if De Stijl seemed to the majority of its contemporaries like a relatively harmless and useless exercise that operated in a vacuum, its goals were sincere and far more grandiose – nothing less than the salvation of mankind, in fact – for which it warrants our attention and appreciation today.

NOTES
1. See Nancy Troy, *The De Stijl Environment*, M.I.T. Press, 1983, p.8 ff, for a discussion of initial collaborations amongst those who became De Stijl members, and p.187 ff for members' work after the dissolution of the movement in the 1930s.
2. Troy, ibid., p.187.
3. Troy, ibid., pp.3-4
4. The inspiration for Mondrian's theories on Neoplasticism, Dr. Schoenmaekers' *The New Image of the World*, was published in the first issue of *De Stijl*, I (1917), pp.2-6.
5. Ibid.
6. Mondrian came into contact with Dr. Schoenmaekers on moving to Laren in 1915, the same year that he began to correspond with van Doesburg.
7. Mondrian's initial theories on Neoplasticism underwent modification as he explored their application. His treatise *Le Néo-Plasticisme: Principe general de l'équivalence plastique*, published on his return to Paris in 1920, provided a summary of the core of his beliefs at that point.
8. For examples of van der Leck's use of this technique, see Rudolf W. D. Oxenaar, "van der Leck and De Stijl 1916-1920", *De Stijl 1917-1931 Visions of Utopia*, exhibition catalogue, Walker Art Center, Minneapolis, 1982, pp.70 and 74.
9. Mondrian discussed the expendability of art in various articles, including "Het Neo-Plasticisme in schilderkunst, bouwkunst, muziek, litteratuur", *Het Vaderland*, October 17, 1924; and "De Jazz en de Neo-Plastiek", *10* 1, 1927, pp.421-427.
10. For a discussion on the confrontation between De Stijl artists and architects, see Sergio Polano, "De Stijl/Architecture = Nieuwe Beelding", *De Stijl 1917-1931 Visions of Utopia*, op.cit., p.87 ff.
11. Huszar, "Over de Moderne Toegepaste Kunsten", *Bouwkundig Weekblad* 43, 1922, pp.75-76.
12. Published on the occasion of the second De Stijl architecture exhibition in Paris in 1924. Point 16 declared architecture to be the synthesis of Neoplasticism, thereby denying the viability of painting and sculpture as separate elements. Architecture's primacy meant that it incorporated all the arts in its very essence.
13. Siegfried Giedion, *Mechanisation Takes Command: A Contribution to Anonymous History*, Cambridge: The Harvard University Press, 1947, p.485.
14. See also Rietveld's reminiscences in 1971 on the Red/Blue chair, quoted in Daniele Baroni, *The Furniture of Gerrit Thomas Rietveld*, London, 1977, pp.42-43; see also the discussion in *Gerrit Rietveld: A Centenary Exhibition*, exhibition catalogue, Barry Friedman Ltd., New York, 1988.
15. Scott Burton, "Furniture Journal: Rietveld", *Art in America*, November 1980, p.106.
16. For a discussion on the Zig-Zag chair, see Paul Overy, *De Stijl*, London, 1991, p.83 ff; for an opposing view, see Martin Filler, "The Furniture of Gerrit Rietveld: Manifestoes for a New Revolution", *De Stijl: 1917-1931 Visions of Utopia*, op.cit., p.135.

BAUH
1919-1933

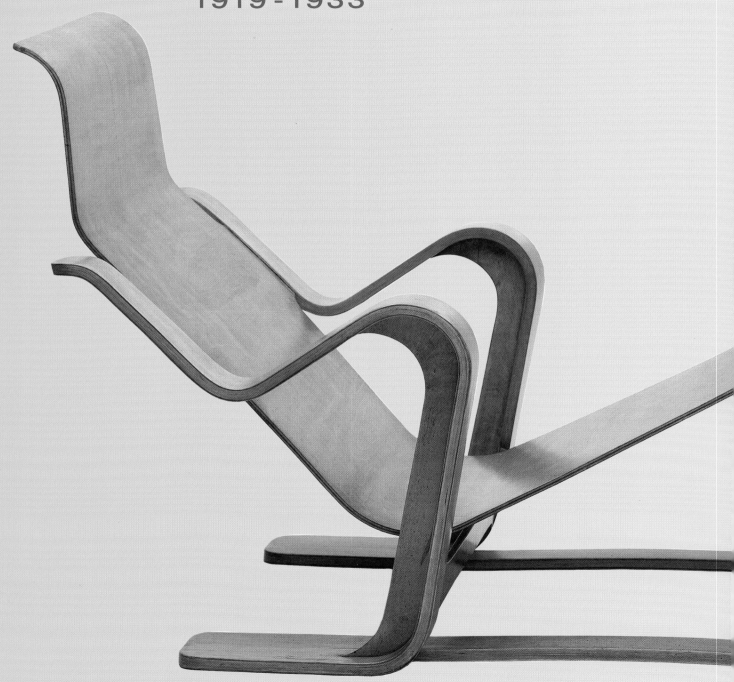

MARCEL BREUER (1902-1981) German-American
Chaise Longue, c.1935. Bent laminated plywood. Made by Isokon Furniture, Ltd., London.
H: 30 ¾in (78.1cm) x W: 56in (142.2cm) x D: 24in (61cm)

A U S

The year 1919 was an inauspicious one to try to start anything in Germany, let alone an art school run along radical, if not revolutionary, lines. Following its defeat, and the abdication of the Kaiser, the country was in chaos, with inflation, hunger and unemployment rampant. Chaotic, too, at its inception was the Bauhaus, plagued by a lack of adequate faculty, facilities, materials and funding, which, in addition to internal feuding and relentless external political attacks, served quickly to stifle its progress and to temper idealism with realism.

Yet during its brief history (1919-33), the Bauhaus left an indelible mark on 20th century design, one whose influence is still felt. All art schools owe a debt to some degree to its study of such issues as how art and craft should be taught, the nature of three-dimensional design, materials, color theory, and the effects that buildings have on those who live in them, questions that are still being asked today and with the same urgency. As Wolf von Eckhardt noted in a 1961 magazine article, the Bauhaus "created the patterns and set the standards of present-day industrial design; it helped to invent modern architecture; it altered the look of everything from the chair you are sitting in to the page you are reading now".[1]

Like other late 19th/early 20th century movements, such as Art Nouveau, the origins of the Bauhaus can be

When the Nazis closed the Bauhaus school in 1933, Marcel Breuer, like so many artist-instructors, fled the country. Urged by his mentor and former colleague, Walter Gropius, he soon emigrated to England. Gropius was acting as a consultant for the London firm Isokon (a contraction of Isometric Unit Construction) which specialized in modern furniture constructed of laminated plywood. Breuer was invited to design a variant of his successful spring aluminum recliner first produced in 1932. The conversion of the design into plywood met with technical difficulties from the start and ran through numerous models and modifications in the first years of production, 1935-36.

The materials and form of all Isokon chairs were intended to suit traditional English tastes. This chaise-longue in particular is sculpted to fit the human body, one of the first to do so in an organic manner and, as such, a forecast of the biomorphic designs to follow in the 1940s and '50s. Breuer designed five pieces for Isokon, all forming some of his most important works in bentwood. They continue to rank among the signature pieces of Modernism.

traced to the issues at the heart of the crusade launched by William Morris in the mid-1800s against the Industrial Revolution, issues that are addressed more fully in other essays in this volume. Suffice it to note here that Morris's vision of an obsolete cottage-industry system of handicrafts as the means by which to salvage mankind from the innate evils of the machine brought about one of the very things that he was trying to prevent: the gradual isolation of the individual artist-craftsman from the marketplace, where the prices of his handmade wares were undercut by those manufactured by machine. Thanks to the rapid progress made in engineering technology in the early Victorian era, steam-driven engines, lathes and looms could soon stamp, cut and fashion almost any substance faster and with more consistency than the human hand. The inexorable progress of the machine could not therefore be halted by Morris's idealized vision. Mechanized production translated into lower prices and higher profits, the latter which served to spur on an expanding entrepreneurial class.

Clearly, it was the artist and craftsman, rather than the machine, whose futures were endangered, yet both continued to learn their trades as if the Industrial Revolution had never happened; artists continued to be instructed in the refined atmosphere of the academies, while craftsmen still acquired their skills within an apprenticeship system that had remained virtually unchanged since the Middle Ages.

For several years resident in England as a political refugee, the German architect Gottfried Semper (1803-1879) was another critical observer at the 1851 Crystal Palace exhibition. Unlike Morris, however, Semper realized that technological progress was irreversible. So instead of devising ways to keep traditional crafts alive, he proposed the education of a new kind of artist-craftsman who would understand and exploit the machine's potential with artistic sensitivity.

In his treatise of 1852, *Wissenschaft, Industrie und Kunst* ("Science, Industry, and Art"), in which he provided his impressions of the Crystal Palace exhibition the previous year, Semper stressed the significance of industrialization for the arts. His admonition that existing craft traditions needed to be supplanted by a revised system based on new attitudes to art – the necessity for an honest union between

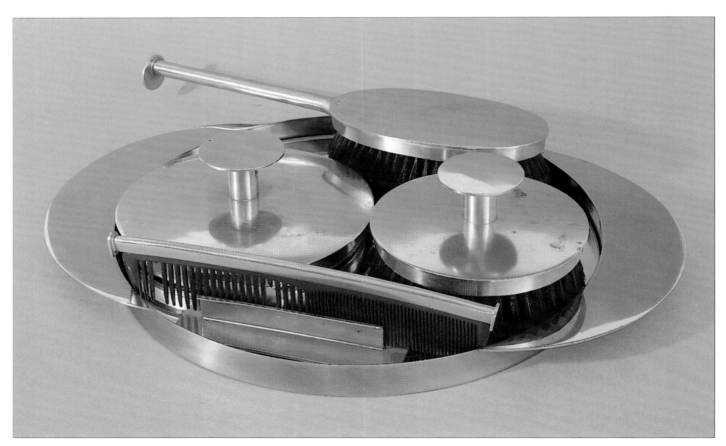

EMMY ROTH (dates unknown) German
Dresser Set, c.1930. Metal alloy, glass, red dyed bristle.
Hairbrush: H: 1 ½in (3.8cm) x W: 10 ½in (26.7cm) x D: 3 ¼in (8.3cm) marks on back: *EMMY ROTH, Made in Germany*. Circular Brush: H: 2 ½in (6.4cm) x D: 4 ⅛in (10.2cm); Comb: H: 1 ¼in (3.2cm) x W: 7 ¼in (18.4cm) x D: ⅛in (0.2cm); marks under stand: *EMMY ROTH*. Comb stand: H: ¾in (1.9cm); W: 4 ⅜in (11.2cm) D: 1 ½in (3.8cm); Circular Mirror: H: 2in (5.1cm) x D: 5 ¼in (13.3cm); Tray: H: ¾in (1.9 cm) x W: 13in (33cm) x D: 10in (25.4cm); marks on underside of tray: *EMMY ROTH*.

JOSEF HARTWIG (1880-1955) German
Chess Set (in original box), 1923. Comprised of 32 pieces. Wood (natural and stained black). Designed at Weimar Bauhaus.
Marks (stamped on bottom of a black piece): *GES.GESC.*
Box: H: 5 ⅛in (13cm) x W: 5 ⅛in (13cm) x D: 2 ¼in (5.7cm)

This celebrated chess set by Josef Hartwig sold very well when first introduced in the early Twenties. While the production of the sets is officially attributed to the Bauhaus Carpentry Workshop, they were handmade by a carpenter/joiner who had been relieved of his job in a piano factory (and who subsequently organized a strike). The chess set and other Bauhaus commissions enabled him to start his own firm. Reduced to basic geometric elements, the design of each piece indicates its move. Though the set was initially well received, its life was relatively short. Today, the official chess pieces sanctioned by the International Chess Federation are the familiar Staunton figures. While the art of chess represents the epitome of cerebral abstraction, the official game continues to be played in the most traditional formats.

materials and workmanship, and the reunification of the arts within the buildings which housed them – anticipated the theories that later formulated the road ahead for the Bauhaus. In his search for practical solutions to the problems of art education, craft, design and architecture in his homeland, Semper invented a German equivalent to the English phrase "Arts and Crafts", *Kunstgewerbe.*[2]

Of the numerous craft societies that sprang up in Germany towards the end of the century, it was the one in Munich that had the greatest impact on the future of design. The Deutsche Werkstätte, founded there in 1897 by Karl Schmidt, was in the vanguard of the international movement that evolved towards 1900 away from the concept of handcraftsmanship and towards that of serial production. For the Germans, the issue was confronted and clearly defined well before it was in England or elsewhere in Europe: should the Morris tradition of the individual craftsman continue to be upheld and consolidated or should it yield to an industrialized form of manufacture based on

standardized components (T*ypenmobel*)? The debate was, of course, fundamental to that facing designers everywhere at the time: how to reconcile – if, in fact, at all – individual versus industrial design. As noted, Germany's answer was soon forthcoming, due to the efforts, amongst others, of Muthesius, van de Velde, and Behrens, all who in focusing on various aspects of the total issue, and often directly at odds with each other, dominated the intellectual debate that served not only as the prologue in Germany to the Bauhaus, but to the other schools and movements that emerged elsewhere after the First World War, including the Union des Artistes Modernes (U.A.M.) in Paris, and the International Style, each with its own interpretation of, and goals for, 20th century design.

In 1896, the German government had created a special post at its London embassy for the architect Hermann Muthesius (1861-1927) to study and report on British town-planning and housing policies. Muthesius stayed for seven years, following which he published an influential book, *Das Englische Haus*

KARL PETER RÖHL (1890-1975) German
Untitled Composition (*Yellow Square*), c.1923.
Tempera on paper.
H: 24½in (62.2cm) x W: 18½in (47cm) // H: 34 x W: 27¼in
(69.2cm)

KARL PETER RÖHL (1890-1975) German
Untitled Composition (*Red-Orange Circles*), c.1923.
Tempera on paper.
H: 24½in (62.2cm) x W: 18½in (47cm) // H: 34in (86.4cm) x
W: 27¼in (69.2cm)

GUSTAV HEINKEL (1907-1945) German
Bodenvase (Floor Vase), 1930. Glazed stoneware. Manufacturer: Karlsruhe Majolika-Manufaktur, Karlsruhe, Germany.
Marks: inscribed signature: *GH* and impressed *Karlsruhe* stamp on side. H: 27in (68.6cm) x D: 15in (38.1cm)

Representing one of the finest examples of non-objective abstract design applied to a ceramic monumental form, this floor vase, one of only two known to exist, is equally important for its provenance. Soon after it was completed, the vase was acquired by the E. L. King family, who wanted to refurbish and modernize their summer home, *Rockledge*, built in 1912 by the Arts and Crafts architect George Washington Maher. Sited beneath a cliff along the Mississippi River near Homer, Minnesota, *Rockledge* was one of Maher's finest designs. Regrettably, the house was destroyed in 1985. In the mid-thirties the King family traveled throughout Europe bringing back the finest furnishings available, including this piece.
Gustav Heinkel began his career at the Maloyka Manufaktur in Karlsruhe serving as an apprentice ceramics painter, where he remained active with the firm until 1944. This mature work embodies many elements of Bauhaus doctrine, particularly the non-objective abstract design but, uncharacteristically, it is tempered with many human touches. The atmospheric effects suggest the watercolors of Paul Klee rather than the flat, hard-edged designs of Josef Albers. The shapes are hand-drawn, colors are permitted to run outside the drawn-in outlines, and mists of color appear to have been sprayed or spattered on the crackle-glaze finish, all contributing to a strong painterly effect which was Heinkel's forté. Little is known about this gifted ceramicist, but it is evident in this work alone that he possessed a superior command of the medium while simultaneously introducing new and extremely expressive artistic techniques.

(1904), in which he detailed his findings, including his opinion on how English industrialization should best be implemented in Germany. Specifically, Muthesius believed that ornament and mechanized production were irreconcilable, "what we expect from machine products is smooth form reduced to its essential function".[3] Following his return from London, Muthesius was appointed superintendent of the Schools of Arts and Crafts by the Prussian Board of Trade. In this capacity, he encouraged the formation of training workshops in which students would learn by actually making things rather than only designing them on paper.

In his continuing search for a synthesis between the "machine style" and the craft movement, Muthesius co-founded in 1907 the Deutsche Werkbund in Munich. The society's goal was to effect a genuine cooperation between the finest artists and craftsmen on the one hand, and trade and industry on the other. A group of twelve industrialists and twelve artists were invited to assist in formulating for the Werkbund standards of mass production appropriate to the new machine-age and to determine the means whereby qualified designers could be infiltrated into industry.

On leaving the artist's colony in Darmstadt in 1903, Peter Behrens was appointed by Muthesius to the

PETER BEHRENS (1868-1940) German
Tea Kettle, c.1909. Hammered brass with wicker-bound handle. Teardrop form with incised striations. Made by AEG (Allemeine Electricitäts-Gesellschaft), Berlin.
H: 8 ½in (21.6cm) x W: 8in (20.3cm) x D: 6in (15.2cm)

directorship of the Arts and Crafts school in Düsseldorf where, on realising the implications of industrialization and the potential of the machine, he reorganized the school's curriculum in an attempt to reconcile traditional craftsmanship and mechanized production.

Four years later, Behrens accepted the position of chief designer at A.E.G., Germany's general electric company and one of its largest utilities. Behrens designed several of the firm's buildings (most notably, its turbine-construction hall in Berlin), many of its products (including telephones, fans, kettles, and street lamps), and all of its typography, the last-mentioned in a spartan and highly distinctive

PETER BEHRENS (1868-1940) German
Electric Tea Kettle, c.1908-09. Model no. 3599. Brass with wicker-bound handle. Octagonal form.
Made by AEG (Allemeine Electricitäts-Gesellschaft), Berlin.
Marked on bottom: *AEG Serial #42517*.
H: 8 ½in (21.6cm) (base to handle) x W: 8in (20.3cm)

WALTER DEXEL (1890-1973) German
Verwende stets nur Gas (Always use only gas for cooking, baking, heating and lighting because it is practical, clean and cheap.
Saves work, time and money. Information and exhibition in Municipal Gas Works), 1924. Poster / color letterpress.
Designed for German State Gasworks. Imprint: Dexel Jena.
H: 20 ¼in (57.4cm) x W: 26 ½in (67.3cm) // H: 27 ¼in (69.2cm) x W: 33in (83.8cm)

modernist style. For a few months, Charles Edouard Jeanneret, later to call himself Le Corbusier, worked as a junior in Behrens' private architectural practice, as did two future directors of the Bauhaus, Walter Gropius and Mies van der Rohe.

Like Muthesius and Behrens a founding member of the Werkbund, Henry van de Velde, the director of the Weimar Arts and Crafts Academy, presented a contrasting viewpoint to that advocated by Muthesius: that the creation of national norms – i.e., standard sizes for everything – would eliminate individual creativity. The crafts, now more than ever, provided an essential counterbalance to the straitjacket imposed by standardization. Noting his debt to Morris, van de Velde nevertheless designed objects which could be made equally well by hand or by machine. The future of functional design in Germany lay with Muthesius and his disciples, however; van de Velde's doctrine of

individual artistic expression lost out, if not immediately, then by the outbreak of the First World War.

It is clear today that the ideology of modern design in Germany was greatly advanced by the Werkbund. The floral exuberances of the *Jugendstil,* so wildly fashionable barely a decade earlier, seem to today's observer so much further removed in both time and concept, as do the similarly fanciful Art Nouveau creations of Gallé, Guimard and Gaudí to the south.

In April 1915, the Grand Duke of Saxe-Weimar invited Walter Gropius to succeed van de Velde as director of the Weimar Arts and Crafts academy. As a foreigner, van de Velde was subject to internment should he remain in Germany, which he left shortly for his native Belgium. Gropius's proposal that the academy be amalgamated with the nearby Grand Ducal Saxon Academy for Pictorial Art was agreed to

WALTER DEXEL (1890-1973) German
Composition F-J, 1925. Gouache. Marks: signed, dated and titled,
Figuration F-J, on back.
H: 9in (22.9cm) x W: 4 ¼in (10.8cm)

architecture, a concept which paralleled Gropius' reformist goals for crafts and industry. These plans were shelved, however, after the art academy's building was converted during the war into a reserve military hospital and addressed again only at the cessation of hostilities.

Born in Berlin in 1883, Gropius had trained as an architect before establishing his own practice in 1910. The Fagus shoe-last factory at Alfeld-an-der-Leine, which he designed in 1910-11 in association with Adolf Meyer, was startlingly progressive in its novel use of steel and glass in place of conventional load-bearing walls. The youngest member of the Werkbund, and clearly one of its most driven and articulate in his pursuit of radical solutions to the status quo in manufacturing, Gropius was an obvious choice when the search for van de Velde's successor began. Yet the program which he put into effect turned out to many of the surviving faculty at the Arts and Crafts academy – all older and more conservative than Gropius – to be entirely different to that which they had envisioned when they appointed him, a problem compounded by the fact that many of them stayed on to teach the new curriculum. These differences between the staff and the new director, both artistic and political, were later explained by Gropius as a dramatic manifestation of the generation gap.

The Bauhaus became a reality in April, 1919, with the contract signed by Gropius and the office of the Head Marshall of Weimar, which was ratified by the Ministry of State. Gropius outlined his three primary goals for the school in a Manifesto and "Program of the State Bauhaus in Weimar" published in the same month.[5]

and implemented.

Gropius was still at the front when the offer was made – he served the entire war in the German infantry – and it became apparent during the protracted negotiations that ensued that he intended to modify significantly van de Velde's curriculum at the academy in accordance with the proposals which he had detailed in the treatise "Memorandum of the Industrial Prefabrication of Houses on a Unified Artistic Basis", which he had drafted with Behrens in 1910.[4] At this time, also, professors at the two academies began independently to explore the feasibility of a counselling service as the means to forge a closer relationship between the arts and

HERBERT BAYER (1900-1985) Austrian-American and LÁSZLÓ MOHOLY-NAGY (1895-1946) Hungarian
Staatliches Bauhaus in Weimar, 1919-1923. Exhibition catalogue, 1923. Cover design by Bayer: title page and layout by Moholy-Nagy. The book documented the first public exhibition of the Bauhaus.
H: 9 ¾in (24.8cm) x W: 10in (25.4cm)

HOOGST

SLOEG HET

HY

RECLAME PAUL SCHUITEMA

PAUL SCHUITEMA (1897-1973) Dutch
Advertising Leaflet, c.1929. Lithograph.
H: 11in (27.9cm) x W: 8 ⅜in (21.3cm) // H: 16 ⅝in (42.2cm) x
W: 13in (33cm)

HERBERT BAYER (1900-1985) German
Europäisches Kunstgewerbe, 1927. Poster / color lithograph, 1927.
Executed for Exhibition of European Arts and Crafts, Leipzig, 1927.
Printer: Ernst Hedrich Nachf, Leipzig.
H: 22 ⅞in (58.1cm) x W: 35in (88.9cm) // H: 41 ⅜in x
W: 42 ½in (108cm)

Whereas the tone of the Manifesto ranged from vague to ecstatic and utopian, its basic intentions were clearly defined.

The school's first aim was to rescue all of the arts from the isolation in which each then apparently found itself, and to train future craftsmen, painters and sculptors to embark on collaborative projects in which their skills would be combined and therefore interdependent. These projects would be buildings because, in the grandiose declaration with which the Manifesto began, "The ultimate aim of all creative activity is the building".[6]

The second aim was to elevate the status of the crafts to that traditionally enjoyed by the "fine arts". As the Manifesto explained, "There is no essential difference between the artist and the craftsman… The artist is an exalted craftsman. Let us then create a new guild of craftsmen without the class-distinctions that raise an arrogant barrier between craftsman and artist!"[7]

The third aim, less clearly articulated than the first two, but of increasing importance once the Bauhaus was operational, was to establish "constant contact with the leaders of the crafts and industries of the country". This was more than an article of faith; it was to become a matter of economic survival as the Bauhaus hoped gradually to free itself from its dependence on public subsidy by selling its products and designs to the public at large and to industry. Contact with the outside world would ensure that the school did not become an ivory tower and that its students would be familiar with the commercial world they would later enter.

To realize his goals for the school, Gropius devised a dual syllabus in which students were trained in every

BRUNO PAUL (1874-1968) German
Samovar, 1904. Cast and wrought brass. Kettle with liner, lid and tray. Executed by: Vereinigte Werkstätten für Kunst im Handwerk, Munich (established 1897).
H: 11 ½in (29.2cm) x D: 15 ¼in (38.7cm) (with tray)

A work clearly ahead of its time, this samovar is a courageous declaration of modernism. It anticipates by fifteen years both the spirit and ideals of the German Bauhaus movement. Its clean lines, mechanistic detailing (particularly the neck) and implied disdain of decoration result in a work of exceptional strength, an early essay in functionalism.
In 1900 Bruno Paul's work still followed a restrained version of German Art Nouveau (Jugendstil), giving little indication of what was shortly to erupt in his designs. Inspired by the writings of Hermann Muthesius, and encouraged by his new appointment as director of the Berlin Art School, Paul quickly became a champion of industry combining quality craftsmanship with new machine technology. Both he and Peter Behrens were instrumental in forging successful collaborations between designers and industry and, as such, were key progenitors of Bauhaus design.

subject by two masters, one a professor to teach its theory and the other an artist-craftsman to teach its practice. This division of instruction – in effect, into classrooms and workshops – was unavoidable at the start as no teachers were found with sufficient mastery of both disciplines, i.e., of both theory and application. To develop such "ambidexterity" in its students was the purpose of the Bauhaus.

By merging the theoretical syllabus of the academy of pictorial art with the practical syllabus of the Arts and Crafts academy, Gropius sought to provide a comprehensive form of tuition by which students would be taught to recognize the composite character of the building and its contents. As he noted, "the Bauhaus strives to coordinate all creative effort, to achieve, in a new architecture, the unification of all training in art and design".[8] The school's ultimate goal was therefore the collective work of art, in which there were no barriers to separate a building's structural and decorative elements. A one-year preliminary course was mandatory, after which students could determine their specialty. The majority were German, male and in their early twenties, some ex-servicemen.

The Bauhaus's first faculty was drawn from the two academies, but as the war had created vacancies at both, new appointments had to be filled. The initial three newcomers were Johannes Itten, Lyonel Feininger and Gerhard Marcks, while Adolf Meyer, Paul Klee, Oskar Schlemmer, Wassily Kandinsky, and László Moholy-Nagy were amongst staff added between 1919 and 1923. It is today hard to imagine that such a stellar roster of faculty members – a pantheon of avant-garde 20th century artist-designers – could be assembled at the same time by such a fledgling institution, and one whose short existence was so precarious.

The school remained a lightning rod within the community on various economic and political issues throughout its infancy. Attacked by the rightist government, the *Volkischen*, on the suspicion that it harbored "Bolshevist" or other socialist sympathizers,

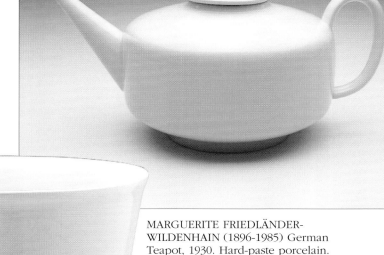

MARGUERITE FRIEDLÄNDER-WILDENHAIN (1896-1985) German Teapot, 1930. Hard-paste porcelain. Manufacturer: German State Porcelain Factory, Berlin.
H: 5in (12.7cm) x W: 11in (27.9cm) x D: 7in (17.8cm)

MARGUERITE FRIEDLÄNDER-WILDENHAIN (1896-1985) German Vase, c.1931. Porcelain. *Hallesche* form. Manufacturer: Staatliche Porzellan Manufaktur, Berlin. Marks: *ZYC* / Mark of manufacturer in underglaze blue.
H: 11 ½in (29.2cm) x D: 5 ⅜in (13.7cm)

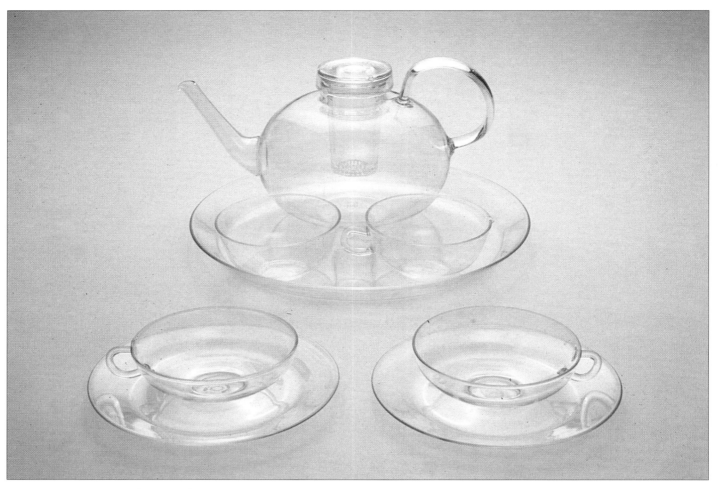

WILHELM WAGENFELD (1900-1990) German
Tea Service, 1930-34. Clear fireproof glass. Manufacturer: Jenaer Glaswerk, Schott & Genossen, Jena, Thuringia, Germany. Comprised of: Teapot: H: 6in (15.2cm) x W: 9 ½in (24.1cm); Serving Platter: H: 1 ¼in (3.2cm) x W: 11 ⅛in (28.3cm); six cups: H: 1 ¾in (4.4cm) x W: 4 ⅞in (12.4cm); six saucers: H: ¾in (1.9cm) x W: 6 ⅜in (16.2cm); Sugar bowl: H: 2 ⅛in (5.4cm) x W: 3 ¾in (9.5cm); Creamer: H: 2 ⅛in (5.4cm) x W: 4 ¼in (10.8cm); six plates: H: ⅞in (2.2cm) x W: 7 ¾in (19.7cm).
Marks impressed on bottom: *Jenaer Glas* / manufacturer's insignia / *Tefla*.

it was at the mercy of the Department of Finance, which either slowed or ignored its subsidy payments. Unanticipated opposition came also from the local craft guilds, which claimed unfair competition in the fact that it was offering for sale goods manufactured with state funding. Amongst the public, too, there was resentment, many considering the school elitist or irrelevant in a time of universal austerity. And questions were raised even amongst academicians at other institutions regarding Gropius's intentions: if he genuinely believed the machine to be the modern means of production, why did he place such emphasis on craft-related subjects in the school's syllabus? Industry and the applied arts were fundamentally opposed to each other, both in theory and practice, so why did he suppose a knowledge of the latter to be vital to a student's education?

Internally, matters seemed at times equally bad. Initially there were no tools or materials, so practically nothing was produced until 1921-22, except in the weaving and bookbinding workshops. Curriculums had to be set and tried and teachers prepared. Gropius and Itten feuded constantly over procedures, which created conflicting camps within the faculty, a problem that did not resolve itself until Itten's resignation in early 1923. Fortunately, the creative drive amongst the staff and students was not extinguished by such conflicts and adversities, and a communality between the staff and students quickly developed, both on and off campus, in part due to the shared privations of all within a vanquished and inflation-wracked nation.

In 1923 Gropius published *Idee und Aufbau des Staatlichen Bauhauses Weimar*, in which he laid out his on-going vision for the school.[9] Its basic concept remained the reunion between creative artists and the industrial world. Tuition at traditional academies was too firmly established, to the point that practical training never advanced beyond dilettantism. Today's

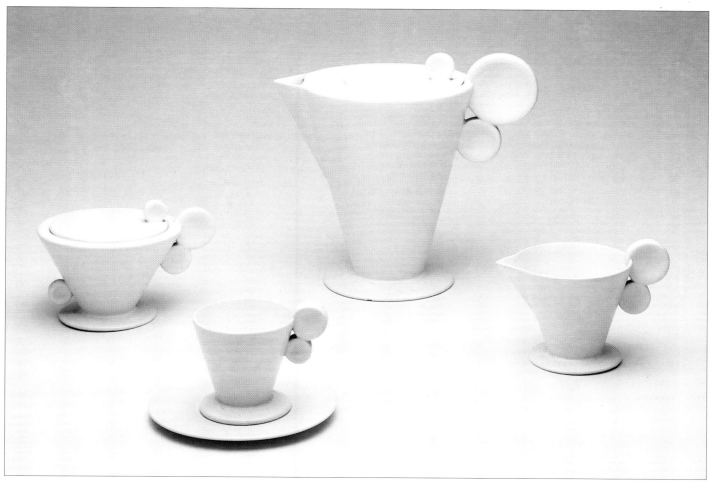

MARGARETE HEYMANN-MARKS LÖBENSTEIN (1899 -) German
Tea Service, c.1930. Ceramic. Comprising: teapot and cover, milk jug and sugar bowl with cover. Conical bodies on circular feet, graded circular handles, flat covers with circular finials. Manufacturer: Haël-Werkstätten, Marwitz, Germany. Marks: *FOREIGN* / artist's monogram / *182 / 29*. Teapot: H: 6 ¾in (17.1cm) x D: 7 ½in (19.1cm); Sugar Bowl: H: 3in (7.6cm) x D: 5in (12.7cm); Creamer: H: 3in (7.6cm) x D: 4 ½in (11.4cm); Cup & Saucer: H: 2 ¾in (7cm) x D: 4 ¼in (10.8cm)

demand in business, however, was for specialized designers. Industries were searching for staff who could design products that were both outwardly attractive and technically and economically competitive. Technicians on their own could not produce what was necessary, nor could artists, who were too far removed from the real world around them. The Bauhaus alone met the need for a new class of industrial designers, ones who would graduate with a thorough practical training acquired in workshops that were actively engaged in production, coupled with sound theoretical instruction in the laws of

EMMY ROTH (dates unknown) German
Tea Caddy and Tea Extract Pot, c.1928. Silver with ivory handles (#800 silver). Signed on the bottom of each piece.
Tea Caddy: H: 3 ⅞in (9.8cm) x W: 4 ⅞in (12.4cm) x D: 4 ¼in (10.8cm)
Tea Extract Pot: H: 4 ½in (11.4cm) x W: 6in (15.2cm) (to handle) x D: 4 ⅞in (12.4cm)

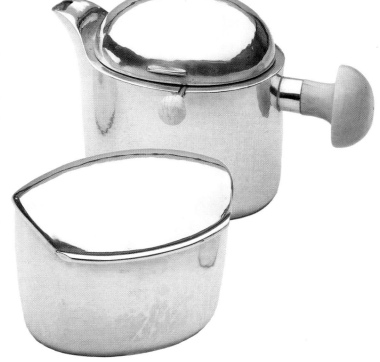

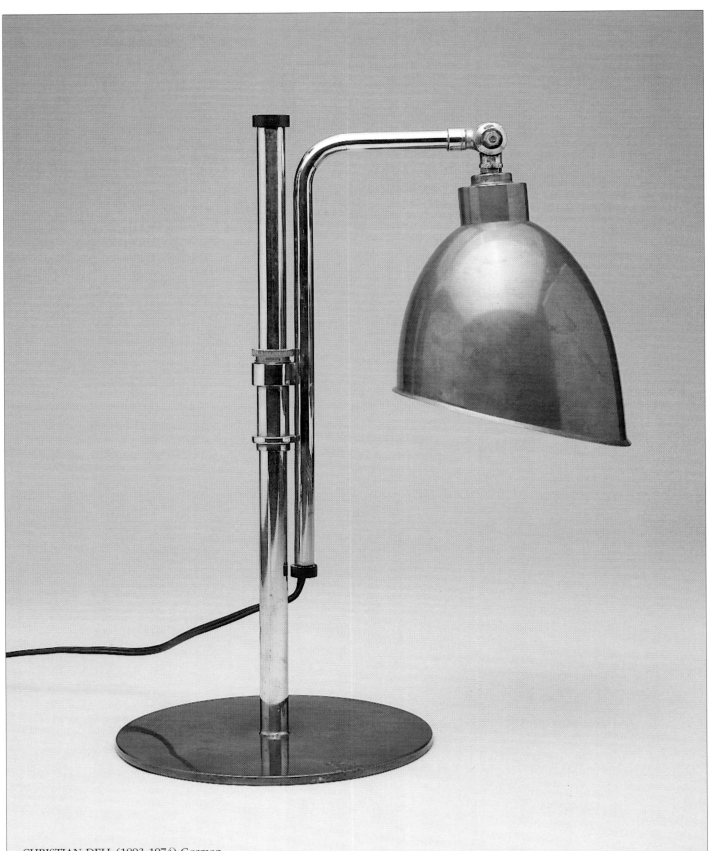

CHRISTIAN DELL (1893-1974) German
Table Lamp, 1928. Copper shade, chromium-plated metal.
Adjustable shade. Manufacturer: Betmag, Zurich.
H: 16 ½in (41.9cm) x W: 9 ½in (24.1cm)

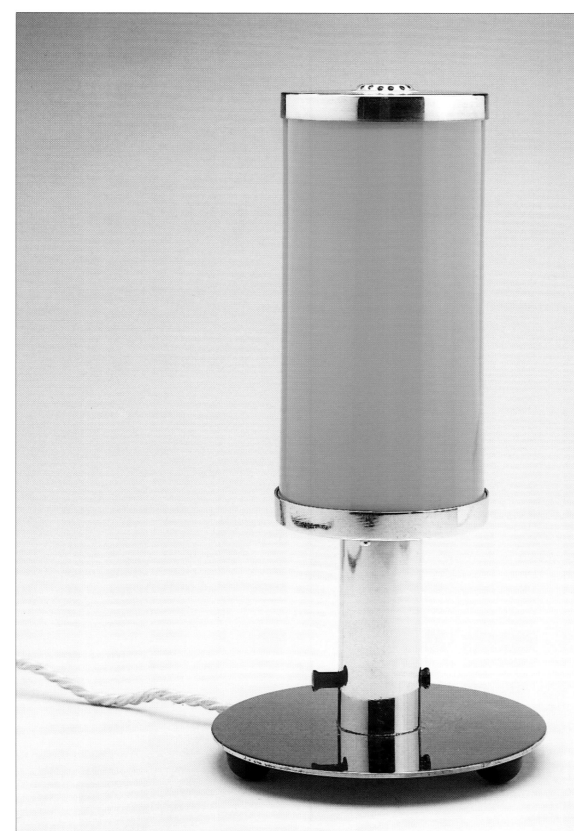

FRITZ AUGUST BREUHAUS DE GROOT (1883-1960) German
Table lamp, c.1928. Chromium-plated metal and glass.
Manufacturer: Württembergische Metalwarren Fabrik (WMF), Geislingen, Germany.
Marks: *WMF*. Attributed to Fritz August Breuhaus de Groot.
H: 11 ½in (29.2cm) x D: 5 ⅞in (14.9cm)

design. In sum, the school was the only institution concerned with the integration of all aspects of contemporary culture.

In the same year, and at the request of the Thuringian legislative assembly, the school staged an exhibition entitled "Art and Technology, a new Unity". If its early years had emphasized the investigation of properties common to all the arts and the revival of handcraftsmanship, then in 1923 it shifted irrevocably towards the education of a new breed of designers capable of conceiving inexpensive, quality artefacts made by machine. Morris would probably have felt at home in the early Bauhaus; now he would not have recognized it as his progeny.

A review at this point of some of the Bauhaus staff and students, and of objects which they designed while there (objects which in some cases were also manufactured in its workshops) can serve to determine the progress and direction of the Bauhaus during its initial phase, i.e 1919-24. The most renowned of these is today the Hungarian Marcel Breuer, a student who was promoted to master in 1925 when the cabinetmaking and metal workshops were combined. Inspired initially by the de Stijl concepts of perpendicularity and use of primary colors only, Breuer's plywood chair of 1924, lacquered in two colors, evokes strongly the Rietveld prototype of seven years earlier. Within a year, however, Breuer graduated to tubular steel furniture, his first chair design incorporating a fabric seat, back and armrests. Strikingly simple and aggressively geometric, and designed to be easily assembled from standardized components, the model illustrated the dramatic shift in philosophy from craft traditions to industrialization embraced at the Bauhaus towards the mid-1920s. Another worker in wood and the master of the wood-carving workshops, Josef Hartwig in 1924 created a novel chess set in which the design for each piece was determined by its movement on the board. A table in beechwood was designed by Heinz Nosselt the following year to house the set.

In the metal workshops, Wilhelm Wagenfeld likewise generated some classic modernist designs, including a table lamp in glass and chromed metal, which he created in 1923-24 in collaboration with K. J. Jucker. Wagenfeld's spartan functionalism is seen also in a series of molded glass tea services and stemware. Christian Dell, the master of the metal workshop between 1922-25, likewise produced progressively functional designs for chromed metal light fixtures, teapots and tea infusers. A similar modernist vernacular of design was applied in the school's ceramic department by Walter Dexel and, after 1925, by Marguerite Friedlander in their designs for porcelain tea and mocha services. Friedlander's designs were executed by the Staatliche Porzellan

FRITZ AUGUST BREUHAUS DE GROOT (1883-1960) German
Centerpiece Bowl, c.1930. Chrome with ebonized wooden feet. Manufacturer: Württembergische Metalwarren Fabrik (WMF), Geislingen, Germany.
Attributed to Fritz August Breuhaus de Groot.
H: 3 ⅜in (8.6cm) x D: 14in (35.6cm)

PAUL SPECK (1896-1966) Swiss
Tea Caddy, 1926-30. Glazed earthenware with handpainted
geometric design. Executed by the Staatliche Majolika
Manufaktur, Karlsruhe, Germany. Marks: PSP / Maker's Mark:
Made in Germany / 1620/15.
H: 5 ⅜in (13.7cm) x W: 4 ½in (11.4cm) x D: 2 ⅜in (7cm)

MARGARETE HEYMANN-MARKS LÖBENSTEIN (1899-)German
Dinner Plate, c.1930. Ceramic.
D: 9 ⅞in (25.1cm)

Manufaktur, Berlin.

A student in the print department in Weimar, Karl Peter Röhl came under the early influence of the Dutch art critic-artist-architect and De Stijl propagandist, Theo van Doesburg, in his creation of abstract compositions comprised only of the letters in the work's title (for example, posters and program covers), which he italicized and grouped at different angles and/or on different planes. Rohl designed the school's first seal, which was replaced in 1921 by a more de Stijl-inspired version by Oskar Schlemmer. Of significance also in a typographical context, Herbert Bayer ran the department between 1925-28, generating a wide range of abstract and sharply eye-catching modernist compositions for advertisements, book covers, posters, invitation cards and bank notes for the State of Thuringia in 1923. Bayer designed type faces in which serifs and capitalized letters were eliminated.

Around Christmas, 1924, Gropius and his staff felt compelled by the persistently menacing attitude of the government of Thuringia to close the institution on

their own initiative on the expiration of their contracts on April 1, 1925. It was felt that it was best to dissolve the school voluntarily in order to forestall its destruction, a decision that proved to be right despite all prophecies to the contrary. The faculty's decision was approved by the students, who likewise quit, pending the school's relocation. Negotiations were opened with various cities, including Frankfurt, Hagen, Mannheim and Darmstadt, before the initiatives of the mayor of Dessau, Dr. Fritz Hesse, were accepted. A small and ancient town located in the center of the mid-German coal-belt and only two hours from Berlin, Dessau was home to the Junkers airplane factory and for this and other reasons thought to be a suitable venue. Hesse, an ardent Bauhaus supporter, appropriated housing and the funds for a new building, which Gropius designed. The staff and students made the transfer from Weimar in the spring of 1925.

The move to Dessau corresponded with a new generation of teachers. The continuing staff were

LUDWIG MIES VAN DER ROHE (1886-1969) German
MR 20 Armchair, c.1931. Tubular chrome with original caning.
Manufacturer: Bamberg Metallwerkstätten, Berlin-Neukoln.
Marks: original Berlin label.
H: 32in (81.3cm) x W: 22in (55.9cm) x D: 33in (83.8cm)

WILHELM WAGENFELD (1900-1990) German
Kubus, set of storage containers, 1938. Clear pressed glass comprising ten separate refrigerator storage containers, designed for stacking with interchangeable lids. Made by Kamenz Glassworks of Vereinigte Lausitzer Glaswerke AG, Weisswasser, Germany.
Assembled size: H: 8 ¼in (21cm) x W: 10 ½in (26.7cm) x D: 7 ½in (19.1cm)

MARCEL BREUER (1902-1981) Hungarian-American
Nest of Tables, 1926-30. Model B9-9c.Chromium-plated steel with ebonized wood tops. Manufacturer: Thonet.
H: 23 ⅝in (60cm) x W: 27 ½in (69.9cm) x D: 15 ¼in (38.7cm) (largest table)

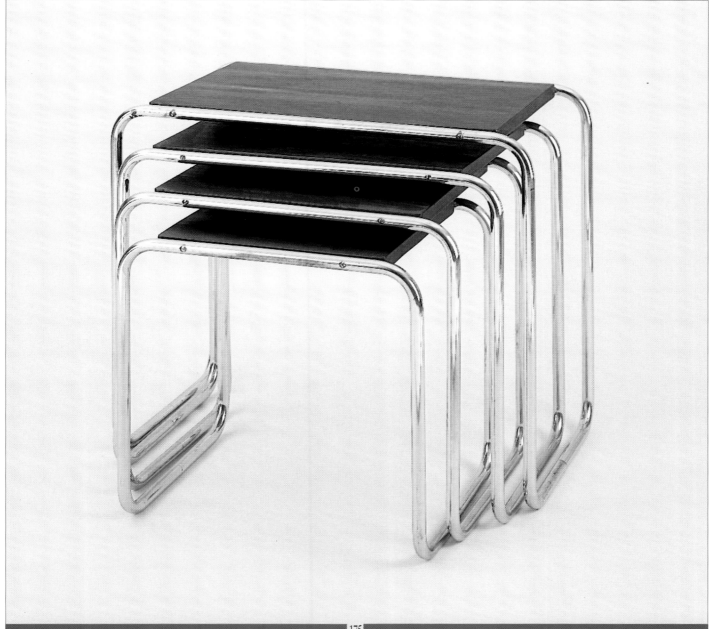

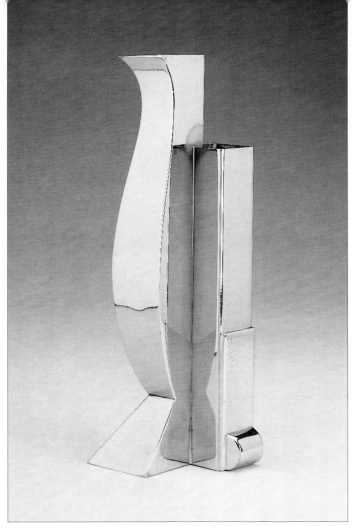

DESIGNER UNKNOWN (German)
Vase, 1930. Chromium plated metal. Manufacturer:
Württemburgische Metalwarren Fabrik (WMF), Geislingen,
Germany. Marks: *WMF.*
H: 10 ⅛in (25.7cm) x D: 2 ¾in (7cm) x W: 5 ⅜in (13.7cm)

joined by five former students, who were all appointed masters: Josef Albers, Herbert Bayer, Marcel Breuer, Hinnerk Scheper and Joost Schmidt.

Whereas the Bauhaus remained a thorny issue at the centre of community politics and election campaigns throughout its existence, the mood at the school in Dessau was generally buoyant. Gropius's clean-lined, functional and assertively modern building served as a constant reminder that it had come of age and was no longer a place where old-fashioned crafts lived on in rejuvenated form. The period of experimentation was over; now it was a serious, practical and effective institution, where a new breed of industrial designer was trained, one who would know how to make industry adopt his improvements and inventions, and also how to make the machine the vehicle of his ideas.

Another important change was implemented in the curriculum at Dessau by the cancellation of the dual system of tuition by craftsmen and artists. Now that the school's own students had graduated and joined the staff, only one master was required for each course. New

ideas began to flow and designs for many familiar adjuncts of daily living – for example, steel furniture, modern textiles, dishes, lamps, and modern typography and layout – were commissioned by outside firms or created for manufacture by the Bauhaus itself. Royalties from commercial commissions helped the school gain a measure of financial independence.

Gropius submitted his resignation in early 1928, recommending as his successor, Hannes Meyer, the head of the architecture department, whose appointment was ratified by the town's municipal council. Associated always in the public's mind with every polemic concerning the school, Gropius felt that his departure would allow both a fresh start. Breuer, Bayer and Moholy-Nagy resigned at the same time, in protest. The resignation two years later of Meyer led to the third and final phase of the school's existence and the appointment of its last director, Ludwig Mies van der Rohe, again with Gropius's endorsement.

In 1930 van der Rohe was a well-known Berlin architect, celebrated especially for his design of the German pavilion at the 1929 World's Fair in Barcelona. His spatial solutions for the building, conceived as a matrix of interlacing rooms, were hailed by the critics, as were his distinctive steel and leather chairs, which have become icons of 20th century design. Van der Rohe's design for the House Tugendhat in Brunn the following year further cemented his reputation.

Van der Rohe remained at the Bauhaus until it was closed by the National Socialist regime on April 11, 1933, at which point the school was occupying an abandoned telephone factory building in Berlin, to which it had moved the previous October. Now it was the Nazis' turn to attack the Bauhaus as "a breeding ground for Bolshevism". As Hitler's seizure of power and his despotic legislation rendered all legality questionable, the Dessau government rescinded on its contractual obligations and, thereby, withdrew its financial support, leaving the school to depend on royalties from the licenses it sold. Clearly, the end was at hand. It came when police and storm troopers seized and searched the building, and then sealed its doors.

The migration of "Bauhauslers" began almost immediately, as did the dissemination of the school's ideas. The United States was the prime beneficiary, as many alumni – both ex-students and faculty – left Germany as Hitler consolidated his power in the mid-1930s. Gropius, who had been in self-exile in London, accepted a post at Harvard in 1937, while Albers held teaching positions at both the Black Mountain College in North Carolina (1933-49) and at Yale (1950-59). Moholy-Nagy founded the "New Bauhaus" in Chicago in 1937, and a year later the Museum of Modern Art in New York staged the first retrospective exhibition on the school, "Bauhaus 1919-1928", in which precautions were taken in the accompanying catalogue to prevent the identity,

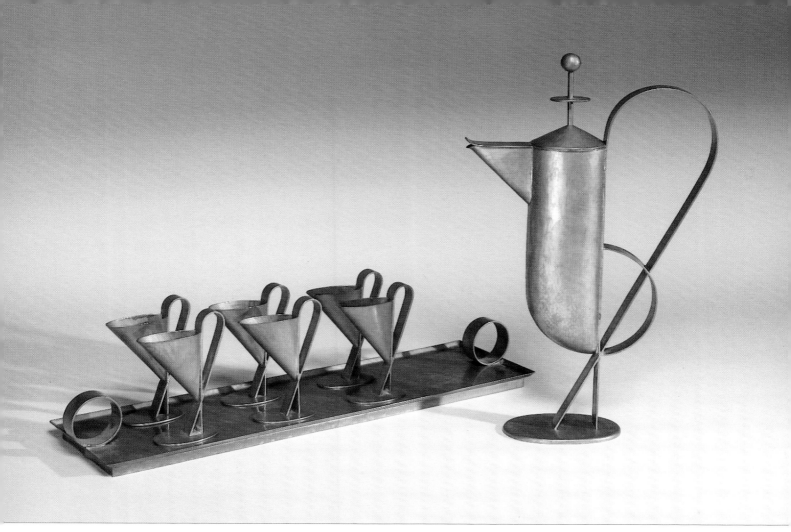

H. OTTMANN (1892-1971) German
Cocktail / Schnapps Set, c.1930. Tray, decanter and six cordials. Handwrought brass with traces of silver wash on various surfaces.
Possibly a work of the Burg Diebichenstein in Halle near Berlin. Marks: signed *H. Ottmann, Made in Germany, Handarbeit.*
Tray: H: 2 ¼in (5.7cm) x W: 19in (48.3cm) x D: 5 ¼in (13.3cm) Decanter: H: 14 ⅜in (36.5cm) x W: 9in (22.9cm) x D: 3in (7.6cm)
Cordials: H: 4 ¾in (12/1cm) x W: 3 ¼in (8.3cm) x D: 1 ½in (3.8cm)

and therefore probable victimization, of Bauhaus personnel still in Germany.[10]

The exodus extended also to Hungary, the Netherlands, Switzerland, Estonia and Japan. In Germany itself, a *Hochschule für Gestaltung* (Institute of Design) based on Bauhaus philosophies was established in Ulm in 1950, with Max Bill, a former student, as director. Difficult to define, but no less important, has been the influence worldwide since the second World War of Bauhaus ideas in countless schools of architecture, art education, industrial design and the applied arts.

To the general public, however, the Bauhaus name has always been something of an enigma as it has been broadly used to describe anything geometric, seemingly functional, and made by machine and with modern materials. To this, Gropius, who always denied the existence of a Bauhaus style, dogma, system or decree of any type, responded that the school sought to develop an attitude towards creative variety rather than one that would lead to stylistic uniformity which he felt led

inexorably to academic stagnation. The Bauhaus did not slavishly follow an aesthetic convention; if its objects appeared homogeneous, this was the outcome of a unified conception of art developed by all workers in their common search behind changing forms for the fluidity of life itself.

NOTES
1. Wolf von Eckhardt, "The Bauhaus", *Horizon*, November 1961, vol.IV, No.2, p.68. For a comprehensive work on all aspects of the Bauhaus, see the massive volume by Hans M. Wingler, *The Bauhaus*, M.I.T. Press, 1978.
2. See *Wissenschaft, Industrie und Kunst*, Braunschweig, 1852, for Semper's impressions of the Crystal Palace exposition.
3. Hermann Muthesius, *Das Englische Haus*, 3 vols., Berlin (1904, 1905 and 1908).
4. See also the Deutsche Werkbund Yearbooks, 1914-1919.
5. Walter Gropius, Manifesto and "Programm des Staatlichen Bauhauses in Weimar", a four-page brochure published by the Bauhaus School with a woodcut cover design by Lionel Feininger, April 1919.
6. Ibid., the opening sentence in the Manifesto.
7. Ibid.
8. For Gropius's texts and transcripts of his speeches on the philosophies of the Bauhaus, see Frank Whitford, *Bauhaus*, London, 1984, pp.202-210.
9. In-house Bauhaus publication, Berlin & Munich, 1923.
10. Herbert Bayer, Walter Gropius and Ise Gropius (eds.), *Bauhaus 1919-1928*, retrospective exhibition catalogue, Museum of Modern Art, New York, 1938.

ART

1920 - 1940

Art Deco is now seen as the first universal style based on legitimate principles of design to have emerged in 125 years. The 19th century largely failed to create a distinctive style; contemporary critics referred repeatedly to "le style sans style". Art Nouveau, although unified and international, was later deemed to be a worthy, but invalid, attempt to break new ground. So just as the elaborate fussiness of Louis XV decoration had been superceded by the discipline of Louis XVI, so Art Nouveau yielded to Art Deco.

Yet Art Deco was in reality a pastiche of styles, an unlimited and sometimes contrasting mix of traditional and modern artistic impulses that defies precise definition. Its reach embraced the two extremes of the historical continuum, from the ancient past to the distant future, from the pyramids of pharaonic Egypt and the Aztecs to the futuristic world of Buck Rogers. Any motif that expressed the spirit of the age was permitted.

From its immediate world, the style drew especially on developments in avant-garde painting. Elements from Cubism, Russian Constructivism and Italian Futurism – abstraction, distortion and simplification – are readily evident in the decorative arts vernacular employed by most Art Deco exponents. Examination of the style's standard iconography – abstract floral bouquets, gamboling young maidens, overlapping patterns of zig-zags, chevrons, and lightning bolts, and the ubiquitous fountain and *biche* (doe) – reveals further influences, such as the world of haute couture, the Orient, tribal Africa and the Ballets Russes. To these must be added in the 1920s the growing impact of the machine, and in the 1930s streamlined forms derived from the principles of aerodynamic design.

VALÉRY BIZOUARD (1875-1945) French
Légumier (Covered Vegetable Dish with Presentation Underplate), c.1925. Silver with carved ivory handles; the vegetable dish with gilt interior. Manufacturer: Tétard Frères, Paris. Retailer: Fouguet-Lapar, Paris. Attributed to Valéry Bizouard.
Dish: H: 8 ½in (21.6cm) x W: 13in (33cm) x D: 9in (22.9cm); Underplate: H: 2 ½in (6.4cm) x W: 24in (61cm) x D: 15in (38.1cm)

DECO

In short, Art Deco was the catch-all style of the inter-war years, but one that had no precise beginning or end as it was conceived before the Great War and lingered on (in architecture) into the 1940s. Described variously at the time as *Moderne*, Modern, or the style of the Jazz Age, the Roaring Twenties, and the "flapper", Art Deco took its present abbreviated name in the 1960s from the title of a book on the era's foremost exhibition, *L'Exposition Internationale des Arts Décoratifs et Industriels Modernes*, staged in Paris in 1925.[1]

The 1925 Exposition was a long time in the making. Conceived as early as 1907, it was scheduled and rescheduled as the First War came and went. Planning was begun again in 1919 for 1922, then for 1924, and finally for April–October, 1925. Most European countries participated, except for Germany, which was now a vanquished enemy nation, although the influence of the Bauhaus was strongly evident in many exhibits. Also absent was the United States, as its Secretary of Commerce, Herbert Hoover, felt that it could not meet the Modernist requirements for entry laid out in the Exposition's charter.[2] Notwithstanding these omissions, the show was considered by most critics as a major showcase for progressive design,

especially for the host nation, whose lavish displays and provocative architecture dominated the entire event. The major French exhibits were lined up along the Esplanade des Invalides, a park in front of Les Invalides on the Left Bank. Pride of place was reserved for the nation's top department stores – Au Bon Marché, Au Printemps, Les Galeries Lafayette and Le Louvre – whose art studios designed and furnished their own pavilions. Interspersed with these were the private exhibitors, quite unawed by their larger neighbors. The press was unanimous in its choice of Ruhlmann's Hôtel du Collectionneur as the Exposition's most spectacular event. After that, in varying order of preference, came Sue et Mare's Un Musée d'Art Contemporaine; the Lalique display; and L'Ambassade Française, the pavilion of the members of La Societé des Artistes Décorateurs.[3]

The Salon of La Societé des Artistes Décorateurs was one of two exhibitions used in the interwar years by modernist artist-decorators as the vehicle by which to bring their most recent creations to the attention of the critics and public. The other was the Salon d'Automne. It was at these two Salons immediately prior to the First World War that the first examples of high-style Art Deco imagery appeared, particularly in the lavish floral basket motifs employed by Paul Follot and André Groult on their furniture, and it was here also that the

This *piéce-de-resistance* was featured in the French Silver Section of the Paris 1925 Exposition (Exposition Internationale des Arts Décoratifs et Industriels Modernes) from which Art Deco derives its name. It is the quintessential Art Deco work. Its strong sculptural form, immaculate surface and ivory accents epitomize the spirit and elegance, the very essence, of *La Mode Parisienne*. Because of its color, silver is sometimes described as a *dry* medium. To give it life without using surface ornamentation, silversmiths had to rely on an interplay of light, shadow and reflection created by contrasting planes and curves. To relieve the soberness of form and color, semiprecious stones, rare woods, ivory and horn were incorporated. Later, in the '30s, gilded sections and thin plates of gold soldered to or inlaid into the surface were added to the repertoire. These materials, when used with restraint so as not to overwhelm the balance and purity of the design, add warmth, richness and textural contrast.

EDGAR BRANDT (1880-1960) French
Firescreen, c.1923. Polished cast-iron with fountain motif. Originally backed with a fine wire mesh screen. Marks: stamped *E. Brandt*.
H: 45in (114.3cm) x W: 35in (88.9cm)

Edgar Brandt was an exceptional artist and craftsman, possessing the genius and skills to render a seemingly crude medium – ironwork – with a sense of grace and dignity. His supremacy in the field of ironsmithing stems from his innate feel for materials and a rigorous discipline. Throughout his life he fostered a deep appreciation for the revered tradition of French decorative arts, making every effort to keep France in the forefront of contemporary design. Brandt's work is no less appreciated today for the intrinsic beauty of his materials, the meticulous detailing and the finely executed craftsmanship.
This fireplace screen is one of many Brandt designs executed over the years featuring a stylized fountain motif. Representing the eternal source of life, it became a favorite Art Deco theme in the '20s.

RENÉ LALIQUE (1860-1945) French
Pannier de Fleurs (*Surtout*), c.1933. Molded glass fitted into bronze mount. Motif of a basket of daisies modeled in high relief in clear and frosted glass. Base is fitted for electricity. Both pieces signed: *R. Lalique*. Model introduced c.1933 and discontinued in 1937.
H: 18 ½in (47cm) x W: 21 ½in (54.6cm)

revolutionary transition from wood to metal took place in furniture manufacture after 1925. For many in the 1920s and 1930s, therefore, the Salons remained the prerequisite forum by which to launch new concepts in design and technology.

The ocean liner provided a further forum for the era's artist-designer. A string of luxury vessels was launched between the wars, starting with the *Paris*, in 1921. Described variously by an ecstatic and jingoistic press as floating palaces or museums of decorative arts, the ocean liners afforded the nation's foremost interior designers an excellent international showcase. They became, in effect, an extension of the annual Salons. After the *Paris* came the *Île-de-France*, *La Fayette*, *Atlantique*, and the *Normandie*, amongst several others, each in its turn heralded as just that much more

splendid than its predecessor. The race for the North and South Atlantic was on and the French government both sponsored and subsidized these emblems of national pride.

In the context of this essay, Art Deco relates specifically to the decorative style of the Paris Salons, particularly between 1920/1925. Here the style manifested itself emotionally, with zest, color and playfulness. Its purpose, in the words of a recent critic, was "for luxury and leisure, for comfort and conviviality. It is an exciting style and should, like the archetypal drink of the period, be enjoyed while it is still laughing at you".[4] As such, Art Deco cannot be viewed as the antithesis of Art Nouveau, which it had set out to eradicate, but an extension of it in its preoccupation with sumptuous ornamentation,

KEITH MURRAY (1892-1981) English
Vase, c.1930. Ceramic with matt green glaze. Manufacturer:
Wedgwood & Sons, (founded, 1759), Burslem, Staffordshire.
H: 11in (27.9cm) x W: 8in (20.3cm)

Louis XVI period furniture, Art Deco cabinetmakers applied an opulent mix of newly fashionable exotic woods and materials – including Macassar ebony, palmwood, palisander, and amaranth inlaid with veneers of ivory, shagreen, snakeskin, and tortoiseshell – to a wide range of furnishings that made their debuts at the annual Salons. Amongst the practitioners, Ruhlmann reigned supreme. Had the France of the 1920s been a monarchy, in fact, Ruhlmann would certainly have held the title of *ébéniste du roi*. No work as exquisite as his had been seen for one hundred years, and none since. Although many of his most celebrated works were designed before 1920, his furniture is today considered the epitome of the Art Deco style, and its finest expression. Worthy competitors included the partnership of Louis Sue et André Mare, Jules Leleu, Paul Follot, Léon and Maurice Jallot, and Dominique.[6]

Apart from the traditionalists, furniture was designed in the Art Deco idiom by others whose stylistic individualism defies easy categorisation. Included were Eileen Gray, Pierre Legrain, Marcel Coard and Armand Albert Rateau.

In the field of graphic arts, the 1920s poster artist drew on the rich and enduring Belle Epoque traditions

WINOLD REISS (1886-1953) German-American
Flower Design for Wallpaper or Textile Design, n.d. Gouache on heavyweight board. Marks: on verso stamp with rectangular outline, lettered *Winold Reiss Studios / 230 W. 13th ST., NEW YORK CITY*, inscribed in pink crayon *FLOWERFANTASY 8*.
H: 40 ⅛in (101.9cm) x W: 30 ¹⁄₁₆in (76.4cm) // H: 42 ½in (108cm) x W: 35in (88.9cm)

superlative craftsmanship and fine materials.

Certainly there was the need following the *fin-de-siècle* mania for ornamental excess to return to basics, such as the need firstly to consider an object's form versus its function, but decoration remained an integral part of the design equation. Its proponents argued that beauty in the home was vital to man's psychological well-being. Paul Follot defended this belief in a 1928 speech, "We know that the 'necessary' alone is not sufficient for man and that the superfluous is indispensable for him… or otherwise let us also suppress music, flowers, perfumes… and the smiles of ladies!"[5]

That Art Deco was quintessentially French, and specifically Parisian, becomes increasingly evident as the decorative designs from the period are analysed. This relates especially to furniture, in which inspiration was drawn from the nation's *ancien régime*. In the heritage of the 18th century *ébénistes* lay the proven roots of a continuing rich French tradition. Emile-Jacques Ruhlmann, for one, actively encouraged a comparison with Riesener and Weisweiler, and in the Paris of the 1920s no accolade could be greater.

Drawing on the purity of form and refinement of

SHELLEY POTTERIES (English)
Tea-For-Two Service, c.1930. Porcelain, with black and yellow sunrise motif. Comprised of: teapot, sugar holder and creamer with two cups and matching saucers. Manufacturer: Shelley Potteries, The Foley, Longton. Marks on underside of teapot: *Shelley / ENGLAND / 11742 E / Rd2 756533* (D and 2 intertwined).
Teapot with Saucer: H: 4 ¾in (12.1cm) x W: 8 ¼in (21cm) x D: 5 ¼in (13.3cm)
Creamer: H: 2 ¾in (7cm) x W: 4 ¼in (10.8cm) x D: 3in (7.6cm)
Sugar Holder: H: 1 ¾in (4.4cm) x W: 3 ⅜in (8.6cm) x D: 3 ⅜in (8.6cm)
Cup and Saucer: H: 2 ⅝in (6.7cm) x D: 5 ⅝in (14.3cm)

Shelley's Art Deco tableware designs in fine, almost transparent porcelain, were among the most beautiful and inventive produced in Britain. Their daring designs and colors applied to bone china, rather than inexpensive earthenware, were unequalled anywhere in the industry. It was one thing to produce modern designs for expendable earthenwares which would be replaced by the latest fashion within a couple of years, but quite another to try to persuade the buyer to choose a dramatically modern design for her best bone china. Most of the fine china manufacturers avoided producing very modern designs, relying instead on adaptations of traditional patterns which would not date. Upbeat and playful, this tea-for-two service makes full use of the sunrise motif which became an extremely popular Art Deco icon in Great Britain – avant-garde but with stylish flavor. A similar service is in the collection of the Victoria & Albert Museum, London.

of Toulouse-Lautrec, Jules Chéret and Alphonse Mucha. Works ranged from the somewhat whimsical high-style interpretations of Leonetto Cappielo prior to the First World War and Robert Bonfils and Jean Dupas later, to the rigorous geometric compositions of Cassandre. Like the latter, many of the period's artists took inspiration from the movements in avant-garde painting a decade or so earlier. Cubism and Futurism, in particular, provided powerful new advertising tools. Cubism added fragmentation, abstraction, overlapping images and color; Futurism contributed the new century's preoccupation with speed and power, translated brilliantly by poster artists into potent images of the era's new giant ocean liners and express locomotives. And from the de Stijl and Constructivist movements came pure line, form and color. By borrowing some of the concepts of these rather esoteric and intellectual movements, the Parisian poster artist helped make them more comprehensible to the public at large, who viewed them on Paris's ubiquitous *colonnes d'affiche*.

Jean Puiforcat emerged as the doyen of Art Deco silversmiths, from an early stage in his career concentrating on methods of construction by which to unify design and function. Superfluous ornamentation was pared away in his pursuit of this goal, which he

CHARLES CATTEAU (1880-1966) French
Monumental Vase, c.1925. Earthenware with craqueleur ground. Designed by Catteau for Boch Freres Keramis, Belgium. This model was featured in the Belgian Section of the Exposition des Arts Décoratifs et Industriels Modernes, Paris, 1925.
H: 33 ½in (85.1cm) x D: 18in (45.7cm)

MANUFACTURE NATIONALE DE SÈVRES (Founded 1740) French
Tropiques, Monumental Jar and Cover, 1937. Polychrome pastel impasto glazes on porcelain. Form designed by Henri Rapin, c.1925.
Decoration conceived and executed by Anne-Marie Fontaine (designer at Sèvres, 1928-38). Ovoid body decorated with continuous
tropical landscape depicting distant mountains and sailboats, stylized palms, exotic birds and butterflies. Capped with cover in matching
blue glaze. Marks: vase signed *AM Fontaine 90.37* (90th design accepted in 1937); Cover signed *AMF*; base printed with *S / SEVRES
MANUFACTURE NATIONALE FRANCE L* and incised *16-12-37 PM*.
H: 22 ½in (57.2cm) x D: 15in (38.1cm)

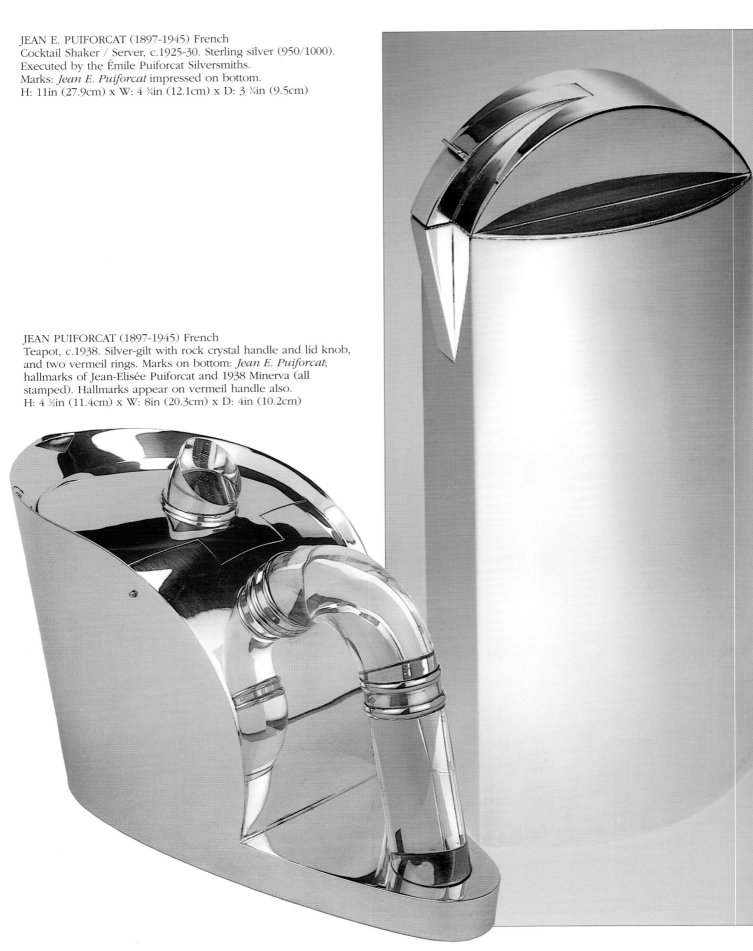

JEAN E. PUIFORCAT (1897-1945) French
Cocktail Shaker / Server, c.1925-30. Sterling silver (950/1000).
Executed by the Émile Puiforcat Silversmiths.
Marks: *Jean E. Puiforcat* impressed on bottom.
H: 11in (27.9cm) x W: 4 ¾in (12.1cm) x D: 3 ¾in (9.5cm)

JEAN PUIFORCAT (1897-1945) French
Teapot, c.1938. Silver-gilt with rock crystal handle and lid knob,
and two vermeil rings. Marks on bottom: *Jean E. Puiforcat*;
hallmarks of Jean-Elisée Puiforcat and 1938 Minerva (all
stamped). Hallmarks appear on vermeil handle also.
H: 4 ½in (11.4cm) x W: 8in (20.3cm) x D: 4in (10.2cm)

DAUM FRÈRES (Founded 1878) French
Vase, c.1930. Glass with metal inclusions. Presented in wrought-
iron mounts designed by Louis Majorelle (1859-1926).
Marks incised on bottom: *DAUM, NANCY, FRANCE.*
H: 12 ½in (31.8cm) x W: 7in (17.8cm)

achieved largely by the use of three fundamental shapes: the sphere, cone or cylinder. Combining elegance and simplicity, Puiforcat generated a formidable range of silverware tea services, flat- and hollow-ware, table-top objects such as cruet dishes and *chocolatiers*, and liturgical pieces. The grandest of these were encrusted with lapis-lazuli, ivory, ebony and crystal. Whereas the term "Cubist" was sometimes applied to Puiforcat's style, he preferred to call it "mathematical".[7]

A latecomer to the field of silver, Jean Tetard abandoned simple geometric shapes for a combination of more complex flattened forms made of identical sections joined by flat conforming bars. His only concessions to ornament were beautiful sculpted handles in rare woods that seemed to grow out of the silver. Tetard's development of serpentine surfaces, in which concave and convex planes were alternated to create the impression of spiralling movement, was especially dramatic and elegant.

The technique of electroplating, which was developed in the 1840s and 1850s, is still closely associated with Charles Christofle, who purchased all of the existing French patents during that period. By the 1920s, the Christofle firm was producing a full range of household silverplate that was virtually indistinguishable from real silver, including vessels adorned with Art Deco patterns applied by the *dinanderie* technique, in which inlays of patinated metals were applied to machine-stamped blanks. The firm drew readily on the talents of outside designers, including Gio Ponti, Maurice Daurat and Luc Lanel.

Several Parisian jewelers were drawn to the related fields of silver and pewter in the interwar years,

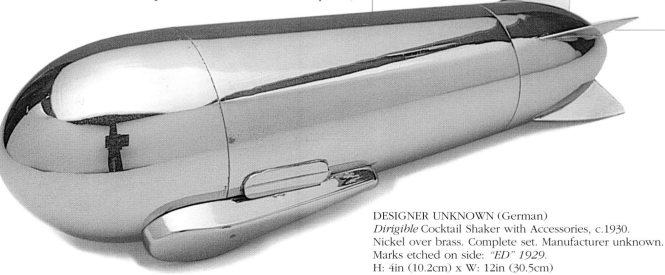

DESIGNER UNKNOWN (German)
Dirigible Cocktail Shaker with Accessories, c.1930.
Nickel over brass. Complete set. Manufacturer unknown.
Marks etched on side: *"ED" 1929.*
H: 4in (10.2cm) x W: 12in (30.5cm)

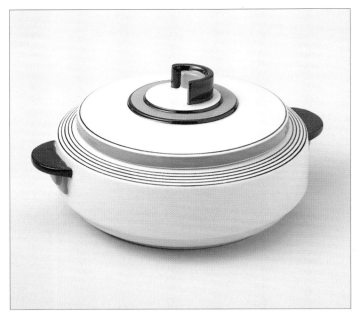

ROBERT T. LALLEMANT (1902-1954) French
Vase, c.1925-30. Ceramic. Molded Cubist form glazed in off-white
with painted abstract decoration. Marks on bottom: *T R
LALLEMANT / MADE IN FRANCE.*
H: 8 ½in (21.6cm) x W: 9in (22.9cm) x D: 3 ¾in (9.5cm)

THE ROYAL DOULTON POTTERIES, Burslem, Stoke-on-Trent
(English)
Casino Ware Covered Dish, 1934. Glazed ceramic. *Marquis* style.
Marks: within glaze on bottom: Royal Doulton manufacturer's
insignia */ RADIANCE / D5421 x.*
D: 10 ½in (26.7cm)

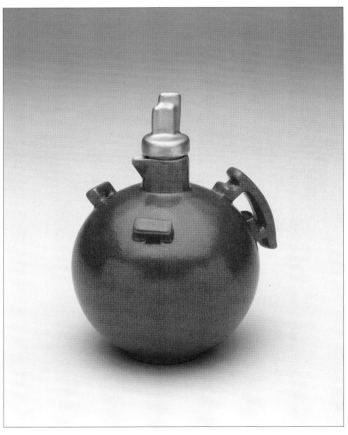

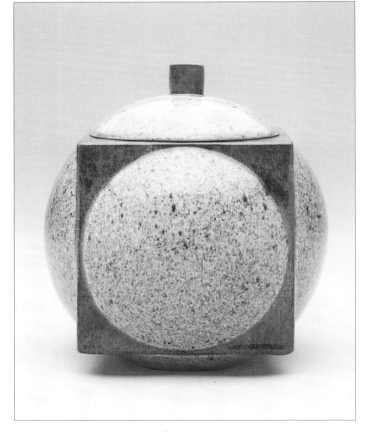

DESIGNER UNKNOWN (German)
Bottle with Stopper, c.1930. Earthenware. Executed by Werner
Gotheim, Germany. Marks impressed on bottom: *insignia, MADE
IN GERMANY, 68.*
H: 6 ¼in (15.9cm) x W: 5in (12.7cm)

MARCEL GUILLEMARD (1886-1932) French
Vessel with Lid, c.1930. Glazed stoneware in architectonic *circle-
in-the-square* form.
H: 8in (20.3cm) x W: 7 ⅛in (18.1cm) x D: 7 ⅛in (18.1cm)

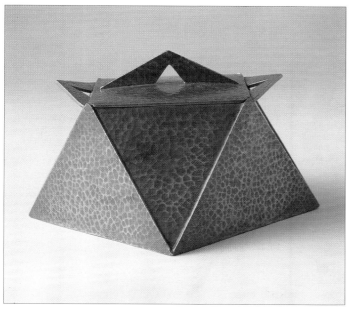

DESIGNER UNKNOWN (English)
Covered Box, c.1925. Hammered pewter in a modern form.
Manufacturer: *Roundhead*. Marks inscribed in bottom:
ROUNDHEAD / manufacturer's insignia /*LEADLESS PEWTER* /
MADE IN ENGLAND / *8379*.
H: 4 ⅜in (11.1cm) x W: 5 ⅜in (13.7cm)

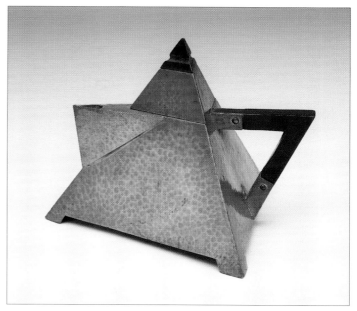

DESIGNER UNKNOWN (English)
Teapot, c.1920. Hammered pewter. Executed by Wm. Hutton &
Sons, Birmingham, England. Marks on bottom: manufacturer's
insignia, *WM. HUTTON & SONS, LD.* / *ENGLISH PEWTER* / *04787 1/2*
H: 5 ⅜in (14.6cm) x W: 8in (20.3cm) x D: 7 ⅛in (18.1cm)

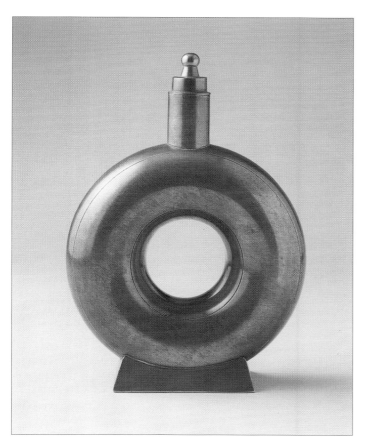

H. F. GROSS (dates unknown) Danish
Decanter, c.1930. Pewter. Made by Frederiksberg Tin, Denmark.
Marks: MANDIX / DENMARK / PEWTER.
H: 8 ¼in (21cm) x W: 6 ⅛in (15.6cm)

PIERRE DU MONT (dates unknown) French
Tea Service, c.1925. Pewter. Marks: DuMont / Made in France.
H: 5 ½in (14cm) x W: 7in (17.8cm) x D: 3 ⅛in (7.9cm) (teapot)
H: 2in (5.1cm) x W: 3 ½in (8.9cm) x D: 2 ⅜in (6cm) (creamer)
H: 2 ⅜in (6cm) x W: 3in (7.6cm) x D: 2 ¾in (7cm) (sugar basin)

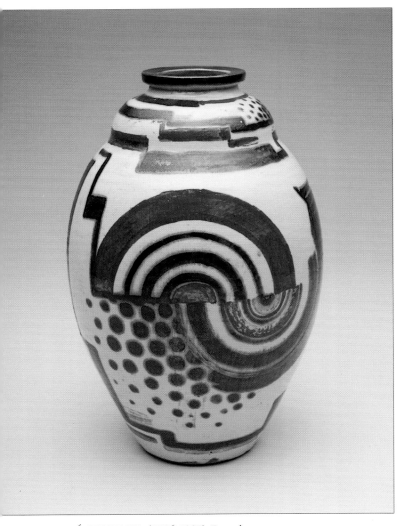

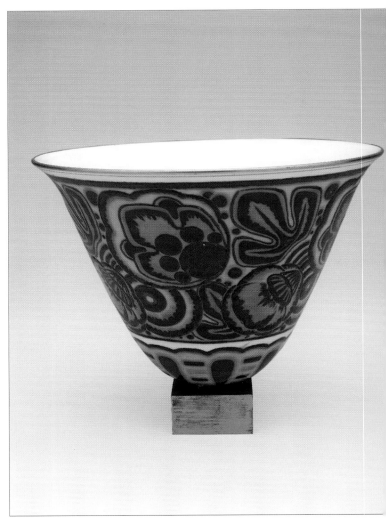

RENÉ BUTHAUD (1886-1987) French
Vase, 1925-30. High-fire pottery vase with hand-painted abstract
decoration in rust, black and silver on a cream-colored ground.
Marks: signed *J. Doris* (pseudonym).
H: 11in (27.9cm) x W: 7 ½in (19.1cm)

EMILE-JACQUES RUHLMANN (1879-1933) French
Vase, 1925. Ceramic. Mounted on bronze base. Manufacturer:
Manufacture Nationale de Sèvres, Founded 1740.
Form design by Ruhlmann and decoration by M. Herbillon.
Marks: *S / Sèvres / Manufacture National FRANCE / Herbillon.*
H: 8 ¼in (21cm) x D: 9 ¾in (24.8cm) AD

including Gerard Sandoz, who produced a limited number of distinctive objects of arresting design enhanced with lizard skin, *galuchat* and ivory, which added color and refinement. Jean Desprès designed a range of starkly simple, if not brutal, modernist vessels with heavily *martelé* (hammered) surfaces and boldly hewn bolts and rivets. A similarly rugged machine-made imagery was utilized by Jacques Le Chevallier in a series of metal table lamps in which the bolt heads were exposed so that they were integrated into the design of the piece. The epoque's ultra-modern lamp designer remained the Maison Desny, however, whose highly distinctive yet spartan designs echoed those of the leading International Style architects: crisply contoured chromed metal shades enclosed inverted reflecting bowls that concealed the bulbs and projected the light rays upwards. The firm's

illuminated bibelots, comprised of rows of rectangular or triangular lime-tinted glass slats mounted on a central column, had no other function than to brighten a sombre corner.

Outside France, the Danish silversmith Georg Jensen emerged as a major figure in 20th century silver, despite the fact that he was not a great innovator. His foremost accomplishment lay in turning handcrafted modern silver into a successful commercial enterprise by producing it at a cost which made it available to the new bourgeoisie. Joined by the painter Johan Rohde, Jensen introduced a restrained brand of progressive design to Scandinavian silver in his Blossom and Acorn flatware patterns. Harald Nielsen, who joined the firm in 1909, later introduced a crisp functional style derived from the Bauhaus.

The huge interest in Japanese art spawned in the late

19th century contributed greatly to the resurgence of interest in lacquer in France. Jean Dunand, who became the most accomplished artist to work in this technique, was able to develop shades of yellow, green and coral lacquer that had even eluded Japanese artisans. To achieve white, a color unobtainable with the vegetable dyes used to create lacquer, he mastered the intensely laborious art of *coquille d'œuf*, in which particles of crushed eggshell were inlaid into the uppermost layers of the lacquer. Dunand applied lacquer to his metalwork utensils and toiletry accessories in arresting geometric patterns that provided vibrant new Art Deco images, as did another French metalworker, Claudius Linossier, and the Limoges enamelists, Camille Faure and Sarlandie.[8]

Glass became another fundamental component of the 1920s design aesthetic in its rejection of both traditional and *fin-de-siècle* materials and modes of ornamentation. Functionalism, complemented by restrained Art Deco imagery and a pale palette, became the medium's new focus. In short, the bright glass confections of Messrs. Emile Gallé and Louis Comfort Tiffany were banished after 1918.

The Daum *cristallerie* of Nancy, which had

LEGRAS ET CIE (Founded 1864) French
Vase, c.1920. Enamelled and acid cut glass. Manufacturer: Legras et Cie, Saint Denis, France. Marks: *Legras* signature on side.
H: 12 ½in (31.8cm) x D: 5 ½in (14cm)

CHARLES SCHNEIDER (1881-1953) French
Vase, c.1930. Glass with acid etched geometric design with orange overlay at bottom third and a deep purple-black base. Le Verre Français line (1918-40). Marks: *Le Verre Français* inscribed on top of base; *MADE IN FRANCE* etched on bottom.
H: 14in (35.6cm) x W: 6 ½in (16.5cm)

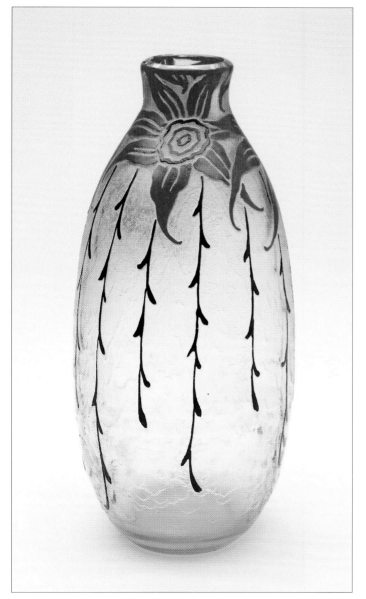

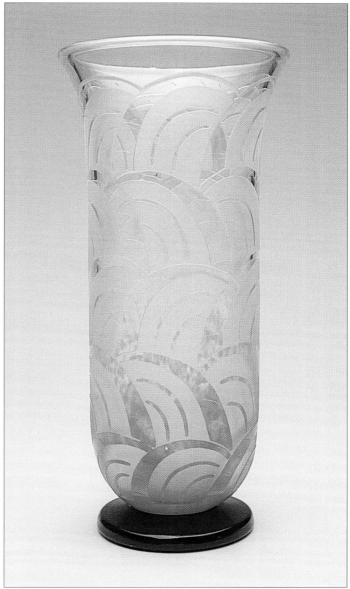

established itself at the turn of the century as a worthy rival of its neighbor, Gallé, re-opened at the cessation of hostilities in 1919 and grew in prestige as the town's other ateliers went into decline. The firm produced a line of thick-walled vases in transparent and opaque colored glass that was on occasions deeply etched with bold geometric patterns, some of which were then mounted in wrought-iron or bronze armatures made by Majorelle. The backgrounds on these pieces were roughly finished to contrast with the polished relief sections, a technique borrowed from Maurice Marinot. Daum also produced cameo vases and lamps in crystal or single colors etched with stylized designs of animals, repeating floral patterns, sunbursts or swirls.

At nearby Epinay-sur-Seine, Ernest and Charles Schneider created large lamps and vases decorated

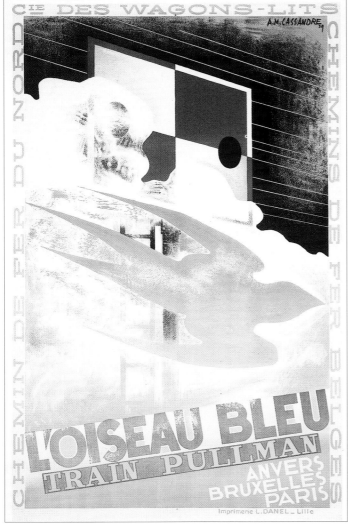

A. M. (ADOLPHE JEAN MARIE MOURON) CASSANDRE (1901-1968) Ukranian-French
L'Oiseau Bleu, 1929. Poster / color lithograph.
Printer: Mouron, Paris.
H: 39in (99.1cm) x W: 24in (61cm) // H: 46in (116.8cm) x W: 31in (78.7cm)

M. A. MILES (dates unknown) English
For the Zoo, 1933. Poster / color lithograph. Printer: The Baynard Press.
H: 39in (99.1cm) x W: 24 ⅜in (61.9cm) // H: 46 ⅜in (117.8cm) x W: 31 ⅜in (79.7cm)

with internal bubbles and mottled or marbleized color effects. Some pieces were decorated with boldly colored glass trailings fashioned into stylized flowers, others with engraved geometric whorls, stylized flora or portrait medallions. Opaque black and orange were among the firm's most distinctive Art Deco colors. Schneider glassware was also sold under the trade names Charder and Le Verre Français or, without a signature, identified by an embedded millefiore cane.

René Lalique's discovery of glass came towards 1900 in the course of his search for new and less expensive materials for his jewelry. Early experimentation included vitreous enamels and glass cast by the *cire perdue* method. It was in the latter technique that Lalique produced his first all-glass objects between

M. A. MILES (dates unknown) English
Kew Gardens, 1934. Poster / color lithograph. Printer:
The Baynard Press.
H: 39 ⅝in (100.6cm) x W: 24 ⅝in (62.5cm) // H: 46 ⅜in (117.8cm)x
W: 31 ⅜in (79.7cm)

exquisite jewel-like colors ranging from emerald green
to ruby red. Other forms of decoration were achieved
by painting or staining with enamels, frosting with
acids, "antiquing" or simulating the effects of aging, or
by polishing with rouge or high speed buffers.

Lalique's repertoire of decorative motifs was equally
varied: naturalistic or stylized animals, flowers, human
and mythical forms, and abstract geometric patterns. A
wide array of items was produced for the domestic
market: vases, tableware, *garnitures de toilette*, *brûle
parfums*, jewelry, clock cases, mirrors, *luminaires* and
light fixtures, plus architectural paneling, fountains
and car mascots for the world beyond. Lalique's huge
success led predictably to a host of imitators, including
Marius-Ernest Sabino, Edmond Etling, Legras & Cie.,
and Genet & Michon.[9]

ROBERT BONFILS (1886-1972) French
Paris, 1925. Poster / color lithograph, 1925. Printer: Imprimerie
de Vangirand, Paris. The official poster commissioned for
L'Exposition des Arts Décoratifs et Industriels Modernes in Paris,
1925.
H: 23in (58.4cm) x W: 15in (38.1cm) // H: 31 ½in (80cm) x
W: 23 ½in (59.7cm)

1893-97. Continuing to explore the medium, his glass
vessels in 1906 caught the attention of the *parfumier*
François Coty, who commissioned him to create labels
and *flaçons* for his various perfume lines. Gradually
phasing out his jewelry production, he consolidated
his emphasis on glass in 1918 with the purchase of a
large factory at Wingen-sur-Moder.

Lalique's glassware, which incorporated
exceptionally high relief and finely detailed
decoration, was made in three ways: by blowing the
molten glass into molds by mouth; mechanically by an
aspirée soufflé or *pressé soufflé* process, or by casting
with a stamping press. The base material was always
demi-crystal, glass with a 50% lead content that was
either left clear or colored to produce an array of

Glass produced in the interwar years in the rest of Europe and Scandinavia was derivative of the styles and techniques developed in France, with one exception. At Orrefors, in Sweden, glass designers brought new techniques and decorative effects to the medium in its creation of Graal and Ariel, both in part through the innovative genius and energies of the firm's formidable duo of Simon Gate and Edward Hald. The later addition of Vicke Lindstrand and Edvin Öhrström provided Orrefors with the era's most dynamic team of modernist designers.

The wealth of artistic talent in the modernist ceramics of the 1919-39 period in France fell broadly into three distinct categories: first, and most important, the creations of the artist-potter, direct heir to the reform movements of the late 19th/early 20th century era; second, the wares of the more traditional manufactories, especially Sèvres, which had been in continuous production since the 18th century; and third, the birth of industrial ceramics – the offspring of the union between art and industry – in which wares were designed expressly for serial production.

The potteries of Robert Lallemant, dating from the 1920s and early 1930s, reflected the vogue in France at the time for angular forms. These pieces were generally decorated with sporting scenes, stylized 18th century vignettes, or quotations from popular verse. A similar series of crisply angular forms and bird figures designed at the time by Jacques and Jean Adnet were produced by the Faïencerie de Montereau.

In Belgium, the modern style was vigorously adopted by the firm of Keramis, owned by Boch *frères*, in La Louvrière. Charles Catteau designed a wide selection of Parisian high-style ceramics wares in which leaping gazelles and flower sprays predominated. His choice of brilliant turquoise blue glazes on crackled ivory grounds was reminiscent of Edmond Lachenal's 1900 palette. Further north, at the Gustavsberg Porcelain Works outside Stockholm, Wilhelm Kåge produced an edition of Agenta stoneware characterized by high-style Art Deco chased silver images applied to green-glazed grounds that resemble verdigris bronze.

In England, Clarice Cliff's "Bizarre" tablewares, produced by the Newport Pottery from 1928, have come to symbolize the decorative exuberances and

JEAN DUNAND (1877-1942) Swiss-French
Dresser Set, 1925-30. Black lacquer background with inlaid *coquille d'œuf* (crushed eggshell). Marks on bottom of covered box: *JEAN DUNAND*. Three pieces en suite as a set comprised of: a. Plateau. Coquille d'œuf, lacquer on copper
H: 10 ¾in (27.3cm) x W: 10 ¾in (27.3cm) b. Covered Box. Coquille d'œuf, lacquer on wood H: 2in (5.1cm) x D: 6in (15.2cm)
c. Hand Mirror. Coquille d'œuf, lacquer on wood with mirror H: 13 ¾in (34.9cm) x W: 6 ¼in (15.9cm)

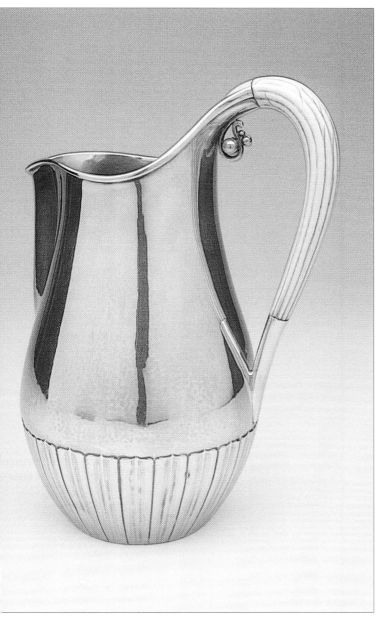

JOHAN ROHDE (1856-1935) Danish
Pitcher, c.1920. Handwrought sterling silver with carved ivory handle. Made by Georg Jensen, Copenhagen (founded 1904). Marks incised on bottom: *DESSIN* / manufacturer's mark / *925.S* / *DENMARK* / *GEORGE JENSEN* monogram / *STERLING* / *4B5*. H: 11 ¼in (28.6cm) x W: 8in (20.3cm) x D: 5 ½in (14cm)

CAMILLE FAURÉ (1872-1944) French
Vase, c.1925. Limoges enamel-on-copper. Pyriform vessel enameled in low and medium relief with arcs and circles in cobalt, turquoise, gray-blue, white and black. Marks: Signed in gilt *C. Fauré Limoges*. H: 12in (30.5cm) x W: 7in (17.8cm)

excesses of the Art Deco style in their use of riotous colors and eccentric geometric shapes. Clever marketing schemes and moderate prices helped to popularize her wares.

The application to American design in the 1920s and 1930s of the two European Art Deco strains of progressive design – the Art Deco of France and the Modernism of Germany and Austria – fell into two distinct categories: those of architecture and the broad spectrum of the decorative (i.e. applied) arts. As will become evident, vanguard European decorative art

was interpreted differently in the U.S. in these two fields, both of which then underwent pronounced modifications of their own in the wake of the stock market crash of October, 1929. The impact of the crash cannot be overstated. Among its influences on the decorative arts was the creation of the profession of industrial designer, which in turn led to a vast project of product re-design, carefully staged to re-stimulate consumer buying in the 1930s.

The American architect adopted as his modernist grammar of ornament the vibrantly colored and

WIWEN NILSSON (1897-1974) Swedish
Coffee Service, 1930. Sterling silver. Three-piece set comprised of coffee pot, creamer and sugar basin with lid. Made by A. Nilsson, Lund, Sweden. Marks inscribed on bottom: *Wiwen Nilsson* / manufacturer's insignias / *STERLING*.
Coffee pot: H: 10 ⅛in (20.6cm) x W: 6 ½in (16.5cm) x D: 4in (10.2cm)
Creamer: H: 4 ⅛in (104.8cm) x W: 3 ½in (8.9cm) x D: 2 ½in (6.4cm)
Sugar basin: H: 3in (7.6cm) x W: 5 ¼in (13.3cm) x D: 3 ½in (8.9cm)

SIMON GATE (1883-1945) Swedish
Centerpiece Bowl with Underplate, 1925. Wheel engraved glass. Designed for Orrefors Glasbruk, Orrefors, Småland, Sweden. Design exhibited in the 1925 Paris Exposition des Arts Décoratifs et Industriels Modernes. Marks: signed.
H: 4 ½in (11.4cm) x W: 15in (38.1cm) x D: 9in (22.9cm)

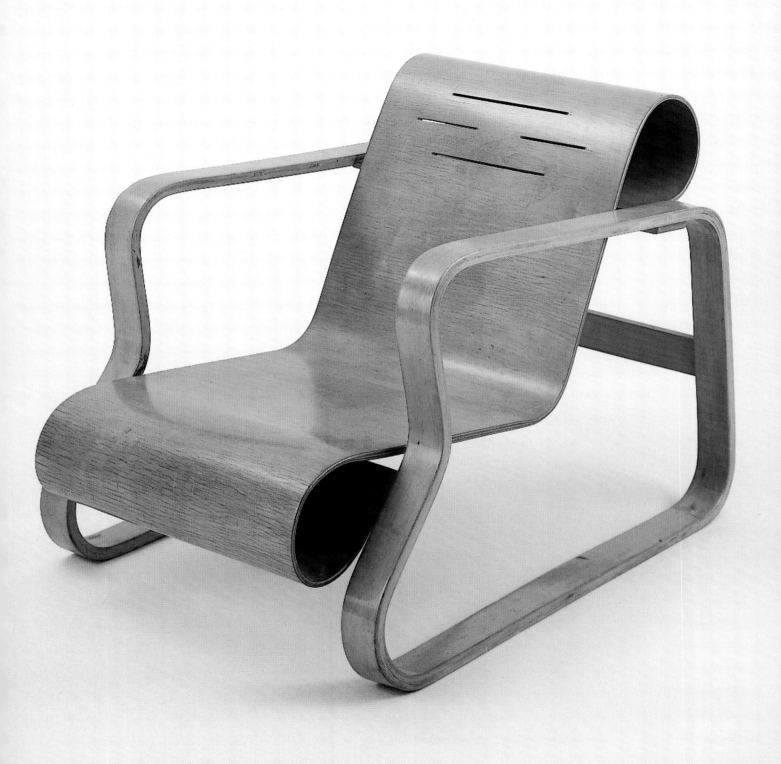

ALVAR AALTO (1898-1976) Finnish
Paimio Lounge Chair, 1931-32. Original finish, on seat and back of molded and laminated plywood with
laminated birch sides bent into a closed form. Model no. 41. Marks: *NEW FURNITURE, CORPORATED* (Number obscured)
ROCKEFELLER PLAZA, NEW (obscured) *YORK CITY N.Y.* stamped on back of seat.
H: 26in (66cm) x W: 23 ¾in (60.3cm) x D: 35in (88.9cm)

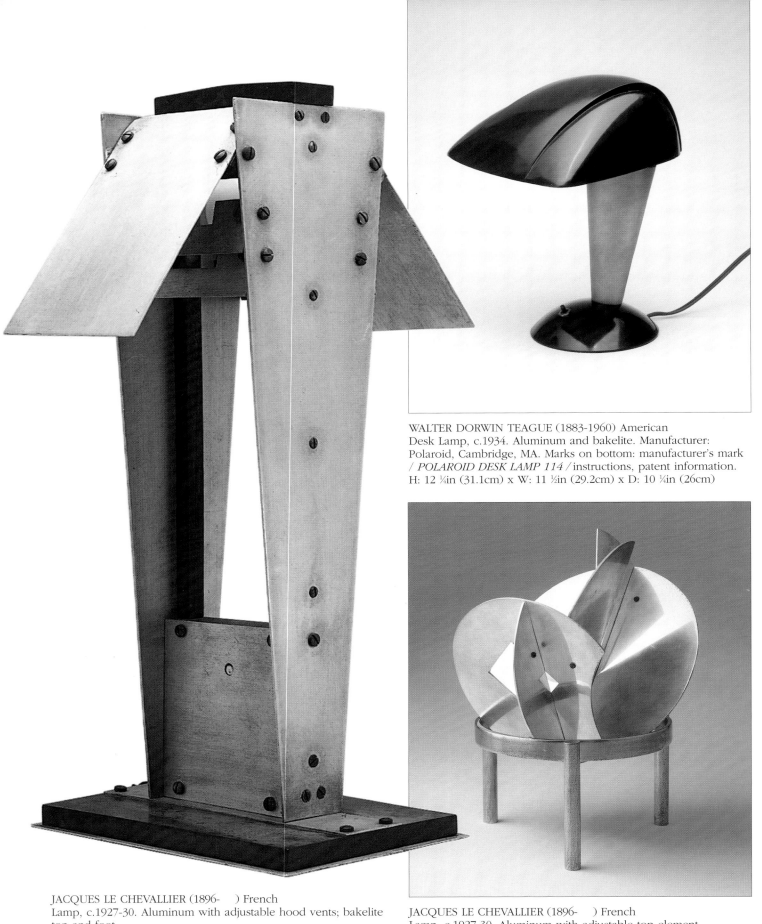

WALTER DORWIN TEAGUE (1883-1960) American
Desk Lamp, c.1934. Aluminum and bakelite. Manufacturer:
Polaroid, Cambridge, MA. Marks on bottom: manufacturer's mark
/ *POLAROID DESK LAMP 114 /* instructions, patent information.
H: 12 ⅛in (31.1cm) x W: 11 ½in (29.2cm) x D: 10 ⅛in (26cm)

JACQUES LE CHEVALLIER (1896-) French
Lamp, c.1927-30. Aluminum with adjustable hood vents; bakelite
top and foot.
H: 16 ½in (41.9cm) x W: 7 ½in (19.1cm) (at base) x
D: 11in (27.9cm) (variable)

JACQUES LE CHEVALLIER (1896-) French
Lamp, c.1927-30. Aluminum with adjustable top element.
H: 10in (25.4cm) x W: 9in (22.9cm)

DESIGNER UNKNOWN (French)
Jumo Desk Lamp, 1945. Bakelite plastic with articulated chrome
and brass arms designed to collapse into its base.
H: 18in (45.7cm) x W: 11in (27.9cm) x D: 7 ⅜in (18.8cm) (extended)

J. BRUNDAGE (dates unknown) American
Lamp, c.1928-30. Frosted glass, chrome plated metal and Bakelite.
Prototype design.
H: 10 ½in (26.7cm) x D: 6 ½in (16.5cm) (at base)

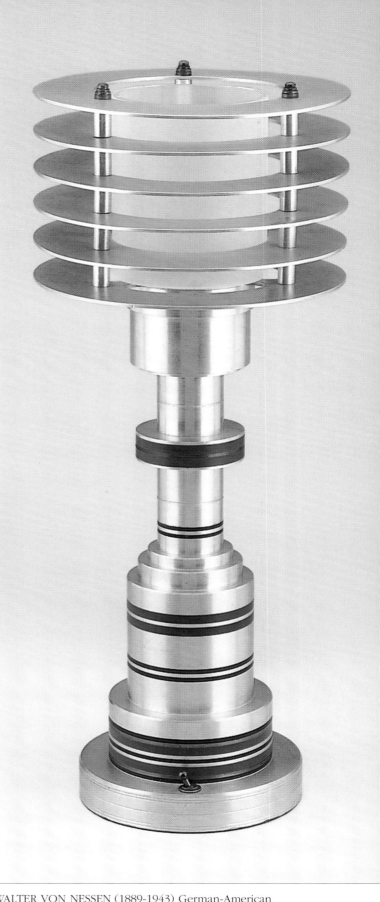

WALTER VON NESSEN (1889-1943) German-American
Table Lamp, 1935. Aluminum, bakelite and glass.
Manufacturer: Pattyn Products Co., Detroit.
H: 20in (50.8cm) x D: 8in (20.3cm) (shade)

DESIGNER UNKNOWN (Italian)
Tea and Coffee Service, c.1930.
Silver. Four-piece set comprising coffee pot, teapot, creamer and sugar basin.
Teapot: H: 7in (17.8cm) x W: 7in (17.8cm) x D: 6in (15.2cm)

Most silverware designers had to be more conservative than their counterparts in the other
arts because they had a more traditional clientele. The Modernist philosophy of eliminating
surface decoration could not be applied at once. What emerged was a traditional *Modern
Class* style, a marriage between new and old and, more often than not, dignified, rational
and understated. Not so the Italians. Their designs of the interwar years are notable for
innovative, unadorned forms, often suggesting a streamlined dynamism. Unsurprising,
since it was the Italian poet Marinetti who, as early as 1909, published the Futurist
manifesto which heralded the machine, urban life and *speed* as the visual expressions
of a new reality. In comparing coffee and tea services of this period, one can trace
their functional development, particularly how similar functions were resolved
for each piece and how the respective elements related to one another. The
handle suggests a reference to both irons and tea kettles of the same period.
This is one of the few services in which each piece is identical except in
size. When placed in a row, as was obviously intended, they successfully
capture the essence of movement. Marinetti would have been pleased.

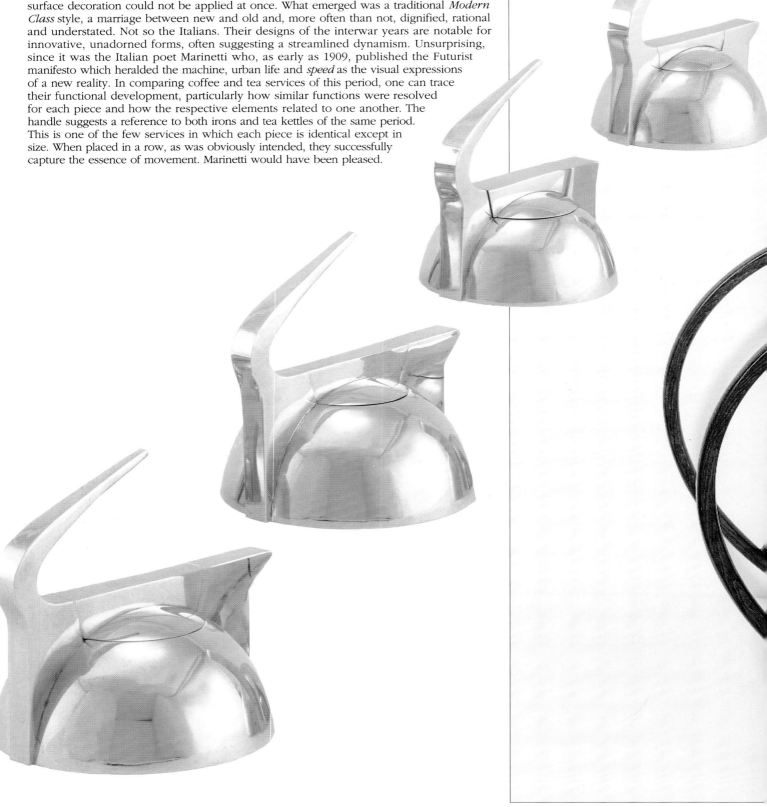

DESIGNER UNKNOWN (Italian)
Egg Rocking Chair, c.1922. Polished beech; back and seat in cane. Manufacturer: Società Anonima
(Antonio Volpe), Udine, Italy. Model No. 267 in the firm's sales catalogue.
H: 29 ¼in (74.3cm) x W: 21 ¼in (74.3cm) x D: 42 ¼in (107.3cm)

One of the most arresting forms of the 20th century, this celebrated *Egg Rocker* seldom fails to elicit an immediate response.
As sculptural form, the chair stands alone, but its provenance also greatly adds to its flavor. For years, traditional
scholarship attributed the design to Josef Hoffmann, and it was thought to have been made by Jacob and Josef Kohn,
a Viennese firm in specializing in bentwood furniture. A new body of information now supports the argument
that the chair is Italian made, not Viennese, manufactured by the firm Antonio Volpe (designer unknown),
in Udine some time in the 1920s. Volpe began manufacturing bentwood furniture as early as 1884
and by the turn of the century it was promoting its highly original designs as a marketing device.
Curiously – adding further to the enigma – the chair has a J & J Kohn manufacturer's label
attached to the bottom of the seat. Yet, this model does not appear in any known Kohn
catalogue, and no example has yet been found that bears a Kohn label or the mark
of any other manufacturer. Over the years, the chair has been informally and
affectionately referred to as the *Egg Rocker* in deference to its two oval side
elements. It was produced in various forms, including a version with an
adjustable back-rest and one with an adjustable leg-rest. Devoid of
decoration other than its structural elements, it echoes the
form follows function tenets of the Bauhaus,
but with considerable élan.

A.M. (ADOLPHE JEAN MARIE MOURON) CASSANDRE (1901-1968) Ukrainian-French
Nord Express, 1927. Poster / color lithograph. Designed for French National Railway. Printed by Hachard et Cie, Paris.
H: 41 ¾in (105.1cm) x W: 29 ½in (74.9cm) // H: 45 ½in (115.6cm) x W: 33in (83.8cm)

PIERRE-FÉLIX FIX-MASSEAU (1905-1994) French
Exactitude, 1932. Poster / color lithograph. Printer: Edita, Paris. Designed as an advertisement for the
French State (État) Railways. H: 39 ⅛in (99.7cm) x W: 24 ¼in (61.6cm) // 44in (111.8cm) x 29 ½in (74.9cm)

GERALD SUMMERS (1899-1967) English
Armchair, c.1934. Laminated birch. Manufacturer: Makers of
Simple Furniture, Ltd., London. Original label affixed to seat.
H: 30 ⅛in (76.5cm) x W: 24in (61cm) x D: 34in (86.4cm)

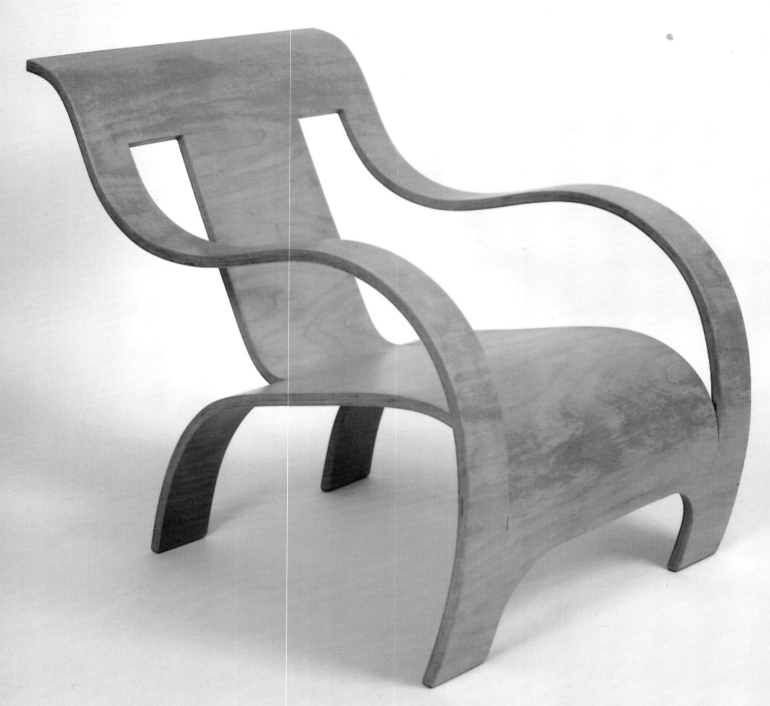

Cut from a single sheet of plywood and given its final form without joinery of any kind, Gerald Summers' armchair is audaciously simple in construction. Although Summers must have been aware of the modern plywood furniture of Finnish architect-designer Alvar Aalto (shown in London in 1933), the immediate impetus for this design was apparently a commission for furniture to be used in tropical climates; by eliminating joinery and upholstery, Summers avoided the problems of weakened joints and rotting caused by extreme humidity. The chair was manufactured by Summers' own London firm, The Makers of Simple Furniture. As an early work of single-piece construction, it would not be equaled again for several decades as the same objective continued to elude designers working in metal and plastics. Its Zen-like simplicity, fluid contour and implied minimal production cost continue to satisfy those bent on practicality as well as the high-minded design connoisseur. Today, it stands as a textbook example of ingenious problem-solving in industrial design.

JULES BOUY (1872-1937)
French-American
Music Cabinet, c.1925-30.
Maple, ebonized and green
stained wood; nickeled bronze
and velvet drawer lining.
H: 65in (165.1cm) x W: 28in
(71.1cm) x D: 14in (35.6cm)

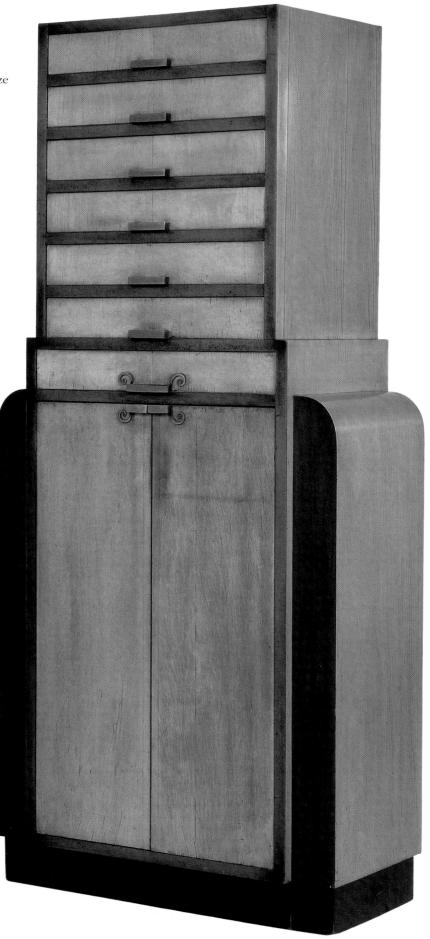

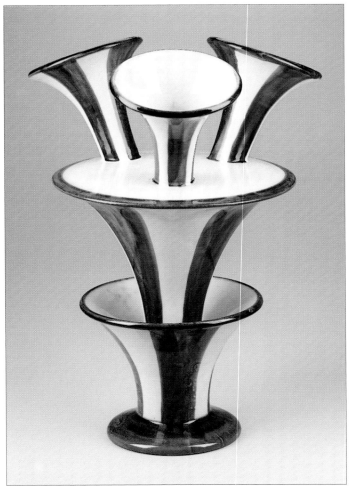

VERNON GOTHEIN (1892-1935) German
Vase, 1930-35. Ceramic (glazed majolica). Manufacturer: Karlsruhe
Majolica Manufacture. Marks: Artist mark incised on bottom.
H: 13 ½in (34.3cm) x D: 8in (20.3cm)

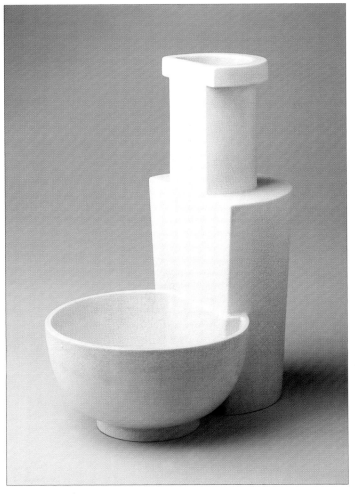

WILHELM KÅGE (1889-1960) Swedish
Vase / Bowl, c.1940. Matt white glaze with craqueleur surface.
Designed by Kåge for Gustavberg's *Surrea* series. Manufacturer:
Gustavsberg Pottery (founded 1827), Värmdö, Sweden.
H: 13in (33cm) x W: 7 ¼in (18.4cm) x D: 10 ¼in (26cm)

fanciful style which ruled the French capital in the immediate post-First World War years, and which arrived in the United States before the older, more austere and restrained Austrian-German variation.

The reason for this was largely because architecture's advances preceded those of the decorative arts in the U.S. by five to seven years. In 1923-25, when the skyscraper boom began in earnest, the only distinctly modern, and therefore appropriate, decorative style on which the architect could draw to embellish his setbacks and entrance lobbies, was to be found at the Paris Salons. In the U.S., quite simply, no modern style existed. As an architectural critic explained in 1912, "We have almost always borrowed our ornament from Europe. The plan and construction of all our buildings, from houses to skyscrapers, is as distinctly American as their ornament is European. It has always been so, and the discouraging aspect of 'this modernism' is that we are continuing the same practice, for while we are

evolving our own forms we are taking our ornament from the exposition of modern decorative arts in Paris or from the European publications exploiting the modern movement. Why do we do this? Because the forms of our buildings are determined by factors of stern necessity – purpose, cost, and available materials; the ornament is an amenity. 'They do things better in France', and we are so frightfully rushed that no architect seems to have time to evolve original ornament. The study of original design is not taught in our architectural schools, and we have no important schools of industrial design; in consequence, we have no great decorative artists..."[10]

For American architecture to come of age, and thereby to obtain independence, it had to rid itself of all traces of past influence. All at once neoclassical entablatures, columns, flying buttresses, gargoyles, architraves and all the standard Beaux-Arts motifs were *passé*, tired remnants of bygone eras. And if the jazzy

WILHELM KÅGE (1889-1960) Swedish
Vase, c.1930-40. Porcelain with mottled green glaze and
modernist geometric design overlaid in silver deposit. Marks:
GUSTAVSBERG / ARGENTA (with anchor); in script *Made in
Sweden; A27VJ; gold stamp.* Designed for Gustavsberg Pottery
(founded 1827), Värmdö, Sweden. Attributed to Wilhelm Kåge.
H: 13in (33cm) x D: 5 ⅛in (13cm)

CLARICE CLIFF (1892-1972) English
Sun Ray Double-handled Lotus Jug, 1929-30. Glazed pottery with
sun ray and skyscraper motif.
H: 11 ¾in (29.8cm) x W: 10in (25.4cm)

zig-zags, lightning bolts and sunbursts that took their
place were not native-born, at least they were
spankingly new.

Art Deco decoration was used as a transitional
device to alert the eye to a change in the building's
contours. Stepped vertical decoration was found to
accentuate a skyscraper's height, horizontal
decorative bands that of the rhythmic ascent of its set-
backs. In addition to its exterior use in this manner,
ornamentation was concentrated on that part of a
building seen and used most by its occupants, i.e. the
entranceway, including its exterior grillework, doors,
vestibule and bank of elevators. Often a sumptuous
combination of stone, brick, terracotta and metal
were combined to transform an otherwise bland
1920s structure into a source of great civic pride.
French Art Deco motifs found their way in this
manner also on to the facades and interiors of movie
palaces, diners, banks, gas stations, bars, hotels and

schools throughout the nation.

The immediate post-war Art Deco style in France
appealed to the emotions, its late 1920s Modernist
successor to the intellect. The traditional artist-
designers of Paris, such as Ruhlmann, Leleu, Follot,
and Sue et Mare, faced a new and contradictory brand
of Modernism when the curtain fell on the 1925
Exposition Universelle, one which advocated
functionalism, mass production, and new materials
appropriate to the new age; in short, France's first
authentic 20th century style, one whose protagonists
rallied at the 1930 Salon of La Société des Artistes
Décorateurs under the banner of the Union des
Artistes Modernes (U.A.M.).[11] Foremost exponents
included Herbst, Jourdain, Adnet, and Mallet-Stevens.
These modernists were increasingly outspoken in their
criticism of Art Deco designers who catered to select
clients in the creation of elaborately crafted *pièces
uniques*. The new age required nothing less than

LA MAISON DESNY (French)
Centerpiece *Coupé*, c.1927-28. Nickel-plated brass. Designed by Desnet and René Nauny. Manufacturer: La Maison Desny, Paris.
Marks: signed *DESNY PARIS MADE IN FRANCE DEPOSE,* manufacturer's mark.
H: 6in (15.2cm) x W: 10in (25.4cm) x D: 10 ⅜in (26.4cm)

excellent design for everyone; quality and mass production were not mutually exclusive. The future of the decorative arts did not rest with the rich and even less with their aesthetic preferences. An object's greatest beauty lay, conversely, in its perfect adaptation to its usage. Each epoque must create a decorative vocabulary in its own image to meet its specific needs, and in the late 1920s this aim was best realized by the machine.

It was this second phase of the French Art Deco movement which in the late 1920s helped to establish the modernist artist-designer in the U.S. This time, however, France's role was not that of pioneer. Long before the sharply functional furnishings of the French vanguard architect Pierre Chareau were first seen in 1928 at New York department stores, north European immigrants such as Bruno Paul and Lucian Bernhard, from Germany; William Zorach and Boris Lovet-Lorski from Russia; and Joseph Urban, Paul Frankl and Wolfgang and Pola Hoffmann, from Austria, had been working hard to promote the same ideology in their adopted country. The arrival of the later French examples served simply to reinforce the foundations already laid.

Other immigrants, both in the 1920s and earlier, included from Germany, Peter Müller-Munk and Walter von Nessen; from Hungary, Ilonka and Mariska Karasz; from Switzerland, William Lescaze; from Greece, John Vassos; from Denmark, Erik Magnussen, and from Finland, Eliel Saarinen. Their reasons for selecting the U.S. were diverse, including an escape from economic hardship and political oppression, and the chance of a fresh beginning in the New World. Modernism's cause was assisted in New York from

DESIGNER UNKNOWN (German)
Handbag, c.1930. Aluminum with enamel insert decoration and silk lining. Calling cards inside impressed: *Clementine E. Byrne*.
H: 5 ¾ in (14.6cm) x W: 8 ⅜in (22.2cm) x D: 1 ¾in (4.4cm) (open at base)

DESIGNER UNKNOWN (German)
Handbag, c.1930. Various leathers and glass mirror. Marks: D.R.P. Nurnberg.
H: 5 ⅜in (14.6cm) x W: 12 ½in (31.8cm) x D: 1 ⅛in (3.2cm)

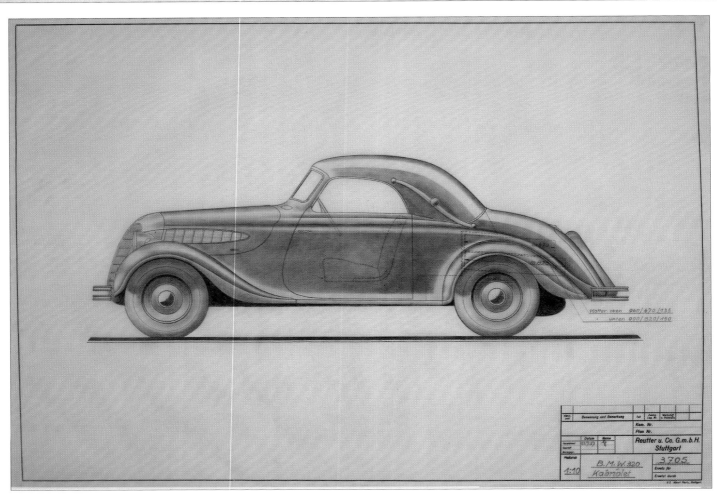

Koffer oben 960/670/135
unten 900/820/150

	Benennung und Bemerkung	Tol	Zultg Ing.-Nr.	Werkstoff u. Halbzeug			
			Kom. Nr.				
			Plan Nr.				
Gezeichnet	Datum 25.7.37	Name	Reutter u. Co. G.m.b.H.				
Geprüft			Stuttgart				
Norm.-gepr.							
Maßstab 1:10	Werkstoff		B.M.W. 320	3705			
			Kabriolet	Ersatz für			
				Ersatz durch			

R. BUCKMINSTER FULLER (1895-1983) American
Dymaxion Car, 1934. Pencil on trace paper.
H: 12 ¾in (32.4cm) x W: 41 ⅜in (106cm) // H: 12 ¾in
(32.4cm) x W: 50 ¼in (127.6cm)

REUTTER & COMPANY, Stuttgart (German)
BMW Sport Kabriolet 320, 1937. Shaded pencil on
waxed parchment. Drawing No. 3705. Scale size: 1:10.
H: 17 ½in (44.5cm) x W: 24 ⅜in (62.5cm)

ROBERT GRESENDORF (dates unknown) American
Presentation drawing, 1936. Rendering of 1937 Nash
Lafayette coupe. Gouache and watercolor on paper.
H: 24in (61cm) x W: 35in (89cm)

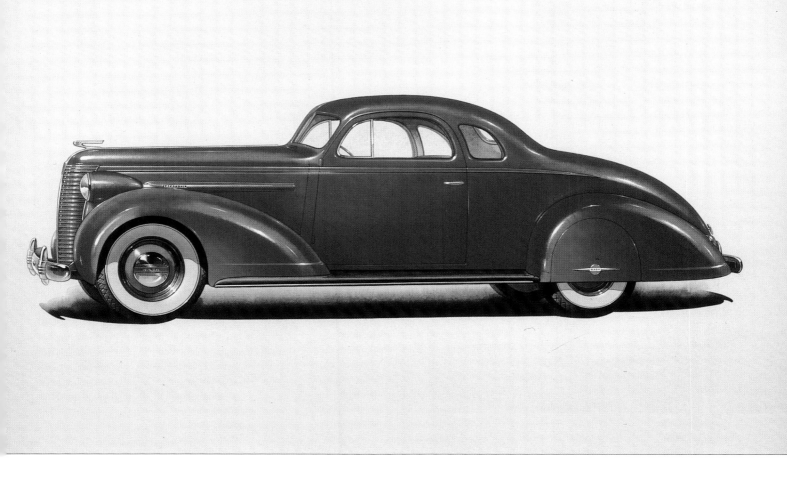

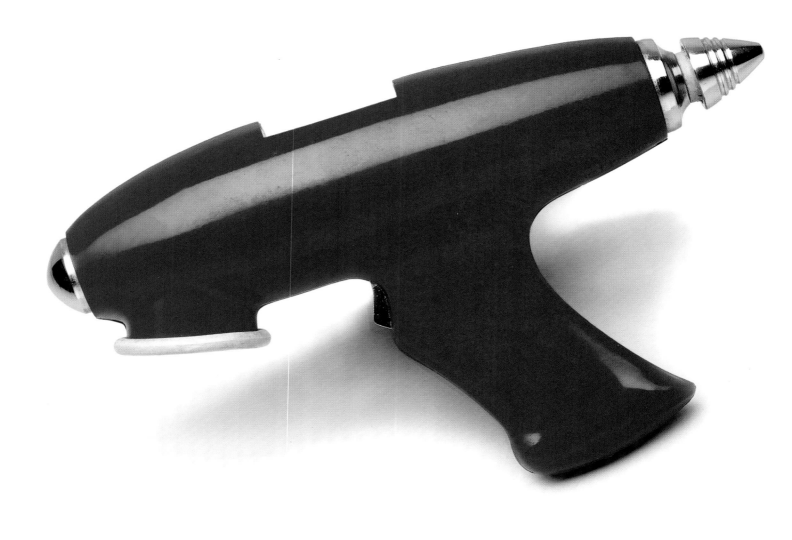

DESIGNER UNKNOWN (American)
Ice Gun, 1935. Enameled steel. Manufacturer: Opco Company, Los Angeles.
H: 6 ½in (16.5cm) x W: 11in (27.9cm) x D: 2 ¾in (7cm)

Philip Nowland and Dick Caulkins began the *Buck Rogers* comic strip in 1930. While the cities portrayed in the serial tended to the eclectic and ornamental, there was little doubt about the future tense of the gadgetry. Earlier sequences in the strip featured teardrop-shaped spaceships, but the space hardware – especially the ray guns – of later adventures became evermore fanciful, inspiring such ingenious devices as this ice gun introduced by the Opco Company in 1935. Activated by a spring-loaded plunger and trigger mechanism, the ice gun was designed to instantly crush an ice cube, "shooting" the ice spray through the hole in the bottom. Extremely rare, it's doubtful that many of these manly playthings were put into production. The few proud possessors must have looked forward to cocktail hour with considerable relish.

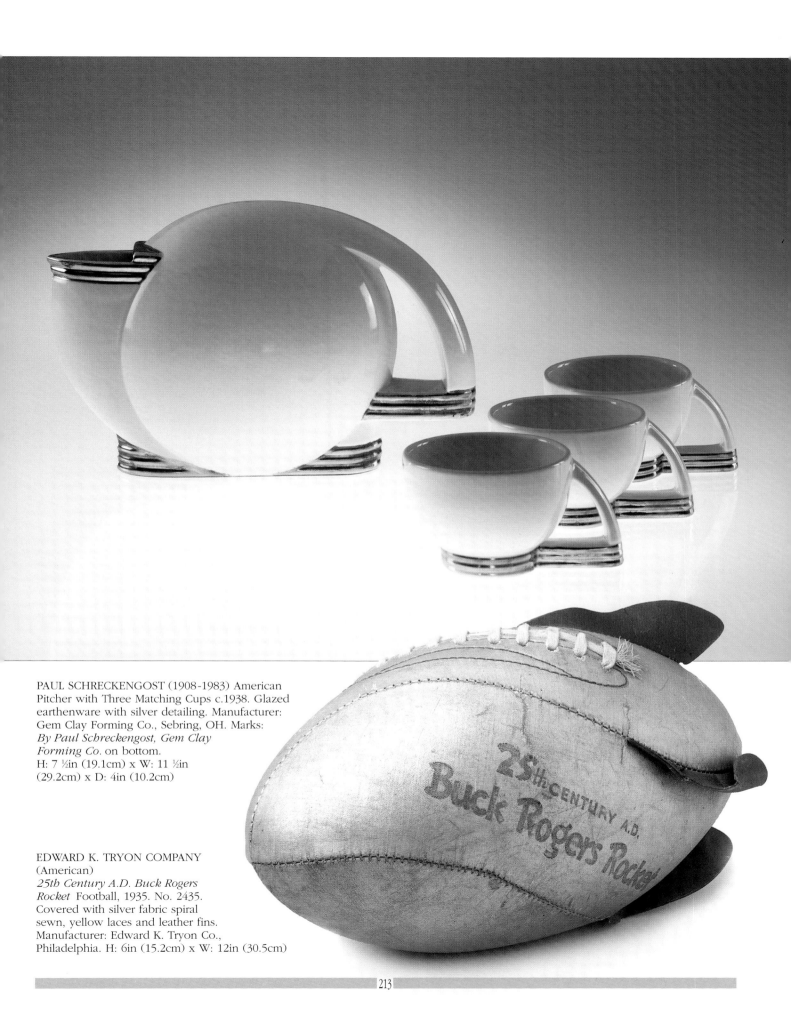

PAUL SCHRECKENGOST (1908-1983) American
Pitcher with Three Matching Cups c.1938. Glazed
earthenware with silver detailing. Manufacturer:
Gem Clay Forming Co., Sebring, OH. Marks:
*By Paul Schreckengost, Gem Clay
Forming Co.* on bottom.
H: 7 ½in (19.1cm) x W: 11 ½in
(29.2cm) x D: 4in (10.2cm)

EDWARD K. TRYON COMPANY
(American)
*25th Century A.D. Buck Rogers
Rocket* Football, 1935. No. 2435.
Covered with silver fabric spiral
sewn, yellow laces and leather fins.
Manufacturer: Edward K. Tryon Co.,
Philadelphia. H: 6in (15.2cm) x W: 12in (30.5cm)

EVA ZEISEL (1906-) Hungarian-American
Coffee pot and Teapot, c.1952. Ceramic. From *Tomorrow's Classic* line produced by Hall China Co., East Liverpool, OH.
H: 6in (15.2cm) x W: 9in (22.9cm) x D: 5in (12.7cm) (coffeepot)
H: 9 ¼in (23.5cm) x W: 4 ¼in (10.8cm) x D: 7 ¾in (19.7cm) (teapot)

1916 by Rena Rosenthal, whose gallery offered contemporary European works by Hagenauer, Josef Hoffmann and others, and by the Wiener Werkstätte, which maintained a Fifth Avenue showroom between 1922-24.

For these immigrant artist-designers joining ranks with the handful of aspiring local modernists, progress was uneven, not only because, in many instances, they were new disciples to modernism's cause and had not yet developed a consistent style or body of work with which to promote themselves, but also because of the country's deep-rooted conservatism and corresponding resistance to change.

Part of the reason for this was because the modernist was too eager in his attempt to be in the vanguard of the movement's growth in America and came on too strongly. Also, unlike his French and German counterparts, the American artist-designer had no Beaux-Arts tradition to fall back on. Until the late 1920s, when American modernist designers were forced to band together to promote their works through the American Designers' Gallery, AUDAC and Contempora, there were no annual exhibitions to match those at the Paris Salons, the German Werkbund, or the Austrian Hagenbund. Had it not been for the ground-breaking efforts of certain individuals, such as John Cotton Dana at the Newark Museum around 1912, to promote progressive European design through traveling museum shows and, later, industrial art exhibitions at New York's Metropolitan Museum of Art, modernism in the U.S. would have existed in a vacuum until the 1926 traveling museum exhibition of items from the 1925 Exposition Universelle. Even the American department stores, which could have learned from the large Parisian *maisons* how to establish themselves as arbiters of taste by controlling their manufacturers and thereby their products, vacillated until they were thrown into the modernist arena with everyone else in 1927 and 1928. Government and private financial support, so vital to the establishment and growth of European design schools such as the Bauhaus and Wiener Werkstätte, were likewise absent in the U.S. until the New Deal public works of art programs were

H. V. THADEN
(dates unknown) American
Chair, 1947.
Bent plywood with metal fasteners.
Manufacturer: Thaden Jordan Furniture
Corp., Roanoke, VA.
H: 42 ¾in (108.6cm) x
W: 20in (50.8cm) x D: 32in (81.3cm)

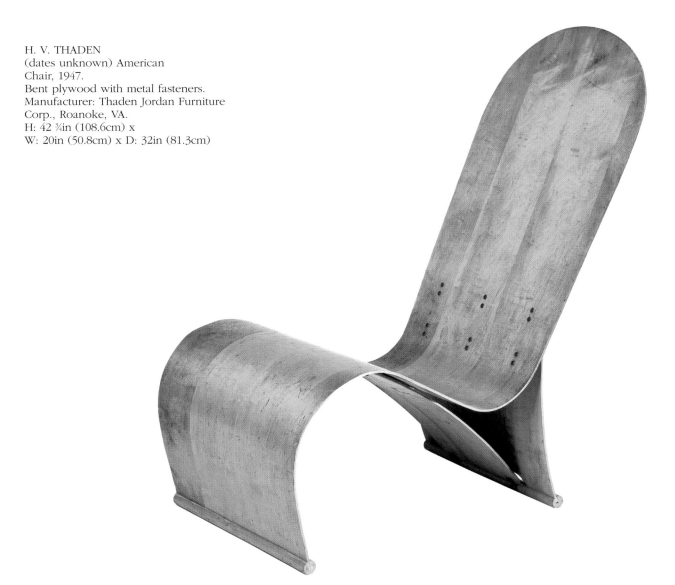

implemented, from 1933.

Modernism's progress was therefore uneven in the U.S., due in part also to the fact that its application within the different disciplines of the decorative arts varied. The sparkling new designs introduced in the fields of silver, sculpture, ceramics and textiles often matched those by the premier Europeans of the time; in furniture, however, models were frequently too garish or gimmicky; in glass, mostly nondescript; and in jewelry, in large part non-existent. The reasons for this discrepancy depended on the amount of resistance that the modernist faced from the traditionalists in his field – both manufacturer and consumer – and on the extent of his own creativity. Many of the early models produced by modernist furniture designers, for example, were seen to be in such bad taste that they fortified the position of the period-revival manufacturer. In silver, conversely, the modernist designer, either because he understood better the conservative nature of his market, or because he was less adventuresome, created progressive models which did not offend the

conservative taste of his clientele. For a while, at least until the American critics and public had learned to distinguish between good and bad design, the apologists of Modernism took refuge behind the statement that modern art lent itself very well to some disciplines, but not at all to others.

Designers of accessories for the urban home soon drew on the city's premier 1920s image, the skyscraper, as an appropriate design concept, its terraced form providing the inspiration for a host of home furnishings and appliances.

The first to utilize the skyscraper as a decorative motif, Paul Theodore Frankl arrived in the U.S. in 1914. His first commission, a beauty parlor in the modernist idiom, was for a Mrs. Titus, later known professionally as Helena Rubenstein. Frankl assumed the role of modernism's most ardent crusader and publicist. His writings, including five books, were didactic: modernism championed repeatedly against history's gilded atrocities.[12] Frankl introduced his novel series of skyscraper furnishings in 1926-27, which in their ziggurat forms echoed the contours of the buildings

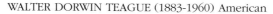

WALTER DORWIN TEAGUE (1883-1960) American
Nocturne Radio, c.1937. Mirrored glass with satin-finished chrome work and silver-finished wood. Floor model, no. 1186. Designed in 1935, first produced in 1936. About ten models known to exist; also produced in mirrored peach glass. Manufacturer: Sparton Corp., Jackson, MI.
H: 46in (116.8cm) x W: 43 ¼in (109.9cm) x D: 12in (30.5cm)

If one were to select the ultimate icon of modernity, one dramatically ahead of its time, the *Nocturne* Radio would have to be among the choices. The Sparton Corporation in Jackson, Michigan, introduced this floor model almost 60 years ago. Designed by Walter Dorwin Teague, the *Nocturne* is one of the most compelling radios ever produced. In 1936, it sold for $350 (costing nearly as much as a new Ford car) and was intended for posh hotel foyers where the swank could tune in sumptuous sound (its twelve-tube receiver and twelve-inch electrodynamic speakers provide a far more mellow sound than that found in today's transistor radios). It also features a turning eye *Viso-Glo* tube, push-pull audio output, 1RF and 2RF stages, and an adjustable IF bandwidth control, all installed behind a circular sheath of cobalt blue, mirrored glass. Breaking away from the traditional Gothic, setback mold, the radio was calculated to appeal to a masculine clientele who were more inclined to respond to its future-shock form and space-age technology. The *Nocturne* serves as a clear reminder that good design is timeless.

WALTER DORWIN TEAGUE (1883-1960) American
Sparton Radio, 1936. Cobalt blue mirror, wood and chromium steel. Model #517.
Manufacturer: Sparton Corporation, Jackson, MI.
H: 9in (22.9cm) x W: 18in (45.7cm) x D: 8in (20.3cm)

In contrast to those Art Deco designs cleverly disguised to hide their function, the Sparton radio is emphatically modern. Sight and sound are combined to herald the unlimited promises of tomorrow, its futuristic streamlining suggesting supersonic movement as if it were hurtling through space. As with so many products designed by Walter Teague and Norman Bel Geddes, everything from aerodynamically designed pencil sharpeners to washing machines, the streamlining was more symbolic than functional. Against the rather grim backdrop of the Depression, their ultimate mission was to inspire confidence and create a market. Horizontal lines, rounded corners, sleek surfaces, bold typography and new technology (mica glass) came to typify modernistic design in the 1930s – all conveying a boundless faith in the power of the machine to make a better world. With this radio, Modernism has come full circle, from an anti-machine ethic in the 1870s to unqualified embracement.

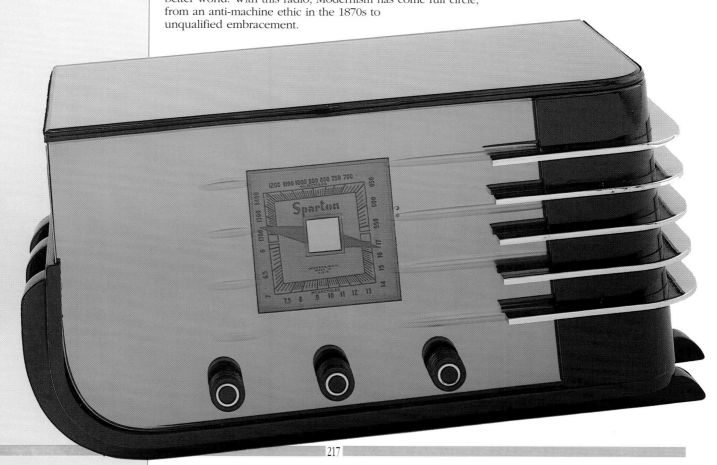

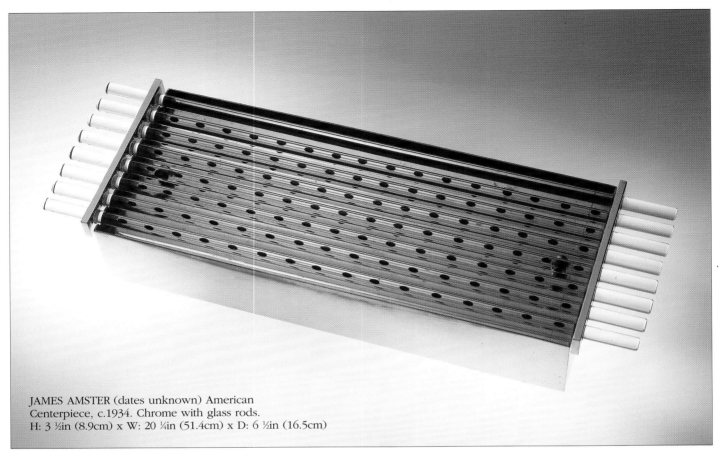

JAMES AMSTER (dates unknown) American
Centerpiece, c.1934. Chrome with glass rods.
H: 3 ½in (8.9cm) x W: 20 ¼in (51.4cm) x D: 6 ½in (16.5cm)

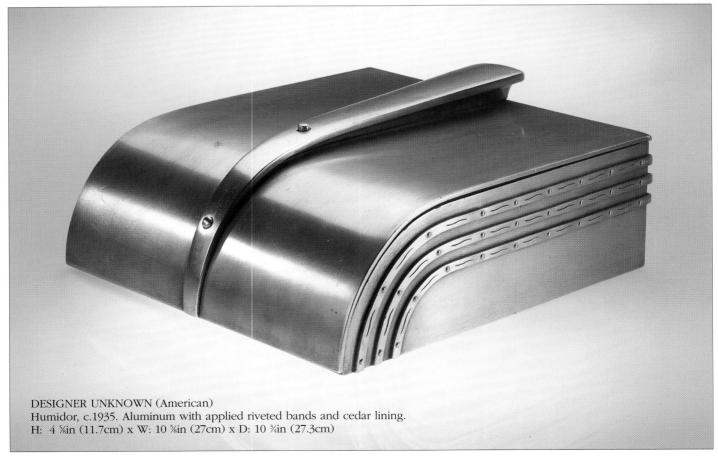

DESIGNER UNKNOWN (American)
Humidor, c.1935. Aluminum with applied riveted bands and cedar lining.
H: 4 ⅝in (11.7cm) x W: 10 ⅝in (27cm) x D: 10 ¾in (27.3cm)

DESIGNER UNKNOWN (English)
Toast Rack, 1927. Silver. Manufacturer: Hukin &
Heath, London. Elements spell out the word:
TOAST. Marks: Hukin & Heath / lion passant / C
/ #10529.
H: 5in (12.7cm) x W: 4in (10.2cm) x
D: 2 ½in (6.4cm)

DESIGNER UNKNOWN (American)
Electric *Handy-Hat* toaster, c.1940. Chrome-
plated and painted metal with plastic feet and
handles. Manufacturer: Chicago Electrical Mfg.
Co., Chicago. Marks: Label affixed to bottom.
H: 7 ⅞in (20cm) x W: 8 ⅝in (21.9cm) x
D: 4 ⅞in (12.4cm)

DESIGNER UNKNOWN (American)
Stapling Pliers, c.1935. Enamel on chromium-
plated metal in geometric art deco design.
Manufacturer: E.H. Hotchkiss Co., Norwalk, CT.
H: 2 ⅜in (7cm) x W: 5 ¹¹⁄₁₆ (14.3cm) x D: ½in (1.3cm)

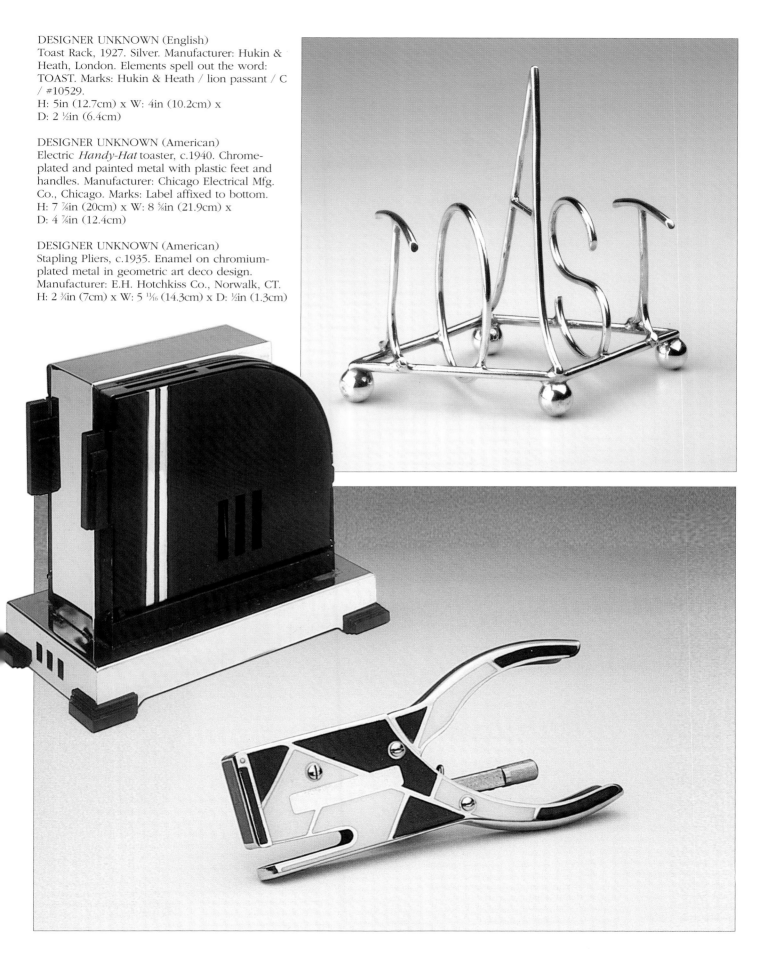

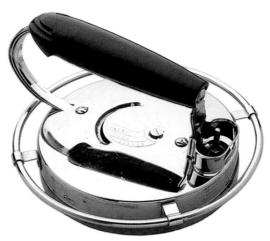

CLIFFORD BROOKS STEVENS (1911-) and EDWARD P.
SCHREYER (dates unknown) American
Petitpoint Iron, c.1941. Chromium and plastic. Manufacturer:
Waverly Tool Co., Sandusky, OH.
H: 4 ⅞in (12.4cm) x W: 10in (25.4cm) x D: 5in (12.7cm)

DESIGNER UNKNOWN (American)
Iron, c.1935. Chrome with Bakelite handle. Manufacturer: Knapp
Monarch Co., St. Louis.
H: 5in (12.7cm) x W: 8in (20.3cm) x D: 7in (17.8cm)

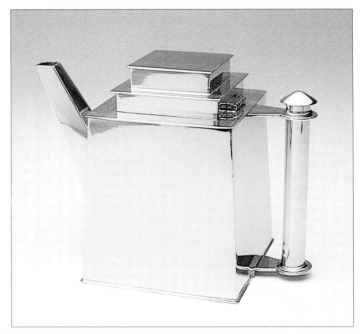

GILBERT ROHDE (1894-1944) American
Z Clock, c.1933. Chromium-plated metal and etched glass.
Manufacturer: Herman Miller Clock Co., Zeeland, MI.
H: 11 ¼in (28.6cm) x W: 9 ½in (24.1cm) x D: 3in (7.6cm)

LOUIS W. RICE (dates unknown) American
Apollo Skyscraper Teapot, c.1927. Silver-plated copper and brass.
Apollo Skyscraper line. Skyscraper with smokestack as handle.
Manufacturer: Bernard Rice's Sons, New York City. Marks
inscribed on bottom: *SKYSCRAPER / APOLLO E.P.N.S. / MADE IN
U.S.A. BY BERNARD RICE'S SONS INC./ 5259.*
H: 6 ½in (16.5cm) x W: 6 ⅛in (15.6cm) x D: 4 ⅝in (11.7cm

DESIGNER UNKNOWN (American)
Ice Bucket with Cover, c.1937. Chromium plated metal with
frosted glass panels and lid. Manufacturer: American Thermos
Bottle Co., Norwich, CT.
H: 5 ⅞in (14.9cm) x W: 10 ¼in (26cm) x D: 8 ¾in (22.2cm)

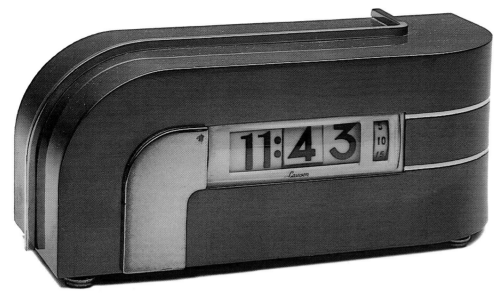

KEM (KARL EMANUEL MARTIN) WEBER
(1889-1963) German-American
Desk Clock, c.1933. Brass and copper.
Original finish. Digital numbers with
celluloid clockface in modernist design.
Manufacturer: Lawson Time Inc.,
Pasadena, CA. Marks on back: inscribed
26463; on metal label: *Lawson ELECTRIC
CLOCK* / model no., pat. no, etc.
H: 3 ½in (8.9cm) x W: 8in (20.3cm) x
D: 3 ⅛in (7.9cm)

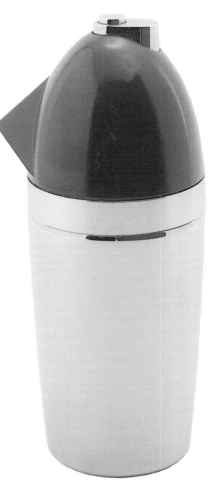

KEM (KARL EMANUEL MARTIN) WEBER
(1889-1963) German-American
Vase, c.1928-29. Handwrought pewter.
Designed by Weber and executed by
Porter Blanchard Silver Company,
Burbank, CA. Marks stamped on side:
*PORTER BLANCHARD / COLONIAL
PEWTER / BURBANK, CAL.*
H: 13in (33cm) x W: 5 ¼in (13.3cm) x
D: 3 ¾in (9.5cm)

RUSSEL WRIGHT (1904-1976) American
Cocktail Set, c.1930. Pewter. Comprised of
shaker, six cups and matching tray. Marks:
Stamped *RW* on bottom of tray and on bottom
of cups.
Shaker: H: 9 ¼in (23.5cm) x D: 4 ½in (11.4cm)
Cups (not illustrated): H: 2 ½in (6.4cm) x D:
2in (5.1cm)
Tray (not illustrated): H: 1 ⅜in (3.5cm) x
D: 10 ⅛in (25.7cm)

NORMAN BEL GEDDES (1893-1958)
American
Soda King Syphon Bottle, c.1935.
Chromium-plated metal, blue enamelled
metal with rubber fittings. Manufacturer:
Walter Kidde Sales Co., Bloomfield, NJ.
H: 13 ½in (34.3cm) x D: 4 ¼in (10.8cm)

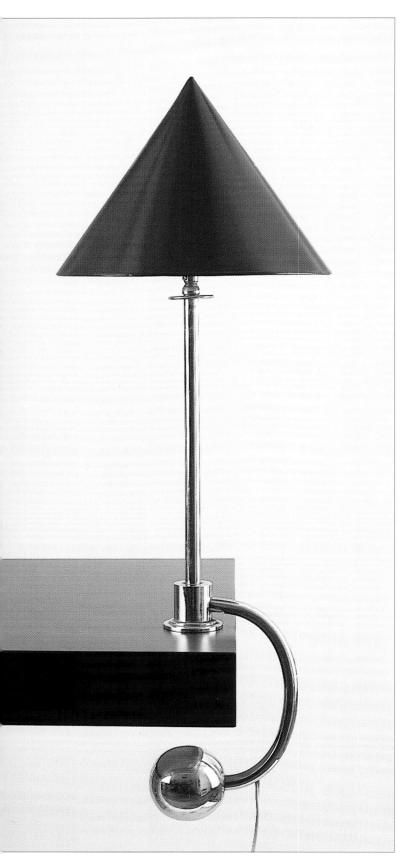

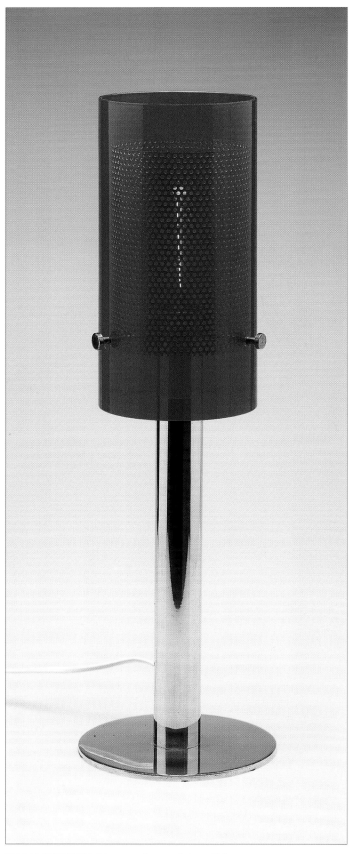

WILLIAM LESCAZE (1896-1969) Swiss-American
Lamp, c.1933. Counter balance form with original chrome plate
and replacement parchment shade. Attributed to Lescaze.
H: 32in (81.3cm) x W: 11in (27.9cm) (shade)

HAJ MARKARYD (dates unknown) Swedish
Table Lamp, c.1950. Solid and perforated brass with circular glass
shade. Marks: signed on base: HAJ MARKARYD, B61.
H: 21 ⁵⁄₁₆in (54.1cm) x D: 6 ¼in (15.9cm) (base)

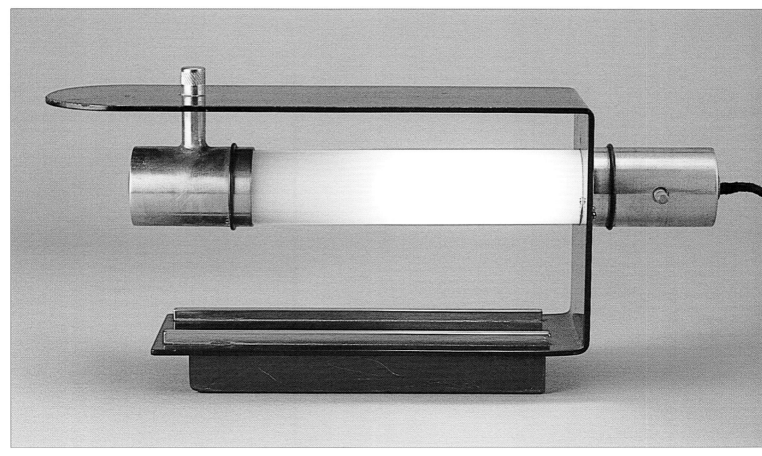

PETER PFISTERER (1907-) German-American
Desk Lamp, c.1935-40. Chrome-plated and enameled steel, with walnut base.
H: 6 ¼in (15.9cm) x W: 13 ½in (34.3cm)

DESIGNER UNKNOWN (American)
Electric Pointer Pencil Sharpener, c.1950. Bakelite. Pat. 1113.
H: 5 ¾in (14.6cm) x W: 3 ½in (8.9cm) x D: 8 ¼in (21cm)

DESIGNER UNKNOWN (American)
Britcher Surgical Spotlight, 1949-50. Bakelite shell casing (Durez thermo-setting phenolic plastic) with cold quartz ultraviolet light.
H: 5 ½in (14cm) x W: 4 ⅝in (11.7cm) x D: 12in (30.5cm)

PAUL T. FRANKL (1887-1958) Austrian-American
Skyscraper Chair, c.1927-30. Red lacquer and silver leaf on wood (restored).
H: 26in (66cm) x W: 20in (50.8cm) x D: 18in (45.7cm)

PAUL T. FRANKL (1887-1958) Austrian-American
Desk, c.1930. Hardwood with red lacquer finish (restored) and chromium-plated
steel, flat band support and brushed chromium crescent handles.
H: 31in (78.7cm) x W: 27 ½in (69.9cm) x D: 20 ½in (52.1cm)

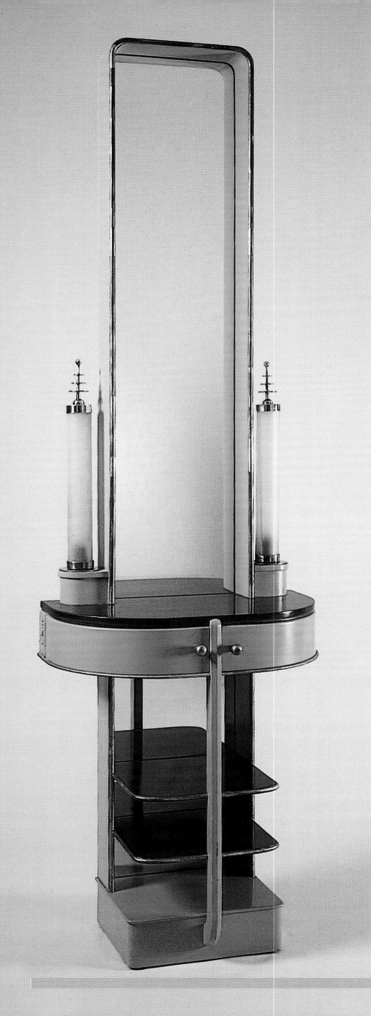

KEM (KARL EMANUEL MARTIN) WEBER (1889-1963)
German-American
Skyscraper Side Table/Vanity, 1928-29. Mirror, burr walnut, glass, silvered and painted wood, chromium-plated metal, maple, and cedar with metal tag: *KEM WEBER*. Designed for Mr. and Mrs. John Bissinger, San Francisco.
H: 75 ⅜in (191.5cm) x W: 22 ⅝in (57.5cm) x D: 12 ¼in (31.1cm)

This bedside table was designed to fit between two twin beds serving as a nightstand with shelves, a dressing mirror and reading lights on two sides. Typical of several architect/designers of the 1920s, the unit is architectonic, part skyscraper form and part futuristic stage-set. This piece has become a celebrated icon of American moderne design, appearing in numerous publications and exhibitions over the years.

that soared above his mid-town New York gallery.

The silver manufacturer, Bernard Rice's Sons, was another effectively to utilize the skyscraper's powerful vertical imagery in a nickel-plated "Apollo" tea and coffee service in which the rectangular vessels were surmounted by architectural set-back tops flanked by handles shaped as smokestacks. Conservative by training in his native Denmark, Erik Magnussen deviated from convention in his brazen design of "The Lights and Shadows of Manhattan" coffee service which was commissioned in 1927 by the Gorham Manufacturing Company. Comprised of triangular panels of burnished, oxidized and gilded silver that evoked the kaleidoscopic effects of sunlight and shade on the American urban skyline, the service stirred passionate sentiments at the time on the issue of whether modern silver design should reflect advancement in other disciplines; in this instance, architecture. Peter Müller-Munk was another European *émigré* silversmith to embrace the modern idiom in the confines of traditionalism, the latter instilled in his Teutonic upbringing.

Amongst the large commercial enterprises whose reputations had been built on period-revivalism, the International Silver Company of Meriden, Conn., provided a spirited contribution to the modern movement in a range of hollow- and flat-ware in silver, silver-plate and pewter, the last two through divisions such as the Wilcox Silver Plate Co. The key to the firm's success lay in its decision to retain outside design consultants to provide it with state-of-the-art modernism, a step from which most large firms by tradition had shied away. Included in its stable of independent designers were Gilbert Rohde, Lurelle Guild, Gene Theobald and Virginia Hamill, the last two who designed three-piece tea services as architectural units housed on conforming trays, which propelled the firm smartly into avant-gardism. Although apparently machine-made, the prototypes had to be finished by hand. The Chase Copper and Brass Company of Waterbury, Conn., was another

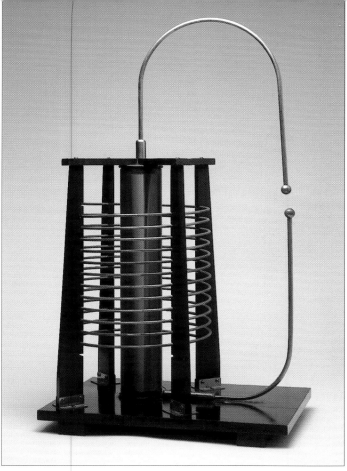

NIKOLA TESLA (1856-1893) Serbian-American
Tesla Coil (High-frequency Discharge Demonstrator),
1931. Steel, copper, wire and wood.
Manufacturer: Welch Scientific Co., Chicago. Label affixed to base:
W.M. Welch Scientific Co., Chicago, IL.
H: 29in (73.7cm) x W: 18 ½in (47cm) x D: 12 ½in (31.8cm)

manufactory to offer a selection of modernist designs
within its standard repertory of traditional styles by the
retention of a number of noted freelance designers,
including Lurelle Guild, Rockwell Kent, Gilbert Rohde,
and Dr. Albert Reimann, the Director of the Reimann-
Schuker School in Berlin.

Most other conservative silver manufactories,
including Tiffany & Company, Reed & Barton, and
Edward F. Caldwell, showed a reluctance to pursue the
modern aesthetic, at least until the mid-1930s. Tiffany's
modernist silver display in the House of Jewels at the
1939 World's Fair surpassed those of its competitors,
showing that it had been corporate policy, rather than
a lack of progressive design expertise, that had kept it
from participating in current trends.

Amongst metal-workers, it was another immigrant,
Walter von Nessen, who emerged as the premier

RAYMOND LOEWY (1893-1986) French-American
Clock-Radio, 1930. Mahogany case in a skyscraper form with clock
face housed in the upper front; radio dials installed on right side
and speaker mounted on top.
Manufacturer: Westinghouse Co., Pittsburgh.
H: 60 ⅛in (152.7cm) x W: 13 ¼in (33.7cm) x D: 11 ½in (29.2cm)

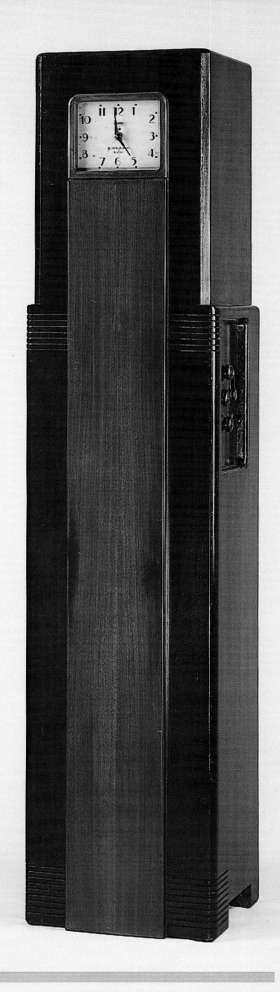

BELLE KOGAN (1902-) American
Serving Dish with Lid, 1938. Silver plate with gilt interior. Lid also functions as serving dish. Designed by Kogan for Reed & Barton, Taunton, MA. Marks: *REED & BARTON 1610 E.P.N.S.* with trumpet and hallmarks.
H: 3in (7.6cm) x W: 13 ⅝in (34.6cm) x D: 9 ¼in (23.5cm)

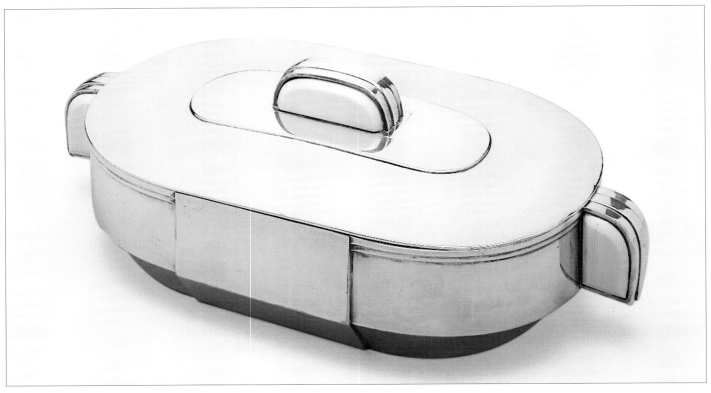

LUC LANEL (dates unknown) French
Covered Serving Dish, c.1930. Silverplate with celluloid handles. Attributed to Luc Lanel. Marks: Christofle touchmark / Gallia #604l.
H: 7 ¾in (19.7cm) x W: 14 ¾in (37.5cm) x D: 7 ¼in (18.4cm)

modernist designer in his adopted country. Establishing his studio in New York after 1923, von Nessen produced a wide range of contemporary metal furnishings and light fixtures, principally for architects. To accommodate both direct and indirect illumination, von Nessen's shades could tilt, rotate and upend themselves, devices utilized also by one of his lighting competitors, Kurt Versen.

The Depression put an end to skyscraper imagery, with its connotations of capitalism and unbridled entrepreneurship, which seemed suddenly so inappropriate to the new age. Even Frankl, who had achieved such celebrity through it, fully reversed himself in 1932 in his observation that "skyscrapers… are a passing fad. The tallest of them, the Empire State, is but the tombstone on the grave of the era that built it… skyscrapers are monuments to the greedy".[13]

From 1930 an authentic fresh image was needed to stimulate both industry and the buying public, and to propel the nation out of economic stagnation. Based on sound aerodynamic principles, the optimum form became that of the teardrop, amoeba, or parabolic curve, which provided an image of fluid, energy-efficient motion. By smoothing down the contours of an object, and by levelling its bumps and hollows, a shape was achieved which suggested a bullet, teardrop or one of the simpler fishes. The concept had been developed initially in the designs of planes, racing automobiles and boats to reduce wind resistance caused by surface friction. The "streamlined" shape, symbolizing forward movement, industrial progress, and the hope for economic revival, became the accepted form for a wide new range of products.

Handcrafting, already on the decline, now became altogether too expensive. Simplicity and standardization were the keynotes of the new Modernism. American designers concentrated on the production of machine-made articles in quantity, at reasonable prices, which would still meet a high aesthetic standard. An old adage was recalled, "it is what is left out that makes a work of art". The machine, for so long a silent partner in all this, was venerated in the exhibition "Machine Art" held at the Museum of Modern Art, New York, in 1934. The public came in droves to reconsider the aesthetic merit of such mundane items as ball bearings, cam shafts, gears, axles, plate warmers and carpet sweepers.

The industrial designer set about restyling practically everything, particularly household goods, so that

MALCOLM S. PARK (dates unknown) American
Vacuum Cleaner, 1938. *De Luxe* model with automatic cord control. Aluminum cased vacuum with cloth bag. Manufacturer: Singer Manufacturing Company, Elizabethport, NJ.
H: 43in (109.2cm) x W: 13in (33cm) x D: 16in (40.6cm)

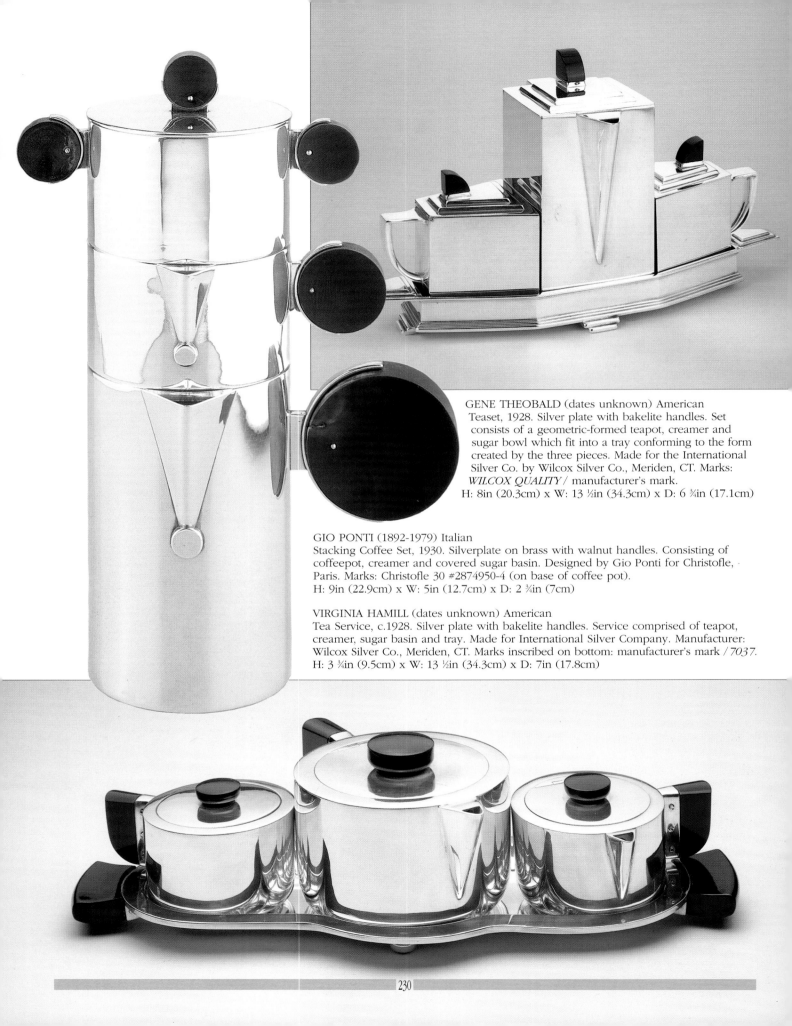

GENE THEOBALD (dates unknown) American
Teaset, 1928. Silver plate with bakelite handles. Set
consists of a geometric-formed teapot, creamer and
sugar bowl which fit into a tray conforming to the form
created by the three pieces. Made for the International
Silver Co. by Wilcox Silver Co., Meriden, CT. Marks:
WILCOX QUALITY / manufacturer's mark.
H: 8in (20.3cm) x W: 13 ½in (34.3cm) x D: 6 ¾in (17.1cm)

GIO PONTI (1892-1979) Italian
Stacking Coffee Set, 1930. Silverplate on brass with walnut handles. Consisting of
coffeepot, creamer and covered sugar basin. Designed by Gio Ponti for Christofle,
Paris. Marks: Christofle 30 #2874950-4 (on base of coffee pot).
H: 9in (22.9cm) x W: 5in (12.7cm) x D: 2 ¾in (7cm)

VIRGINIA HAMILL (dates unknown) American
Tea Service, c.1928. Silver plate with bakelite handles. Service comprised of teapot,
creamer, sugar basin and tray. Made for International Silver Company. Manufacturer:
Wilcox Silver Co., Meriden, CT. Marks inscribed on bottom: manufacturer's mark / *7037*.
H: 3 ¾in (9.5cm) x W: 13 ½in (34.3cm) x D: 7in (17.8cm)

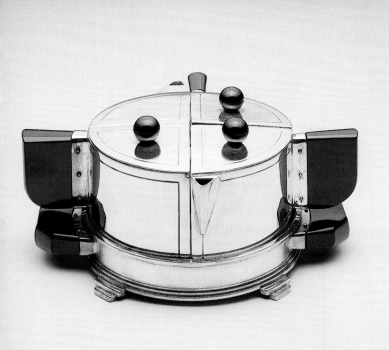

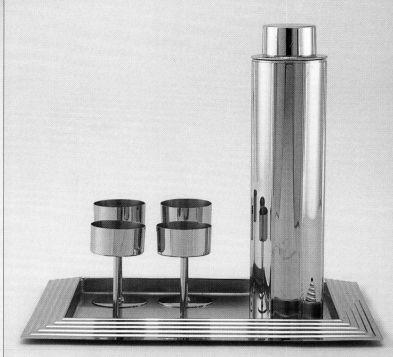

GENE THEOBALD (dates unknown) American Breakfast Set, c.1928. Silver plate with pewter. Comprised of a demilune tea or coffee pot and pie-shaped creamer and sugar bowl designed to fit within circular tray. Made for the International Silver Co. by Wilcox Silver Co., Meriden, CT.
H: 3 ¾in (8.3cm) x
W: 8 ½in (21.6cm) x
D: 7in (17.8cm)

NORMAN BEL GEDDES (1893-1958) American *Skyscraper* Cocktail Shaker Service, c.1934. Chromeplated brass. Removable liner inside. Eight glasses, *Manhattan* serving tray, and two matching candlesticks (designed by Frederick Priess). Manufacturer: Revere Copper and Brass Co., Rome, NY. Marks: *REVERE ROME NY* stamped on base.
H: 12 ¾in (32.4cm) (shaker)
W: 14 ½in (36.8cm) x D: 11 ⅝in (29.5cm) (tray)

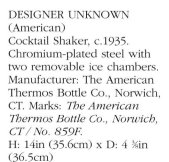

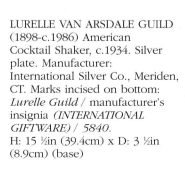

DESIGNER UNKNOWN (American) Cocktail Shaker, c.1935. Chromium-plated steel with two removable ice chambers. Manufacturer: The American Thermos Bottle Co., Norwich, CT. Marks: *The American Thermos Bottle Co., Norwich, CT / No. 859F.*
H: 14in (35.6cm) x D: 4 ⅜in (36.5cm)

LURELLE VAN ARSDALE GUILD (1898-c.1986) American Cocktail Shaker, c.1934. Silver plate. Manufacturer: International Silver Co., Meriden, CT. Marks incised on bottom: *Lurelle Guild* / manufacturer's insignia (*INTERNATIONAL GIFTWARE*) / 5840.
H: 15 ½in (39.4cm) x D: 3 ½in (8.9cm) (base)

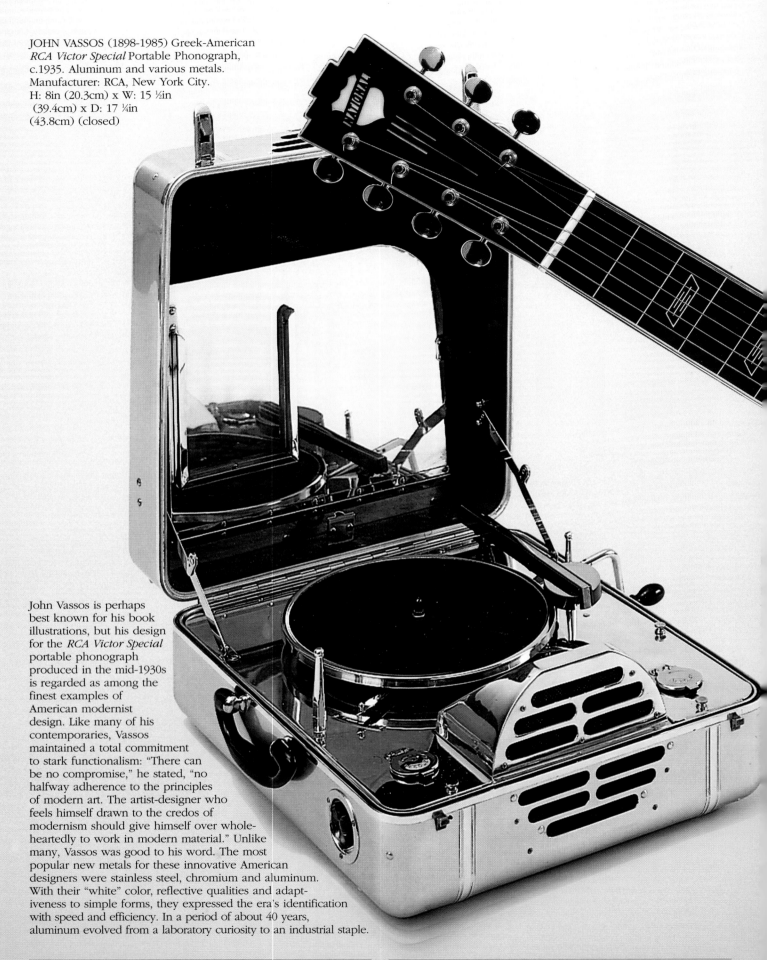

JOHN VASSOS (1898-1985) Greek-American
RCA Victor Special Portable Phonograph,
c.1935. Aluminum and various metals.
Manufacturer: RCA, New York City.
H: 8in (20.3cm) x W: 15 ½in
(39.4cm) x D: 17 ¼in
(43.8cm) (closed)

John Vassos is perhaps
best known for his book
illustrations, but his design
for the *RCA Victor Special*
portable phonograph
produced in the mid-1930s
is regarded as among the
finest examples of
American modernist
design. Like many of his
contemporaries, Vassos
maintained a total commitment
to stark functionalism: "There can
be no compromise," he stated, "no
halfway adherence to the principles
of modern art. The artist-designer who
feels himself drawn to the credos of
modernism should give himself over whole-
heartedly to work in modern material." Unlike
many, Vassos was good to his word. The most
popular new metals for these innovative American
designers were stainless steel, chromium and aluminum.
With their "white" color, reflective qualities and adapt-
iveness to simple forms, they expressed the era's identification
with speed and efficiency. In a period of about 40 years,
aluminum evolved from a laboratory curiosity to an industrial staple.

existing models would quickly appear outdated. Philip Johnson explained the marketing strategy behind this in his introduction to the catalogue which accompanied the exhibition at the Museum of Modern Art, "in the 1920s there developed in America a desire for 'restyling' objects for advertising. Styling a commercial object gives it more 'eye appeal' and therefore helps sales".[14]

The machine's new profile was met by the general public either with exaltation or rejection. In effect, it made its entrance into the American home by sneaking through the back door into service areas like the garage, kitchen and bathroom. Yet for his living spaces the householder continued to prefer a potpourri of period furnishings, for the reason given at the time that modern man felt a nostalgia for a past age when life appeared simpler and it seemed possible to control one's own destiny. A residence was not a "Machine for Living" as Le Corbusier defined the home, but a refuge from the rushed realities and confusions of modern life.

Industrial design became an essential component of the manufacturing process in the late 1920s, when the huge advances made during the war years in mass production resulted in a market saturated with competing products of equal performance, which closed the gap between consumer demand and available supply. Marketing executives were quick to realize that in most cases it was only an object's appearance which distinguished it from similar products. A new merchandizing plan was thus required

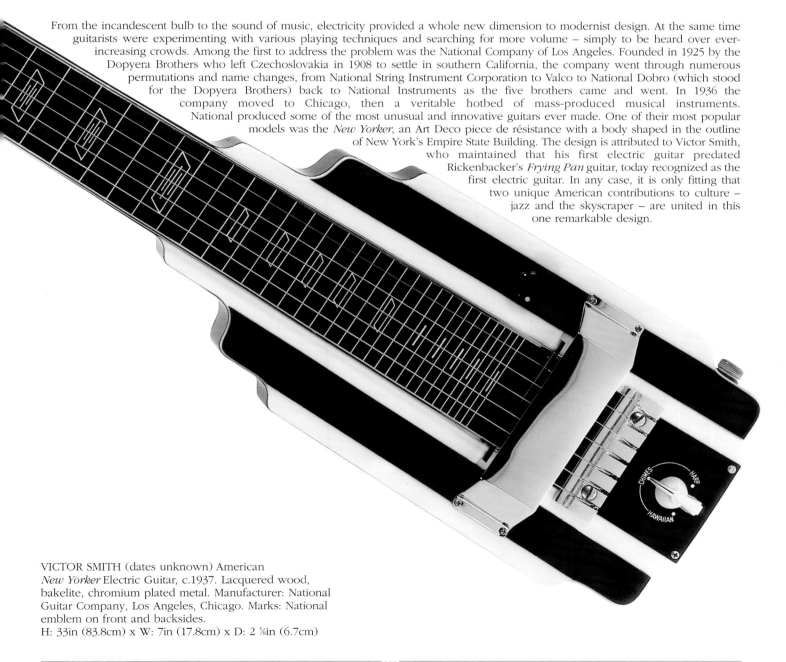

From the incandescent bulb to the sound of music, electricity provided a whole new dimension to modernist design. At the same time guitarists were experimenting with various playing techniques and searching for more volume – simply to be heard over ever-increasing crowds. Among the first to address the problem was the National Company of Los Angeles. Founded in 1925 by the Dopyera Brothers who left Czechoslovakia in 1908 to settle in southern California, the company went through numerous permutations and name changes, from National String Instrument Corporation to Valco to National Dobro (which stood for the Dopyera Brothers) back to National Instruments as the five brothers came and went. In 1936 the company moved to Chicago, then a veritable hotbed of mass-produced musical instruments. National produced some of the most unusual and innovative guitars ever made. One of their most popular models was the *New Yorker*, an Art Deco piece de résistance with a body shaped in the outline of New York's Empire State Building. The design is attributed to Victor Smith, who maintained that his first electric guitar predated Rickenbacker's *Frying Pan* guitar, today recognized as the first electric guitar. In any case, it is only fitting that two unique American contributions to culture – jazz and the skyscraper – are united in this one remarkable design.

VICTOR SMITH (dates unknown) American
New Yorker Electric Guitar, c.1937. Lacquered wood, bakelite, chromium plated metal. Manufacturer: National Guitar Company, Los Angeles, Chicago. Marks: National emblem on front and backsides.
H: 33in (83.8cm) x W: 7in (17.8cm) x D: 2 ⅝in (6.7cm)

ILONKA KARASZ (1896-1981) Hungarian-American
Tea Set, c.1925. Nickel silver. Comprised of teapot, creamer and sugar bowl. Manufacturer: Paye & Baker, North Attleboro, MA. Marks (bottom of handles): 505 / E.P.N.S. / Made in U.S.A./ IK. Makers Mark: P & B (in hearts).
Teapot / H: 5in (12.7cm) x W: 6 ¼in (15.9cm) x D: 4in (10.2cm)
Creamer / H: 2 ½in (6.4cm) x W: 6 ⅜in (16.2m) x D: 3 ⅞in (9.8cm)
Sugar Bowl / 4in (10.2cm) x W: 6 ½in (16.5cm) x D: 4in (10.2cm)

RENA ROSENTHAL (dates unknown) American
Pitcher, c.1938-40. Hammered brass, ovoid vessel resting on a teardrop shaped foot. Handle is mounted section of bamboo. The work was likely executed by Hagenauer Werkstätte, Vienna.
Marks: *Made in Austria* and designer's mark.
H: 10in (25.4cm) x W: 5 ½in (14cm) x D: 8in (20.3cm)

SYLVIA STAVE (1908-) Swedish
Pitcher, c.1930. Silver plate. Designed by Stave for the Swedish firm, Carl Gustav Hallberg, Stockholm. Marks stamped on bottom: *CGHG* / manufacturer's mark/*ALP*.
H: 6 ¾in (17.1cm) x W: 7 ¼in (18.4cm) x D: 5 ½in (14cm)

ELSA TENNHARDT (dates unknown) American
Centerpiece Bowl with Matching Candlesticks, 1928. Silver-plated brass. Manufacturer: E. & J. Brass Co.
Marks inscribed on bottom: *E. & J. B.*
Centerpiece bowl: H: 6 ⅜in (16.2cm) x W: 10 ⅞in (27.6cm) x D: 9 ⅜in (23.8cm)
Candlesticks: H: 3 ⅝in (9.2cm) x W: 5 ¼in (13.3cm) x D: 2 ⅜in (6cm)

ERIK MAGNUSSEN (1884-1961) Danish
Modern America Pitcher, 1928. Sterling silver with gilt interior; bakelite handle. Manufacturer: Gorham Manufacturing Co., Providence, RI. Retailed by J.E. Caldwell & Co. Marks: *EM Monogram / 14058 / STERLING / GORHAM /* Gorham maker's mark.
H: 8 ¼in (21cm) x W: 10in (25.4cm) x D: 5 ¼in (13.3cm)

PETER MÜLLER-MUNK (1904-1967) German-American
Normandie Pitcher, c.1935-37. Model 723. Chromium-plated brass. Manufacturer: Revere Copper and Brass Co., Rome, NY.
H: 12in (30.5cm) x W: 9 ½in (24.1cm) x D: 3 ¼in (8.3cm)

THOMAS W. MCCREARY
(dates unknown) American
Ruba Rombic Fishbowl, c.1928.
Molded glass. Manufacturer: Phoenix
Glass Company, Monaca, PA. Marks
impressed on side: *PATENTED SEPT.
4, 1928 P.C. CO.*
H: 7 ½in (19.1cm) x D: 14 ½in (36.8cm)

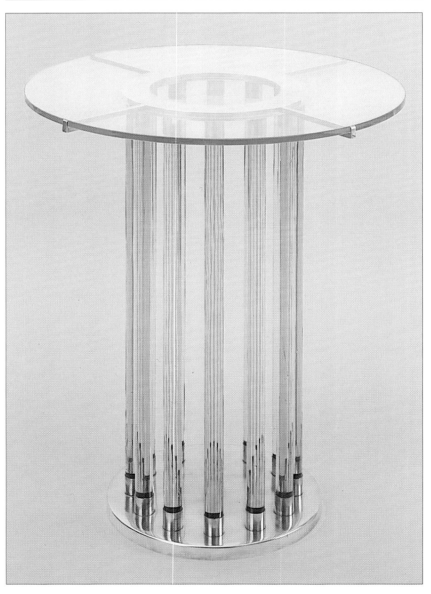

DOROTHY C. THORPE
(dates unknown) American
Table, c.1937. Silvered bronze with
solid glass rods supporting glass top.
H: 24in (61cm) x D: 21in (53.3cm)

NICHOLAS KOPP
(dates unknown) American
Vase, c.1928. Molded glass.
Made by Kopp Glass, Inc., Swissvale, PA.
H: 8 ½in (21.6cm) x W: 3 ¾in (9.5cm) x
D: 3 ¾in (9.5cm)

FREDERICK CARDER (1863-1963) American
Vase, 1928. Acid-cut glass with stylized
floral decoration. Designed for Steuben
Glass Works, Corning, N.Y. Marks: acid
signed with Steuben monogram.
H: 12in (30.5cm) x D: 6in (15.2cm)
(at shoulder)

WALTER DORWIN TEAGUE (1883-1960) American
Embassy Stemware (4), c.1933. Clear glass with
vertically ribbed flat-section stems. Design credited
jointly to W. D. Teague and Edwin W. Fuerst for
1939 New York World's Fair. Manufacturer: Libbey
Glass Co.,Toledo. Founded 1878.
H: 8 ¾in (22.2cm) x W: 3in (7.6cm) / Dinner Wine
H: 6 ½in (16.5cm) x W: 2 ⅞in (7.3cm) /Champagne
H: 6 ¾in (17.1cm) x W: 2 ⅝in (6.7cm) / Goblet
H: 6 ½in (16.5cm) x W: 2 ½in (6.4cm) / Cordial
(not illustrated)

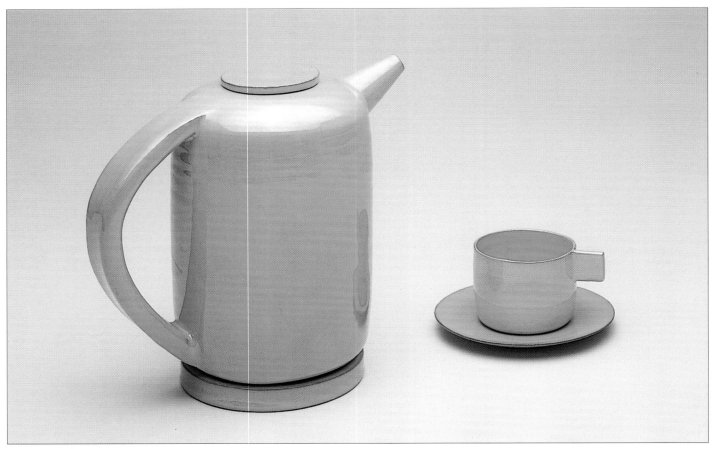

GERTRUD (1908-1971) AND OTTO (1908-) NATZLER (Austrian-American)
Coffee Set, c.1942. Glazed ceramic. Number: 2528, Chartreuse glaze 29918. Comprised of lidded coffee pot, six cups, each with matching saucers, an open sugar bowl and creamer (not illustrated). Marks: *G.O.N* and *NATZLER*.
Teapot: H: 7in (17.8cm) x W: 6 ⅝in (17.5cm); Cup and saucer: H: 2in (5.1cm) x W: 4in (10.2cm)

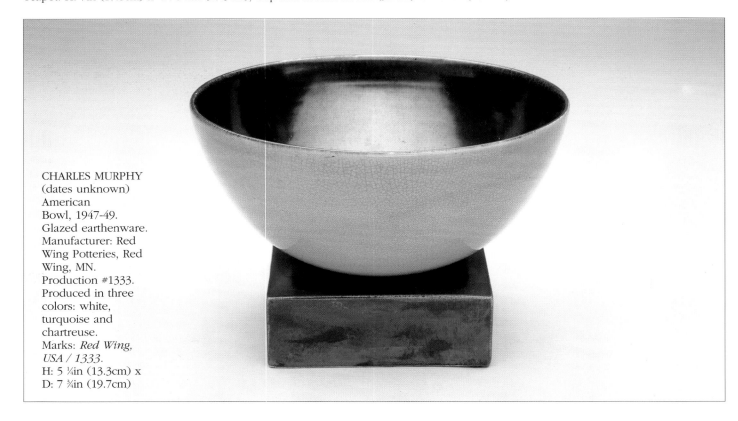

CHARLES MURPHY
(dates unknown)
American
Bowl, 1947-49.
Glazed earthenware.
Manufacturer: Red
Wing Potteries, Red
Wing, MN.
Production #1333.
Produced in three
colors: white,
turquoise and
chartreuse.
Marks: *Red Wing,
USA / 1333*.
H: 5 ¼in (13.3cm) x
D: 7 ¾in (19.7cm)

EVA ZEISEL (1906-) Hungarian-American
Museum Coffee pot, c.1942-45. Glazed porcelain. From the
Museum dinner service. Manufactured by Shenango Pottery, New
Castle, PA for Castleton China, New York.
H: 10 ½in (26.7cm) x W: 7 ⅝in (19.4cm) x D: 5 ½in (14cm)

to boost one's share in a competitive market. Product
redesign was seen as the most likely solution. This, in
turn, ushered in the concept of planned obsolescence.

The men who emerged to supply this new sort of
expertise were a varied group of ex-commercial artists,
stage designers, advertising men, former craftsmen
and jacks-of-all-trades. As soon became evident, the
ability to lure the consumer by creating illusions
became more important to some of them than the need
to produce a better product.

This new breed of "industrial designers", as they
preferred to be called, established themselves mostly
as independent freelance consultants to industry
midway between the engineer and the businessman.
By the mid-30s as much celebrity had been injected
into the profession itself as into its products. As Gilbert
Rohde noted in 1936, "'industrial design' has become a
glamorous name. Certain magazine articles, calculated
to 'dramatize' a new profession, have drawn a picture
of industrial design as being the exclusive and
mysterious possession of a handful of supermen who
are revolutionizing everything from hairpins to
locomotives at a fabulous price. The stories are

ALFONSO IANNELLI (1888-1965) Italian-American
Candlestick, 1926. Brushed aluminum. Designed for the Church of
Christ the King, Tulsa, OK. Francis Barry Byrne, architect.
H: 36in (91.4cm) x D: 8in (20.3cm) (at base)

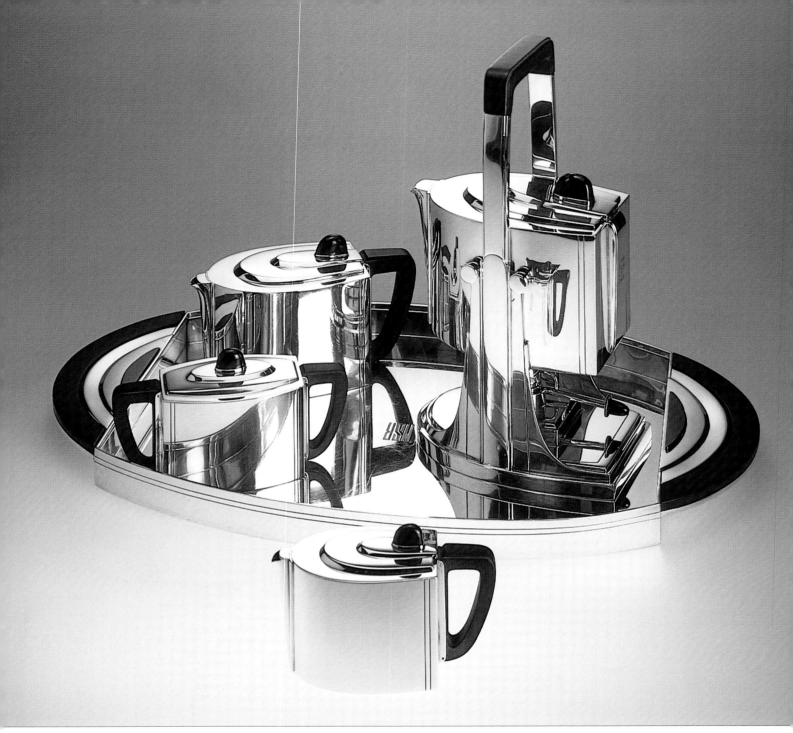

ALBERT L. BARNEY (-1955) American
Tête-à-Tête Tea Service, 1939. Sterling silver with New Zealand jade finials and synthetic fiber handles.
Designed for 1939 New York World's Fair and first exhibited in the House of Jewels Pavilion. Marks: *Tiffany & Co. Makers /
Sterling Silver / 22647 M* on the botttom of each piece. Engraved with the initials MSR (Melvina Schultz Raymer) who acquired
the service at the New York World's Fair in 1939. Attributed to Albert L. Barney, principal designer for Tiffany & Company.
H: 13 ⅞in (35.2cm) (kettle)
W: 24 ½in (62.2cm) x D:14in (35.6cm) (tray)

In marked contrast to European designers, participation in world fairs had been a low priority in America. Most design firms
were indifferent at best. Their primary marketing tool continued to be print advertising stressing name recognition, product quality,
silverware-as-art, and its importance in daily life. At the 1939 New York World's Fair, however, Tiffany & Company sought to
demonstrate in one grand gesture that their designs were every bit as *moderne* as their French counterparts.
While the unadorned surfaces and clean lines of this *pièce unique* do reflect a strong French influence, its sleek streamlining is more
common to American designs of the period. Even more avant-garde is the black *synthetic* fiber inset into the handles (a daring
statement when combined with a precious metal such as sterling silver). The service was designed for and first displayed in the
House of Jewels pavilion where Tiffany, Cartier and Black, Starr & Frost-Gorham all exhibited their finest and most expensive work
(its production cost in 1939 was $2,200).

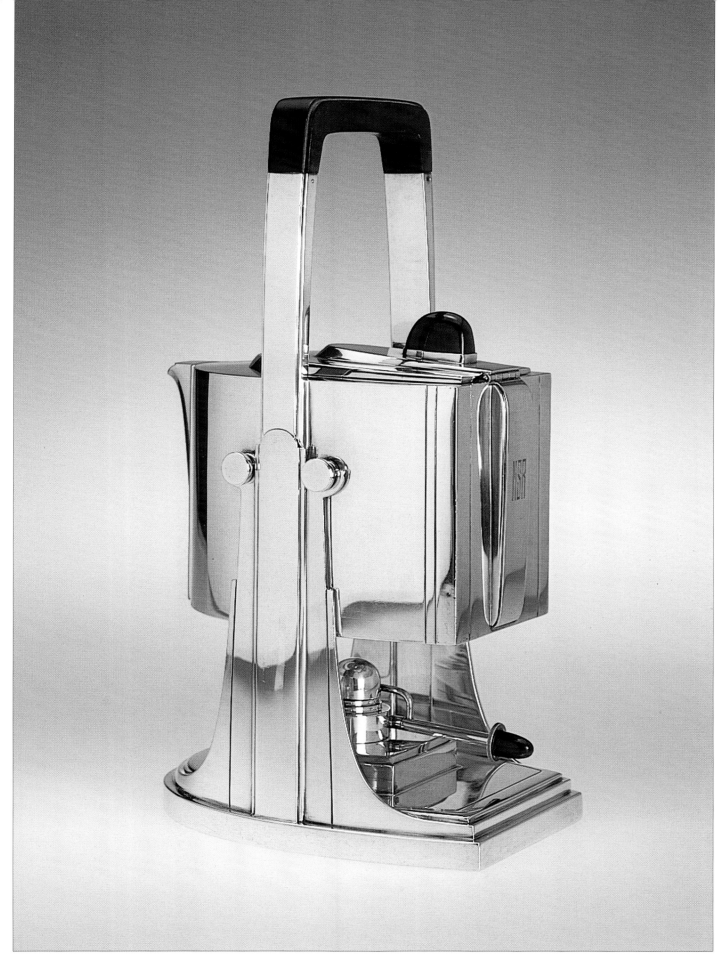

JEAN PROUVÉ (1901-1984) French
Antony Chair, c.1950. Molded plywood seat with bent and painted tubular and flat steel frame.
H: 33 ¾in (85.7cm) x W: 20in (50.8cm) x D: 26in (66cm)

JEAN PROUVÉ (1901-1984) French
Scissor Leg Occasional Table, c.1940-45.
Oak with black painted steel.
H: 28in (71.1cm) x W: 28 ½in (72.4cm) x D: 14in (35.6cm)

ILONKA KARASZ (1896-1981) Hungarian-American
Desk, c.1928. Lauan mahogany. Designed by Karasz for her New York studio.
H: 28 ½in (72.4cm) x W: 48in (121.9cm) x D: 35 ½in (90.2cm)

exaggerated… stripped of hocus-pocus, industrial design is a very simple matter; it is design brought up to date, design in terms of a mass production economy instead of a handcraft economy".[15] Rohde went on to define the profession's required skills rather vaguely as "a modicum of art and engineering abilities… it is the combination which is important".[16]

Detractors felt that the profession did nothing more than dress up the product, adding little or no practical or aesthetic value. It did not help the image of the industrial designer that some of the new profession's leading lights – especially Bel Geddes and Loewy – projected a brand of irrepressible showmanship which seemed to focus less on their designs than on themselves. Many of Geddes' futuristic renderings remained unrealized, which helped to earn him the soubriquet of the "P. T. Barnum of Industrial Design".

Walter Dorwin Teague projected the most professional image of the industrial designers, due to

his sincere belief that better business methods and products would improve the quality of life of the ordinary person. Several blue-chip accounts attested to his ability, including Eastman Kodak, Westinghouse, Steuben Glass, Texaco, and the Pittsburgh Plate & Glass Company. Like Teague, Henry Dreyfuss and Harold van Doren enjoyed wide respect within the realm of 1930s American commerce.

One of the giants of the industrial design movement, Donald Deskey formed an association in New York with Phillip Vollmer in 1927. The firm's elite and wealthy clientele, including several Rockefellers and Adam Gimbel, President of Saks-Fifth Avenue, yielded in the 1930s to work for large manufacturers, such as the Ypsilanti Furniture Company in Michigan, for whom Deskey designed a wide range of furnishings, textiles and rugs for mass production. Over 400 pieces of his furniture designs were put into production between 1930-34 alone. Interchanging modern materials with great facility

ANTON KLIEBER (dates unknown) Austrian
Vase, c.1925. Hand-painted earthenware. Made by the *Keramos*
Wiener Kunstkeramik, Vienna.
H: 9 ½in (24.1cm) x D: 4 ½in (11.4cm)

DESIGNER UNKNOWN (Czechoslovakian)
Bookcase, c.1920. Stained oak.
H: 57in (144.3cm) x W: 27 ½in (69.9cm) x D: 14 ½in
(36.8cm)

– for example, vitrolite, cork, formica, bakelite,
chromium-plated brass, and spun and brushed
aluminum – Deskey sought solutions for
confined living spaces in the inner city.

A relatively late starter within the design
profession, Gilbert Rohde sealed his reputation
around 1934 with a series of tubular chromed
pieces for the Hermann Miller Furniture Co.
and the Troy Sunshade Co. Like Deskey, Rohde
concentrated on the problems of cramped
urban living, for which he designed
multipurpose living-sleeping-dining sectional
units of furniture. Contemporary magazines
bear witness to his indefatigable pursuit of the
machine aesthetic as the means to improve the
quality of life. No other designer carried as
much authority in the Grand Rapids furniture-
making community. High on Rohde's list of
achievements were the startlingly modern

RADEBAUGH (dates unknown) American
Bendix Products, 1937. Poster / color lithograph. Advertising poster for the Bendix Co.
Attributed to Radebaugh (first name unknown). H: 33in (83.8cm) x W: 20 ½in (52.1cm)

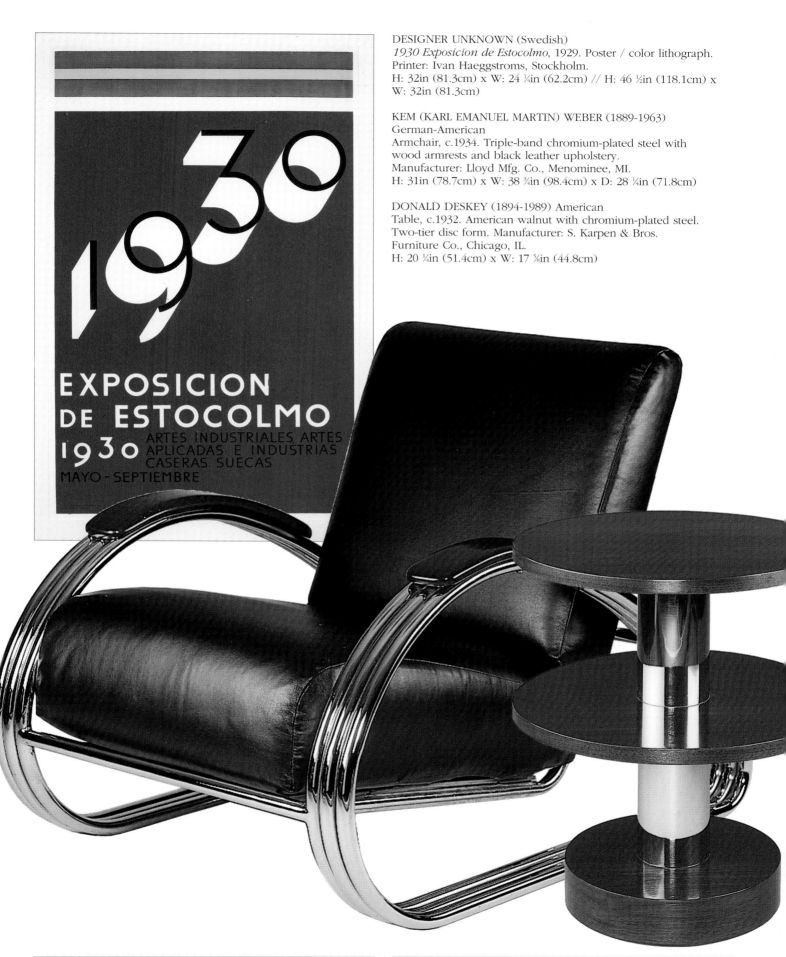

DESIGNER UNKNOWN (Swedish)
1930 Exposicion de Estocolmo, 1929. Poster / color lithograph.
Printer: Ivan Haeggstroms, Stockholm.
H: 32in (81.3cm) x W: 24 ¼in (62.2cm) // H: 46 ½in (118.1cm) x
W: 32in (81.3cm)

KEM (KARL EMANUEL MARTIN) WEBER (1889-1963)
German-American
Armchair, c.1934. Triple-band chromium-plated steel with
wood armrests and black leather upholstery.
Manufacturer: Lloyd Mfg. Co., Menominee, MI.
H: 31in (78.7cm) x W: 38 ⅜in (98.4cm) x D: 28 ¼in (71.8cm)

DONALD DESKEY (1894-1989) American
Table, c.1932. American walnut with chromium-plated steel.
Two-tier disc form. Manufacturer: S. Karpen & Bros.
Furniture Co., Chicago, IL.
H: 20 ¼in (51.4cm) x W: 17 ⅝in (44.8cm)

clocks he designed for the Herman Miller Clock Company.

Trapped in California at the outbreak of the First World War, Karl Emanuel Martin (Kem) Weber was denied permission to return to his native Germany. Opening his own design studio in Hollywood in 1927, Weber developed a distinctly personal style in which flamboyant "Zig-zag Moderne" colors and forms dominated. In the 1930s this evolved into a mature streamlined style based on horizontal, rather than vertical, planes. One of the first to seize the new design freedoms afforded by the invention of the digital mechanism for clocks, Weber replaced the traditional dial with two small windows for the hour and minutes, which allowed the clock case to be of any preferred form. His models for Lawson Clocks of Pasadena included sleek kinetic contours that personify for today's collector the 1930s streamlined idiom.

The youngest member of the industrial design movement which evolved in the late 1920s, Russel Wright confined his work mainly to the domestic sphere. Wright saw that the Depression led inevitably to informal home entertaining, and to this end he concentrated on the creation of utensils that were sturdy enough for cooking and handsome enough for serving. Comprised either of spun aluminum or ceramics, his wares captured the decade's spirit of functional elegance. The sleek curvilinear contours of his 1937 "American Modern" dinnerware service captured precisely the essential concepts of streamlining.

In the stampede to modernize practically everything, no attempt was made to distinguish in form between functional and non-functional streamlining. All objects, moving or stationary, were cased in sleek, aerodynamic bodies emblematic of the era's obsession with speed and efficiency. The technical fact that at most speeds streamlined styling did not, in fact, save much energy and that, in stationary ones, it saved none at all was completely ignored. Nevertheless, this style came to represent the machine and the hope that it held for the future, though the manufacturer was only too aware of the risks of adopting styling so exaggerated that the public would no longer buy his products.

Amongst streamlining's opponents was the critic John MacArthur, who commented, "The Bauhaus was closed about the time the streamlining mania began, but it would have rejected the streamlined form for objects such as cocktail shakers and fountain pens where its use is nonsense. Typical Bauhaus designs, whether for chairs, lighting fixtures or ash trays, are free of both modernistic and streamlined aberrations; sound Bauhaus training would not permit them".[17] To another critic, "streamlining has been perverted from functional design to a mere selling trick".[18]

By the mid-1940s streamlining was seen as the expression of a false optimism. The public was bored of a style which after fifteen years had become institutionalized. In addition, several industrial designers were commissioned after the Japanese attack in 1941 on Pearl Harbor to design war-related projects, and their absence caused the movement to lose continuity and momentum. And after the Second World War the American people saw the obverse side of the machine – its potential for destruction through aerial bombardment, poison gas and, ultimately, the atomic bomb. It was harder after Hitler and Hiroshima to sell the machine as humanity's savior. Streamlining's popularity therefore waned throughout the decade.

NOTES
1. Credit is given to Bevis Hillier for the phrase "Art Deco", which he used as the title of his book on the decorative arts of the interwar years: *Art Deco*, London, 1968.
2. The stipulations for entry into the 1925 Exposition Universelle were listed in *The Decorative Furnisher*, May 1925, p.81.
3. For the participants in the pavilion of the Société des Artistes Décorateurs at the 1925 Exposition Universelle, see Catalogue General Officiel, *Exposition Internationale des Arts Décoratifs et Industrielles Modernes, Paris, Avril-Octobre, 1925*, Ministère de Commerce et de l'Industrie des Postes et des Télégraphiques, Paris, n.d.; for illustrations of their interiors in the pavilion, see *Une Ambassade Française*, ed. Charles Moreau, Paris (48 pls.), n.d.
4. Brian J. R. Blench, *News*, The Art Deco Society of New York, vol. 5, no. 1, Spring 1985, p.2.
5. Part of Follot's speech at the 1928 exhibition in Paris by the London firm of Waring & Gillow, quoted by Jessica Rutherford, "Paul Follot", *Connoisseur*, June 1980, p.90.
6. For biographies on most Art Deco furniture designers and cabinetmakers, see Alastair Duncan, *Art Deco Furniture*, London, 1984.
7. For a biography on Puiforcat and illustrations of his work, see Françoise de Bonneville, *Jean Puiforcat*, 1986.

8. For a biography on Dunand and illustrations of the range of his work in metal and lacquer, see Félix Marcilhac, *Jean Dunand His Life and Works*, London, 1991.
9. For Lalique's work in glass, see Félix Marcilhac, *R. Lalique Catalogue Raisonné de l'Œuvre de Verre*, 1994 (updated reprint).
10. Thomas E. Tallmadge, "Will this Modernism Last?", *House Beautiful*, January 1929, p.44.
11. For a description of the Union des Artistes Modernes, see Duncan, op.cit., pp.10-11.
12. Frankl's five books are *New Dimensions, Form and Re-Form, Machine-Made Leisure, Spaces for Living* and *Survey of American Textiles*.
13. Paul T. Frankl, *Machine-Made Leisure*, 1932, p.140.
14. See *Machine Art*, exhibition catalogue, The Museum of Modern Art, New York, March 6 – April 30, 1934, unpaginated.
15. Gilbert Rohde, "What is Industrial Design?", *Design*, December 1936, p.3.
16. G. Rohde, "The Design Laboratory", *The American Magazine of Art*, vol. XXIX, no. 10, October 1936, p.638 ff.
17. John MacArthur, "Modernist and Streamlined", *The Bulletin of the Museum of Modern Art*, vol. 15, no. 6, December 1938, p.2.
18. "Design Decade", *Architectural Forum*, October 1940, p.220.

ARTIST-DESIGNER-ARCHITECTS
IDENTIFIED WITH MODERNISM

Entries preceded by a dot (.) indicate individuals currently represented in the Norwest Collection

ARTS and CRAFTS (1875-1915)

EUROPE
. Ashbee, Charles Robert (1863-1942). Metalwork. Founder of the Guild and School
 of Handicraft and the Arts and Crafts Exhibition Society (1888)
Baillie Scott, Mackay Hugh (1865-1945). Architecture, furniture
. Baker, Oliver (1859-1938). Metalwork
. Benson, William Arthur Smith (1854-1924). Metalwork and glassware
Burne-Jones, Sir Edward Coley (1833-1898). Paintings, drawings, stained glass
Burges, William (1827-1881). Architecture, furniture
Crane, Walter (1845-1915). Graphics, wallpaper, textiles
De Morgan, William Frend (1839-1917). Ceramics
. Dresser, Dr. Christopher (1834-1904). Metalwork, ceramics, graphics
Gimson, Ernest William (1864-1919). Furniture
Jones, Owen (1809-1874). Wallpaper
Lethaby, William Richard (1857-1931). Furniture
Lutyens, Sir Edward Landseer (1869-1944). Architecture
Mackmurdo, Arthur Heygate (1851-1942). Graphics, furniture
. Morris, William (1834-1896). Architecture, interiors, wallpapers, graphics
Muthesius, Hermann (1861-1927). Architecture, interiors
Paxton, Joseph (1803-1865). Architecture, engineering, landscaping
. Searle, Walter Henry (dates unknown). Metalwork
Sevin, Louis-Constant (1821-1888). Furniture
. Taylor, Ernest Archibald (1874-1951). Furniture, stained glass design
. Voysey, Charles Francis Annesley (1857-1941). Architecture, wallpaper, textiles,
 badges, bookplates, memorial tablets, metalwork, furniture
. Walton, George (1867-1933). Furniture
. Williams, John (dates unknown). Metalwork

AMERICA
(Prairie School; Mission Style; California Style)
Bradstreet, John Scott (1845-1914). Furniture
Chelsea Keramic Art Works, Chelsea, Mass. (1872-1889). Ceramics
. Craftsman Workshops, Eastwood, N.Y. (Founded 1900). Furniture
. Dedham Pottery, Dedham, Mass. (1896-1943). Ceramics
Dominick & Haff, New York City. Founded 1872. Metalwork
Ellis, Harvey (1852-1904). Architecture, furniture, drawings
. Fulper Pottery, Flemington, NJ (c.1805-1930). Ceramics
Gorham Manufacturing Corporation, Providence, RI. Founded c.1815-18. Metalwork
Greene Brothers (Charles Sumner 1868-1957 & Henry Mather 1870-1954).
Architecture, interiors, furnishings, furniture
. Grueby Pottery (Grueby Faience Co.) Boston (1894-1913). Ceramics
. Hubbard, Elbert (1856-1915). Furniture, furnishings
Jarvie, Robert (1865-1941). Metalwork
. Lebolt & Company, Chicago. Founded 1899 by J. Meyer H. Lebolt. Metalwork, jewelry
. Limbert, Charles P. (1854-1923). Furniture
. Maher, George Washington (1864-1926). Architecture, furniture, furnishings
Marblehead Pottery, Marblehead, MA (1905-1936). Ceramics
McLaughlin, M. Louise (1847-1939). Ceramics
. Newcomb College Pottery, New Orleans. Founded 1885. Ceramics
. Ohr, George E. (1857-1918). Ceramics
Paul Revere Pottery, Boston (1906-1942). Ceramics
Pewabic Pottery, Detroit. Founded 1903. Ceramics
. Purcell & Elmslie (William Gray 1880-1964 & George Grant 1871-1952). Architecture, furnishings
. Roycrofters Workshops, East-Aurora, NY (1895-1938). Furniture, metalwork, furnishings
. Shreve & Co., San Francisco. Founded 1852. Metalwork, jewelery
. Stickley, Gustave (1857-1942). Furniture, furnishings
Stickley, L. & J. G., Fayetteville, NY. Founded 1900. Furniture
T.C. Shop, Chicago (1910-1923). Metalwork
United Crafts, Syracuse, NY. Furniture

University City Pottery, University City, MO. Founded 1907. Ceramics
Van Erp, Dirk (1860-1933). Lamps
. Weller Pottery, Zanesville, OH. Founded 1873 by Samuel A. Weller.
 See also: Jacques Sicard (1865-1923) Sicardoware under American Art Nouveau.
. Welles, Clara Barck (1868-1965). Metalwork
. Wright, Frank Lloyd (1867-1956). Architecture, furnishings, drawings
. Zimmermann, Marie (1878-1972). Metalwork

ART NOUVEAU (1880-1910)

FRANCE
. Benouville, Léon (1860-1903). Architecture, furniture
. Bonvallet, Paul-Hugues-Lucien (1861-1919). Metalwork
. Bussière, Ernest (1863-1913). Ceramics
Charpentier, Alexandre Louis-Marie (1856-1909). Sculpture, graphics, furniture
. Chéret, Jules (1836-1932). Posters
. Colonna, Edouard (1862-1948). Furniture, porcelains
Dammouse, Albert-Louis (1848-1926). Ceramics, glassware
. Daum Frères (Auguste 1853-1908 and Antonin 1864-1930). Glassware
. De Caranza, Amédée (1875-1914). Ceramics, enamels, glassware, drawings
De Feure, Georges (1868-1943). Metalwork
. Doat, Taxile-Maximim (1851-1938). Porcelains
. Dufrêne, Maurice-Elysée (1876-1955). Porcelains, furniture, posters
Eiffel, Gustaf (1832-1923). Architecture, engineering. Eiffel Tower, Paris, 1889
Fix-Masseau, Pierre-Félix (1869-1937). Posters
Gaillard, Eugene (1862-1933). Furniture
. Gaillard, Lucien (1861-1933). Metalwork
. Gallé, Emile (1846-1904). Furniture, glassware
Grasset, Eugene (1841-1917). Graphics
. Guimard, Hector (1867-1942). Architecture, furniture, ironwork
. Habert-Dys, Jules-Auguste (1850-1924). Metalwork
. Lachenal, Edmond (1855-1930). Ceramics
. Larche, François-Raoul (1860-1912). Sculpture, lamps
. Landry, Abel (1871-1923). Architecture, furniture, interior design
. Majorelle, Louis (1859-1926). Furniture
Moreau-Vauthier, P. (1871-). Metalwork
. Mucha, Alphonse Maria (1860-1939). Posters, graphics
. Rassenfosse, Armand (1862-1934). Posters
Toulouse-Lautrec, Henri de (1864-1901). Drawings, paintings, posters
Vallin, Eugene (1856-1922). Furniture

BELGIUM / HOLLAND:
. Eisenlöffel, Johannes (Jan) (1876-1957). Metalwork
Horta, Victor (1861-1947). Architecture, furnishings
. Serrurier-Bovy, Gustave (1858-1910). Furniture
. Toorop, Jan Theodor (1858-1928). Posters, graphics
. Van de Velde, Henry (1863-1957). Architecture, furnishings
. Zuid-Holland manufactory, Gouda, Holland. Founded 1898 by E. Estié and A. Jonker. Ceramics

GERMANY (Jugendstil) / AUSTRIA / HUNGARY / ITALY (Stile Floreale / Stile Liberty) / SPAIN / PORTUGAL / SCANDINAVIA:
. Adler, Friedrich (1878-1942). Furniture, metalwork, textiles
. Arte della Ceramica, Florence, Italy. Founded 1898 by Conte Vincenzo Giustiniani. Ceramics
. Auchentaller, Joseph Maria (1865-1949). Posters
. Bauer, Leopold (1872-1938). Glassware, lamps
. Behrens, Peter (1868-1940). Architecture, interiors
. Dachsel, Paul (active: 1904-10). Ceramics
. Eckmann, Otto (1865-1902). Metalware, ceramics
. Elmquist, Hugo C. M. (1862-1930). Metalwork
Endell, August (1871-1925). Architecture, furnishings
Gaudí, Antoni (1852-1926). Architecture, furnishings
. Gipkens, Julius (1883-). Posters
. Gradl, Hermann (1869-1934). Ceramics
Holubetz, Robert (dates unknown). Glassware
Kok, J. Jurriaan (1861-1919). Porcelains
. Läuger, Max (1864-1952). Ceramics
. Leven, Hugo (1874-1956). Furniture, metalwork
. Liisberg, Carl Frederick (1860-1909). Ceramics
. Neureuther, Christian (1869-1921). Ceramics

. Olbrich, Josef Maria (1867-1908). Architecture, furnishings, books. Co-founder of the
 Vienna Secession, whose exhibition building he designed, 1898-99.
Pankok, Bernhard (1872-1943). Architecture, furnishings
. Riemerschmid, Richard (1868-1957). Furniture, metalwork
. Rörstrand Porslinsfabrik AB, Stockholm. Founded 1726. Ceramics
. Sattler, Josef (1867-1931). Posters
. Thonet, Gebrüder, Vienna. Founded 1853
. Vierthaler, Ludwig (1875-1967). Metalwork
. Württembergische Metallwaren Fabrik (WMF), Geislingen, Germany. Founded 1853.
 Metalwork
. Zsolnay, Vilmos (1828-1900). Ceramics

ENGLAND / SCOTLAND:
Baillie Scott, Mackay Hugh (1865-1945). Architecture, furniture
. Beardsley, Aubrey Vincent (1872-1898). Drawings, illustrations, posters
Crane, Walter (1845-1915). Illustrations
. Harris, Kate (active c.1890-1910). Metalwork
. Knox, Archibald (1864-1933). Metalwork
. Logan, George (1866-1939). Architecture, furniture, furnishings
. Mackintosh, Charles Rennie (1868-1928). Architecture, furnishings
. Macdonald, Margaret Frances (1865-1933). Textiles, door panels
Mackmurdo, Arthur Heygate (1851-1942). Textiles, graphics
Napper, Harry (1860-1930). Textiles
. Rhead, Frederick Hurten (1880-1942). Ceramics, graphics
Townsend, Charles Harrison (1851-1928). Architecture

AMERICA:
. Bradley, William (Will) H. (1868-1962). Posters, graphics
Durand, Victor (dates unknown). Glassware
. Durgin, William (1833-1905). Metalwork
. Parrish, Maxfield (1870-1966). Posters
 Penfield, Edward (1866-1925). Posters
. Pond, Theodore Hanford (1872-1933). Metalwork
. Rookwood Pottery, Cincinnati. (1880-1960). Ceramics
. Sicard, Jacques (1865-1923). Ceramics. See also: Weller Pottery under Arts and Crafts.
. Sullivan, Louis H. (1856-1924). Architecture, interior elements
. Tiffany, Louis Comfort (1848-1933). Ceramics, glassware, lamps, stained glass windows
. Tiffany & Company, New York City. Founded 1900. Metalwork, glassware
. Van Briggle Pottery, Colorado Springs, CO. Founded 1901. Ceramics

WIENER WERKSTÄTTE (1903-1933)

. Bauer, Leopold (1872-1938). Furnishings
Benirschke, Max (dates unknown). Furniture
. Breitner, Joseph (dates unknown). Graphics
. Czeschka, Carl Otto (1878-1960). Glassware, textiles, posters
Fischl, Adolf Carl (dates unknown). Typography
. Flögl, Mathilde (1893-1950). Glassware, wallpaper
. Hagenauer, Karl (1888-1956). Metalwork
. Hoffmann, Josef (1870-1956). Architecture, interiors, furnishings, typography
 Co-founder, with Koloman Moser, of the Wiener Werkstätte, 1903.
Kammerer, Marcel (1878-1969). Furniture
. Klaus, Karl (1889-). Ceramics
Klimt, Gustav (1862-1918). Drawings, paintings, murals
. Likarz-Strauss, Maria, (1893-). Fashion designs, graphics
. Löffler, Berthold (1874-1960). Paintings, posters
Loos, Adolf (1870-1933). Architecture, furniture
. Margold, Emmanuel Josef (1888-1962). Metalwork
. Moser, Koloman (1868-1918). Furniture, metalwork, glassware, posters
 Co-founder, with Josef Hoffmann, of the Wiener Werkstätte, 1903
Niedermoser, Michal (dates unknown). Furniture
. Öfner, Hans (1880-). Architecture, furnishings
. Peche, Dagobert (1886-1923). Glass, metalwork
. Prutscher, Otto (1880-1949). Glassware
. Roller, Alfred (1864-1935). Embroidery design
Schmidt, Wilhelm (dates unknown). Furniture
. Sika, Jutta (1877-1964). Ceramics
. Trethan, Thérèse (1879-). Ceramics
Urban, Josef (1872-1933). Architecture, furniture, furnishings

. Wagner, Otto (1841-1918). Architecture, interiors, furniture
Wieselthier, Vally (1895-1945). Ceramics
Wimmer-Wisgrill, Eduard Josef (1882-1961). Textiles, jewelry
Witzmann, Karl (1883-1952). Furniture

DE STIJL (1917-1928)

César, Domela (1900-). Paintings
. Doesburg, (Theo) Christian Emil Marie Kupper van (1883-1931).
 Architecture, paintings. The Movement's principal theorist
Eesteren, Cornelis van (1897-1988). Architecture
. Gispen, Willem Hendrik (1890-1981), Lighting
Graeff, Werner (1901-1978). Graphics
. Hooft, Theodore (1918-1965). Metalwork
Huszar, Vilmos (1884-1960). Graphics
Klaarhamer, P. J. (dates unknown). Furniture
. Leck, Bart Anthony van der (1876-1958). Paintings, posters, graphics
Mondrian, Piet (1872-1944). Paintings, drawings
. Oud, Jacobus Johannes Pieter (1890-1963). Architecture, furnishings
. Rietveld, Gerrit Thomas (1888-1964). Architecture, furniture
. Sandberg, Willem (1897-1984). Graphics
. Vanderlaan, Kees (dates unknown). Posters
van't Hoff, Robert (1887-1979). Architecture
Vantongerloo, Georges (1886-1965). Paintings, sculpture
. Wijdeveld, Hendrikus Theodorus (1885-1987). Graphics
. Zwart, Pieter (Piet) (1885-1977). Graphics, furniture

BAUHAUS (1919-1933) / DEUTSCHE WERKBUND (1907-1934)

Albers, Anni Fleischmann (1899-1994). Textiles
Albers, Josef (1888-1976). Theoretician, paintings, prints
. Bayer, Herbert (1900-1985). Architecture, graphics
. Behrens, Peter (1868-1940). Architecture, product designs, graphics
Brandt, Marianne (1893-1983). Glassware, metalwork
. Breuer, Marcel Lajos (1902-1981). Architecture, furniture
. Breuhaus de Groot, Fritz August (1883-1960). Architecture, furnishings
. Dell, Christian (1893-1974). Metalwork
. Dexel, Walter (1890-1973). Graphics
Feininger, Lyonel (1871-1956). Paintings, drawings, graphics
. Friedländer-Wildenhain, Marguerite (1896-1985). Ceramics
Gropius, Walter (1883-1969). Founder of the Movement. Architecture
. Hartwig, Josef (1880-1955). Chess set, graphics
Itten, Johannes (1888-1967). Paintings, textiles
Kandinsky, Wassily (1866-1944). Paintings, watercolors, graphics
Klee, Paul (1879-1940). Paintings, drawings, graphics
Lindig, Otto (1895-1966). Product designs, ceramics
. Löbenstein, Margarete Heymann-Marks (1899-). Ceramics
Marcks, Gerhard (1889-1981). Sculpture, pottery
Meyer, Hannes (1889-1954). Architecture
. Mies van der Rohe, Ludwig (1886-1969). Architecture, furniture
. Moholy-Nagy, László (1895-1946). Paintings, photography, typography,
 stage designs
Muche, Georg (1895-1987). Paintings, writings
. Oud, Jacobus Johannes Pieter (1890-1963). Architecture, furnishings
. Paul, Bruno (1874-1968). Metalwork
. Riemerschmid, Richard (1868-1957). Furniture, furnishings
. Röhl, Karl Peter (1890-1975). Paintings, drawings
. Roth, Emmy (dates unknown). Metalwork
Scheper, Hinnerk (1897-1957). Wall paintings (murals)
Schlemmer, Oskar (1888-1943). Paintings, sculpture, stage designs
Schmidt, Joost (1893-1948). Graphics
. Schuitema, Paul (1897-1973). Graphics
. Schwitters, Kurt (1887-1948). Graphics
Stolzl, Gunta (1897-1983). Textile designs
. Sutnar, Ladislav (1897-1976). Ceramics
Tumpel, Wolfgang (1903-1978). Product design
. Wagenfeld, Wilhelm (1900-1990). Product design

EUROPE
. Aalto, Alvar Hugo Hendrik (1898-1976). Architecture, furniture, glassware
Adnet, Jacques (1900-1984). Architecture, lighting
Arbus, André-Léon (1903-1969). Furniture
. Argy-Rousseau, Gabriel (1885-1953). Glassware, ceramics
Bakst, Léon (1866-1924). Stage designs
. Benedictus, Edouard (1878-1930). Tapestries, rugs, portfolios
. Bizouard, Valéry (1875-1945). Metalwork. See also: Tétard Frères (Maison Tétard), Paris
Block, Robert (dates unknown). Furniture
. Bonfils, Robert (1886-1971). Ceramics, textiles, graphics
. Bouy, Jules (1872-1937). Furniture
. Brandt, Edgar William (1880-1960). Ironwork
Bugatti, Carlo (1855-1940). Furniture
Buquet, Edouard Wilfred (dates unknown). Lighting
Burkhalter, Jean (1895-1984). Furniture
. Buthaud, René (1886-1987). Ceramics
. Cassandre, A. M. (Adolphe Jean Marie Mouron) (1901-1968). Posters
Chareau, Pierre (1883-1950). Architecture, furniture
Christofle, L'Orfèvrerie. Founded 1829. Jewelry, metalwork
. Cliff, Clarice (1899-1972). Ceramics
Coard, Marcel (1889-1975). Furniture
Colin, Paul (1892-1985). Graphics
. Cooper, Susie (1902-1995). Ceramics
. Copier, Andries Dirk (1901-1991). Glassware
. Daum Frères (Jean-Louis-Auguste and Jean-Antonin Daum). Founded 1875. Glassware
Decorchemont, François-Emile (1880-1971). Glassware
. Desny (La Maison Desny) Paris. Metalwork
Djo-Bourgeois, Edouard-Joseph (Georges) (1898-1937). Furniture
Dufet, Michel (1888-1985). Furniture
. Dufrêne, Maurice (1876-1955). Furniture
. Dunand, Jean (1877-1942). Furniture, lacquer work
. Dupas, Jean (1882-1964). Paintings, posters
Erté (Romain de Tirtoff) (1892-1990). Fashion, theater sets, graphics
. Fauré, Camille (1872-1944). Enamelware
Follot, Paul Fréderic (1877-1941). Furniture
. Fouquet, George (1862-1957). Metalwork
. Gate, Simon (1883-1945). Glassware
Gesmar, Charles I. (1900-1928). Posters, theater sets
Goulden, Jean (1878-1947). Metalwork and enamelware
Gray, Eileen (1878-1976). Furniture
Groult, André (1884-1967). Furniture
Hald, Edvard (1883-1980). Glassware
. Henningsen, Poul (1894-1967). Lighting
Herbst, René (1891-1935). Architecture, furniture, furnishings
. Hoffmann, Wolfgang (1900-) and Pola (dates unknown). Furniture
Hoppe, Emil Otto (1878-1972). Graphics
Iribe, Paul (1883-1935). Furnishings
. Jensen, Georg Arthur (1866-1935). Metalwork. See also: Rohde, Johan
Jourdain, François (1876-1958). Furnishings
. Kåge, Wilhelm (1889-1960). Ceramics, glassware, graphics
Kauffer, E. McKnight (1890-1954). Posters
. Lalique, René Jules (1860-1945). Glassware, jewelry
. Le Chevallier, Jacques (1896-1987). Lighting, stained glass
. Le Corbusier, Charles Edouard Jenneret (1887-1965). Architecture, furnishings
Legrain, Pierre (1889-1929). Furniture, bookbindings
Leleu, Jules (1883-1961). Furniture
. Le Verre Français, Paris (Ernest 1877-1937 and Charles 1881-1953 Schneider). Glassware
Linossier, Claudius (1893-1953). Metalwork
. Luce, Jean (1895-1964). Ceramics
Lurçat, André (1894-1970). Furniture
Lurçat, Jean (1892-1966). Ceramics
. Magnussen, Erik (1884-1961). Metalwork
. Mallet-Stevens, Robert (1886-1945). Architecture, interiors
. Mary, F. L. (dates unknown). Posters
Marinot, Maurice (1882-1960). Glassware
Mathsson, Bruno (1907-1988). Architecture, furniture, furnishings
Mendelsohn, Erich (1887-1953). Architecture

Miklos, Gustave (1888-1967). Sculpture
. Miles, M. A. (dates unknown). Graphics
. Murray, Keith (1892-1981). Ceramics
. Perriand, Charlotte (1903-). Architecture, furnishings
Perzel, Jean (1892-). Lighting, glassware
Poiret, Paul (1879-1944). Couture
. Ponti, Gio (1892-1979). Architecture, furniture, furnishings
Printz, Eugène (1889-1948). Furniture
Prou, René (1889-1947). Furniture
. Prouvé, Jean (1901-1984). Furniture
. Puiforcat, Jean E. (1897-1945). Metalwork
Rateau, Armand-Albert (1882-1938). Furniture, ironwork
. Rohde, Johan (1856-1935). Metalwork
. Ruhlmann, Emile-Jacques (1879-1933). Furniture, ceramics
Saarinen, Eero (1910-1962). Architecture, furniture, furnishings
Sant'Elia, Antonio (1880-1916). Architecture, conceptual designs
. Sèvres, Manufacture Nationale de, Paris. Founded 1756. Porcelains, ceramics
Sognot, Louis (1892-1970). Furniture
Stam, Mart (1899-1986). Furniture
Süe et Mare / Louis Süe (1875-1968) and André Mare (1885-1932). Furniture
. Summers, Gerald (1899-1967). Furniture
. Tétard Frères (Maison Tétard) Paris. Founded 1880. Metalwork. See also: Valéry Bizouard.
Thuret, André (1898-1965). Glassware
Wegner, Hans J. (1914-). Lighting

AMERICA (ART MODERNE)

. Bel Geddes, Norman (1893-1958). Applied and industrial design
. Bouy, Jules (1872-1937). Furniture, lighting
. Carder, Frederick (1863-1963). Founder of Steuben Glass Works. Glassware
. Deskey, Donald (1894-1989). Furniture
. Dreyfuss, Henry (1904-1972). Applied and industrial design
. Faidy, Abel (1894-1965). Furniture
. Frankl, Paul Theodore (1887-1989). Furniture
. Fuller, Richard Buckminster (1895-1983). Architecture, engineering, graphics
. Guild, Lurelle van Arsdale (1886-1985). Metalwork
. Hamill, Virginia (dates unknown). Metalwork
. Hentschel, William Ernst (Billy) (1892-1962). Graphics
. Hoffman, Wolfgang (1900-1969). Interiors, furniture
Hood, Raymond M. (1881-1934). Architecture, furniture
. Iannelli, Alfonso (1886-). Architectural elements, drawings
. Karasz, Ilonka (1896-1981). Furniture, textiles, metalwork, ceramics
. Kogan, Belle (1902-). Metalwork
. Lescaze, William (1896-1969). Furnishings
. Loewy, Raymond (1893-1986). Industrial design
. Müller-Munk, Peter (1904-1967). Metalwork
. Natzler, Gertrud (1908-1971) and Otto (1908-). Ceramics
Neutra, Richard Joseph (1892-). Architecture, furnishings
. Pfisterer, Peter (1907-). Applied design
. Reiss, Winold (1886-1953). Designs, drawings, paintings
. Rice, Louis W. (dates unknown). Metalwork
. Rohde, Gilbert (1894-1944). Furniture, clocks, metalwork
. Rosenthal, Rena (dates unknown). Metalwork
Saarinen, Eliel (1873-1950). Architecture, furnishings
Schindler, Rudolph (1887-1953). Architecture, furnishings
. Schreckengost, Paul (1908-1983). Ceramics
Schreckengost, Viktor (1906-). Ceramics
. Teague, Walter Dorwin (1883-1960). Applied and industrial design
. Tennhardt, Elsa (dates unknown). Metalwork
. Thaden, H. V. (dates unknown). Furniture
. Theobald, Gene (dates unknown). Metalwork
. Thorpe, Dorothy C. (dates unknown). Furniture, furnishings
. Tiffany & Company, New York City. Founded 1900. Metalwork, glassware
Urban, Joseph (1872-1933). Architecture, furniture, furnishings
. Vassos, John (1898-1985). Applied and industrial design, graphics
. von Nessen, Walter (dates unknown). Lamps, metalwork
. Weber, Kem (Karl Emanuel Martin) (1889-1963). Architecture, furniture, furnishings
. Wright, Russel (1904-1976). Metalwork, ceramics
. Zeisel, Eva Sricker (1906-). Ceramics

HECTOR GUIMARD (1867-1942) French
Le Castel Beranger. L'Art dans l'Habitation Moderne, 1898. Complete portfolio with 65 plates. Fiberboard cover, lithographed title page, and stencilled color loose-leaf plates. Published by Librairie Rouam et Cie., Paris, 1898.
H: 13 ¼in (33.7cm) x W: 17 ½in (44.5cm)

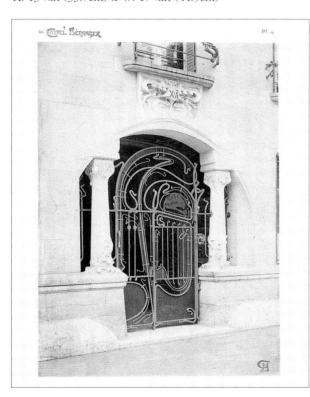

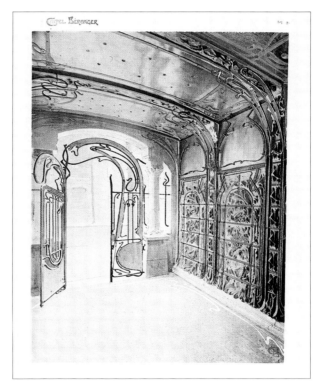

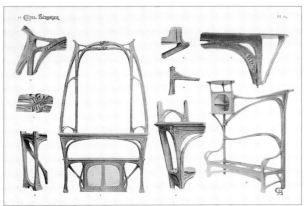

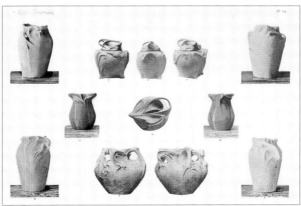

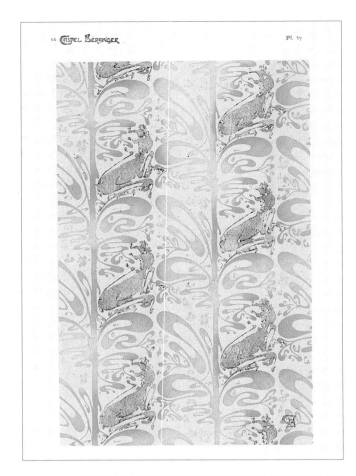

BIBLIOGRAPHY

The following books were used extensively in researching and assembling the Norwest collection. The list serves as a current sampling of publications available on Modernism – specifically modernist design – intended primarily for the interested reader and collector. Those pursuing further academic research are encouraged to refer to those titles having comprehensive bibliographies, foreign publications and pertinent periodicals and journals such as *The Journal of Decorative and Propaganda Arts*.

The list is divided first by an overview, followed by the six styles represented in the Norwest collection. Each section is further divided, general overviews are followed by monographs on individual designers/design firms. All books are in English unless noted otherwise. An asterisk (*) denotes publications prepared in conjunction with a gallery or museum exhibition.

MODERNISM OVERVIEW
1880-1940

Arwas, Victor. *Glass: Art Nouveau to Art Deco.* Harry N. Abrams, New York, 1987.

Banham, Reyner. *Theory and Design in the First Machine Age.* Architectural Press, London, 1960.

Barré-Despond, Arlette, ed. *Dictionnaire International des Arts Appliqués et du Design.* Editions du Regard, Paris, 1996. Text in French.

Bayley, Stephen, et al. *Twentieth-Century Style & Design.* Van Nostrand Reinhold, New York, 1986.

Benton, Tim and Charlotte. *Form Follows Function, A Source Book for the History of Architecture and Design: 1890-1939.* The Open University Press, London, 1975.

Brandt, Frederick R. *Late 19th and Early 20th Century Decorative Arts.* The Sydney and Frances Lewis Collection in the Virginia Museum of Fine Arts, Richmond. Distributed by the University of Washington Press, Seattle, 1985.

Bröhan, Torsten, ed. *Glas Kunst der Moderne: Von Josef Hoffmann bis Wilhelm Wagenfeld.* Klinkhardt & Biermann, Munich, 1992.

Bröhan, Torsten and Thomas Berg. *Avantgarde Design: 1880-1930.* Benedikt Taschen Verlag, Cologne, 1994.

Brunhammer, Yvonne and Suzanne Tise. *The Decorative Arts in France / La Société Des Artistes Décorateurs / 1900-1942.* Rizzoli International Publications, New York, 1990.

Byars, Mel. *The Design Encyclopedia.* Calmann & King, London, 1994.

Cameron, Ian et al. *The Random House Collector's Encyclopedia: Victoriana to Art Deco.* Random House, New York, 1974.

The Collector's Encyclopedia: Victoriana to Art Deco. With an introduction by Roy Strong. Studio Editions, London, 1974.

Collins, Michael. *Towards Post-Modernism: Design Since 1851.* British Museum Publications, London, 1987.

Cousins, Mark. *20th Century Glass.* Quintet Publishing, London, 1989.

Doordan, Dennis P., ed. *Design History: An Anthology. A Design Issues Reader.* The MIT Press, Cambridge, MA, 1995.

Drexler, Arthur, Intro. *The Design Collection: Selected Objects.* The Museum of Modern Art, New York, 1970.

Duncan, Alastair. *Fin de Siècle Masterpieces from the Silverman Collection.* Abbeville Press, New York, 1989.

Durant, Stuart. *Ornament: From the Industrial Revolution to Today.* The Overlook Press, Woodstock, N.Y, 1986.

Edelberg, Martin, ed. *Designed for Delight: Alternative Aspects of Twentieth-Century Decorative Arts.* Montreal Museum of Decorative Arts/Flammarion, 1997.

Encyclopedia of Interior Design, 2 vols. Fitzroy Dearborn Publishers, Chicago, 1997.

Everdell, William R. *The First Moderns.* The University of Chicago Press, 1997.

Fiell, Charlotte and Peter. *Modern Chairs.* Benedikt Taschen Verlag, Cologne, 1993.

Forty, Adrian. *Objects of Desire: Design and Society from Wedgwood to IBM.* Pantheon, New York, 1968.

DESIGNER UNKNOWN
(Russian)
Fabric section with Russian avant-garde graphic design, c.1930. Silk.

ILIAZDE (Ilia Zdanevitch)
(1894-1974) Russian
L'éloge de Ilia Zdanevitch, 1922.
Printed for a Dada conference,
May 22, 1922.

EL LISSITZKY (1890-1941)
German
Dilia Golosa (*For the Voice*),
1923. A book of poems by the
Russian poet/playwright
Vladimir Mayakovsky.

Garner, Philippe, ed. *The Encyclopedia of Decorative Arts: 1890-1940*. Van Nostrand Reinhold, New York, 1979.

Greenhalgh, Paul, ed. *Modernism in Design*. Reakrion Books, London, 1990.

Greenhalgh, Paul. *Quotations and Sources on Design and the Decorative Arts*. St. Martin's Press, New York, 1993.

Hardy, William et al. *Decorative Styles: 1850-1935*. Wellfleet Press, Secaucus, NJ, 1988.

Hartmann, Carolus. *Glasmarken Lexikon: 1600-1945. Signaturen, Fabrik und Handelsmarken. Europa und Nordamerika*. Arnoldsche, Stuttgart, 1997.

Heskett, John. *Industrial Design*. World of Art Series, Oxford University Press, New York, 1980.

Hiesinger, Kathryn B. and George H. Marcus. *Landmarks of Twentieth-Century Design: An Illustrated Handbook*. Abbeville Press, New York, 1993.

The Illustrated Dictionary of 20th Century Designers. Mallard Press, New York, 1991.

Jervis, Simon. *The Penguin Dictionary of Design and Designers*. Penguin Books, Harmondsworth, Middlesex, 1984.

Julier, Guy. *The Thames and Hudson Encyclopaedia of 20th Century Design and Designers*. World of Art Series, Thames and Hudson, London, 1993.

Kaplan, Wendy, ed. *Designing Modernity: The Arts of Reform and Persuasion, 1885-1945*. Selections from the Wolfsonian collection, Miami Beach, Fla. Thames & Hudson, 1995.*

Kjellberg, Pierre. *Le Mobilier du XXe Siècle: Dictionnaire des Créateurs*. Les Editions de L'Amateur, Paris, 1994.

Klein, Dan and Margaret Bishop, eds. *Decorative Art: 1880-1980*. Phaidon / Christie's, London, 1986.

Knowles, Eric. *Victoriana to Art Deco: A Collector's Guide*. Miller's, Divison of Reed Consumer Books, London, 1992.

Koch, André. *Struck by Lighting. An Art-Historical Introduction to Electrial Lighting Design for the Domestic Interior*. Uitgeverij De Hef, Rotterdam, 1994.

Lambert, Susan. *Form Follows Function? Design in the 20th Century*. Victoria & Albert Museum, London, 1993.

McDermott, Catherine. *Design Museum Book of 20th Century Design*. The Overlook Press, Woodstock and New York, 1977.

McFadden, David R., ed. *Scandinavian Modern Design: 1880-1980*. Harry N. Abrams, New York, 1982. *

Marcus, George H. *Functionalist Design: An Ongoing History*. Prestel, Munich, 1995.

Margolin, Victor, ed. *Design History: History / Theory / Criticism*. University of Chicago Press, Chicago, 1989.

Marshall, Jo. *Glass Source Book: A Visual Record of the World's Great Glass Making Traditions*. Quarto Publishing, London, 1990.

Massey, Anne. *Interior Design of the 20th Century*. World of Art Series, Thames & Hudson, London, 1990.

Miller, R. Craig. *Modern Design: 1890-1990:In the Metropolitan Museum of Art*. Harry N. Abrams, New York, 1990.

Moody, Ella. *Modern Furniture*. Dutton Pictureback / Studio Vista, London, 1966.

Musée d'Orsay. *Catalogue Sommaire Illustré des Arts Décoratifs*. Editions de la Réunion des Musées Nationaux, Paris, 1988.

Museum Boymans van-Beuningen, Rotterdam. *Silver of a New Era. International Highlights of Precious Metalware from 1880 to 1940*. Distributed by University of Washington, Seattle, 1992. *

Museum für Kunsthandwerk / Grassimuseum, Leipzig. *Erlesenes aus Jugendstil und Art Deco: die Sammlung Giorgio Silzer*. Passage-Verlag, Leipzig, 1997. Text in German.

Naylor, Colin, ed. *Contemporary Designers*. St. James Press, Chicago, 1990.

O'Neill, Amanda. *Introduction to the Decorative Arts: 1890 to the Present Day*. Shooting Star Press, New York, 1990.

Opie, Jennifer H. *Scandinavian Ceramics & Glass in the Twentieth Century. The Collections of the Victoria & Albert Museum (London)*. Rizzoli International Publications, New York, 1990. *

Ostergard, Derek, ed. *Bentwood and Metal Furniture: 1850-1946*. The American Federation of Arts, New York, 1987. *

Page, Marion. *Furniture Designed by Architects*. Whitney Library of Design, New York, 1980.

Parish, Keith, ed. *Design Source Book: A Visual Reference to Design from 1850 to the Present*. QED Publishing, Ltd., London / Chartwell Books, Secaucus, NJ, 1986.

Pevsner Nikolaus. *The Sources of Modern Architecture and Design*. World of Art Series, Thames & Hudson, London, 1968 /1985.

Pevsner, Nikolaus. *Pioneers of Modern Design from William Morris to Walter Gropius*. Penguin Books, Harmondsworth, Middlesex, 1936/1987.

Pile, John. *Dictionary of 20th-Century Design*. Roundtable Press, New York, 1990.

Rudoe, Judy. *Decorative Arts: 1850-1950*. A Catalogue of the British Museum Collection. British Museum Press, London, 1991/1994. *

Sembach, Klaus-Jürgen et al. *Twentieth-Century Furniture Design*. Benedikt Taschen Verlag, Cologne, 1995 (?).

Sparke, Penny. *An Introduction to Design and Culture in the Twentieth Century*. Unwin Hyman, London, 1986.

Sparke, Penny. *Design in Context*. Quarto Publishing, London / Chartwell Books, Secaucus, NJ, 1987.

Sparke, Penny. *Italian Design, 1870 to the Present*. Thames and Hudson, London, 1988.

Stedelijk Museum. *Industry & Design in the Netherlands: 1850-1950*. Stedelijk Museum, Amsterdam, 1986. *

Te Duits, T. G., *Applied Arts and Industrial Design: 1800 – The Present*. Museum Boymans-van Beuningen, Rotterdam / De Bataafsche, Leeuw, Amsterdam, 1996. In Dutch and English.

Troy, Nancy. *Modernism and the Decorative Arts in France: Art Nouveau to Le Corbusier*. Yale University Press, New Haven, CT, 1991.

Venable, Charles L. *Silver in America: 1840-1940. A Century of Splendor*. Dallas Museum of Fine Arts, 1995. Distributed by Harry N Abrams, New York. *

Weston, Richard. *Modernism*. Phaidon Press, London, 1996.

Woodham, Jonathan M. *Twentieth-Century Ornament*. Rizzoli International Publications, New York, 1990.

Zahle, Erik. *A Treasury of Scandinavian Design*. Golden Press, New York, 1961.

Zühlsdorff, Dieter. *Keramik-Marken Lexikon: 1885-1935 Europa*. Arnoldsche, Stuttgart, 1994.

GRAPHIC DESIGN

Ades, Dawn. *The 20th-Century Poster: Design of the Avant-Garde*. Walker Art Center, Minneapolis / Abbeville Press, New York, 1984. *

Anikst, Mikhail and Elena Chernevich, eds. *Russian Graphic Design: 1880-1917*. Abbeville Press, New York, 1990. *

Barnicoat, John. *A Concise History of Posters*. Oxford University Press, New York, 1979.

Blackwell, Lewis. *20th Century Type*. Rizzoli International Publications, 1922.

Booth-Clibborn, Edward and Daniele Baroni. *Graphics: The Language of Graphics*. Harry N. Abrams, New York, 1979.

Brandt, Frederick R., ed. *Designed to Sell: Turn-of-the-Century American Posters*. Virginia Museum of Fine Arts, Richmond, VA, 1995. *

Broos, Kees and Paul Hefting. *Dutch Graphic Design: A Century*. The MIT Press, Cambridge, MA, 1993.

Craig, James and Bruce Barton. *Thirty Centuries of Graphic Design: an Illustrated Survey*. Watson-Guptill Publications, New York, 1987.

Gallo, Max. *The Poster in History*. Wellfleet Press, Secaucus, NJ, 1989.

Heller, Steven and Louise Fili. *Italian Art Deco: Graphic Design Between the Wars*. Chronicle Books, San Francisco, 1993.

Hillier, Bevis. *Posters*. Spring Books, London, 1969.

Hollis, Richard. *Graphic Design: A Concise History*. World of Art Series, Thames & Hudson, London, 1994.

Kiehl, David W, ed. *American Art Posters of the 1890s*. The Metropolitan Museum of Art / Harry N. Abrams, New York, 1987. *

King, Julia. *The Flowering of Art Nouveau Graphics*. Peregrine Smith Books, Salt Lake City, 1990.

Livingston, Alan and Isabella. *Graphic Design & Designers*. World of Art Series, Thames & Hudson, London, 1992.

Lupton, Ellen and Elaine Lustig Cohen. *Letters from the Avant Garde: Modern Graphic Design*. Princeton Architectural Press, New York, 1996.

Margolin, Victor. *American Poster Renaissance: The Great Age of Poster Design, 1890-1900*. Castle Books, Secaucus, NJ, 1975.

Meggs, Philip B. *A History of Graphic Design*. Van Nostrand Reinhold, New York, 1983.

Pack, Susan. *Film Posters of the Russian Avant-garde*. Benedikt Taschen Verlag Cologne, 1995.

Prokopoff, Stephen S., ed. *The Modern Dutch Poster: The First Fifty Years*. Krannert Art Museum, University of Illinois, Urbana-Champaigne, IL / The MIT Press, Cambridge, MA, 1987.

Spencer, Herbert. *Pioneers of Modern Typography*. Revised Edition. The MIT Press, Cambridge, MA, 1985.

LUCIEN BERNHARD (1883-1972)
Austrian-American
Adler Typewriter, 1908.

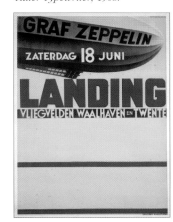

KEES VAN DER LAAN
(dates unknown) Dutch
Graf-Spee Landing, 1932. Poster
/ lithograph.

Spencer, Herbert, ed. *The Liberated Page: An Anthology of Major Typographic Experiments of This Century as Recorded in Typographica Magazine*. Bedford Press, San Francisco, 1987.

Walker Art Center. *Graphic Design in America: A Visual Language/History*. Harry N. Abrams, New York,1989. *

Weill, Alain. *The Poster: A Worldwide Survey and History*. G.K. Hall & Co., Boston, 1984.

Wember, P. *Die Jugend der Plakate: 1887-1917*. Scherpe Verlag, Krefeld, Germany, 1961.

Wrede, Stuart. *The Modern Poster*. The Museum of Modern Art, New York, 1988. *

INDIVIDUAL DESIGNERS

BERTHON, PAUL and EUGÈNE GRASSET
Arwas, Victor. *Berthon & Grasset*. Academy Editions, London, 1978.

BRADLEY, WILL
Hornung, Clarence P. *Will Bradley: His Graphic Art*. Dover Publications, New York, 1974.

MUCHA, ALPHONSE
Bridges, Ann. *Alphonse Mucha: The Complete Graphic Works*. Harmony Books, New York, 1980.
Ellridge, Arthur. *Mucha: The Triumph of Art Nouveau*. Editions Pierre Terrail, Paris, 1992.

ARTS AND CRAFTS
1875-1915

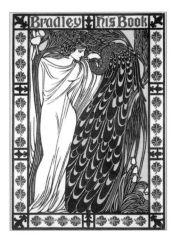

See page 46

MAXFIELD PARRISH (1870-1966)
American
The Century, 1897.

Adams, Steven. *The Arts & Crafts Movement*. Quintet Publishing, London, 1987.

Anscombe, Isabelle and Charlotte Gere. *Arts & Crafts in Britain and America*. Academy Editions, London, 1978.

Bowman, Leslie G., ed. *American Arts & Crafts: Virtue in Design*. Los Angeles County Museum of Art, 1990. *

Cathers, David M. *Furniture of the American Arts and Crafts Movement*. NAL Books, New York, 1981.

Clark, Robert Judson, ed. *The Arts and Crafts Movement in America: 1876-1916*. Princeton University Press, Princeton, NJ, 1972.*

Darling, Sharon S. *Chicago Metalsmiths*. Chicago Historical Society, Chicago, 1977. *

Duncan, Alastair. *Treasures of the American Arts and Crafts Movement*. Harry N. Abrams, New York, 1988.

Gere, Charlotte and Michael Whiteway. *Nineteenth Century Design: From Pugin to Mackintosh*. Harry N. Abrams, New York, 1994.

Haslam, Malcolm. *Arts and Crafts*. Collectors' Style Guide. Macdonald Orbis, London, 1988.

Kaplan, Wendy, ed. *The Encyclopedia of Arts and Crafts: The International Arts Movement, 1850-1920*. E.P. Dutton, New York, 1989.

Larner, Gerald and Celia. *The Glasgow Style*. Astragal Books, London, 1979.

Moon, Karen. *George Walton: Designer and Architect*. White Cockade Publishing, Oxford, 1993.

Naylor, Gillian. *The Arts and Crafts Movement*. Trefoil Publications, London, 1971 / 1990.

Parry, Linda. *Textiles of the Arts and Crafts Movement*. Thames & Hudson, London, 1988 / 1990.

Puig, Francis J. and Michael Conforti, eds. *American Craftsman and the European Tradition, 1620-1820*. The Minneapolis Institute of Arts, Minneapolis, 1989. *

Trapp, Kenneth R., ed. *The Arts and Crafts Movement in California: Living the Good Life*. Abbeville Press, New York, 1993. *

INDIVIDUAL DESIGNERS

ASHBEE, CHARLES ROBERT
Crawford, Alan. *C.R. Ashbee: Architect, Designer and Romantic Socialist*. Yale University Press, New Haven, CT, 1985.

DRESSER, CHRISTOPHER
Dresser, Christopher. *The Language of Ornament: Style in the Decorative Arts*. Originally published under the title, *Studies in Design,* 1876. Portland House, New York, 1988.

Widar, Halén. *Christopher Dresser, A Pioneer of Modern Design.* Phaidon Press, London, 1993.

ELMSLIE, GEORGE GRANT
Spencer, Brian A. *The Prairie School Tradiition.* Whitney Library of Design, New York, 1979.

MATHEWS, ARTHUR and LUCIA
Jones, Harvey L. *Mathews: Masterpieces of the California Decorative Style.* Oakland
 Museum of Art, 1972. *

MORRIS, WILLIAM
Henderson, Philip, ed. *William Morris: His Life, Work and Friends.* Thames & Hudson,
 London, 1967.
MacCarthy, Fiona. *William Morris: A Life For Our Time.* Alfred A. Knopf, New York, 1995.
Parry, Linda, ed. *William Morris and the Arts & Crafts Movement: A Source Book.* Portland
 House, New York, 1989.
Parry, Linda, ed. *William Morris.* Harry N. Abrams, New York, 1996. *
Watkinson, Ray. *William Morris as Designer.* Trefoil, London, 1990.

STICKLEY, GUSTAV
Gray, Stephen and Robert Edwards, eds. *Collected Works of Gustav Stickley.* Turn of the
 Century Editions, New York, 1981.
Gray, Stephen. *The Early Work of Gustav Stickley.* Turn of the Century Editions, New York, 1987.

VOYSEY, CHARLES FRANCIS ANNESLEY
Simpson, Duncan. *C.F.A. Voysey: An Architect of Individuality.* Lund Humphries, London, 1979.

WRIGHT, FRANK LLOYD
Fischer Fine Art. *Frank Lloyd Wright: Architectural Drawings and Decorative Art.* Fischer
 Fine Art, Ltd., London, 1985. *
Hanks, David. *The Decorative Designs of Frank Lloyd Wright.* E.P. Dutton, New York, 1979.
Hanks, David. *Frank Lloyd Wright: Preserving an Architectural Heritage. Decorative
 Designs from the Domino's Pizza Collection.* Dutton, New York, 1989.
Hirschl & Adler Modern. *Frank Lloyd Wright: Art in Design.* Hirschl & Adler Modern
 Gallery, New York, 1983.
Kelmscott Gallery. *Frank Lloyd Wright.* Kelmscott Gallery, Chicago,1981. *
Yale University School of Architecture. *The Chairs of Frank Lloyd Wright.* Yale University,
 New Haven, CT, 1987.

NATALIYA GONCHAROVA
(1881-1962) Russian
Grand Bal de Nuit, 1923.

ART NOUVEAU
1880-1910

Amaya, Mario. *Art Nouveau.* Dutton Pictureback / Studio Vista, Ltd., London, 1967.
Bloch-Dermant, Janine, *The Art of French Glass: 1860-1914.* The Vendome Press, 1974 /1980.
Bouillon, Jean-Paul. *Art Nouveau: 1870-1914.* Skira / Rizzoli International Publications,
 New York, 1985.
Brunhammer, Yvonne, ed. *Art Nouveau: Belgium / France.* Institute for the Arts, Rice
 University, Houston, 1976. *
Buffet-Challié, Laurence. *Art Nouveau Style.* Rizzoli International Publications, New York,
 1982.
Costantino, Maria. *Art Nouveau.* Gallery Books, New York, 1989.
Dry, Graham, Intro. *Art Nouveau Domestic Metalwork.* Reprint of 1906 catalogue
 documenting the work of Württembergische Metallwaren Fabrik. Antique Collectors'
 Club, Woodbridge, Suffolk, 1988.
Duncan, Alastair. *Art Nouveau and Art Deco Lighting.* Simon and Schuster, New York, 1978.
Duncan, Alastair. *Art Nouveau.* World of Art Series, Thames & Hudson, London, 1994.
Éri, Gyöngyi and Zsuzsa Jobbágyi. *A Golden Age: Art and Society in Hungary, 1896-1914.*
 Barbican Art Gallery, London / Corvina, London, 1990. *
Fahr-Becker, Gabriele. *L'Art Nouveau.* Könenman Verlag, Cologne, 1997. In French.
Gruber, H.R. *Jugendstilglas.* Mittelrheinisches Landesmuseum, Mainz, Germany, 1976. *
Gysling-Billeter, Erika. *Objekte des Jugendstils.* Benteli Verlag, Bern, Switzerland, 1975. In German.
Hardy, William. *A Guide to Art Nouveau Style.* Chartwell Books, Secaucus, NJ, 1986.
Haslam, Malcolm. *Art Nouveau.* Collectors' Style Guides. Macdonald & Co., London, 1988.

See page 95

CHARLES RENNIE
MACKINTOSH AND MARGARET
MACDONALD-MACKINTOSH
(1868-1928 / 1865-1933) Scottish
Haus Eines Kunstfreundes
(House for an Art Lover), 1902.

HECTOR GUIMARD (1867-1942)
French
*Le Castel Beranger. L'Art dans
l'Habitation Moderne*, 1898.
Complete portfolio with 65
plates, Paris, 1898.

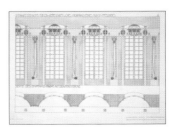

Haslam, Malcolm. *In the Nouveau Style*. Little, Brown & Co., Boston, 1989.

Heller, Carl Benno. *Art Nouveau Furniture*. Artline Editions, Thornbury, Bristol, England, 1990.

Heskett, John. *German Design: 1870-1918*. Taplinger Publishing Co., New York, 1986.

Hessisches Landesmuseum Darmstadt. *Jugendstil Kunst Um 1900*. Eduard Roether Verlag, Samstadt, Germany, 1982. In German.

Hiesinger, Kathryn, ed. *Art Nouveau in Munich*. Philadelphia Museum of Art / Prestel Verlag, Munich, 1988. *

Johnson, Diane Chalmers. *American Art Nouveau*. Harry N. Abrams, New York, 1979.

Just, Johannes. *Meissen Porcelain of the Art Nouveau Period*. Seven Hills Books, Cincinnati, 1983.

Krekel-Aalberse, Annelies. *Art Nouveau and Art Deco Silver*. Thames & Hudson, London, 1989.

Lenning, Henry F. *The Art Nouveau*. Martinus Nijhoff, The Hague, 1951.

Levy, Mervyn. *Liberty Style: The Classic Years, 1898-1910*. Rizzoli International Publications, New York, 1986.

Madsen, Stephan T. *Art Nouveau*. World University Library Series, McGraw-Hill Book Co., New York, 1967.

Madsen, Stephan T. *Sources of Art Nouveau*. Da Capo Press, New York, 1975 / 1980.

Masini, Lara-Vinca. *Art Nouveau*. Arch Cape Press, New York, 1976.

Mebane, John. *The Complete Book of Collecting Art Nouveau*. Coward, McCann, New York, 1970.

Mourey, Gabriel. *The Art Nouveau Style*. Dover Publications, Inc., New York, 1980.

Musée des Arts Décoratifs. *Pionniers du XXe Siècle: Guimard / Horta / Van de Velde*. Musée des Arts Décoratifs, Paris, 1971. *

Museum für Kunst und kulturgeschichte der Stadt Dortmund. *Prager Jugendstil*. Brausdruck, Heidelberg, 1992. In German. *

Nebehay, Christian M. *Ver Sacrum: 1898-1903*. Rizzoli International Publications, New York, 1977.

Revi, Albert Christian. *American Art Nouveau Glass*. Schiffler Publishing, Exton, PA, 1968 / 1981.

Rheims, Maurice. *The Flowering of Art Nouveau*. Harry N. Abrams, New York, 1966.

Sänger, Reinhard W. *Das Deutsche Silber-Besteck: Biedermeier – Historismus – Jugendstil (1805-1918)*. Arnoldsche Verlagsanstalt, Stuttgart,1991. In German.

Schmutzler, Robert. *Art Nouveau*. Harry N. Abrams, New York, 1978.

Selz, Peter and Mildred Constantine, eds. *Art Nouveau: Art and Design at the Turn of the Century*. The Museum of Modern Art, New York / Doubleday & Co., Inc., Garden City, NY, 1960.

Staatliche Museen Kassel. *Wege in Die Moderne: Jugendstil in München*. Staatliche Museen, Kassel / Klinkhardt & Biermann Verlag, Munich/Berlin, 1997. In German.

Uecker, Wolf. *Art Nouveau and Art Deco Lamps and Candlesticks*. Abbeville Press, New York, 1986.

Ulmer, Renate. *Museum Künstlerkolonie Darmstadt: Katalog*. Museum Künstlerkolonie, Damstadt, Germany, 1990. In German.

Waddell, Roberta, ed. *The Art Nouveau Style in Jewelry, Metalwork, Glass, Ceramics, Textiles, Architecture and Furniture*. Dover Publications, New York, 1977.

Weisberg, Gabriel P. *Art Nouveau Bing: Paris Style 1900*. Smithsonian Institution Traveling Exhibition Service (SITES) / Harry N. Abrams, New York, 1986.

Weisberg, Gabriel P. *Stile Floreale: The Cult of Nature in Italian Design*. The Wolfsonian Foundation, Miami Beach, Fl, 1988. *

Weisberg, Gabriel P. and Elizabeth K. Menon. *Art Nouveau: A Research Guide for Design Reform in France, Belgium, England and the United States*. Garland Publishing, Hamden, CT, 1998.

Wichmann, Siegfried. *Jugendstil Art Nouveau: Floral and Functional Forms*. A New York Graphic Society Book. Little, Brown & Co., Boston, 1984.

INDIVIDUAL DESIGNERS and DESIGN FIRMS

ADLER, FRIEDRICH
Leonhardt, Bridgitte, et al. *Friedrich Adler: Zwischen Jugendstil und Art Déco*. Arnoldsche Verlagsanstalt, Stuttgart, 1994. In German.

BUGATTI, CARLO
Dejean, Philippe. *Bugatti: Carlo / Rembrandt / Ettore / Jean*. Éditions du Regard, Paris, 1981.

COLONNA, EDWARD
Eidelberg, Martin. *E. Colonna*. Dayton Art Institute, Dayton, OH, 1983. *

GALLÉ, EMILE
Duncan, Alastair and Georges de Bartha. *Glass by Gallé*. Harry N. Abrams, New York, 1984.
Garner, Philippe. *Emile Gallé*. Academy Editions, London, 1976 / 1990.
Musée du Luxembourg. *Gallé*. Musée du Luxembourg, Paris, 1985. *
Newark, Tim. *Emile Gallé*. Chartwell Books, Secaucus, NJ, 1989.
Warmus, William. *Emile Gallé Dreams Into Glass*. The Corning Museum of Glass, Corning, NY, 1984. *

GAUDÍ, ANTONI
Bassegoda i Nonell, Joan. *The Mila House: 1906-1912*. Fundació Caixa de Catalunya, Barcelona, 1989.
Costantino, Maria. *Gaudí*. Park Lane Books, London, 1993.
Zerbst, Rainer. *Antoni Gaudí*. Benedikt Taschen Verlag, Cologne, 1991.

GUIMARD, HECTOR
Graham, F. Lanier. *Hector Guimard*. The Museum of Modern Art, New York, 1970. *
Musée d'Orsay. *Guimard*. Musée d'Orsay, Paris, 1993. In French. *
Rheims, Ferré. *Hector Guimard*. Harry N. Abrams, New York, 1985.

HORTA, VICTOR
Aubry, Françoise and Jos Vandenbreeden, eds. *Horta: Art Nouveau to Modernism*. Ludion Press, Ghent, 1996.
Oostens-Wittamer, Yolande. *Victor Horta / L'Hotel Solvay / The Solvay House*. 2 vols. Collège Erasmé Louvain-la Neuve, Belgium, 1980.

LALIQUE, RENÉ
Barten, Sigrid. *René Lalique Schmuck und Objets d'Art 1890-1910*. Prestel-Verlag, Munich, 1977.

MACKINTOSH, CHARLES RENNIE
Billcliffe, Roger. *Mackintosh Furniture*. E. P. Dutton, New York, 1985.
Billcliffe, Roger. *Charles Rennie Mackintosh: Textile Designs*. Pomegranate Art Books, San Francisco, 1993.
Buchanan, William. *Mackintosh's Masterwork: Charles Rennie Mackintosh and the Glasgow School of Art*. Chronicle Books, San Francisco, 1989.

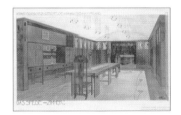

Crawford, Alan. *Charles Rennie Mackintosh*. World of Art Series, Thames & Hudson, London, 1995.
Fiell, Charlotte and Peter. *Charles Rennie Mackintosh*. Benedikt Taschen Verlag, Cologne, 1995.
Hackney, Fiona and Isla. *Charles Rennie Mackintosh*. Shooting Star Press, New York, 1989.
Jones, Anthony. *Charles Rennie Mackintosh*. Wellfleet Press, Secaucus, NJ, 1990.
Kaplan, Wendy, ed. *Charles Rennie Mackintosh*. Glasgow Museums / Abbeville Press, 1996.*
Macleod, Robert. *Charles Rennie Mackintosh: Architect and Artist*. E.P. Dutton, New York, 1983.
Seibu Museum of Art. *Charles Rennie Mackintosh*. Seibu Museum of Art, Tokyo, 1979.
Steele, James. *Charles Rennie Mackintosh: Synthesis in Form*. Academy Editions, London, 1994.

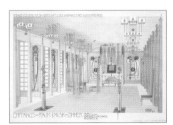

MAJORELLE, LOUIS
Bouvier, Roselyne. *Majorelle*. La Bibliothèque des Arts. Éditions Serpentoise, Paris, 1991.
Duncan, Alastair. *Louis Majorelle: Master of Art Nouveau Design*. Harry N. Abrams, New York, 1991.

OLBRICH, JOSEPH MARIA
Haiko, Peter and Bernd Krimmel. *Joseph Maria Olbrich: Architecture*. The complete reprint of the original plates of 1901-1914. Rizzoli International Publications, New York, 1988.

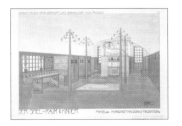

PAUL, BRUNO
Ziffer, Alfred. *Bruno Paul: Deutsche Raumkunst und Architektur. Zwischen Jugendstil und Moderne*. Münchner Stadtmuseum / Klinkhardt & Biermann, Munich, 1992. In German. *

JOHAN THORN-PRIKKER
(1868-1932) Dutch
Holländische Kunstusstellung,
1903.

RIEMERSCHMID, RICHARD
Münchner Stadtmuseum. *Richard Riemerschmid vom Jugendstil zum Werkbund: Werke und Dokumente.* Münchner Stadtmuseum, Munich, 1983. In German. *

SERRURIER-BOVY, GUSTAVE
Watelet, Jacques-Grégoire. *Gustave Serrurier-Bovy: À L'Aube de L'Esthetique Industrielle.* Beaunord, Centre Wallonie-Bruxelles, Paris, 1989. In French. *

SULLIVAN, LOUIS
De Wit, Wim, ed. *Louis Sullivan: The Function of Ornament.* Chicago Historical Society / W. W. Norton & Co., New York, 1986. *
Millett, Larry. *The Curve of the Arch: The Story of Louis Sullivan's Owatonna Bank.* Minnesota Historical Society, St. Paul, 1985.
Cardinal-Pett, Clare. Masterpiecework. An exhibition comprised of blueprints of Louis Sullivan's Owatonna Bank. Iowa State University, Ames, IA, 1995. *
Twombly, Robert. *Louis Sullivan: His Life and Work.* Viking Press, New York, 1986.
Weingarden, Lauren S. *Louis H. Sullivan: The Banks.* The MIT Press, Cambridge, MA, 1987.
Weingarden, Lauren S. *Louis H. Sullivan: A System of Architectural Ornament.* Rizzoli International Publications, New York, 1990.

THONET, GEBRüDER
Von Vegesack, Alexander. *Thonet: Classic Furniture in Bent Wood and Tubular Steel.* Hazar Publishing, London, 1996.
Wilk, Christopher, intro. *Thonet Bentwood & Other Furniture. The 1904 Illustrated Catalogue.* Dover Publications, New York, 1980.
Zelleke, Ghenete. *Against the Grain: Bentwood furniture from the Collection of Fern and Manfred Steinfeld.* The Art Institute of Chicago, 1993. *

TIFFANY, LOUIS COMFORT
Doros, Paul E. *The Tiffany Collection of the Chrysler Museum at Norfolk.* Chrysler Museum, Norfolk, VA, 1977.
Duncan, Alastair, et al. *Masterworks of Louis Comfort Tiffany.* Renwick Gallery, Washington, D. C. / Thames & Hudson, London, 1989. *
Paul, Tessa. *The Art of Louis Comfort Tiffany.* Exeter Books, New York, 1987.

VAN DE VELDE, HENRY
Sembach, Klaus-Jürgen. *Henry van de Velde.* Rizzoli International Publications, New York, 1989.

ZSOLNAY, VILMOS
Csenkey, Éva. *Zsolnay Szecessziós Kerámiák.* Helikon Kiadó, 1992. In Czech.

ZUID-HOLLAND
Museum het Catharina Gasthuis. *N.V. Koninklijke Plateelbakkerij Zuid-Holland.* Museum het Catharina Gasthuis, Gouda / Waanders Uitgevers, Zwolle, n.d. In Dutch. *

See page 115

WIENER WERKSTÄTTE
1903-1933
VIENNA MODERNE
1895-1940

Adlmann, Jan E. *Vienna Moderne: 1898-1918. An Early Encounter Between Taste and Utility.* Sarah Blaffer Gallery, University of Houston, 1978. *
Centre Georges Pompidou, Paris. *Vienne 1880-1938: L'Apocalypse Joyeuse,* 1986. *
Fahr-Becker, Gabriele. *Wiener Werkstätte: 1903-1932.* Benedikt Taschen Verlag, Cologne, 1995.
Fanelli, Giovanni. *La Linea Viennese: Grafica Art Nouveau.* Cantini Editore, Florence, 1989.
Kallir, Jane. *Viennese Design and the Wiener Werkstätte.* Galerie St. Etienne / George Braziller, New York, 1986. *
Palazzo Grassi, Venice. *Le Arti a Vienna: Dalla Secessione Alla Caduta Dell'Impero Asburgico.* Edizioni La Biennale, Mazotta Editore, Milan, 1984.
Rich, Maria F. *Art in the Home: 1900-1930.* Historical Design Collection, New York, 1996. *

Schorske, Carl E. *Fin-de-Siècle Vienna, Politics and Culture.* Alfred A. Knopf, New York, 1980.

Schweiger, Werner J. *Wiener Werkstätte, Design in Vienna 1903-1932.* Abbeville Press, New York, 1982/1984.

Varnedoe, Kirk. *Vienna 1900: Art, Architecture & Design.* The Museum of Modern Art, New York, 1986.

Vergo, Peter. *Art in Vienna 1898-1918.* Phaidon Press, London, 1975.

INDIVIDUAL DESIGNERS

HOFFMANN, JOSEF

Baroni, Daniele and Antonio D'Auria. *Josef Hoffmann e la Wiener Werkstatte.* Electa Editrice, Gruppo Editoriale Electa, Milan, 1981.

Gebhard, David. *Josef Hoffmann: Design Classics.* The Fort Worth Art Museum, 1982. *

Noever, Peter, ed. *Josef Hoffmann Designs: MAK-Austrian Museum of Applied Arts,* Vienna. Prestel Verlag, Munich, 1992.

Sekler, Eduard F. *Josef Hoffmann: The Architectural Work.* Princeton University Press, Princeton, NJ, 1985.

LOOS, ADOLF

Gravagnuolo, Benedetto. *Adolf Loos.* Rizzoli International Publications, New York, 1982.

MOSER, KOLOMAN

Baroni, Daniele and Antonio D'Auria. *Kolo Moser: Graphic Artist and Designer.* Rizzoli International Publications, New York, 1986.

PECHE, DAGOBERT

Eisler, Max. *Dagobert Peche.* Arnoldsche Verlagsanstalt, Stuttgart, 1992.

Zentralsparkasse u. Kommerzialbank. *Dagobert Peche 1887-1923.* Zentralsparkasse u. Kommerzialbank, Vienna, n.d. *

POWOLNY, MICHAEL

Frottier, Elisabeth. *Michael Powolny: Keramik und Glas aus Wien, 1900 bis 1950, Monografie und Werkverzeichnis.* Bohlau Verlag Gesellschaft und Co. K.G., 1990.

PRUTSCHER, OTTO

Hochschule für Angewandte Kunst in Wien. *Otto Prutscher: 1880-1949.* Hochschule für Angewandte Kunst in Wien, Vienna, 1997. In German and English.

DE STIJL
1917-1928
DUTCH MODERN
1920-1950

HENDRIK NICOLAS (H.N.)
WERKMAN (1882-1945) Dutch
The Next Call, 1925.

KURT SCHWITTERS (1887-1948)
German
THEO VAN DOESBURG (1883-1931)
Dutch
Kleine Dada Soiree, 1922.

Blotkamp, Carel, et al. *De Stijl: The Formative Years.* The MIT Press, Cambridge, MA, 1982.

Foundation Cini. *Mondrian e De Stijl: L'Ideale Moderno.* Foundation Cini, Venice and Milan, 1990.

Friedman, Mildred, ed. *De Stijl: 1917-1931: Visions of Utopia.* Walker Art Center, Minneapolis / Abbeville, Press, New York, 1982. *

Giedion, Sigfried. *Mechanisation Takes Command: A Contribution to Anonymous History.* Harvard University Press, Cambridge, MA, 1947.

Haags Gemeentemuseum, The Hague. *De Stijl: New Plasticism in Architecture.* Delft University Press, 1983. *

Jaffe, H.L.C. *De Stijl: 1917 - 1931.* Harry N. Abrams, Inc., New York, 1971.

Overy, Paul. *De Stijl.* Dutton Pictureback / Studio Vista, London, 1969.

Overy, Paul. *De Stijl.* World of Art Series, Thames & Hudson, London, 1991.

Petersen, Ad, ed. *De Stijl.* Republication and complete reprint, vols I - VII and remaining numbers (1921-32). 2 vols. Athenaeum, Amsterdam / Bert Bakker, The Hague / Polak & Van Gennep, Amsterdam, 1968.

Timmer, Petra. *Metz & Co. de Creatieve Jaren.* Uitgeverij, Rotterdam, 1995. In Dutch.

See page 144

Troy, Nancy. *The De Stijl Environment*. MIT Press, Cambridge, MA, 1983.
Warncke, Carsten-Peter. *De Stijl: 1917-1931*. Benedikt Taschen Verlag, Cologne, 1991/1994.

INDIVIDUAL DESIGNERS

GISPEN, W.H.
Koch, André. *Industrial Designer Wh. Gispen: 1890-1981: A Modern Eclectic*. Uitgeverij de
hef, Rotterdam, 1988.

RIETVELD, GERRIT
Baroni, Daniele. *The Furniture of Gerrit Thomas Rietveld*. Barron's Educational Series,
Woodbury, NY, 1977-78.
Barry Friedman (Gallery). *Gerrit Rietveld: A Centenary Exhibition: Craftsman and
Visionary*. Barry Friedman, New York, 1988. *
Küper, Marijke and Ida van Zijl. *Gerrit Th. Rietveld: The Complete Works: 1888-1964*.
Centraal Museum, Utrecht, 1992. *
Overy, Paul, et al. *The Rietveld Schröder House*. The MIT Press, Cambridge, MA, 1988.
Vöge, Peter. *The Complete Rietveld Furniture*. 010 Publishers, Rotterdam, 1993.

VAN DER LECK, BART
Kröller-Müller Museum. *Bart van der Leck*. Kröller-Müller Museum, Otterlo, 1994. *

WIJDEVELD, HENDRIKUS THEODOROUS
Wereldtentoonstelling Voor Kolonien, Zeevaart en Vlaamsche Kunst te Antwerpen, 1930.
De Spieghel, Amsterdam, 1930. Introduction in four languages, description in Dutch and
French.

BAUHAUS
1919-1933

DEUTSCHE WERKBUND
1907-1934

See page 164

Bauhaus Archiv. *Die Metall Werkstatt am Bauhaus*. Bauhaus Archiv, Berlin, 1992. In
German. *
Bauhausdruck Co-Op. *Bauhaus: Junge Menschen Kommt Ans Bauhaus!* Bauhausdruck
Co-Op, Dessau, 1929.
Bayer, Herbert, ed. *Bauhaus 1919-1928*. The Museum of Modern Art, New York, 1938.
Buddensieg, Tilmann. *Berlin: 1900-1933. Architecture and Design*. Cooper-Hewitt
Museum, New York / Gebr. Mann Verlag, Berlin, 1987. *
Burckhardt, Lucius, ed. *The Werkbund: Studies in the History and Ideology of the Deutscher
Werkbund 1907-1933*. Gruppo Editoriale Electa,Venice, 1977 / Barron's Educational
Series, Inc. and the The Design Council, London, 1980.
Campbell, Joan. *The German Werkbund: The Politics of Reform in the Applied Arts*.
Princeton University Press, Princeton, NJ, 1978.
Dearstyne, Howard. *Inside the Bauhaus*. Rizzoli International Publications, New York, 1986.
Droste, Magdalena. *Bauhaus 1919-1933 / Bauhaus Archiv*. Benedikt Taschen, Cologne,
1990.
Ehrlich, Doreen. *The Bauhaus*. Brompton Books / Mallard Press, New York, 1991.
Fricke, Roswitha, ed. *Bauhaus Photography*. The MIT Press, Cambridge, MA, 1969-85.
Gunther, Sonja, Intro. *Thonet Tubular Steel Furniture*. Vitra Design Museum, Weil am
Rhein, Germany, 1989.
Hochman, Elaine S. *Bauhaus: Crucible of Modernism*. Fromm International Publishing
Corp., New York, 1997.
Itten, Johannes. *Design and Form: The Basic Course at the Bauhaus*. Reinhold Press, New
York, 1964. Translated by John Maass.
Lupton, Ellen and J. Abbott Miller, eds. *The abc's of... The Bauhaus and Design Theory*.
Princeton Architectural Press, New York, 1991 / 1993.
Museum für Gestaltung Zürich. *Bauhaus: 1919-1923 / Meister-Und Schülerarbeiten:
Weimar / Dessau / Berlin*. Benteli Verlag, Bern, 1988. In German. *
Naylor, Gillian. *The Bauhaus*. Dutton Pictureback / Studio Vista, London, 1968.

Naylor, Gillian. *The Bauhaus Reassessed: Sources and Design Theory*. E.P. Dutton, New York, 1985.

Neumann, Eckhard. *Bauhaus & Bauhaus People*. Van Nostrand Reinhold, New York, 1993. Rev. ed.

Rowland, Anna. *Bauhaus Source Book. Bauhaus Style and its Worldwide Influence*. Van Nostrand Reinhold, New York, 1990.

Royal Academy of Arts. *Bauhaus*. Württembergischer Kunstverein, Stuttgart / Royal Academy of Arts, London, 1968. *

Scheidig, Walther. *Bauhaus Weimar 1919-1924: Werkstättarbeiten*. Süddeutscher, Munich, 1966.

Schwartz, Frederic J. *The Werkbund: Design Theory & Mass Culture Before the First World War*. Yale University Press, New Haven, CN, 1996.

Sharp, Dennis. *Bauhaus, Dessau / Walter Gropius*. Architecture in Detail Series, Phaidon Press, London, 1993.

Weltge, Sigrid Wortmann. *Women's Work: Textile Art from the Bauhaus*. Chronicle Books, New York / San Francisco, 1993.

Westphal, Uwe. *The Bauhaus*. Gallery Books, London, 1991.

Whitford, Frank. *Bauhaus*. World of Art Series, Thames & Hudson, London, 1984.

Whitford, Frank. *The Bauhaus: Masters & Students by Themselves*. Conran Octopus, London, 1992.

Wick, Rainer. *Bauhaus Pädagogik*. DuMont, Cologne, 1982.

Wingler, Hans M. *The Bauhaus*. The MIT Press, Cambridge, MA, 1969-84.

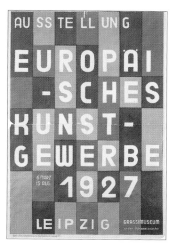

See page 165

INDIVIDUAL DESIGNERS

BAYER, HERBERT
Cohen, Arthur A. *Herbert Bayer: The Complete Work*. The MIT Press, Cambridge, MA, 1984.

BEHRENS, PETER
Buddensieg, Tilmann. *Industriekultur: Peter Behrens and the AEG, 1907-1914*. Gebr. Mann Verlag, Berlin / The MIT Press, Cambridge, MA, 1984.

BREUER, MARCEL
Droste, Magdalena and Manfred Ludewig. *Marcel Breuer*. Benedikt Taschen, Cologne, 1992.
Wilk, Christopher. *Marcel Breuer: Furniture and Interiors*. The Museum of Modern Art, New York, 1981.*

GROPIUS, WALTER
Busignani, Alberto. *Gropius*. Twentieth-century Masters Series, Mamlyn Publishing Group, 1973.
Giedion, Sigfried. *Walter Gropius*. Dover Publications, New York, 1992.

MIES VAN DER ROHE, LUDWIG
Art Institute of Chicago. *Mies Reconsidered: His Career, Legacy and Disciples*. Art Institute of Chicago / Rizzoli International Publications, New York, 1986.
Blaser, Werner. *Mies van der Rohe: The Art of Structure*. Whitney Library of Design Series, Watson-Guptill Publications, New York, 1993.
Johnson, Philip C. *Mies van der Rohe*. The Museum of Modern Art, New York, 1947. *
Schulze, Franz. *Mies van der Rohe: A Critical Biography*. The University of Chicago Press, 1985.

ART DECO
1920-1940

Arwas, Victor. *Art Deco*. Harry N. Abrams, New York, 1980.

Barré-Despond, Arlette. *Union des Artistes Modernes*. Éditions du Regard, Paris, 1986. In French.

Battersby, Martin. *The Decorative Twenties*. Walker & Co., New York, 1969.

Battersby, Martin. *The Decorative Thirties*. Walker & Co., New York, 1971.

Bayer, Patricia. *Art Deco Interiors: Decoration and Design Classics of the 1920s and 1930s*. Thames & Hudson, London, 1990.

Bony, D'Anne. *Les Années 30*. 2 vols. Éditions de Regard, Paris, 1972.

Bouillon, Jean-Paul. *Art Deco*. Skira / Rizzoli International Publications, New York, 1989.

The Brooklyn Museum. *The Machine Age in America, 1918-1944.* Harry N. Abrams, New York, 1986. *

Brunhammer, Yvonne. *The Nineteen Twenties Style.* Paul Hamlyn, London, 1969.

Brunhammer, Yvonne. *Arts Décoratives Des Années 20.* Editions du Seuil et Regard, Paris, 1991.

Brunhammer, Yvonne. *Le Mobilier Français: 1930-1960.* Editions Massin, Paris, 1997. In French.

Brunhammer, Yvonne and Suzanne Tise. *The Decorative Arts in France: La Société des Artistes Décorateurs 1900-1942.* Rizzoli International Publications, New York, 1990.

Bush, Donald J. *The Streamlined Decade.* George Braziller, New York, 1975.

Darton, Mike, ed. *Art Deco: An Illustrated Guide to the Decorative Style, 1920-40.* Quintet Publishing, London, 1989.

Detroit Institute of Arts. *Design in America: The Cranbrook Vision 1925-1950.* Harry N. Abrams, New York, 1983. *

Duncan, Alastair. *Art Deco Furniture.* Holt, Rinehart and Winston, New York, 1984.

Duncan, Alastair. *American Art Deco.* Harry N. Abrams, New York, 1987. *

Duncan, Alastair. *Art Deco.* World of Art Series, Thames & Hudson, New York, 1988.

Duncan, Alastair. *The Encyclopedia of Art Deco: An Illustrated Guide to a Decorative Style from 1920 to 1939.* E.P. Dutton, New York, 1988.

Duncan, Alastair. *The Paris Salons 1895-1914.* 8 vols. The Antique Collectors' Club, Woodbridge, Suffolk, 1995-97.

Glassgold, R.L. Leonard and C.A., eds. *Modern American Design by the American Union of Decorative Artists and Craftsmen.* Ives Washburn, New York, 1930. Reprint: Acanthus Press, New York, 1992.

The Grand Palais, Paris. *Industrial Design: Reflection of a Century.* Flammarion/APCI, Paris, 1993. *

Greif, Martin. *Depression Modern: The Thirties in America.* Universe Books, New York, 1975.

Hageney, Wolfgang, ed. *Repertoire Modern Interior Design: 1928-1929, Vols. 1-5.* Archi Books, Belvedere, Rome, 1986.

Haslam, Malcolm. *Art Deco: Collector's Style Guide.* Ballantine Books, New York, 1988.

Heide, Robert and John Gilman. *Popular Art Deco: Depression Era Style and Design.* Abbeville Press, New York, 1991.

Hillier, Bevis. *Art Deco of the '20s and '30s.* Dutton Pictureback, Studio Vista, London, 1968.

Hillier, Bevis. *Art Deco.* The Minneapolis Institute of Arts, 1971. *

Hillier, Bevis and Stephen Escritt. *Art Deco Style.* Phaidon Press, London, 1997.

Horsham, Michael. *'20s & '30s Style.* The Apple Press, London, 1989.

Kjelberg, Pierre. *Le Mobilier du XXe Siècle: Dictionnaire des Créateurs.* Les Éditions de L'Amateur, Paris, 1994.

Klein, Dan, et al. *In the Deco Style.* Rizzoli International Publications, New York, 1987.

Leonard, R.L. and C. A. Glassgold. *Modern American Design by the American Union of Decorative Artists and Craftsmen.* Acanthus Press Reprint Series, New York, 1992.

Lesieutre, Alain. *The Spirit and Spendour of Art Deco.* Castle Books, Seacaucus, NJ, 1974.

Lichtenstein, Claude and Franz Engler. *Streamlined: A Metaphor for Progress. The Esthetics of Minimized Drag.* Lars Muller Publishers, Baden, Switzerland, n.d. *

McClinton, Katharine Morrison. *Art Deco: A Guide for Collectors.* Clarkson N. Potter, New York, 1972.

McCready, Karen. *Art Deco and Modernist Ceramics.* Thames & Hudson, London, 1985.

Meikle, Jeffrey L. *Twentieth Century Limited: Industrial Design in America, 1925-1939.* Temple University Press, Philadelphia, 1979.

Menten, Theodore. *The Art Deco Style.* Dover Publications, New York, 1972.

The Montreal Museum of Fine Arts. *The 1920s: Age of the Metropolis.* The Montreal Museum of Fine Arts, 1991. *

Morgan, Sarah. *Art Deco: The European Style.* Dorset Press, 1990.

Musée d'Art Moderne de la Ville de Paris. *Meubles: 1920-1937.* Coédition Paris - Musées et Sociétié des Amis de Musée d'Art Moderne, 1986. In French. *

Musée d'Ixelles. *Art Deco Belgique, 1920-1940.* Editions I.P.S.,1988. In French. *

The Museum of Modern Art, New York. *Machine Art.* Distributed by Harry N. Abrams, 1934. Reprint edition, Arno Press, 1969. Sixtieth Anniversary Edition, The Museum of Modern Art, New York, 1994. *

Néret, Gilles. *The Arts of the Twenties.* Rizzoli International Publications, New York, 1986.

Ostergard, Derek, E. and Nina Stritzler-Levine. *The Brilliance of Swedish Glass, 1918-1939: An Alliance of Art and Industry.* Yale University Press, New Haven, CT, 1996. *

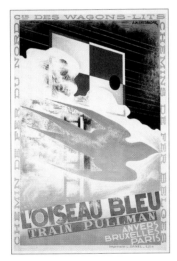

See page 192

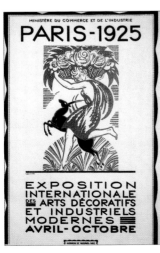

See page 193

Primus, Zdenek. *Tscheschische Avantgarde: 1922-1940*. Reflexe Europäischer Kunst und Fotografie in der Buchgestaltung. Vier-Türme-Verlag, Münsterschwarzach, 1996. In German.

Rassegna #26. *Furniture Design in France, 1919-1939*. Milan, 1979. In Italian with English translation.

Read, Herbert. *Art and Industry: The Principles of Industrial Design*. Horizon, New York, 1954.

Société des Expositions du Palais des Beaux-Arts Bruxelles. *L'Art Deco en Europe*. Palais des Beaux-Arts, Brussels, 1989. In French. *

Sparke, Penny. *As Long As It's Pink: The Sexual Politics of Taste*. Pandora, London, 1995.

Spours, Judy. *Art Deco Tableware: British Domestic Ceramics, 1925-1939*. Rizzoli International Publications, New York, 1988.

Teague, Walter Dorwin. *Design This Day: The Technique of Order in the Machine Age*. Harcourt, Brace & Co., New York, 1949.

Van de Lemme, Arie. *A Guide to Art Deco Style*. Chartwell Books, New York, 1986.

Vegesack, Alexander von, ed. *Czech Cubism: Architecture, Furniture and Decorative Arts, 1910-1925*. Princeton Architectural Press, New York, 1992.

Weber, Eva. *Art Deco in America*. Execter Books, New York, 1985.

Whitney Museum of American Art. *High Styles: Twentieth Century American Design*. Summit Books, New York, 1985. *

INDIVIDUAL DESIGNERS & DESIGN FIRMS

AALTO, ALVAR
Blaser, Werner. *Il Design di Alvar Aalto*. Electa, Milan, 1981. In Italian.
Pallasmaa, Juhani, ed. *Alvar Aalto Furniture*. Museum of Finnish Architecture. Distributed by The MIT Press, Cambridge, MA, 1985. *
Schildt, Göran. *Alvar Aalto: The Complete Catalogue of Architecture, Design and Art*. Rizzoli International Publications, New York, 1994.

BEL GEDDES, NORMAN
Bel Geddes, Norman. *Horizons*. Little Brown, Boston, 1932.

CARDER, FREDERICK
Gardner, Paul V. *Frederick Carder: Portrait of a Glassmaker*. The Corning Museum of Glass, Corning, NY, 1985. *

CHAREAU, PIERRE
Rubino, Luciano. *Pierre Chareau & Bernard Vijvoet, Dalla Francia Dell'Art Déco verso un'Architettura Vera*. Edizioni Kappa, Rome, 1982. In Italian.
Taylor, Brian Brace. *Pierre Chareau: Designer and Architectt*. Benedikt Taschen Verlag, Cologne, 1992.
Vellay, Marc and Kenneth Frampton. *Pierre Chareau: Architect and Craftsman*. Rizzoli International Publications, New York, 1984.

COPIER, A.D.
Ricke, Helmut. *A.D. Copier: Trilogie in Glas*. Uitgeverij de Hef, Rotterdam, 1991. In German.

DESKEY, DONALD
Hanks, David A. and Jennifer Toher. *Donald Deskey: Decorative Designs and Interiors*. E.P. Dutton, New York, 1987.

DREYFUSS, HENRY
Dreyfuss, Henry. *Designing for People*. Simon & Schuster, New York, 1955.

DUNAND, JEAN
Marcilhac, Felix. *Jean Dunand: His Life and Works*. Harry N. Abrams, New York, 1991.

GRAY, EILEEN
Garner, Philippe. *Eileen Gray: Designer and Architect*. Benedikt Taschen Verlag, Cologne, 1993.
Johnson, J. Stewart. *Eileen Gray: Designer*. Debrett's Peerage, London, 1979. *

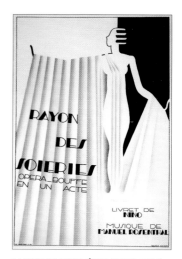

MAURICE DUFRÈNE (1876-1955)
French
Rayon des Soieries, 1930. Poster / color lithograph.

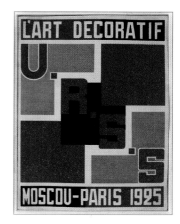

ALEXANDER RODCHENKO (1891-1956) Russian
One of the catalogues for the Russian section of the 1925 Paris Exposition.

ERTÉ (Romain de Tirtoff) (1892-1990) French
Shoebox, c.1950. One of a series of boxes and related graphics commissioned for the Young-Quinlan Department Store, Minneapolis.

JOURDAIN, FRANTZ, FRANCIS and FRANTZ-PHILIPPE
Barré-Despond, Arlette. *Jourdain*. Rizzoli International Publications, New York, 1988.

KIESLER, FREDERICK
Phillips, Lisa, ed. *Frederick Kiesler*. Whitney Museum of American Art / W.W. Norton & Co., New York, 1989. *

LE CORBUSIER
De Fusco, Renato. *Le Corbusier, Designer: Furniture, 1929*. Barron's, Woodbury, NY, 1977.

LOEWY, RAYMOND
Loewy, Raymond and Peter Mayer. *Industrial Design: Raymond Loewy*. The Overlook Press, Woodstock, NY, 1979.
Schönberger, Angela, ed. Raymond Loewy: *Pioneer of American Industrial Design*. Prestel-Verlag, Munich, 1990.

NATZLER, GERTRUD and OTTO
American Craft Museum. *Gertrud and Otto Natzler: Collaboration / Solitude*. American Craft Museum, New York, 1993. *

ORREFORS GLASSWORKS
Duncan, Alastair. *Orrefors Glass*. Antique Collectors' Club, Woodbridge, Suffolk, 1995.

PUIFORCAT, JEAN
De Bonneville, Françoise. *Jean Puiforcat*. Éditions du Regard, Paris, 1986.

PROUVÉ, JEAN
Sulzer, Peter. *Jean Prouvé: Œuvre Complete: Vol. 1, 1917-1933*. Ernst Wasmuth Verlag, Tübingen / Berlin, 1995. Text in French and English.
Van Geest, Jan. *Jean Prouvé: Furniture*. Benedikt Tashen Verlag, Cologne, 1991.

TEAGUE, WALTER DORWIN
Teague, Walter Dorwin. *Design This Day: The Technique of Order in the Machine Age*. Harcourt, Brace & Co., New York, 1940.

URBAN, JOSEPH
Carter, Randolph and Robert Reed Cole. *Urban: Architecture/ Theater/ Opera/ Film*. Abbeville Press, New York, 1992.

WEBER, KEM
Gebhard, David and Harriette Von Breton. *Kem Weber: The Moderne in Southern California, 1920-1941*. Art Galleries, University of California, Santa Barbara, 1969. *

WRIGHT, RUSSEL
Hennessey, William J. *Russel Wright: American Designer*. The MIT Press, Cambridge, MA, 1983.
Kerr, Ann. *The Collector's Encyclopedia of Russel Wright Designs*. Collector Books, Paducah, NY, 1990.

ZEISEL, EVA
Eidelberg, Martin. *Eva Zeisel: Designer for Industry*. Le Château Dufresne, Musée des Arts Décoratifs de Montreal, Montreal and University of Chicago Press, Chicago, 1984. *

CHARLES COINER (1898-1989)
American
Give it Your Best, 1942.

Label copy, descriptive captions, artists' list and bibliography
compiled and written by David Ryan

INDEX

Page references in bold type refer to illustrations and captions

CHRISTIAN DELL (1893-1974) German
Tee-Ei (Tea Diffuser), 1924. Silvered brass.
H: 5 ½in (14cm) x D: ⅝in (1.6cm)